CW01024309

AEGEAN BRONZE AGE ART

How do we interpret ancient art created before written texts? Scholars usually put ancient art into conversation with ancient texts in order to interpret its meaning. But for earlier periods, without texts, such as the Bronze Age Aegean, this method is redundant. Using cutting-edge theory from art history, archaeology and anthropology, Carl Knappett offers a new approach to this problem by identifying distinct actions – such as modelling, combining and imprinting – whereby meaning is scaffolded through the materials themselves. By showing how these actions work in the context of specific bodies of material, Knappett brings to life the fascinating art of Minoan Crete and surrounding areas in novel ways. With a special focus on how creativity manifests itself in these processes, he makes an argument for not just how creativity emerges through specific material engagements but also why creativity might be especially valued at particular moments.

CARL KNAPPETT is the Walter Graham/Homer Thompson Chair in Aegean Prehistory at the University of Toronto. He is author and editor of *An Archaeology of Interaction* (2011), *Network Analysis in Archaeology* (2013) and *Thinking through Material Culture* (2005). Since 2011, he has directed an archaeological fieldwork project at the Bronze Age site of Palaikastro in east Crete.

AEGEAN BRONZE AGE ART

MEANING IN THE MAKING

CARL KNAPPETT

University of Toronto

CAMBRIDGE
UNIVERSITY PRESS

University Printing House, Cambridge CB2 8BS, United Kingdom

One Liberty Plaza, 20th Floor, New York, NY 10006, USA

477 Williamstown Road, Port Melbourne, VIC 3207, Australia

314–321, 3rd Floor, Plot 3, Splendor Forum, Jasola District Centre,
New Delhi – 110025, India

79 Anson Road, #06–04/06, Singapore 079906

Cambridge University Press is part of the University of Cambridge.

It furthers the University's mission by disseminating knowledge in the pursuit of
education, learning, and research at the highest international levels of excellence.

www.cambridge.org
Information on this title: www.cambridge.org/9781108429436
DOI: 10.1017/9781108554695

First published 2020

Printed in Singapore by Markono Print Media Pte Ltd

A catalogue record for this publication is available from the British Library.

Library of Congress Cataloging-in-Publication Data
NAMES: Knappett, Carl, author.
TITLE: Aegean Bronze Age art : meaning in the making / Carl Knappett,
 University of Toronto.
DESCRIPTION: Cambridge ; New York : Cambridge University Press, 2020. |
 Includes bibliographical references and index.
IDENTIFIERS: LCCN 2019038292 (print) | LCCN 2019038293 (ebook) | ISBN 9781108429436
 (hardback) | ISBN 9781108452830 (paperback) | ISBN 9781108554695 (epub)
SUBJECTS: LCSH: Art, Ancient–Aegean Sea Region. | Creation (Literary, artistic, etc.)
CLASSIFICATION: LCC N5475 .K59 2020 (print) | LCC N5475 (ebook) |
 DDC 709/.0130916388–DC23
LC record available at https://lccn.loc.gov/2019038292
LC ebook record available at https://lccn.loc.gov/2019038293

ISBN 978-1-108-42943-6 Hardback

Publication of this book has been aided by a grant from the von Bothmer Publication Fund of
the Archaeological Institute of America.

CONTENTS

FIGURES

ACKNOWLEDGEMENTS

This book has grown out of teaching 'ancient art' in the Department of Art History at the University of Toronto. My department has long housed an Aegean specialist, starting with J. Walter Graham in 1947; after two decades he passed on the baton to Joseph Shaw, who held the post for three decades. The department at one point in those early days was called Art and Archaeology, but it evolved to a point where the archaeology was in a distinct minority. Recently, we have been Art, History of Art and now Art History. But names aside, there is no escaping the fact that undergraduates specialising in this field bring certain expectations to an Art History course – expectations that can be confounded when they realise just how 'archaeological' a course on Aegean Bronze Age art and architecture needs to be. Although for the student there is no escaping this archaeological dimension, by the same token I have had to confront my assumptions about the art-historical dimensions of Aegean material culture and be able to teach this material so that the student of art history can achieve a better grasp. I have come to believe that we can find new ways to penetrate the riches of protohistoric Aegean material culture. There is so much scholarship that we can very fruitfully bring to bear on ancient art and art theory. Furthermore, as I shall argue in Chapter 1, the material offers particular advantages for thinking through how meaning is 'made' in acts of production and use.

While it is my experiences in class that have persuaded me of the need to find new angles, it is my fantastic colleagues who have encouraged me to believe that there do exist means for bringing protohistoric art into various art-historical conversations. I thank Elizabeth Legge for her wise counsel, and John Ricco, Giancarla Periti, Matt Kavaler and Jordan Bear for many a stimulating discussion. Special thanks also go to my colleagues in 'ancient art', Bjoern Ewald and SeungJung Kim. My graduate students – Rachel Dewan, Paula Gheorghiade, Rachel Kulick, Tia Sager and Elana Steingart – have been equally valuable. I have been especially fortunate also in having close colleagues in the Department of Anthropology, not least Ted Banning, Michael Chazan, Gary Coupland and Ed Swenson. More recently, I have enjoyed working closely with Sarah Murray of the Classics Department in teaching a

Methods class as part of the Mediterranean Archaeology Collaborative Specialization.

I really began writing while a Getty Scholar in 2014 at the Getty Research Institute. I am grateful to the then director, Thomas Gaehtgens, Head of the Scholars Program, Alexa Sekyra and Scholars Program Associate, Peter Bonfitto, for this wonderful experience. My fellow scholars at the Getty Villa – Sandra Blakely, Owen Doonan, Alex Knodell, Ariane de Saxcé and Caroline Sauvage – were great company.

Colleagues and students at various institutions – University of California Berkeley, University of California San Diego, University of Cincinnati, McMaster University, Tulane University, the University of Waterloo and Western University – were kind enough to invite me to speak on some of the content I present here, and to share their responses.

I am immensely grateful to Jean-Claude Poursat for reading the manuscript in full. His magnificent two-volume *L'art égéen*, which I am now in the process of translating into English for Cambridge University Press, has served as a foil to my approach in this book. Both Chris Watts and Diamantis Panagiotopoulos also very kindly read through the manuscript and provided feedback. Quentin Letesson, Astrid van Oyen, Florence Gaignerot-Driessen, Matt Kavaler and Morten Pedersen read chapters. All offered invaluable feedback. I am grateful, too, for Lambros Malafouris' help in discussing questions around fragmentation in Mycenaean art and for putting me on to the example from Tiryns. Andrew Shapland has also been most generous in sharing his thoughts on Aegean art. I would like as well to thank two anonymous reviewers for their very helpful insights and constructive feedback.

For help with illustrations, I thank Kostas Paschalidis at the National Archaeological Museum in Athens; Olga Krzyszkowska; Maria Anastasiadou and the Corpus der Minoischen und Mykenischen Siegel; Tania Devetzi and Christos Doumas of the Akrotiri Excavations; Jack Davis and Shari Stocker, for the images from Pylos; Amalia Kakassis, archivist of the British School at Athens; Calliopi Christophi of L'Ecole Française d'Athènes; the Museum of Thebes; Panayiotis Chatzidakis, Ephor of Samos and Ikaria; Penn Museum; Paramount and the AMPAS Library; and Kristina Matevski, my assistant, for particular help with certain figures. A special note of thanks goes to the Heraklion Museum, and its director, Stella Mandalaki, as many of the images come from this fine collection; Georgia Flouda and Katerina Athanasaki were also both very helpful in sourcing these illustrations. Generous publication grants from both the Archaeological Institute of America and the Institute for Aegean Prehistory allowed for the production of the illustrations in colour.

On various Aegean questions, I have always been able to rely on my dear friend, Irene Nikolakopoulou, for advice and discussion. I thank her from the

bottom of my heart for her trust and friendship over the years. Florence Gaignerot-Driessen kindly assisted with French translations in the text.

Beatrice Rehl, editor at Cambridge University Press, has been wonderfully supportive throughout the process of shepherding this book through to press, and I would like to thank her for her long commitment to the publication of Aegean archaeology. Lastly, I dedicate this book to my family – Ermira, Daniela and George.

CHRONOLOGICAL TABLE

Period	Crete	Cyclades	Mainland	Cretan Palatial period	Absolute Dates BC
EBA	EM I	EC I	EH I	**Prepalatial**	3100–2650
	EM II	EC II	EH II		2650–2200
	EM III	EC III	EH III		2200–2000
MBA	MM IA	MC	MH		2000–1925
	MM IB			**Protopalatial**	1925–1800
	MM II				1800–1700
	MM III			**Neopalatial**	1700–1600
LBA	LM IA	LC I	LH I		1600–1525
	LM IB		LH IIA		1525–1450
	LM II	LC II	LH IIB	**Final Palatial**	1450–1400
	LM IIIA	LC III	LH IIIA		1400–1325
	LM IIIB		LH IIIB	**Postpalatial**	1325–1200
	LM IIIC		LH IIIC		1200–1075

Terms Used

Late Neolithic = LN
Final Neolithic = FN
Early Bronze Age = EBA
Middle Bronze Age = MBA
Late Bronze Age = LBA
Early Minoan = EM
Middle Minoan = MM
Late Minoan = LM
Early Cycladic = EC
Middle Cycladic = MC
Late Cycladic = LC
Early Helladic = EH
Middle Helladic = MH
Late Helladic = LH
Prepalatial = EMI to MMIA
Protopalatial = First Palace Period, or Old Palace Period
Neopalatial = Second Palace Period, or New Palace Period

THEORISING 'MEANING IN THE MAKING'

ANCIENT, PREHISTORIC OR PROTOHISTORIC ART?

When we think of 'ancient art', it is probably the architecture, sculpture and paintings of Greece, Rome and Egypt that come to mind. These are archetypes that form our vision of ancient art.[1] That they occur in literate cultures in which art and text go hand-in-hand is hardly a coincidence. As suggested in a recent Companion to Greek Art, Classical archaeologists 'would rarely, if ever, speak of the Athena Parthenos, a gold and ivory cult statue designed by the sculptor Pheidias, without referencing Pliny or Pausanias'.[2] Herein we find another clue to the apparent accessibility of the art of these cultures: that artists may also be named, in this case Pheidias. We might feel that this focus on what Smith and Plantzos call the 'triumvirate' of architecture, sculpture and painting is perfectly reasonable, if these art forms are prevalent, and their study produces rich results. The downside, however, is that it leaves 'much of the rest relegated to the ill-defined catch-all phrase of "minor arts"'.[3]

This bias towards 'major' over 'minor' arts becomes much more problematic when we try to explore other versions of ancient art: versions that may have little sculpture or painting to speak of, or that do not go hand-in-hand with texts. If we have in mind various kinds of prehistoric art, then of course by definition we will not have any kind of interaction between art and text to consider. If such art is then in a sense more isolated, lacking such interaction with other cultural outputs, does this make the treatment of prehistoric art

intrinsically more challenging? Presumably it does make it a different kind of exploration, if one of the main preoccupations of the Classical art historian, for example, is the relationship between art, literature and history.[4] Some prehistoric art is thus hardly treatable under the same rubric as Classical art if such considerations simply do not arise. And to go to some of the very earliest ancient art, in the Middle and Upper Palaeolithic, a division between major and minor arts makes little sense.[5] Yes, there may be some parietal art, but much of what we call art in these periods is small-scale and seems closely concerned with bodily adornment. Most art historians, with some interesting exceptions,[6] are unlikely to give it much attention.

Perhaps one solution is to separate (earlier) prehistoric from (later) ancient art. Yet, what happens to those forms of art that fall in between the two? A prime example is the art of the Bronze Age Aegean. With a timespan from c. 3000 to 1100 BC, it is a largely prehistoric period, though towards the middle part of the Late Bronze Age the deciphered Linear B script appears. Texts do occur in the Middle Bronze Age – Linear A and Cretan Hieroglyphic – but both remain undeciphered. Many of the specialists working in these periods certainly consider themselves prehistorians; and the field is habitually called 'Aegean prehistory', which has the advantage of including the Neolithic period within its broader research questions. In French scholarship, the term 'protohistoire' is used to capture the in-betweenness of the Bronze Age periods in the Aegean – still prehistory, but with texts nonetheless. Protohistory also conveys the sense of this coming a little before the 'history' of first millennium Greece – and of course, in the same geographical locale. Pre- and proto-historic scholarship tends to use the term 'Aegean' rather than Greek because it better incorporates coastal Anatolia, very much part of this world in the third and second millennia BC.

The art of the Bronze Age Aegean is sometimes included in general overviews of ancient Greek art – perhaps increasingly so.[7] Yet, Bronze Age art has little by way of sculpture, architecture and painting, certainly when compared to Classical Greece; and there are no named artists, and nothing by way of art–text relations. And as has been noted by Polychronopoulou, when Bronze Age art was first revealed, scholars struggled with how to treat it, settling on a description of Mycenaean art as a primitive precursor to the true arts of Classical Greece.[8] For the Bronze Age Aegean to be included in textbooks on Greek art involves a delicate balancing act between a recognition that these minor arts deserve attention in their own right, while at the same time they are being implicitly contrasted with the later major arts of the Classical period.[9]

My aim here is not to propose a radical demarcation of prehistoric, protohistoric and ancient art. What I do wish to highlight is the rather limited view of ancient art that comes from regarding it as so closely tied to text. If we are

concerned primarily with the relations between art, literature and history, then it is perhaps inevitable that the major arts come to the fore (since presumably minor arts will feature less in literature and history). But if we loosen this connection, and prise ancient art away from texts, then perhaps it becomes possible to construct a much broader sense of ancient art that can span prehistory, protohistory and history. For that matter, why stop there? Why differentiate something separately 'ancient'? This question is an interesting one, as would be the goal of uniting many different kinds of ancient art. This is not the aim of this book, though, as that becomes a far bigger project. My aim here is more immediate and modest: to use the evidence from the Aegean Bronze Age to show how it can very usefully disrupt some assumptions about ancient art. Arguably due to its transitional, protohistoric status, it attracts quite different kinds of scholarship – both art-historical on the one hand (perhaps in part stemming from its perceived status as pre-Hellenic or Classical archaeology), and anthropological on the other. Let us not pretend, however, that these distinct strands currently are in productive dialogue. The art-historical research lives quite separately from anthropological enquiry, in many cases. The art-historical tradition is mostly atheoretical, drawing little if anything from current art theory, and certainly not from anthropological theory; while the anthropological tradition is quite good at handling everyday material culture, but tends to avoid artworks. And yet by treating artworks and artefacts together using ideas from both art theory and anthropological archaeology, we might give ourselves new interpretative possibilities.

WHAT'S NEW?

The irony is that some of the above may not have seemed all that new in the mid to late nineteenth century. There was then already a reaction against the Enlightenment admiration of individual masterpieces. This was when the study of the past was essentially antiquarian, before the discipline of archaeology had formed. The antiquarian collecting of Classical Greek art in the mid-eighteenth century was led by Winckelmann's intellectualisation and appreciation of Greek ideals of beauty.[10] Outstanding pieces of great beauty were literally put on a pedestal and expected to represent the ideals of an entire ancient culture. The practice of collecting removed such pieces from their context, an act of isolation facilitating their fetishised appreciation. Those from Classical Greece could also, of course, be discussed in relation to the literature and history of the time, which provided a different kind of ideational if not material context.

What is then interesting is how the challenge to this pure, aesthetic approach came about at least in part through the archaeological discovery of prehistoric cultures. Johannes Ranke, for example, writing in 1879, and

influenced by the earlier writings of Gottfried Semper, argued that the every-day objects uncovered from prehistory should be included in our accounts of early art.[11] Others writing at this time, like Alexander Conze, expressed similar sentiments, as did Alois Riegl a little later. The 1870s were when Heinrich Schliemann embarked on his journey of remarkable archaeological discoveries in Greece, and this can hardly be coincidental. One might also consider the contribution of the anthropological collecting of all kinds of 'everyday' things at this time too, with Pitt Rivers the prime example.[12] All of these develop-ments serve to underscore the 'materialist' approach of Semper.

Of course, part of the attraction for these scholars of getting to think about such minor arts was the possibility of charting evolutionary pathways in art's development. This seems common to both art history and anthropology, another sign of their relatively close relationship at this time. We can find in early works, such as those of Semper and Riegl, certain evolutionary ideas that some forms of art are more 'primitive' than others. The more primitive forms are those that remain close to the materials that inspire them – as in the example often taken from Semper, of geometric decoration deriving from basketry forms.[13] It is this phenomenon that is also identified in the Anglo-Saxon literature by Colley March and Haddon and dubbed 'skeuomorphism'.[14] Within the primitive societies in which such artistic expression exists, artefactual change comes about as a material prerogative, rather than through the expression of any individual mental genius. However, in more developed societies, with more advanced forms of expression, the material imperative is transcended by conceptually driven, more abstracted artefacts (i.e., major arts).[15] Change is then wrought by minds, not materials. This was a significant reversal that Riegl introduced to counter Semper's perceived materialism.[16] Rampley has argued that Riegl's countering of Sem-per was influenced by ethnography, yet another indication of the closeness of art history and anthropology at the beginning of the twentieth century; here too one should mention Aby Warburg, famously drawn to ethnography, and indeed also influenced by Semper.[17]

So, the inclusion of all kinds of seemingly everyday things in a reformed art history in the latter part of the nineteenth century might appear quite promising for the study of prehistoric cultures, including the Bronze Age Aegean. But with Riegl's influence, it led to an evolutionary framework in which the major arts of later, more evolved cultures were simply shown to develop from the minor arts of earlier, more primitive cultures. This gave a certain depth to art history, but of a kind that kept the prehistoric firmly in its place and on a quite different level from later cultures. When we look specifically at the Bronze Age Aegean and consider how the study of its art panned out over the early part of the twentieth century, moving from Schliemann's discoveries at Troy and Mycenae to Evans's at Knossos, it is interesting that the art historians who attempt an art-historical

synthesis with these findings are largely working in the German tradition.[18] That is to say, they continue to follow this line from Semper, Conze and Riegl of the value of more everyday items, and not only major arts, which are of course somewhat absent from the prehistoric Aegean. Perhaps their accounts are excessively essentialising and 'mentalist', but at least they are going beyond Classical Greece to pursue art histories in what is essentially prehistory (especially at that time, before the decipherment of Linear B).

Thus, although the move towards the study of more humble materials initiated by Semper in the 1850s was in many ways very progressive, it found itself trapped within a mentalist, evolutionary framework that ultimately did not permit a rounded evaluation of prehistoric 'minor' arts. And this outlook did persist well into the twentieth century. But while the evolutionary and essentialising premises may have been shaken off, many of the mentalist assumptions seem to linger, with the notion that art is a prism, through which one can see more clearly and immediately into the minds of the ancients, still quite prevalent. One can even trace it through to works on Aegean Bronze Age art in the second half of the twentieth century, with Pierre Demargne's 1964 *Naissance de l'art grec*, to Reynold Higgins' 1967 *Minoan and Mycenaean Art*, and Sinclair Hood's 1978 *The Arts in Prehistoric Greece*. A persistent privileging of major over minor arts probably comes in part from the weight of Classical archaeology pushing back upon the treatment of these earlier periods. And we should not pick these works out for special criticism, since 'hylomorphism' – the idea that mind imposes form on material – continues to be a very common if implicit idea.[19]

THE LOCUS OF CREATIVITY IN MINOR/MAJOR ARTS

The problem with the privileging of exquisite artworks at the expense of more mundane objects is that it implicitly suggests that creativity lies in the former and not in the latter. It also reinforces the notion that the locus of creativity is in some mental domain, where ideas are generated and subsequently executed in material form. If one agrees with this, then it makes perfect sense to focus heavily on those artworks that appear to be the most abstracted from nature, as it is these that by extension ought to show the richest mental content. If it is the higher arts that are more mentally pure, then it is these that we should focus upon if we really wish to transcend the material and get to the ancients' thoughts and beliefs. But let us pause for a moment and see what this does for our understanding of Aegean Bronze Age art. Let us take the Aegean art form that is so often credited with a kind of artistic freedom and creativity – the Theran wall paintings.

Within a representational paradigm, it seems quite logical to see these objects as the most expressive form of art in the ancient Aegean (Figure 1.1).

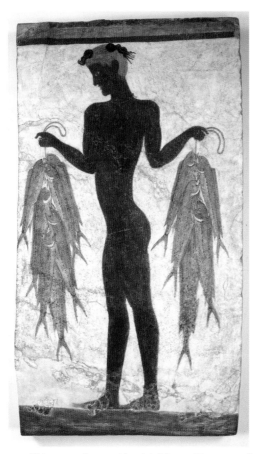

1.1 Fisherman fresco, Akrotiri Thera. Courtesy of the Akrotiri Excavations.

They appear to come from nowhere – figurative painting at this scale is entirely new. We even read sometimes of these including the first life-size male nudes in the history of art. With the creation of line seen in such painting, surely it is acceptable to say that we are witnessing a release from material imperative, and the freedom of creative choice? And when the freedom of movement in Minoan wall painting is contrasted with the rigidity of Egyptian examples, we see the dream of the distant roots of Western art subconsciously expressed.[20] It has been further argued that other existing art forms – minor ones, of course – are somehow rendered mute and lose their innovative edge in the face of this artistic move, with seals now merely recapitulating narrative scenes devised in the medium of fresco.[21]

In this way, the Theran wall paintings are placed on a pedestal and revered as major arts. This might be seen in some sense as a progressive move, because at least it does recognise that this prehistoric society was capable of major arts, which are not the sole preserve of the later historical periods of Classical Greece. But these frescoes are anything but typical of the artistic output of the Bronze Age Aegean. They are relatively few and far between, with a high concentration in one place in one period (Thera, Late Minoan IA). Artistic expression goes way beyond the frescoes, despite the disproportionate attention they receive. And far from rendering mute other art forms, as Blakolmer suggests, the other side of the coin is that they owe their emergence to a preexisting tradition of figural representation, particularly in glyptic; hence the transfer from three dimensions to a two-dimensional form was a development embedded in this tradition.[22] Indeed, some of the earliest figural frescoes, the acrobats and bulls from Knossos, are in high relief,[23] and so could quite conceivably be connected to the long tradition of relief carving in stone. Moreover, the Theran wall paintings are prefigured by narrative scenes on pottery, with a tall jug bearing a scene of human figures pouring a libation (Figure 1.2), a bathtub with a hunting scene and a barrel jar depicting a griffin.[24] Figurative fresco, for all its

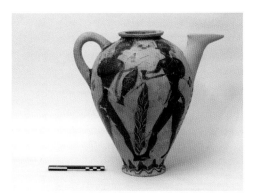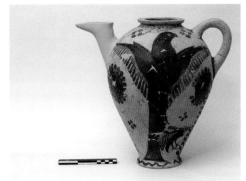

1.2 A bichrome figurative vase, Akrotiri Thera. Courtesy of the Akrotiri Excavations.

creativity, piggybacks on the figuration in glyptic, which rather robs it of some of its freedom, given the functional nature of some glyptic (for sealings used in administration), the closeness of seals to the human body, and their miniature scale, a form often dismissed as banal, playful or child-like.

For the Bronze Age Aegean at least, it makes little sense to ascribe creativity to the major arts alone. Not only are they few and far between, but the so-called minor arts see an enormous amount of creative change. When one looks at the variation and innovation in glyptic, for example, it becomes difficult to really think of it as in any way 'minor'. However, this is certainly not to say that glyptic is just as 'mental' and free from material imperative as wall paintings. The argument I develop in this book is aimed at escaping from this hopeless material vs. mental impasse. What I want to do above all is show **how** creativity is often played out *through* and *with* materials, not as some mentally transcendent (hylomorphic) exercise. In a way, it is to recognise that Semper was on to something. But while Semper's legacy, too, became mired in the hylomorphic way of thinking, what we must do to avoid this is carefully to lay down a model for the mind that shows how it extends into the material world.[25] A key part of this model is the idea of scaffolding, such that ideas can piggyback on, and emerge through, materials and material practices. There is some theoretical groundwork that needs to be done, and we will come to this later in the chapter. What I want to do first though – as I will throughout the book – is work through this idea of scaffolding with some Aegean Bronze Age examples.

SCAFFOLDING A MASTERPIECE?

We have already briefly discussed the Theran wall paintings as attracting a lot of attention as early examples of 'major arts' in a prehistoric setting. Another of the major arts, sculpture, is almost entirely missing from the Bronze Age Aegean – those sculpted pieces in stone that do exist are far too small or crude to warrant

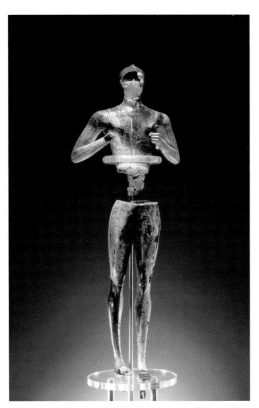

1.3 The Palaikastro kouros. Courtesy of the British School at Athens.

serious attention (or so the cliché goes). And certainly, there is none of the life-size or monumental sculpture so admired from Archaic and Classical Greece. And yet there is one piece that is not that far off – it may only be 50 cm tall, but the exotic materials and exquisite workmanship of the so-called Palaikastro kouros have garnered it the kind of attention usually reserved for major arts (Figure 1.3). It is without doubt an extraordinary piece – indeed it is utterly unique – and fully deserves our awe and admiration.

The figure is 'lithochryselephantine' – a composite creation with a stone head, ivory body and gold belt and sandals. The detail in the carving of its veined hands and feet is quite breath-taking. It was found in the Bronze Age settlement of Roussolakkos at Palaikastro, painstakingly excavated in the late 1980s and early 1990s, and published in impressive detail.[26] The excavators believe that the building in which it was probably housed contained a shrine in the Late Minoan IB period. It was at the end of this period, c.1450 BC, that the building (and indeed much of the town) was destroyed by fire, with the kouros caught up in this destruction. The fineness of the figure's materials and craftsmanship contribute to the sense that this must have been a representation of a deity, a young male god. Moreover, it is hard to resist the notion that this was the product of considerable planning, design, creativity and imagination. In other words, an artist thought this through. It is an externalisation of sophisticated thought. The object's origin lies in the mental domain – this is where the creativity originated. The materials have bended to the artist's will, as demonstrated by the artist's ability to fit together such different materials as ivory, gold and stone. Thanks to the artist's clear mental mastery of the materials, it is as if one is encouraged to seek out the sophisticated mind behind the masterpiece – as if there may be new ways of thinking captured there, in turn stimulating creative response for living in new ways. Thus, 'art' as creative output can influence the course of events and contribute to our projects and goals in life and for life.

However, another figure found nearby bears the same pose of symmetrical hands to torso gesture,[27] but differs in being less tall, made of terracotta,

and with much less refinement and detail
(Figure 1.4). The terracotta figure was
found on the peak sanctuary of Petsophas,
just above the settlement of Roussolakkos
at Palaikastro, and so in all likelihood is
a cult object, taken up to the peak by a
worshipper and offered as a votive of some
sort. The kouros was found in the settle-
ment itself, in and next to what the excav-
ators believe was a shrine. So, both are most
probably cult figures, though the kouros is
interpreted as a deity and the clay figure as a
worshipper.

Neither the material nor the form of
the terracotta figurine suggests any notable
planning or forethought. It does not appear
to be the product of a sophisticated mind.
Indeed, its simplicity is such that one might
even say a child could have made it. One
would not say that the maker has mastered
the materials – if anything, it looks as if the
materials are dictating to the maker – the
legs look just like two sausages of clay rolled
out.[28] Given the relatively straightforward
output, or effect, one assumes the viewer is

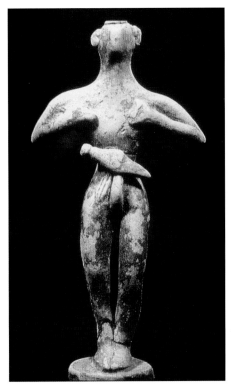

1.4 A male clay figurine from Petsophas peak
sanctuary. Courtesy of the British School at
Athens.

not going to invest too much energy in discerning the cause – because there
appears not to be a sophisticated mind behind this, and hence little scope for
exploring new ways of living and being towards which that creative mind
might lead.

While we might recognise that both objects 'represent' something, the
kouros seems to represent something more complex. The terracotta figurine
presumably worked perfectly well in a given cult practice, substituting for the
worshipper – but the kouros suggests even a new way of thinking about that
cult practice. It is this added content, or value, that presumably encourages us
to think of the kouros as an 'artwork', but not the terracotta figurine. It does
not just symbolise something – it raises the whole issue of what it means to
symbolise.

And yet, the terracotta figurine is not derivative of the kouros; in fact, quite
the opposite. The terracotta figurine is a precursor to the kouros and provides
its context. There was a long tradition through the Early and Middle Bronze
Age of worship at the Petsophas peak sanctuary, with many figurines of this
kind deposited at the peak, presumably in some form of votive dedication.[29]

However exquisite and creative, the kouros relies on the earlier model, piggybacking on this standard form. Its creativity is supported, or 'scaffolded', by the preceding tradition. It is the kouros that comes later, and in the rare setting of the settlement rather than the peak sanctuary (figurines are not often found within settlements in these periods on Crete). So, just as with the wall paintings, it seems that the exquisite artwork owes a debt to more banal predecessors.

Indeed, to continue this deconstruction of the kouros, one might well ask if its exquisite crafting was actually all that effective to its purpose. After all, it does suffer quite a dramatic fate in what looks like an explosive, iconoclastic act – with its face and torso seemingly smashed against the doorway of the building, the fragments scattered across the open area outside the building, and its legs tossed into the burning building.[30] Was this an act of desecration in reaction to its 'perfection'? Perhaps the humbler terracotta figurine was a more suitable material focus for the ineffable, a more apt religious symbol? Viewed from this more functional perspective, taking into consideration the *agency* of art,[31] then perhaps the kouros as high art becomes less a towering achievement and more an aberration.

The lesson here, surely, is that the apparent creativity and representational clarity of an artwork like the kouros has to be put firmly within the context of the other material productions of its time and tradition. The kouros, however magnificent, is only made possible by, and piggybacks on, the prior engagement with materials of the artisans who made clay figurines. Nevertheless, the hylomorphic perspective, which portrays objects like the kouros as outcomes of primarily mental processes, is quite persistent – and is perhaps nowhere more pervasive than in the museum exhibitions that place such artworks on pedestals for contemplation. When these objects are made into museum pieces and removed from their contexts, there is an abstraction at work that is idealistic and aestheticizing; moreover, it is a visual aestheticization that runs counter to their probable inclusion in multi-sensorial experiences in the past.[32] Such aesthetic 'envaluation' (the way in which things are ascribed value) further presents all kinds of ethical questions about the presentation of the past, when Cycladic figurines, for example, are fetishized as visual icons, rather than as objects that would have been touched; even more so when their 'appreciation' leads to their being looted in large quantities from remote and uninhabited Cycladic islands such as Keros, robbing them of their context. And when Classical archaeology still struggles to shake off an aesthetic orientation that is at times uncomfortably close to that of the collector, with individual attribution studies in the style of Beazley not entirely outmoded, then the (anti-representational) prehistorian's instinctive reaction is to shy away from any such association. The aesthetic regimes of institutions may thus seem profoundly aestheticist *and* cognitivist.

Fairly or not, 'art' has come to have these associations in the study of the Aegean Bronze Age. And while it is perhaps unfair to say that art-historical approaches today share much with antiquarian appreciation, they do typically preserve some of the same representationalist biases. That is to say, they persevere with the hylomorphic model of the relationship between mind and material culture, which requires an operation whereby the viewer must abstract from the material to find the meaning that lies behind and beyond it, in the mind of the artisan. When an artefact like the kouros displays such exquisite workmanship and mastery of materials, its evident creativity signals a purposeful mind lying behind the work, a mind working intently to invest its material creation with meaning and hence one that is worth getting to know. While art-historical approaches of this kind certainly survive, they have lost some of their currency with the rise of social, contextual archaeologies since the 1960s, whether in the guise, initially, of processual archaeology or, subsequently, post-processual, or processual-plus. The heavy emphasis on context in social archaeologies has created a much-needed emphasis on the more mundane artefacts that previously escaped attention (and would indeed have very often been discarded in large quantities in early excavations). This emphasis went hand-in-hand with the increasing role of intensive survey, which had to find ways of squeezing maximum information from surface sherds ('mundane'), and this in turn was tied up with the growth of petrographic analysis, necessary for the detailed characterization of coarse wares. The ever more detailed analysis of artefact materialities (and not just pottery, of course) has created not only an understanding of materials that is more scientific and archaeometric, and perhaps more systematic as a result, but also one that is increasingly compartmentalized. There is an irony to this, given that the initial impetus was towards contextualisation – and one has to wonder if now many archaeologists/archaeological scientists really have a contextualised understanding of the ancient materials in which they specialise. So, art objects have dropped off the radar for many Aegean Bronze Age archaeologists, who just do not know how to tackle them. Such objects are thought to require a kind of idealist (cognitive) approach that is universalising and decontextualizing, one which seems at odds with a conception of ancient artefacts that envisages them as existing in a multi-sensorial social world. Moreover, they require a level of cross-craft understanding of the evidence that is increasingly rare. Worse still, artworks are typically mobilised in religious interpretations, which have been chronically unfashionable (though a renaissance is under way).

Rather than simply turn away from artworks altogether though, how might we continue to look at them but not through a lens that is decontextualizing, aestheticizing and representationalist? A very practical, elegant and inclusive solution is that presented by Jean-Claude Poursat, in an exhaustive synthesis of Aegean art. He manages to cover quite encyclopaedically the incredible

spectrum of Aegean artistic production, ranging across architecture, seals, jewellery, pottery, metalwork, stone vases and more, while also being careful to cast way back into the Neolithic period so as to provide a deep temporal context for the various media he surveys.[33] His approach is remarkably holistic, and refuses to place 'major arts' on some pedestal as inherently more eloquent than the everyday. If one wants to understand the broader context of the Palaikastro kouros in the visual and material culture of the Minoan palatial periods, then it is Poursat who supplies it. He shows that we have to consider the fullest range possible of material evidence if we are to understand ancient Aegean society and culture – and so his approach may be viewed as a rich blend of the archaeological and the art-historical. Moreover, its inclusion of the everyday allows for an aesthetic approach to artworks that avoids the pitfalls of aestheticization (we will return to everyday aesthetics in our conclusions).

As persuasive as Poursat's approach is, I would like to put it into a wider theoretical context. It does constitute a very convincing response to the 'problem' of Aegean Bronze Age art. But arguably still more might be done to overturn the hylomorphic model and create a perspective that is even more contextualizing and embedded. If we wish to understand the creativity of Aegean Bronze Age art more fully then we need to ask not only where and how creativity occurs but also **why**. This is a more difficult question, and one might well wonder if creativity is a phenomenon that can ever be *explained* as such. Indeed, there are not only different responses to the question, but differences in the degree to which scholarship considers explanation to be a valid goal. What I will do in the following pages is address the ways in which these issues have been tackled within approaches in archaeology, art history and anthropology that have challenged the hylomorphic, representationalist model. I find it useful to identify three distinct responses, which I gloss as 'biological monism', 'sociocultural non-dualism' and 'cognitive non-dualism', here treated in turn.

Biological Monism

Within this perspective, there is no separate mental world residing above or beyond the material. Everything is material, and everything can have a material explanation. Another way of saying this is that everything is biological, and everything is evolutionary – even art. In other words, we can *explain* the creativity of art scientifically in material, evolutionary terms, without any recourse to mentalist accounts. In other words, art can be reduced to biological imperatives – it must offer some kind of adaptive advantage, and must always have done, back to its prehistoric beginnings. It is perhaps understandable that cognitive scientists would approach art in this way – as in the work of Zeki, for

example.[34] Yet, it is puzzling when art historians today are drawn to these kinds of explanations,[35] given that the drive for explanation (*Erklären*) is more typically a feature of the natural sciences than the social sciences and its quest for understanding (*Verstehen*). In the art history of the mid to late nineteenth century, perhaps more closely connected with evolutionary debates, one can imagine a stronger tendency towards the former, as seen in the debates surrounding the role of ornament in material culture (and its supposed lack of higher creativity). These early approaches, although broadly Darwinian, were also dualist in maintaining a sharp distinction between the mental and the material (and as a close corollary, the major and minor arts). Interestingly enough, many humanists today accept evolutionary models as acceptable for the body, though resisting its application to the mind, as Edward Slingerland has recently argued.[36] So it appears it is possible to buy into evolution while maintaining a mind–body dualism, though Slingerland suggests this is trying to have your cake and eat it. His solution is to develop an approach to the mind rooted in work on embodied cognition and conceptual blending, that 'vertically integrates' the mind with the body, thereby creating a more fully monist perspective. Slingerland's position, as further developed in a volume co-edited with archaeologist Mark Collard, called *Creating Consilience: Integrating the Sciences and the Humanities*,[37] is 'premised on the conviction that there is an ontological continuity between the human/mental and the non-human/material, which justifies approaching these two realms of inquiry with a unified explanatory framework'.[38] This humanistic monism he sees as an essential step in creating a bridge between science and humanities, which otherwise will simply be attached to completely incompatible models, with biology monist and the humanities dualist. His call for 'consilience' echoes that most famously made by the biologist Edward O. Wilson, author of the book *Sociobiology*. Although Slingerland's formulation is more sophisticated than that of Wilson, in which the natural sciences are unmistakably viewed as far ahead of the humanities in their capacity for explaining phenomena, critics see the same aims in both: to educate humanists and correct their dualist vision.[39]

Most approaches in the humanities though that have opened themselves up to biological monism in the form of evolutionary approaches have somehow maintained a cognitive dualism. In art history, for example, treating the perception of art as a mental operation with some evolutionary implications has not led to non-dualist views on the mind. Some art historians have become quite enamoured of the chance to work with neuroscientists and provide biological explanations of aspects of artistic perception. This move has been variously labelled neuroaesthetics and neuroarthistory,[40] and has involved collaboration between some leading figures in their respective fields.[41] Their arguments have received ample press, while also coming under severe criticism for being excessively reductionist – as if artistic behaviour boils down to

neurons and innate biological impulses.[42] This dual affliction, what Raymond Tallis has called 'neuromania' and 'Darwinitis',[43] leads to universalizing, evolutionary interpretations that are rightly controversial in the humanities.[44] And though biologically monist, they remain cognitively dualist (they do not on the whole work with notions of embodied or extended cognition).

Even more than art history, archaeology too has undergone an upsurge in biologizing approaches to culture generally; and to some extent prehistoric art is included. In much of the wider work in evolutionary archaeology, questions of cognition are not particularly to the fore, and so the contrast between biological monism and cognitive dualism is not especially visible. If we narrow our enquiry to those studies that have concerned themselves particularly with art, then we can see clear evolutionary tendencies in the way that Palaeolithic ornaments, for example, have been tackled, at least since the 1980s.[45] Randy White in particular saw ornaments as meaningful artefacts that were potentially of considerable significance in efforts to understand the emergence of symbolic behaviour.[46] These earlier efforts to include Palaeolithic art within evolutionary narratives were cognitively dualist, suggesting that cognition operating at another level behind the artefact could be inferred from the material remains. More recent work has seen a couple of different developments. One is to focus on the technology of these artefacts – that is on how their meaning might have emerged from their coming into being. This approach uses the chaîne opératoire to understand sequences and choices in production technology.[47] Such a move can potentially lead to alternative views on early creativity; it also meshes with more social perspectives on technology, such as those that are more commonly encountered in studies of later prehistoric periods (see below in section on sociocultural non-dualism). A second development has seen the application of ideas drawn from Peircean semiotics.[48] The effect of this approach is to situate meaning pragmatically in action and discourse (particularly through emphasis on the 'interpretant'), which makes the simplistic idea that a shell bead was a static symbol untenable. This approach takes us away from dualist accounts towards the kind of embodied cognition approach envisaged by Slingerland – though note that Iliopoulos is more cognitive in outlook (see also Malafouris), while Kissel and Fuentes are more evolutionary. The different weight these various studies of Palaeolithic art place on cognitive and/or evolutionary processes is of little import though in the second path we are to sketch, as neither set of processes is of much concern; neither is *explanation* in general, with *understanding* more the aim.

Sociocultural Non-Dualism

The second reaction we will now sketch does not locate the answer to the limitations of hylomorphism in biological monism. The way that the

sociocultural non-dualist approach overcomes the dualism of mental and material is to circumvent this dichotomy altogether by focusing on practice. Part of the reasoning is that representational assumptions are problematic because they require a projection, from material to idea, that jars with how everyday life is lived. Life is about activity, praxis and performance – it is lived through bodies that sense and act. Rooted in practice theory and phenomenology, sociocultural non-dualism takes the body as its source of action. It is the body that senses materials with some immediacy, and it is those intimate actions that are performed on, with and through materials that provide a kind of dynamic. Evolutionary perspectives on culture are generally kept at arm's length, for their perceived universalizing remit. Any 'cognitive' dimension to action also rarely features, and so there is little of the vertical integration advocated by Slingerland.[49] Given this aversion to vertical integration of mind, body and material, the ontology that is promoted in non-dualism has been described as 'flat'.[50] Indeed, the anthropology of ontology is not only non-dualist; it also actively uses ethnography to show the wide range of societies that experience the world in ways other than the Cartesian dualism of Western modernity.[51] Michael Scott bundles together a number of non-dualist perspectives within an anthropology of ontology.[52] For example, he includes the 'ecological phenomenology' of Ingold, in which humans are placed in the flow of life, grounded in an ecological web that does not separate nature from culture.[53] In perspectival anthropology, Eduardo Viveiros de Castro has introduced a concerted discussion of ontology, perhaps most famously in his 1998 paper on Amerindian perspectivism;[54] it has been dubbed 'recursive' in its use of perspectivism 'as a bomb with the potential to explode the whole implicit philosophy so dominant in most ethnographers' interpretations of their material'.[55] Philippe Descola has also made very important contributions through his Amazonian ethnographies; his 'ontological cartography' consists of a comparative study and typologization of the various ontologies that are out there in the world, and which can be amply described through ethnographies.[56]

Further approaches that Scott identifies as relevant are the anthropology of personhood and sociality (e.g. Roy Wagner, Marilyn Strathern); material semiotics (e.g. Annemarie Mol, John Law); re-theorisations of animism; the study of human–non-human interactions; and the ontological turn.[57] The last of these Scott associates principally with the *Thinking Through Things* (TTT) volume, edited by Amiria Henare, Martin Holbraad and Sari Wastell, arising from a meeting in Cambridge.[58] These authors critique the enduring dualistic tendency to view meanings as 'fundamentally separate from their material manifestations'.[59] Rather than persist with the idea that things reflect or bear meanings that reside on another plane, the radical proposition of TTT is that things *are* meanings. An example comes in Holbraad's contribution to the

volume, on the meaning of the powder used by Cuban diviners. Rather than strive to explain how the powder *represents* power, Holbraad suggests that we should try to recognise how this powder *is* power. This move becomes an ontological turn because it refocuses attention on ways of being rather than systems of knowledge – an epistemological preoccupation in anthropology that has only exacerbated a separation of things from ideas.

However, in a reevaluation of the TTT contribution, Holbraad goes a step further. He acknowledges that in his TTT study, he relied principally on the accounts of informants in exploring the meaningfulness of things.[60] What about listening to the things themselves, and recognising their properties, or what Holbraad calls their 'conceptual affordances'?[61] This is, in effect, a subtle shift to recognise that a fully relational approach, central to much of the work in the ontological turn, can have the implicit and undesired effect of actually reducing the thing to human desires and motivations. Such an attempt to let the thing speak, as Holbraad puts it, constitutes something of a shift away from aspects of the ontological turn. In fact, one could say that it is a move that brings Holbraad closer, here at least, to the 'new materialisms'.[62] While certainly very influenced by Actor-Network Theory and relational approaches, this is a reaction to the tendency of such work to limit the influence of the actual materiality of things, at the expense of their interrelations with humans (and other 'nonhumans'). Philosopher Graeme Harman has also been key in this move towards an 'object-oriented ontology'.[63] The earlier work of Bill Brown on 'thing theory' also created a lot of interest across various disciplines, though more rooted in literature.[64]

Holbraad explains that this shift of emphasis in his 2011 paper is partly the result of dialogue with archaeologists. Indeed, the term he toys with for a more thing-centred approach, 'pragmatology', is borrowed from the work of archaeologist Chris Witmore.[65] Pragmatology may be somewhat closer to archaeology than much of the object-oriented ontology in its commitment to the 'empirical'. Indeed, much of the interest in non-dualism in archaeology has been stimulated by many of the same authors who inspired TTT, from Marilyn Strathern to Bruno Latour.[66] There is a deeper history to this general perspective in archaeology, one that can be traced back to concerns with agency and practice.[67]

As for treatments of ancient art within this non-dualist perspective in archaeology, these are more typically encountered for later prehistoric periods, from Neolithic to Iron Age.[68] Some are justifiably concerned with the contexts and performative settings of ancient art, as in Richard Bradley's book *Image and Audience: Rethinking Prehistoric Art*, or the volume on Celtic Art by Duncan Garrow and Chris Gosden. In her book *Clay in the Age of Bronze*, Joanna Sofaer explicitly addresses the question of creativity, specifically in relation to the Bronze Age in the Carpathian Basin.[69] Her approach is

non-dualist in seeing creativity as neither a purely mental or material phenomenon, captured in the term 'thinking hands'.[70] Colin Renfrew has also tackled the question of creativity, in modern as well as ancient art.[71] Though his later 'material engagement theory' moves towards a position that is non-dualist,[72] his early 2000s writings on art still appear to treat art within the cognitive processual framework that casts them as symbolic artefacts, though weights and measures, and religious artefacts, are the more direct focus.[73] While Renfrew's gradual transition to a material engagement perspective does entail a shift from dualism to non-dualism, he seemingly maintains his earlier commitment to broader comparative and evolutionary thinking – which is, in other words, a commitment to *explanation*.

Given all of the above discussion, what might a sociocultural non-dualist approach imply for how we view artefacts such as the Palaikastro kouros? The main change of perspective it enables is a shift from worrying about what the kouros figure *represents*, to a focus on the praxis that the kouros would have enabled – how it could have been displayed, lifted, carried in procession, transferred from one set of hands to another, and, as it turns out, ultimately smashed into smithereens. One might argue that this kind of perspective is useful in breaking the dyadic connection representationalism creates between thing and meaning. If things acquire meaning in the course of action, and action is always unfolding and somewhat contingent, depending on the protagonists involved, then one can see how the idea of an object as straightforwardly 'representing' one idea or another is problematic. The notion that meaning emerges in contexts of discourse is actually quite compatible with some of the work inspired by Peirce on speech acts in linguistic anthropology; and Peircean semiotics has been put into play in conjunction with these practice approaches in archaeology, albeit sporadically.[74]

These developments towards non-dualism should be very productive for archaeology – and in many ways they are. It would seem that the time is ripe for launching new projects that really get to grips with things – things in and of themselves, as well as things as entangled in bundles of relations with other things and with humans.[75] And, as Holbraad points out, if there is a discipline that needs approaches that can look at objects in and of themselves and let them find their voice, and not only through their human counterparts, then it is archaeology.[76]

Non-dualist approaches continue to be very much a feature in recent archaeological approaches, with action, praxis and performance to the fore.[77] While they have the capacity to reveal much about how humans relate and respond to materials, phenomenological and sensorial perspectives seem unnecessarily self-limiting in their reluctance to grapple with thought and belief.[78] Indeed, such ontological approaches do not hold within them the possibility of acknowledging that materiality also needs the missing to make

sense.[79] Materiality and presence are predicated on immateriality and absence.[80] And the flattening out of social life whereby it is reduced to sensory performance is to lose the mental, the immaterial and the absent[81] – and indeed some important possible sources of change. Change can come from many directions. It may be led by materials. Performance and action may also generate new directions. But change also comes from new ideas, new conceptualizations. The dynamics of creativity surely involve complex pushes and pulls between all of these.[82] Thus, many versions of sociocultural non-dualism have a problem: in locating the dynamics of change in practice and performance, the significance of cognition in innovation and creativity is rather minimised. To put this another way, their emphasis on interpretive understanding seems to have come at the expense of causal explanation.

But, surely, we can include the mental in our accounts and interpretations without returning to a back-and-forth between the mental and the material as phenomena occupying different planes? In anthropology there are some interesting recent exceptions that manage to find a place for the mental within a non-dualist framework.[83] Indeed, we have already mentioned Holbraad's inclusion of 'conceptual affordances', to which we might add his thinking on a 'vertical axis of materials' transformation into forms of thought'.[84] This idea meshes quite well with Slingerland's 'vertical integration', outlined above, more explicitly growing out of the recent literature on embodied cognition. Moreover, the idea of the thinking hand (see Sofaer) is broadly consistent. Holbraad's thoughts towards vertical integration with the cognitive offer some hope towards a different kind of consilience. Moreover, it is unlike many of the archaeological approaches interested in ontology because of this cognitive dimension. It provides us with a connection to the approach to be developed and adopted in what follows.

Cognitive Non-Dualism

Although *Erklären* and *Verstehen* are often contrasted, we need both causal explanation and interpretive understanding if we are to properly address creativity. There is a third approach that allows us to combine the strengths of each, which here I call 'cognitive non-dualism'. To include the mental, we are not forced to return to Cartesian/ representational formulations such that ideas create material change, or vice versa. Largely unacknowledged by the new materialisms,[85] a series of important directions in cognitive science, psychology, philosophy and anthropology enable and positively encourage more mediated positions in which the mental and the material are codependent. And we can insert gesture, action and performance between them, which aligns the approach with sociocultural non-dualism. This is what *praxeology* allows, which I will elaborate on further below. There is much in these

approaches absolutely consistent with some of the insights of the new materialism, especially in terms of bundles of relations. And what these more developed ideas concerning the interactions of ideas, things and actions allow us is a much richer set of possibilities when it comes to tackling change – something deeper, beyond the flatness of new materialism.

We have to find a way to tackle change that has the *explanatory* ambition, in a sense, of Darwinian models, but which is able to avoid both 'thin' and 'thick' descriptions and find a middle way (hence consilience). On the one hand, in the Aegean Bronze Age and indeed many scenarios of 'cultural evolution', we do have detailed 'thick' descriptions of the evolution of specific styles or types; but these 'thick' descriptions are generally quite culture-historical and, while strong on 'understanding', are poorly integrated within more general models explaining change. This means that for the Aegean Bronze Age at least we lack convincing explanations of how and why styles or types change. In some studies of cultural evolution in other domains, scholars have turned for explanatory power to Darwinian biological models, but these 'thin' hypothetical accounts, though seemingly promising for comparative purposes, and of growing popularity, have had only limited success.[86] Such approaches fall down principally in too quickly and unproblematically identifying units and populations of culture; they see transmission of traits as a transfer of information, with little allowance for the sociocultural complexities of learning; and they 'black-box human ontogeny and the developmental acquisition of cultural traits'.[87] A further problem with Darwinian accounts is that they polarise within-group vertical transmission on the one hand ('branching'), and between-group horizontal transmission on the other ('blending'). This means that we would have to conceptualise changes in Aegean Bronze Age materiality as either a branching process 'within-group', or as a blending process between groups. So, we should resist the temptation to blanket the thick descriptions we find in studies of Aegean Bronze Age materialities – for example, the spread of Cretan artefacts and technologies across much of the southern Aegean c. 1700 BC, often called 'Minoanisation' – with some kind of one-size-fits-all evolutionary model that has been generated in a quite different setting (e.g. for Minoanisation, 'blending').

Finding a framework for tackling change that can fit between these two extremes of 'thick' and 'thin' description is challenging. However, a very interesting suggestion comes from Wimsatt and Griesemer, who propose a 'medium-viscosity' approach.[88] Their project seeks to remain evolutionary in outlook on the one hand, while being critical of Darwinian biological models on the other. In order to counter the flawed 'black-boxing' of ontogeny in Darwinian models, they place *learning* front and centre, to highlight how the acquisition of traits is not a simple transfer of information but unfolds developmentally. In cognitive terms their outlook on learning is embedded and

embodied, in that learning occurs through practice in a world populated by various social and material resources. These resources can be recruited to scaffold learning more efficiently. The idea of *scaffolding* was introduced in work on infant classroom activities by Wood, Bruner and Ross,[89] though it is often considered to be part of the pedagogical tradition inspired by Vygotsky.[90] In a classroom context it is the structuring offered by a tutor that scaffolds learning. This structuring means that learning involves more than mere imitation, but rather less intervention than direct instruction. In his work on how capoeira skills are acquired, Greg Downey observes that:

> A more knowledgeable other, like a capoeira mestre or other teacher, often assists in practical ways, such as altering or exaggerating the movement to be emulated, isolating a particularly tricky portion of a sequence, coaching through difficult stages, or redirecting the novice's attention.[91]

Scaffolding of this kind can exist in less formal settings too, as archaeologist Dietrich Stout has argued in his ethnoarchaeological study of the acquisition of knapping skills in Irian Jaya.[92] Indeed, archaeologists have been particularly interested in questions of learning and apprenticeship in relation to craft skills.[93] Although these studies are more typically directed towards the making of what we might think of as everyday objects, it is not necessarily the case that the enskilment required for the production of 'artworks' in ancient contexts was substantially different. Scaffolded learning was probably relevant in all kinds of making. Here we can return to our initial mention of scaffolding earlier in the chapter, in the context of the Palaikastro kouros and clay figurines. In that discussion, our focus was more on delineating the locus of creativity. But now we can also recognise how scaffolding as a method allows us to bridge both the how and the why of creativity through this medium-viscosity approach. Thinking about the contribution of scaffolding to the acquisition of skilled practice does allow for a very fine-grained, microscale approach. However, in that scaffolding implies social support, and even a 'community of practice', it also enables a broadening out to other scales – hence Wimsatt and Griesemer's use of scaffolding to enable a *developmental* approach that can serve as an effective bridge between micro- and macro-scales, or in other words thick and thin descriptions.[94]

Wimsatt and Griesemer come from a background in the philosophy of biology, looking for ways to include culture in evolutionary perspectives that avoid the pitfalls of neo-Darwinian approaches.[95] And they are not alone, as there are others in related disciplines proposing a broadly similar outlook that involves a developmental approach to cognition and culture. Andy Clark's work in philosophy of mind, and notably his 1997 book *Being There: Putting Brain, Body, and World Together Again*, is one key example.[96] In what is an explicitly philosophical argument for extended cognition, he maintains that

the mind spreads out beyond the brain to co-opt the body and the material world. It is not that mind is always seeking to transcend or overcome materiality – rather, that it piggybacks on things and is often quite dependent on them. His approach also draws on the Vygotskian tradition, though he argues for a broader, more intuitive notion of scaffolding that 'can encompass all kinds of external aid and support whether provided by adults or by the inanimate environment'.[97] What is also quite explicit in *Being There* is how closely Clark is arguing from developmental approaches in both biology and psychology. Cognition is not limited to humans, of course, with examples of 'biological cognition' ranging from the famous example of the tick from von Uexküll to the self-organising, emergent properties of slime mould. *Being There* is incredibly wide-ranging,[98] and as such does an enormous amount to create a platform for what some have labelled 'situated cognition',[99] though another recent moniker is '4EA cognition'.[100] Such umbrella terms incorporate a range of approaches coming from different disciplines, such as cognitive linguistics,[101] cognitive anthropology,[102] and philosophy.[103] Regardless of discipline, together they constitute a reaction against the Cartesian separation of mind, body and matter, and actively run together (to varying degrees) action, perception and cognition.

As mentioned above, Clark draws from Lev Vygotsky and cultural psychology for the idea of scaffolding. Indeed, there is a broader literature in cultural psychology inspired by Vygotsky, such as in the work of James Wertsch, Michael Cole, Chris Sinha and numerous others;[104] and this research tradition has developed the notion of scaffolding in various directions, not least in application to learning and education. Developmental psychology is also oriented towards learning, though placing more emphasis on psychological mechanisms than the sociocultural context of learning, and with considerable debate over the innateness of various forms of reasoning. In developmental psychology there is great emphasis on how infants learn about their environment, with experiments to ascertain when infants can apply different kinds of physical reasoning to understanding basic forms of pragmatic action. According to developmental psychologist Renée Baillargeon, even very small infants learn to understand that objects persist, unless there are interactions – such as occlusion, containment, hitting – that perform transformations upon objects (to make them disappear, break, etc.).[105] Baillargeon says it is unclear if some of these forms of reasoning are innate or learned very early in development, but evidently it is important in early psychological development to be able to recognise how objects behave. This kind of research, in a Piagetian tradition, does not see too much overlap with the Vygotskian literature on scaffolding, which places more stress on the importance of sociocultural conditions for learning. As Baillargeon points out, however, 'studying the sociocultural contexts of development presents many challenges related to empirical test and demonstration'.[106]

Further insights into how cognitive non-dualism may work as an approach can be drawn from anthropology. Clark's *Being There* again serves as the connective tissue, finding inspiration in the work of cognitive anthropologist Ed Hutchins, notably his wonderful book *Cognition in the Wild*, about the distributed cognitive systems of maritime navigation.[107] Hutchins has since written about material anchors as conceptual blends, using the example of a queue of people to get theatre tickets, such that the material structure in the world (the capacity of bodies to form a line) can form a model for the concept of temporal sequence of customer arrival.[108] Again, the point is that material culture is constitutive, and importantly for Hutchins has a stabilising role, and is not just a kind of passive backdrop. Hutchins's work is often held up as the prime example of a distributed cognition approach in anthropology, and indeed there are clear reasons for this, given how his work is commonly cited in cognitive science. However, there are other lines of research within anthropology that are compatible. It is quite interesting that Pierre Lemonnier makes significant use of Hutchins's idea of material anchors in his *Mundane Objects*; at first glance, this is not a book that seems especially cognitive in its aims, and yet it is quite focused on some of the everyday ways in which we use objects to think with.[109] From Lemonnier it is not too great a leap to Jean-Pierre Warnier, also in the French tradition of the anthropology of techniques.[110] Indeed, the scholarly framework within which Warnier has worked for the past few years is called 'Matière à Penser', which conveys quite clearly too the sense that things are good to think with.[111] Warnier's ethnographic work specifically has sought to develop a 'praxeological' approach, intent on providing an alternative to the phenomenological focus on the body, one that is firmly aimed at bodily conduct and gesture.[112] The motor-skills encapsulated in gestures are fundamental. Warnier argues that from motricity we must then also consider sensori-motricity, because there is no motricity without the power of the senses. And from here we must add another dimension, because there is no sensori-motricity without motivation and the accompanying emotions – pleasure, frustration, etc. How then can we not include emotion, consciousness, thought and the cognitive in our efforts to grasp the dynamics of materiality? So, his complete equation for praxeology comes to 'sensori-affectivo-motor conducts geared to material culture'.[113]

What about archaeology? A few examples exist of approaches that have explicitly drawn from cultural psychology and/or cognitive science in seeking to develop a cognitive archaeology.[114] We can also identify work that is more loosely 'cognitive', and perhaps more phenomenological, inspired especially by the work of Tim Ingold.[115] The developmental aspect of some of these approaches is not especially to the fore (despite its prominence in Ingold), even though it is implicit.[116] This might be because cognitive archaeology has only quite recently embraced more 'situated' models of cognition, having

previously, until the 2000s, been predominantly computational/symbolic in outlook.[117] A further possible obstacle to developmental approaches could be the influence of neo-Darwinian biological models in the field. Indeed, this influence probably has something to do with a general resistance in ('humanistic'?) archaeology to cognitive approaches, as they are associated with universalising, evolutionary perspectives.[118]

PRAXEOLOGIES AND THE PRAGMATIC–EPISTEMIC RELATION

So, developmental approaches are already in play across a range of disciplines, archaeology included. Why should we value them? Because they allow us to consider cognitive concerns from the bottom-up (as well as top-down); and they permit a constitutive role for material culture. Moreover, in tackling questions of change and ontogeny, they mark an important contribution to the ontological turn, which has tended to focus on 'being' at the expense of 'becoming'.[119] And for the immediate focus of this book, a developmental outlook means we can include ideas, actions and materials in our efforts to locate creativity.

These kinds of approaches are arguably very good at the microscale of gestures and material engagements: the specific motor-skills and gestures of containment;[120] the physical reasoning children show when presented with specific kinds of object occlusion[121]; or the ways in which a potter works with clay.[122] But how, from these pragmatic foundations, does something more emerge, something more meaningful? The clearest expression of this problem that I have encountered comes in the work of Kirsh and Maglio on expert players of the computer game Tetris.[123] Players can become experts by learning to find successful solutions (epistemic) through physical manipulation of the blocks. Epistemic and pragmatic actions become quite tightly coupled and codependent. Another example from Kirsh's work is in the game of Scrabble, in which players often shuffle the tiles around to create new juxtapositions of letters, and hopefully spark a creative solution to the problem they face – fitting a high-scoring word onto the board. This is a very simple pragmatic action – as is the rotation of the Tetris blocks – but it can be very useful in supporting more meaningful cognitive operations.

These are, of course, relatively straightforward and artificial problems within the confines of games with strict rules. But even here it is not all that clear-cut if and how the epistemic piggybacks on the pragmatic, or whether the epistemic requirements lead pragmatic actions. In 'real-life' scenarios the relationship is evidently more complex, and scholars are quite vulnerable to criticism in their efforts to show the pragmatic bases for cultural dynamics. For example, Warnier's praxeological approach has come in for critique from Thierry Bonnot, who quotes from Bernard Lahire, saying 'On a donc toujours

affaire à un subtil mélange d'habitudes sensori-motrices et d'habitudes planifi-catrices ou réflexives . . .'.[124] In effect what Bonnot says is that Warnier is insufficiently clear on how the epistemic qualities of action couple with or piggyback on pragmatic action. It is one thing to say that containment in the Cameroonian grasslands expands from simple bodily conducts to become a metaphor for entire kingdoms; but how exactly does this work? How does containment develop as something more than pragmatic, to become meta-phorical and laden with meaning?

Warnier's focus is on the praxeology of containment – which makes for an interesting segue into Baillargeon's studies of containment in developmental psychology. Here the focus in her experimental design is evidently on the physical reasoning of young infants, and so objects are subjected to simple physical manipulations, some of which 'violate' infants' expectations of object permanency. At some point in our cognitive development, presumably, phys-ical manipulations come to have some epistemic or metaphoric weight too – as an infant, let us say, begins to associate the filling of a container with milk with its parents, with warmth and affection. The more developmental approaches in psychology do not seem to address this kind of piggybacking of the epistemic on the pragmatic, though more sociocultural approaches do, and indeed Vygotsky believed strongly that the use of signs was key in the mediation of psychological development.[125]

I wonder, if we consider a fuller range of 'praxeologies' beyond just containment, we might not come to a better understanding of this pragmatic–epistemic relation. Warnier limits himself to containment,[126] but Baillargeon's experiments work with various kinds of object transformations, not just putting objects inside others (containment), but also under, on and through other objects, as well as making objects collide. We might conceivably add other kinds of physical actions with objects that do not effect object transformations in quite the same way – such as placing one object next to another. This is unlikely, it would seem, to violate an infant's expectation of object permanency, and so presumably would not be the focus of one of Baillargeon's experiments. And yet, it is the simple act of placing one object next to another – one Scrabble tile next to another – that is what often facilitates the creative epistemic reasoning in the search for the best word (in the case of Scrabble). This straightforward physical action may also be the basis for all kinds of 'metaphoric' reasoning, and indeed it is the basis for 'intarsia',[127] and other composite creations in art.[128] We will come back to this in Chapter 4, where we consider skeuomorphism as a form of composite juxta-position. One might say the same for other physical processes that then become freighted with epistemic qualities – consider also Jennifer Green's work on drawing in sand in central Australia.[129] Is this not too an object transformation, with a hard material inscribing in a soft one? And what about

stamping an imprint in clay with a hard material – is this not too an object transformation, albeit with a different connection between gesture and sign (see Chapter 3)? In Chapter 2 we will confront the question of object substitutions, which does perhaps have some link with the experiments Baillargeon performs on object occlusion – though with substitution, the transformation becomes epistemic as well as pragmatic.

THE EPISTEMIC AND THE SEMIOTIC

Arguably, then, there is something of a gap in scholarship on the connection between the pragmatic and the epistemic. On the one hand, some approaches seem too 'micro' and to not go beyond the immediate confines of specific tasks. In the case of Kirsh and Maglio with their work on Tetris, the focus is not only the microscale, but also on the completion of a limited mental task – performing a physical rotation of the Tetris block, one comes to interpret its 'meaning' in the specific context of the game. While this understanding of the epistemic may be too narrow and functional, when we look to approaches that do include the 'macro', we encounter other problems. Warnier's ethnography, for example, might scale out to the 'macro', but the mechanisms by which meaning is generated beyond the microscale of gestures to encompass the whole kingdom through the metaphor of containment are unclear. As stated above, we need a mesoscale bridging approach that can help us move between 'micro' and 'macro' scales. We need to maintain the specific, goal-oriented emphasis of Kirsh and Maglio, while also allowing the open-endedness of Warnier.

I argue that the answer can be found in Eduardo Kohn's clever use of semiotics, in his book *How Forests Think*.[130] He sees semiosis as key to cognition, and by breaking away from the common equation of semiotics with representation, through Peircean semiotics, he is able to argue that every living being produces meaning. One interesting event he describes in his ethnographic account is the tactic used by hunters in the forest to bring a monkey out into a more exposed position to improve their chances of shooting it.[131] One of the hunters goes to cut down a tree so that the sound of it crashing down scares the monkey, making it move, hopefully to a spot affording the hunter a better shot. For Kohn, the monkey takes the crashing tree as a sign of something, some kind of danger, perhaps on the basis of previous events when such a sound was indeed associated with a predator, such as a leopard dislodging a branch. And then the monkey's rapid movement may itself be taken as a sign by other monkeys, and so on and so on, in an ongoing process of sign-making and interpretation. So, a strength of Kohn's approach is that it allows one to see the processes of sign production as they unfold (semiogenesis), and how the 'epistemic' – or in this case, perhaps more fittingly, the semiotic – comes to be coupled with the pragmatic.

Indeed, Kohn explicitly uses the notion of scaffolding to convey this sense of one sign building upon another, and he makes significant use of Hoffmeyer on biosemiotic scaffolding. His biological emphasis (quite natural when one considers his focus on the relations between humans and other living beings) creates quite strong connections with the approach of Andy Clark, and indeed both cite von Uexküll on the tick's biological cognition. It is perhaps also this biological influence that encourages him to talk of nested hierarchies and the generation of form across scales – which is particularly useful when placed in conjunction with semiotics, for which one can also talk about hierarchies being scaffolded: symbolism builds upon indexicality, and indexicality upon iconicity.[132] This dynamic approach thus marks an improvement over the pragmatic/epistemic microscale viewpoint of Kirsh/Maglio, and the praxeology of Warnier, as it permits us to consider processes of semiogenesis across scales.

However, there is one drawback of Kohn's perspective that we do need to address. His biological pushback against the assumption in Actor-Network Theory, that non-human equals inanimate, is extremely timely; but it does mean that, while arguing that only living forms generate meaning, inanimate entities (i.e. artefacts) are rather left out – although he does concede that inanimate entities can find themselves caught up in the replication of the patterns generated by living forms.[133] While also quite biological in inspiration, Andy Clark allows for a fuller extension of the mind into the inanimate. After all, many organisms utilise the inanimate environment – ants and their mounds, beavers and their dams – to create their niches.[134] So some adjustments are needed if we are to take inspiration from Kohn's work to tackle the scaffolded generation of meaning in material culture. Even if he does not extend semiosis to the inanimate, there are other similar explorations of pragmatic semiotics that do go in this direction, and which ought to be consistent with Kohn's scheme. I am thinking of work based in anthropology on the one hand, and archaeology on the other. In anthropology, Webb Keane's work draws explicitly on Peircean semiotics and addresses itself to materiality.[135] Gell's *Art and Agency* is a wide-ranging anthropological study of the effects of artworks, organised largely around the (Peircean) idea of the index – and actually quite cognitive in outlook, discussing ideas of distributed cognition.[136] In archaeology, we might also point to approaches that attempt a combination of the pragmatic and the semiotic.[137]

If we thereby open up the world of semiosis to include both animate and inanimate entities, does not the sheer range of possible semiotic resources for meaning-making become completely overwhelming? Is it the case that any pragmatic action or event offers equal opportunities for semiogenesis? Or do some everyday materials and techniques afford richer semiotic possibilities than others? Pierre Lemonnier, whose work we cited earlier, seems to suggest that

we should not assume from the outset which materials are more likely to carry more meaning. In his ethnographies in Papua New Guinea, he sees that for one group, the Baruya, a seemingly simple garden fence carries a lot of meaning, while for a neighbouring group a garden fence is just a garden fence. How is it that something so mundane can be what he calls a 'strategic artefact' in one community and not in another? For Lemonnier, this implies that we have to study 'mundane' artefacts from the ground up, in order to reveal which among them turn out to be caught up in social networks in such a way that they serve as strategic artefacts in the communities in question. It is hard to say prior to analysis which objects will perform what we might call an 'art' or 'ritual' function; it is precisely by revealing an artefact's relations through careful study that its position as a 'cognitive resonator' may emerge.[138]

Nonetheless, despite Lemonnier's starting point of equanimity, surely some materialities or technologies hold greater potential than others for semiotic loadbearing? Let us just consider for a moment at the most basic level what we can do pragmatically with things. We can put one thing on, next to, in front of, inside, or behind another. We can swap one thing out for another. We can press a hard surface against a soft surface. We can place things next to one another or hit one thing with another. These are some of the physical things that we can do, or that can just happen. What properties then of these actions allow some of them to become more than physical, to become semiotic – like cutting down a tree in a forest? Are all such actions equally likely to be semiotically exploited? Or are some more amenable to meaning-making than others? After all, do not we see juxtapositional composition frequently recurring through the history of art? Are not scaled-down substitutions also exploited time and time again for semiotic ends? Is it that certain materials and/or forms allow a certain margin of indeterminacy, and this then becomes a useful property for allowing us to rethink what things are? In other words, when we alter the 'real' by rescaling it, redetailing it, impressing it, fragmenting, juxtaposing it, we give ourselves material bases for semiotic/epistemic reasoning about things. All these actions cause one to reevaluate the real. They show the indeterminacy in the real. And when we do that, we create the conditions for seeing how things might change.

This is essentially what I want to explore in this book – how humans convert material resources into semiotic ones.[139] How do material cultures take their forms, and participate in the process of life? It is an explanation of creativity in material culture as part of the life process – the emergence of organisational forms through the scaffolding of meaning on material forms and processes. Scaffolding is an important unifying concept for this book as it draws together the developmental, cognitive and semiotic components of our framework. It can take us towards a very useful position where we see artistic change and technological development – or in other words, cultural evolution – as an

ongoing emergent process in which both persistence and innovation are ontogenetically rooted. In other words, both the artefact and the artwork emerge from learning and through developmental processes, albeit with differing balances between the pragmatic and the semiotic. Meaning is generated creatively as a pragmatic outcome of cognition that is motivated by the ongoing requirements of living. Moreover, scaffolding enables a multiscale perspective across both space and time which, as was argued above, is critical.

We started the chapter with ancient art and specifically that of the Aegean Bronze Age, arguing for its significance as a form of ancient art, unconstrained by texts. But we have since taken quite a detour through some important theoretical terrain. It will soon be time to return to our empirical focus and tackle different aspects of Aegean Bronze Age art chapter by chapter. But we might just briefly return to the examples of the clay figurine and the Palaikastro kouros that we featured earlier. How might we now think of them differently following our discussion of cognition, scaffolding and semiosis? I think it is clear that we have to think about the clay figurine within a long historical trajectory of the creation of figurines, stretching back to the Neolithic. What was it about the malleability of clay that encouraged work at a certain level of detail and at a certain scale? What is the relevance to the choice of scale and detail of the probable closeness to the body of many of these early figurines? One has surely to imagine a gradual coevolution of various affordances, from ease of reproducibility, to graspability, to portability, to resilience. All of these factors seem fundamentally different for the kouros – hardly portable (over short distances perhaps), fragile, composite, non-reproducible. Everything about it is different. In terms of learning, it is difficult to fit within the same tradition. And yet, it has the same posture. Perhaps this is all that is the same. And could this not have been easily copied? If we were to take a representationalist approach, there would be every chance that the kouros would be highly appreciated as a fine work of art. And perhaps, in isolation, it is. But a developmental, situated approach puts it in a different light, showing that it seems to fall outside local trajectories of thought, learning and practice.

ORGANISATION OF THE BOOK

I wish to present a detailed empirical materiality of the Aegean Bronze Age, as there is quite enough materiality theory; materiality has proven to be rather more difficult to do in front of particular things (Elkins 2008).[140] But I do not see why an empirical approach cannot also be synthetic. Warnier's praxeological study of containment is a good example of how to do both. From a starting point in practice and *gesture*, one can work in both directions, towards the mental on the one hand and the material on the other. It is not

quite the case that thinking happens through things. Thinking happens through practices, and these happen through things. Things may be good to think through, but rarely through mere contemplation – it is practice that makes the link. Or, in other words, epistemic action is invariably coupled with pragmatic action through a *gestural* interface.

Which means that we need to pay serious attention to materialities. They are not a factor hampering higher artistic development. They form the basis for it. This does not mean that art is not directed at the expression of the absent, the immaterial. On the contrary, I will argue here that much, if not all, materiality, certainly that bound up with 'art' or 'ritual', exists to evoke immateriality. It operates by accessing absence via presence; or in other words, 'the great problem of how art makes visible the invisible'.[141] It has to *be* there because of what cannot *be* there – whether that is an abstract idea, a deity, or a sense of identity. And to put this in terms of scaffolding, materials help anchor concepts.[142] The method is one that not only allows us access to the cognitive dimensions of these artefacts, but also puts into play the important notion of relationality, whereby the connections among various kinds of materiality contribute tellingly to the meaning of any given object. A further advantage is that we do not have to decide a priori whether a particular thing is worthy of study by attributing it some role as a ritual object or an artwork.

The following five chapters address different material processes – modelling, imprinting, containing, combining and fragmenting – that emerge as bases upon which semiotic processes piggyback or are scaffolded. We start in Chapter 2 with *modelling*, as it follows on from the discussion of figurines and figures introduced here. Moreover, it shows quite effectively the advantage of using a processual category of this kind, enabling the tying together of artefacts usually treated separately: in this case, figurines, house models, and miniatures, typically treated as distinct kinds of object in Aegean Bronze Age artefact studies. Next, in Chapter 3, comes *imprinting*: a discussion of seals, these tiny artefacts that are so emblematic of the Aegean, follows on naturally from a chapter on miniatures and the reduced scale. Although their small scale is an important feature of their materiality, it is their capacity to imprint, and their relationship to other relief artworks, that is fundamental to this chapter. Chapter 4 is about *combining*, not least the composite beings that feature with particular frequency in glyptic art. However, combining is not limited in our discussion to such instances of iconographical composition; it is also extended to the phenomenon of skeuomorphism, treated as a process combining form and material. In Chapter 5 we turn to *containing*, which we have already discussed as a process or *praxeology*, as presented by Warnier. Here it allows us to evaluate jointly the material and semiotic dimensions of houses, tombs and ceramic vessels as containers. *Fragmenting* is the final process taken into

consideration, in Chapter 6; this takes us full circle back to the process of modelling, as in the cases that we encounter it is figurines that seem particularly vulnerable to deliberate fragmentation. In the final chapter I address the cultural mobility of these various processes and suggest that, despite considerable evidence for various forms of stylistic mobility in the Bronze Age Aegean, these artistic processes or praxeologies are much less mobile than we may have imagined.

In each of these chapters I draw on examples from a range of art-historical contexts to supplement my principal focus on the Aegean Bronze Age. As the present chapter has hopefully indicated, my intention is to mobilise the rich material of the Aegean to create an approach that carries wider weight. By positioning Aegean artefacts adjacent to examples from the Classical world, or indeed from the ancient Andes, I hope to show that there is a significant cross-cultural domain here that can open up further. Whether it be discussions of photography theory in relation to imprinting, or arguments concerning skeuomorphism in the Maya world, the processes identified here can be productively mobilised to speak to materialities across multiple contexts, even forming the basis for long-term material histories.

Finally, a key premise of this book is that we *can* (and should) study the 'art' objects of the Aegean Bronze Age in a contextual framework – while also recognising that art objects do something different to everyday objects. A contextual approach means treating all kinds of objects side-by-side, and not deciding a priori which of them are artworks and therefore deserving of special treatment. Analysis should lead the way towards us seeing which artefacts seem more directed towards the immaterial than others. We may think we already know the complexion of Aegean Bronze Age art, but my hope is that this study will reveal a new dimension to such developments as the emergence of figuration across multiple media; the inventive mimicry of one material in another that we see in many forms of skeuomorphism; and the remarkable changes in burial customs, house design, etc. We should try to make these innovations speak to us, not through even thicker descriptions, nor some thin evolutionary account, but through this medium-viscosity approach rooted in learning and development, as recommended by Wimsatt and Griesemer. Hopefully our new framework will help us see how particular kinds of modelling, imprinting, combining, containing and fragmenting have led thought and creativity in some directions, to certain innovations, rather than others.

What becomes promising, then, within a developmental perspective, is the opportunity to attribute art processes with the capacity for extending cognition, and by implication, possibilities for life. They form part of the generation of new organisational forms that can extend life in new ways. The challenge is to show in the following chapters how miniatures and models, seals and

sealings, skeuomorphs and composites, rhyta and pithoi, and broken figurines all offer scaffolded semiotic means for thinking differently.

By looking across the millennium and more of Aegean later prehistory, we give ourselves a good chance of charting some of these developments – and providing new insights into the dynamics of Aegean art in its continuous unfolding and development.

TWO

MODELLING

THREE SUBSTITUTIONS

In the film *Gladiator*, directed by Ridley Scott, the lead character, Maximus (played by Russell Crowe), carries with him two small clay figurines to remind him of his wife and young son (Figure 2.1). As a senior professional soldier, he is separated from his family for months on end. In an early scene, he prays besides these two figurines, beseeching his mother and father to protect them. He kisses the figurine of his wife tenderly. Political events soon take over. A favourite general of the emperor Marcus Aurelius, his position becomes suddenly precarious when the emperor dies at the hands of his son Commodus, who resents his father's love for the general. Commodus issues orders for Maximus's wife and son to be killed – and so, tragically, Maximus never sees his family again, and the clay figurines are all he has left by which to remember them. Events conspire to separate him from these too. The figurines go through quite a cycle, from revelation to concealment. At the end, soon after Maximus's death, his friend Juba returns to the Colosseum to bury the figurines where Maximus had died. Their movements from place to place, the gestures that enact their presence (and absence), their close connection with the body, with light, with dirt, and their intimate associations with cult and death – as substitutes, these miniature figural forms are extremely powerful.

Let us consider a second example of substitution tightly connected to life and death. Our example is again 'ancient', and this time not fictional but real and archaeological. It concerns the Jericho skull models (Figure 2.2), which have

attracted attention from various authors, and are now the subject of a book-length treatment.[1] These very early substitutional artefacts, dating to almost 10,000 years ago from the Pre-Pottery Neolithic B in the Near East, work through the actual metonymic presence of the skull of a dead ancestor, removed from its body and reanimated through treatment with plaster and shell eyes. In order to cope with the loss imposed by the departed ancestor, the absence is filled with a presence – not a representation of the deceased, but a very real presentation. A series of gestures seem to have been involved in the creation of these substitutes. First, there was the burial, often beneath the floor of a house.[2] Then, presumably several years later, after decomposition, someone dug back down to the burial and retrieved the defleshed cranium (without the mandible). Next, the cranium was 'used' in some way, which often involved plastering and painting;[3] then many crania were eventually reinterred, often in caches.[4] Moreover, it also appears that sometimes the plaster was removed from the skulls, as with the 'Ain Ghazal plastered faces'.[5]

2.1 Figurines in *Gladiator*. Image courtesy of the Margaret Herrick Library, AMPAS. With permission of Paramount.

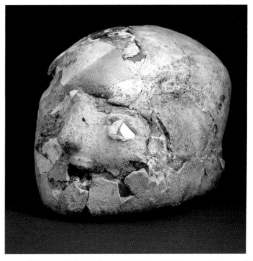

2.2 Plastered skull from Jericho. With permission of the Royal Ontario Museum. © ROM.

Thus, we can see here a fairly complex range of movements and gestures associated with these plastered surrogates; and they must have been emotionally charged, underlining the importance of Warnier's inclusion of emotions in his 'praxeological' approach to bodily conduct.[6]

A third example is more recent, though earlier than the fictional setting of *Gladiator*. Here we turn to the Archaic period in Greece, c. 600 BC, and the very prominent human forms sculpted from marble (Figure 2.3). Although these monumental sculptures may at first glance appear to be 'images' par excellence, some scholars have actually argued that they ought instead to be viewed as stand-ins or doubles.

Jean-Pierre Vernant argued that early Greek statuary evolved out of aniconic figures – slabs of stone and planks of wood – and that such objects represented not through imitation, but through substitution.[7] For Vernant, all of Archaic statuary was an extension of this conceit. So, a statue was a stand-in, not an image. Its

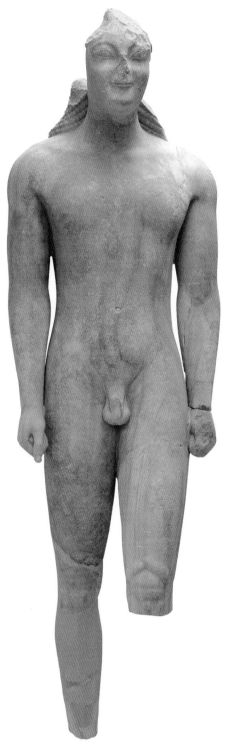

2.3 Colossal Archaic kouros from Samos. 4.8 m tall.
© Hellenic Ministry of Culture and Sports/Ephorate
of Antiquities of Samos and Ikaria.

referent might be a dead person (in the case of funerary art), a divinity (cult statues) or a sacrificial ritual (votives). All were absent in one way or another – but the sign became a constant presence. Hence the dual function of Greek sculpture was to mark absence while overcoming it: presence in absence, presence as absence. These markers were experienced bodily of course and, for an example of how, we can turn to Richard Neer, who has taken up this theme of the image vs. the index in his work on the transition from Archaic to Classical sculpture.[8] He gives us the following, describing a hypothetical encounter at Anavysos in Attica, where:

> . . . a traveler in the early 400s BCE would have passed through fields and orchards, in a region famous for its figs, before encountering a remarkable sight: a naked youth by the roadside . . . Made of pure white marble, with blazing red hair, the youth on sunny days would have gleamed from a distance as you approached. He stood some six feet tall—taller by far than most Athenians—and a base elevated him still further above the passerby. Drawing alongside you could pause to read the inscription on the plinth.[9]

This is just one kind of encounter, in this case with a grave marker; interestingly, given kouroi were often quite generic, with 'stereotyped physiognomies', Neer suggests they were adaptable to a range of situations and uses.[10]

SUBSTITUTION AND LOOKING BACK

All three of our examples – the Gladiator figurines, PPNB plastered skulls, and

Archaic statuary – demonstrate how materials are crucial to the working out of ideas. It is through the power of materials to presence and stand in for what is absent that these artefactual resources can quite conspicuously scaffold and support meaning. In each of these cases, it is the absence created in death that demands material presencing. The salience of substitution as a process is anticipated by Vernant; while he may be more directly concerned with the divine in early Greek art, his comments have a wider reach:

> [I]n the context of religious thought, every form of figuration must introduce an inevitable tension: the idea is to establish real contact with the world beyond, to actualize it, to make it present and thereby to participate intimately in the divine; yet by the same move, it must also emphasize what is inaccessible and mysterious in divinity, its alien quality, its otherness.[11]

This great breadth of perspective is an important inspiration for Hans Belting's 'anthropologie des images', in which he makes substitution a critical process in the production of images.[12] And there is a direct connection here with one of our examples, the Jericho skulls, as Belting affords them prominence in his argument for the deep and intimate connection between cult, death and art. Indeed, it is in all three of our examples – the *Gladiator* figurines, the Jericho skulls and the Archaic statues – that we can apprehend Vernant's key insight, that a substitute is always imperfect and partial, retaining some sense of that inaccessible otherness. The absent cannot be fully attainable. Maybe it is for a reason that the words 'poor' and 'substitute' are so compellingly paired together. Substitutes have to be 'poor', always just a little bit inadequate.[13]

In this notion of substitutional presences always offering something poor, inadequate or partial, we can trace other scholarly resonances. In her important book *On Longing*, Susan Stewart makes longing a key feeling associated with the miniature.[14] This is relevant because substitutions are often, though not always, in miniature form. We might then argue that it is not just miniatures but perhaps substitutes more broadly that are tinged with loss, longing and melancholy. Longing does imply the passage of time, and any substitution surely entails some degree of temporal remove between the absent, which has been made permanently or temporarily distant, and the present stand-in. In all three of our examples used above, a loss has been sustained that the substitutional artefact attempts, albeit imperfectly and partially, to overcome. The Jericho skulls and the Archaic sculpture concern the departed, and the loss is irreversible. For the *Gladiator* figurines, initially the distance is a temporary one, as Maximus is due to see his family again; but then this too becomes a permanent absence, albeit with a promise of reunion in the afterlife. So, there is a sense that these substitutes look back in time, almost nostalgically, in the hope of escaping from the passage of time to return to a previous moment of togetherness.

Drawing on Belting, Alex Nagel and Christopher Wood further develop the theme of substitution in their book *Anachronic Renaissance* – which, as the title suggests, is very much focused on the temporal dimensions of substitution.[15] They also argue that artworks with a substitutional quality, such as icons, have this backward-looking character, such that 'to perceive an artefact in substitutional terms was to understand it as belonging to more than one historical moment simultaneously. The artefact was connected to its unknowable point of origin by an unreconstructible chain of replicas'.[16] In other words, efforts are made over time to preserve the original likeness, because it is this likeness that maintains the connection with the prototypical origin. Through repeated substitution, this kind of object has a timeless quality – as if one really can use it to reach back in time to that long lost, longed after moment.[17]

PERFORMANCE AND LOOKING FORWARD

However, the account as we have it so far would suggest that what substitutes do is look back to a longed-for past. This almost has to be the case for a 'substitute', by definition. But can we really say that all figures and figurines of the kind we have described are destined to only ever act or mean in this nostalgic, backward-looking mode? Can they not also look forward? This dual possibility is essentially the argument put forward by Nagel and Wood, because they talk not only of substitution but also of *performance*. Belting thought that the substitutional model was eventually replaced, but Nagel and Wood argue that it lives on and coexists with substitution, with some works in the Renaissance knowingly combining both forces. As Keith Moxey notes, 'for Nagel and Wood, the binary opposition of the concepts of substitution and performance draws attention to art's capacity to both escape and belong to time'.[18] So if an artwork acts substitutionally, it looks backward, seeking to escape from the strictures of time and suggest that the 'lost' (and longed-for) past is not so far away at all; and if it acts performatively, it is in the here-and-now, quite explicitly linking itself to the present, but also looking forward in the sense that it points to the possibility of further acts and interventions by the artist.

What this means is that we should not be satisfied with automatically describing the figurines, skulls and statues discussed above as 'substitutes'. Yes, the substitutional force may be significant within them, but to call them 'substitutes' closes off the possibility of them also perhaps acting performatively. How can we say just from looking at a figurine if it has a substitutional or performative character? I do not think we can. We require some other term that can accommodate both of these forces.

MODELS CAN SUBSTITUTE AND PERFORM

I argue here that a sensible solution to this problem can be found in the term 'model'. The *Gladiator* figurines, the Jericho skulls and Archaic kouroi can all be described quite adequately as models. While the term 'model' in itself allows for a range of scales, it is often associated with reduced scale, as in model aeroplanes, for instance. And it is in this sense of scale reduction that Claude Lévi-Strauss famously talked of models too. He argued that 'les modèles réduits' offer an important solution to a common cognitive problem: they allow you to get a grip on wholes all at once, in a way that is not normally possible in the 'real' world, where most organisms and artefacts of 'real dimensions' have to be broken down cognitively and perceptually into manageable parts, before one can then arrive at a complete picture.[19] Wholes are mostly unknowable except through what is essentially a process of abstraction such that quantitative reduction produces qualitative simplification. Indeed, he says that with models at reduced scale the relationship between part and whole is inverted – such that the whole is grasped more readily than the parts.[20] What is also very interesting in what Lévi-Strauss observes for scale models is that they are man-made and hand-made, and so are not some kind of straightforward homologue that passively recapitulates the full-scale object – they are interpretations (i.e. abstractions) borne of lived experience and chosen with purpose (rather than a disembodied semiotic meaning).[21]

This is not to say, however, that Lévi-Strauss portrays reduced-scale models as neat pragmatic solutions to cognitive problems. Actually, he sees the illusion of being able to conceive of the whole in a single moment as fundamentally aesthetic.[22] He suggests, quite provocatively, that the scale model is in fact the archetypal artwork – 'le type meme de l'œuvre de l'art' and, soon after, that 'l'immense majorité des œuvres d'art sont aussi des modèles réduits'.[23] He also in the same breath more or less rejects the notion that miniatures are somehow economising. This idea does continue to present itself in a range of contexts. The idea of economy has, for example, been evoked in explaining Graeco-Roman miniature dedications – in that full-size offerings would have been beyond the means of lower socio-economic groups.[24] At the same time, Classical scholarship does also recognise the communicative power of miniatures, however 'modest'.[25] In the field of modern architecture and its use of models, Mark Morris, in line with Lévi-Strauss, argues that savings of time, effort or cost do not really begin to explain architectural models.[26] Moreover, if we consider monumental substitutes like Archaic statues to be models too, then these certainly do not offer any time or cost savings – quite the opposite. Perhaps Lévi-Strauss's aesthetic rather than functional attitude towards miniatures stemmed from his own childhood experiences, as he apparently used his pocket money to buy miniature items of furniture from a Parisian shop.[27]

Wiseman also cites Baudelaire, who was fascinated with toy shops, and who said that 'the cheap, improvised toys of the poor are those that spark the imagination the best'.[28] It is these connections between art, creativity and playfulness that we must explore next.

MODELS AND CREATIVITY

There is a tension at work here. On the one hand, there is the aesthetic sense associated with reduced-scale models, and this comes across in Lévi-Strauss. If what he has in mind are indeed objects like miniature items of furniture, then these are objects that retain detail even while scale is reduced. Some toys do indeed possess this exquisite quality. On the other hand, there is a feeling conveyed here by Baudelaire that some models actually reduce both detail and scale at once. What these models lack in aesthetic appeal, they gain in functionality – that is to say their crudeness is rather more effective than detailed models in enabling creative play. Both kinds of model (or toy) find connection with creativity, just in different ways. One aids creativity, the other bears testament to it. To return to the above discussion on time, what this really means is that the detailed toy acts substitutionally, and so looks back; while the crude toy acts performatively, and so looks forward. Another way of putting this is that there are 'models of', which are retrojective, and 'models for', which are projective.[29]

We can very profitably explore this distinction through the world of architectural models, notably as discussed in a fascinating work by Mark Morris.[30] He introduces us to 'sketch models' and 'process models', which are models for future action, principally for use by architects themselves (Figure 2.4). They may be very simple and highly abstracted. He also discusses 'projective' models, which on the whole have much more detail and are more polished, as they are designed for presentation to clients. Then there are 'retrospective' models, which may be even more detailed and look backwards on the process of creation of the building, perhaps even once it is completed. There are differing balances of functional and aesthetic considerations throughout. The retrospective model may be quite complete in many ways and designed to last; sketch models are just a stage in a process towards a finished product. They are all associated with a very self-consciously creative process, though some of these models are more effective in moving the creative process forward, while some serve to reflect on and communicate that process.

So even within modern architectural practice the term 'model' covers many different kinds of things – ranging across scales, materials and degree of detail or abstraction. Other kinds of objects might be simultaneously 'models of' and 'models for': a map, for example, is a model *of* geographical reality that

2.4 A sketch model by Frank Gehry for Dundee Maggie's Centre. Image provided by Gehry Partners, LLP.

hopefully will be a good model *for* navigation. Obviously, it has to be at reduced scale, and has to cut out a lot of detail. The map is an abstract version of something real, designed with some future action in mind. To what extent can it perform these goals while also being artistic, maintaining some aesthetic sensibility? And what of other kinds of objects, beyond the confines of such evident abstract 'models' for action, which may nonetheless act in similar fashion? Can we, for example, turn this kind of thinking back on the artefacts with which we started – that is to say, the Jericho skulls, figurines or sculpture? With these kinds of ancient objects – all strongly associated with cult and religion – how does the distinction between 'models of' and 'models for' fare? Actually, it has been argued that there is a deep link between the ludic and the cultic, with Hans-Georg Gadamer maintaining that play is deeply rooted in man's religious activities.[31] So there is no reason why we should not also think about these and other ancient religious artefacts as models. Moreover, art historian Marcia Pointon makes a connection between art objects and children's toys in a fascinating paper on eighteenth-century miniature portraits.[32] Children's toys often function as 'transitional objects', according to the influential work of Winnicott.[33] That is to say, a baby does not yet recognise itself as separate from its mother, but at some stage as it becomes an infant the subject undergoes this realisation that it is a separate individual. This

'separation' is potentially troubling, so infants often rely on objects that serve to aid this transition. They may be very simple artefacts that stand for the existence of something 'other-than-me', which Winnicott says to some extent 'stand for the breast'.[34] Of further interest is that the infant will creatively generate this 'transitional object' – it is not given to the infant by the parent. Winnicott also indicates that, although as the individual develops the transitional object loses meaning, this is rather because 'the transitional phenomena have become diffused, have become spread out over the whole intermediate territory between "inner psychic reality, and the external world as perceived by two persons in common", that is to say, over the whole cultural field'.[35] In a sense then, and this is what Pointon picks up on, all material culture might be considered from a psychoanalytical perspective as mediating between inner psychic reality and the external world – and perhaps especially those artefacts that are kept close to the person, and worn on the person. Miniature portraits, then, given their intimate association with the body, and their evident concern with representation of self and other, are an interesting fit for Winnicott's ideas. With the examples Pointon provides, such as Louisa Connolly wearing a miniature with a portrait of her sister, one can see such objects 'serve both to underscore absence and to defend the possessor against it'.[36]

We might often think of toys as somehow trivial, as in the term 'child's play', and therefore that likening artworks to toys is misplaced. However, Winnicott's perspective shows that there is a rather serious dimension to the toy, at least in psychoanalytical terms. Moreover, Gadamer in his work on play says that there is usually a 'sacred seriousness' around play. One has to take part in the game, because not to take part is to be a spoilsport.[37] Gadamer relates this participatory mode to the idea of the festival too, which requires an immersed participation – one cannot celebrate alone.[38] One can see how this thinking could easily extend to religion.[39]

Indeed, with specific reference to religious artefacts, Verity Platt broaches many of these issues in her treatment of Graeco-Roman epiphany. Platt asks: 'How can images be experienced as divine, when their material, their facture, their framing are so clearly dependent upon cultural artifice?'[40] And if we consider this question specifically in relation to images at reduced scale, which have as their source some divine (and hence immaterial) prototype, how can the miniature object really be understood as a model? We can answer this first by saying that 'models of' do not have to be perfect instantiations of the absence that they seek to presence; indeed, in this substitutional role, a degree of imperfection is constructive.[41] Secondly, such artefacts need not only be models of the divine but may also be acting as models *for* accessing the divine. Thus, models can have quite different relations with and effects upon time.

A parallel viewpoint on models can be found in the work of philosopher Andy Clark, who follows a very similar set of steps, from child's play to

religion, working through the idea of 'surrogate situations' (in other words, models). For Clark, a surrogate situation is 'any kind of real-world structure that is used to stand in for, or take the place of, some aspect of a certain "target situation"'.[42] Such tools are necessary because it is difficult for the human mind to grasp the conceptual – a key tenet of the extended mind hypothesis is that human cognition works most efficiently when it can piggyback on the structure already in the world, using the world 'as its own best model'. Interestingly, Clark gives as an example a child being given the 'target' of locating a toy in a room. What kind of 'surrogate situation' might help a child achieve this goal most effectively? According to the research on symbolic functioning in toddlers that Clark cites,[43] children understand certain sets of instructions about a particular goal (like locating a toy in a room), much better when the models that are used in instruction are simpler rather than richer. Apparently, the more 'realistic' the detail, the less able the child is to understand the model as a symbol – the child reacts to too many of the other affordances for action and interpretation offered by the more detailed model. So, in such cases, a model works better when it has less detail and is more abstracted. As a result, Clark identifies two important features of surrogate situations: 'the way they highlight key features by suppressing concrete detail . . . and . . . the way they relax temporal constraints on reasoning'.[44] Though loss of detail need not tally with reduction in scale, often the two do co-occur: and together they serve to create a kind of incompleteness in an artefact that can positively enhance the cognitive task at hand.

A fascinating further step in Clark's argument is that he then turns to a discussion of architectural design, anticipating many of the comments made above in connection with Morris. But what I want to turn to now is his extension into the domain of religion. Can we consider religious artefacts to present 'surrogate situations'? Yes, if we recognise that the target situations are not only distal and absent, but also ultimately intractable. Clark cites the work of Matthew Day, suggesting that when anchored in religious artefacts, divine concepts that are difficult to process in the abstract may become more tractable.[45] This is a useful conceptual move, because it helps us to think of artefacts that we might typically consider as ends in themselves to actually be more like sketch models, artefacts that help in achieving some goal, in the active process of going on in the world. Moreover, by using the idea of models we have been able to draw together play, ritual and creativity – which should serve us in good stead as we attempt to tease out some of the changes we observe in ancient art.

SCAFFOLDING MEANING

Models seem to span an incredible range of possibilities. Just our three examples with which we started are in very different materials – clay, stone,

plaster and bone – not to mention widely varying scales, from monumental, to life-size to miniature. One might say that they do at least all have in common a certain reduction in detail – and in relation to figurines specifically, Bailey has noticed that they tend to only pick out certain salient features of the prototype, not every last detail.[46] Indeed, many miniatures too are abstractions in much the same way. Yet, in other cases, models can also be minutely detailed – and this variation between the crude and the detailed reprises the different views of Lévi-Strauss and Baudelaire mentioned above. Can we see any patterns at all in how different material affordances are exploited for specific semiotic ends? For example, is it possible to say that substitutional (backward-looking) models are more likely to be complete, acting as replicas in a sense; while performative (forward-looking) ones are more likely to be partial and incomplete? It does not seem so – but we should be alert to any patterns that might emerge. If models work alone might they tend to be more substitutional and, if they are combined in microcosmic 'scenes', then do they become more performative?

If each of these parameters can vary, then it means quite a wide range of material strategies is available for enacting substitution; and with such variety in material affordances and their associated bodily gestures, we might imagine the different kinds of substitution generated to be more or less 'effective' as cognitive or social scaffolds – whether in their power to channel longing, or defer melancholy, for example. Yet at the same time as we can envisage variability, we might also recognise the tightness of the bond between material, action and idea – with some recurrent codependencies. We do see some patterns repeated – such as the combination of the plasticity of clay, with reduction in both detail and scale. Often it does seem that substitution draws on this combination – it is probably fair to say that in prehistory rough clay miniatures outnumber all other substitutional forms. Even allowing such codependency, is it at all possible to see some looseness, or room for man-oeuvre? Because, after all, change has to come from somewhere, and tight bonds do not leave much scope for movement. Through our discussion we may see the degree to which the materials and/or gestures of substitution permit change and creativity.

AEGEAN BRONZE AGE MODELS

Turning now to our main focus, the Aegean Bronze Age, we find thousands of examples of reduced-scale models. We will see that many are frequently assumed to be votive offerings of some kind – and indeed one might even say Aegean Bronze Age artworks are generally assumed to be religious. While we might admit that reduced-scale artefacts are devices for providing some kind of access to the 'unknowable whole', we should perhaps suspend judge-ment on what kind of unknowable whole that is – there are potentially other

intractable concepts besides the divine. It is also a question of method – we might be better served thinking about the processes of substitution, rather than rushing ahead to try to decipher the content of that substitution (which is exactly the problem of representationalism critiqued in Chapter 1).

For the Neolithic and Early Bronze Age periods, exercising caution before automatically associating models with the divine is especially advisable. Nonetheless, figurines from these periods have long been associated with deities, with female figurines especially prone to interpretation as mother goddesses. Peter Ucko, in an important critique, focuses on Neolithic figurines from Crete, associated with a mother goddess since their discovery at Knossos by Sir Arthur Evans.[47] Despite Ucko's intervention, such interpretations continue, in what Bailey refers to as 'Mother Goddessism', especially under the influence of Marija Gimbutas.[48] Bailey is principally concerned with the Balkan Neolithic, where indeed there are also many anthropomorphic figurines that have attracted Mother Goddessism. Indeed, such figurines span much of southeast Europe, and Nanoglou, among others, has done important work connecting the evidence from the Balkans with that from Greece.[49] These figurines, often in clay but also stone, and depicting both humans and animals, fit within our general framework of models, being both reduced-scale and with relatively little detail. In terms of regional differences, Nanoglou suggests that human figures in the earlier Neolithic of Thessaly actually show posture and gesture, and figurines may even have been placed together in groups, whereas in the Balkans they are generally just standing and without detail.[50] This one might take to mean that already in the Neolithic different communities across these regions are working out the affordances of figurines – with those in the Balkans using them more substitutionally, and those in Thessaly more performatively. However, there are other reduced-scale artefacts in use in Neolithic Greece and the Balkans, namely miniature vases and house models.[51] Examples from Ovcharovo include sets of miniatures that look like microcosmic scenes (Figure 2.5) that one might associate with some kind of cult practice,[52] though Bailey is sceptical, particularly in his discussion of Cucuteni figurines.[53] Both he and Marangou also discuss the house model containing figurines from Plateia Magoula Zarkou, which also seems to offer much performative potential.[54]

When we move south, as to the Peloponnese, figurines become less frequent, and it is more difficult to assess if they may have had a performative role. Nonetheless, Talalay has an important study that draws on Ucko's example and seeks ethnographic parallels rather than mother goddess interpretations.[55] Poursat also points out the problems with interpreting these figurines as mother goddesses, instead underlining the range of functions they probably indicate, from use in spells, to cult practices, to ancestor worship to birthing amulets.[56] As for animal figurines, these seem to be mostly associated (in

2.5 Miniatures from cult scene found in a large house model at Ovcharovo. Courtesy Professor Doug Bailey.

Thessaly and Macedonia) with ceramic vessels, indeed often as actual features attached to vessels, such as handles.[57] Usually quadrupeds are depicted, with little detail allowing species identification. This might seem like a rather substitutional kind of modelling, but their close association with containers to be handled and used suggests something more performative.

Concerning then the transition to the **Early Bronze Age,** we see quite different patterns on the mainland, in the Cyclades and on Crete. The principal area where we see striking developments in figurines as models is in the Cyclades where, in Early Cycladic I, figurines continue the Neolithic tradition, but are now predominantly made in marble. This pattern continues into Early Cycladic II, when the now famous folded-arm figurines see their full development (Figure 2.6). These really stand out from the typical pattern we see of relatively rough modelling and reduction in scale. Most are very finely modelled, of course; and while some are indeed quite small, numerous examples at quite large scale exist, even 1.5 m in height.[58] Such life-size figures are astonishing 'when one sets them in the perspective of the three or four millennia of miniature figurines which preceded them'.[59] They must surely be acting substitutionally. Is there anything to suggest a performative combination of such figures together with other objects to create a microcosm?[60]

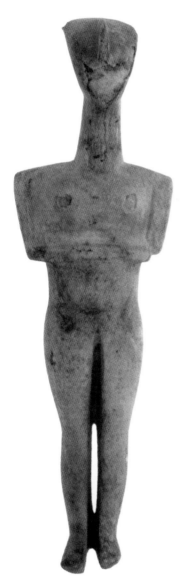

2.6 Early Cycladic figurine. Courtesy of the Akrotiri Excavations.

These Cycladic figures and figurines fade away at the end of Early Cycladic II, and there are no life-size stone figures again until the Archaic period. The Early Bronze Age on the mainland does not see much continuity of the Neolithic figurine tradition, either in stone or clay,[61] though some Cycladic figurines do make their way there, and there is of course the interesting case from Tsoungiza of yoked oxen pulling a plough,[62] which is not the typical abstract, substitutional form, but more action-oriented and performative. Crete does continue the Neolithic tradition to some degree, as for example with the house models from Early Minoan I Ayia Triadha in the Mesara.[63]

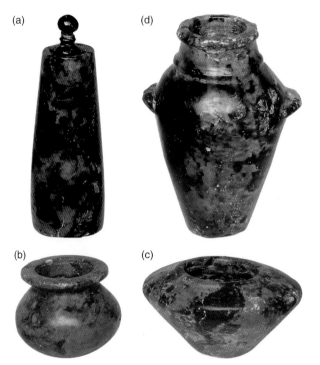

2.7 Four miniature stone vases, Mochlos, cemetery. (a) cylindrical, Ht. 7 cm, Inv.no Λ1237; (b) globular, ht. 3.7 cm, Inv.no Λ1246; (c) nest-shaped. Ht. 3 cm, Inv.no Λ1916; (d) pithoid, ht. 8.5 cm, Λ1234. Archaeological Museum of Heraklion, Hellenic Ministry of Culture and Sports, TAP Service.

Crete consumes marble figurines too, which are both imported from the Cyclades and locally imitated. A tradition of anthropomorphic and zoomorphic vessel figurines also develops on Crete,[64] though we will discuss this trend in Chapter 5 on containers.

As far as concerns miniature vases in the Prepalatial period on Crete, there do not seem to be many ceramic examples, but rather in stone, and Simandaraki suggests that a certain number of these stone vases are imports from Egypt.[65] Warren presents classes of stone miniature amphoras and goblets datable largely to the late Prepalatial, and especially prevalent at Mochlos (Figure 2.7) but also in the Mesara.[66] He stresses the close parallels with Egypt, indeed saying that in the Middle Kingdom there is a proliferation of small and miniature vases.[67] Bevan also mentions these and other miniature forms, underlining that they do copy larger pottery forms and may have been used as 'funerary tokens'.[68] These models or tokens of larger forms mark themselves out with their fine quality and attention to detail – and hence are very different from many of the models we typically see in later periods. Another important feature of these early forms is that they are more frequently found in tombs – as with the examples from Mochlos, and indeed in the Mesara tholos tombs.[69]

This suggests that they are connected with the display of prestige and status, which does not seem particularly common for models. By the early Middle Minoan period the function of small-scale vases has begun to shift, as we see plentiful miniature vases in clay that are much less finely made, and in different settings, such as the peak sanctuary of Juktas. How this transformation occurred from valuable miniature stone vases to miniature clay vases of little value is currently unclear.

Indeed, in the **Middle Bronze Age/late Prepalatial to Protopalatial period** on Crete, it is not just miniature vases that appear, but there is also a flourishing of figurine production; in the Cyclades and on the mainland figurines continue to be rare.[70] On Crete we see thousands of figurines from peak sanctuaries during the late Prepalatial and Protopalatial periods. It is pretty clear, given the location of some of these mountain peaks, that we must be dealing with cult sites, and certainly not settlements or sites of any other function. Moreover, figurines have a very close association with peak sanctuaries (and some other cult sites) and are very rare finds in settlement contexts. Many of the figurines are human in form, both male and female, and they have a range of gestures, hands to torso being perhaps the most common, but a range of others too.[71] As Peatfield has stressed, 'of the thousands of figurines found in 97 years of peak sanctuary exploration no fragment has been conclusively identified as a deity image'.[72] It would seem then that these male and female figurines are best interpreted as adorants or worshippers – in other words, as epiphanic substitutes or catalysts for evocation of a deity or deities.[73]

Animal figurines are also found in their thousands on Minoan peak sanctuaries (Figure 2.8). At the key site of Juktas they are very small and certainly made with a loss of detail – so much so that it is often difficult to identify them as anything more specific than 'quadruped', though most are surely sheep, goat or cattle.[74] This small scale and abstraction of form also characterise those found on Petsophas above Palaikastro, where other animals, such as weasels and tortoises, are also depicted.[75] Curiously, the animal models from the peak sanctuary of Kofinas in the Asterousia are larger in scale, which naturally raises questions about the gestures and practices around their use.[76] Whatever their size, animal figurines are presumably offerings to evoke the deities in some act of epiphany, rather than to represent them directly.

Very few house or shrine models have been reported for the Protopalatial period. The only example found on a peak sanctuary is from Stou Mamalou-kou (Sklaverochori) in the Pediada region of central Crete, which appears to date from early in the period, in Middle Minoan IB.[77] From within settlements we can include both the Loomweight Basement examples from Knossos (Figure 2.9), and the single-roomed model from Monastiraki, in both cases dating to Middle Minoan IIB, i.e. late in the Protopalatial period.[78] The identification of these shrines is in both cases supported by the presence of

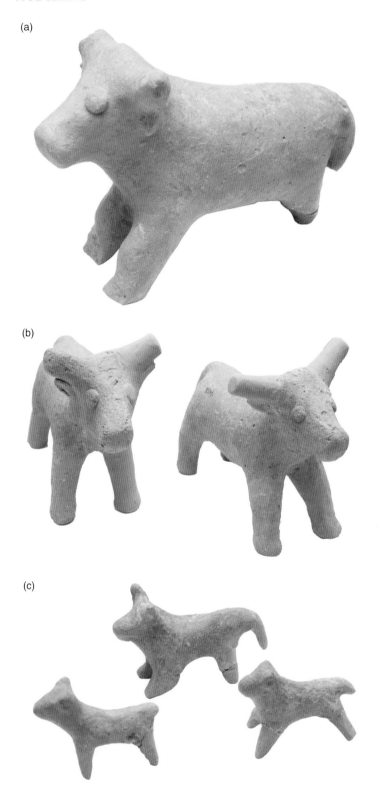

2.8 Six bovine figurines of clay, Mazas hill – Kalo Chorio, peak sanctuary: (a) single figurine, ht. 1.5 cm, Inv.no Π8559; (b) two figurines, ht. 16 cm; c. three figurines, ht. 4 cm, Inv.no Π9847. Archaeological Museum of Heraklion, Hellenic Ministry of Culture and Sports, TAP Service.

horns of consecration. As we will see below, shrine models seem to increase in use in the following Neopalatial period.

The miniature stone vessels mentioned above for the Early Bronze Age do continue at least into the earlier part of the Middle Bronze Age (as many of the tombs from the Mesara continue into Middle Minoan I–II, and it is difficult dating tomb contents closely). So, at the same time as we have the 'crude' figurines from peak sanctuaries, we have fine miniature vases from tombs. These are two quite different kinds of model in existence at the same time, presumably fulfilling different ends (and with a different relation to time). Although it is not entirely clear when miniature ceramic vessels become prominent – we have

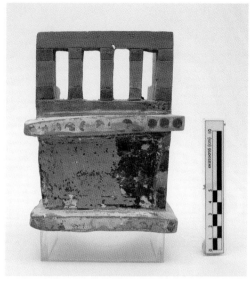

2.9 Shrine model of clay, ht. 10.5 cm, from Loomweight Basement, Palace of Knossos, Inv.no Π2585. Archaeological Museum of Heraklion, Hellenic Ministry of Culture and Sports, TAP Service.

examples from Knossos in Middle Minoan IB, and from various sites (e.g. Malia, Myrtos Pyrgos) in Middle Minoan IIB – they do occur in settlements in the Middle Bronze Age. Some seem quite crude and more like tokens,[79] while others are quite accurate and detailed (Figure 2.10).

It might be that some miniature ceramics are drawing upon the scaled-down logic of the ceramic figurines from peak sanctuaries, while others are more connected to miniature stone vases. This is quite interesting, because it implies two different miniaturising logics side-by-side within settlement contexts – which ought not to be too surprising, given the wide range of uses that miniature vases may have had. It is quite rare, however, that they are found in assemblages – more often they are rather isolated, or seemingly in random association with other finds. We will have to work through these different contexts and consider what their relations tell us about miniatures. Is it still the case that miniatures were frequently used in sets to create microcosmic scenes? Or were they used more atomistically in the Middle Bronze Age? Taking the example of Quartier Mu at Malia, for example, the miniature clay examples do not seem to be in any particular association with the few figurines that have been found in the building; and there are no signs of any house or shrine models.[80] At Knossos, the Middle Minoan IB miniatures from Early Magazine A are associated with drinking and pouring vessels used in feasting, and not with figurines or other models.[81] And there is little to suggest the creation of microcosmic scenes on peak sanctuaries in this period either. This feeling of a

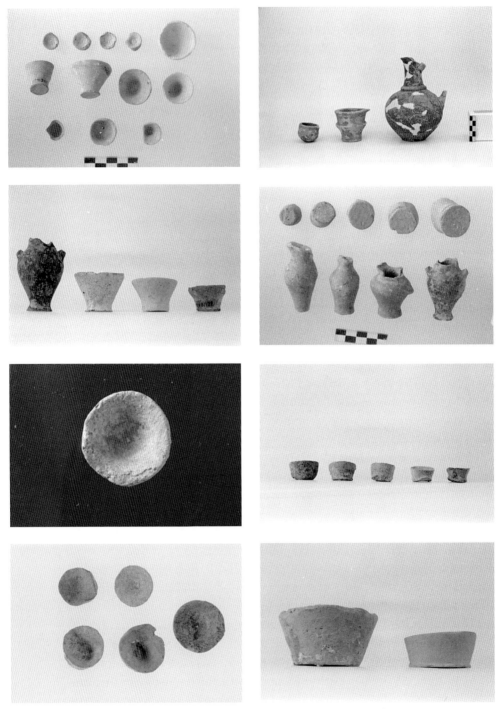

2.10 Varieties of finer and cruder miniatures from Quartier Mu, Malia.

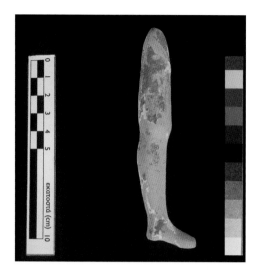
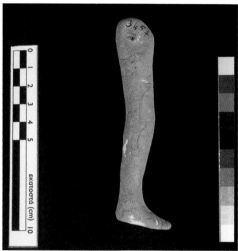

2.11 Two figurines of human body parts (legs), ht. 11cm. Inv.no Π3453, 3454; and two figurines of human body parts (hands), arm-forearm-hand, l. 10 cm, Inv.no Π3447; forearm-hand, 6.5 cm, Inv.no Π3451; all from Petsophas peak sanctuary. Archaeological Museum of Heraklion, Hellenic Ministry of Culture and Sports, TAP Service.

somewhat atomistic use of figurines and miniatures in the Protopalatial period is perhaps also lent support by the votive limbs found at some peak sanctuaries (Figure 2.11), such as Petsophas and Prinias, likened to the modern 'tamata' in Greek Orthodox chapels.[82] These look like they would have been dedicated individually, rather than as parts of a set or scene.

The **Neopalatial period** sees some major changes though. Previously, there are few if any candidates for direct representations of deities. Indeed,

various scholars have noted how difficult it is to find convincing anthropo-
morphic representations of deities in Aegean Bronze Age art generally.[83]
When we do see them, they are evidently a Neopalatial innovation, and seem
to be largely elite representations that do not appear in rural, non-elite
settings.[84] It has even been argued that the goddess – because we are indeed
dealing with depictions of one or several female deities – is a Knossian inven-
tion.[85] Driessen also wonders whether the goddess existed before the Neopa-
latial period, but with a taboo on her depiction; he further notes that perhaps
Minoan religious iconography basically remained aniconic, apart from the
'intermezzo' of the Neopalatial period.[86] If we accept this view, that the
goddess was indeed long worshipped but only depicted directly for a time in
the Neopalatial, then what we are perhaps observing are extensive efforts to
avoid showing the deity, with various images and materialities for generating
epiphany foregrounded instead. Verity Platt, in the context of later Graeco-
Roman art, has some fascinating comments on the 'tension between anthro-
pomorphised form and withheld epiphany'.[87] In some of the few instances
when a female figure can be identified as a goddess, such as on gold finger
rings, not least the famous 'Ring of Minos' (Figure 2.12), there is an apparent
focus on epiphany, with the female figure shown associated with the sky, the
land and the sea;[88] one might say the same for the ivory pyxis from Mochlos.[89]
In most other cases when we see human depictions we are probably dealing

2.12 Gold ring called 'The Ring of Minos', 1.7 cm. Knossos, Inv.no X-A1700. Archaeological
Museum of Heraklion, Hellenic Ministry of Culture and Sports, TAP Service.

with worshippers and not deities, though there are considerable methodo-logical difficulties differentiating the two.[90]

In the same vein as the Ring of Minos and the Mochlos pyxis, a handful of other images are also often evoked as examples of anthropomorphic represen-tations of a god or goddess. One striking fresco from the site of Akrotiri on the Cycladic island of Thera appears to show a deity, again with remarkable detail.[91] This depiction, from Xeste 3, shows a woman seated on a throne, flanked by a griffin (Figure 2.13), and being handed saffron by a blue monkey. She wears exquisite jewellery (e.g. necklaces of ducks and dragonflies), her dress has crocus motifs and she appears to have a snake running through her hair and down her back. She is depicted at a larger scale than the other female figures in the scene, which is oriented around her, and focused on the collection of saffron from crocuses, a plant with evident cultic connotations in various other images from the period.

If she is a goddess, and most commentators believe so, it is a strikingly direct representation. The snake goddesses from the Temple Repositories at Knossos are also often viewed as deities, and they do differ considerably from most other figures in their exotic material (faience, a technology with clear Egyptian connec-tions), their size (c.30 cm in height) and their fine detailing.[92] Another relatively large figure with fine detailing and exotic materials is the so-called Palaikastro kouros, already discussed in Chapter 1.[93] This is a 50 cm tall, composite lithochryselephantine figure, with exquisite veining on the arms and feet and a minutely detailed headdress. Rather less clear is an example from the early Neopalatial shrine at Anemospilia, on the slopes of Juktas. Here a pair of life-size clay feet were found, with tenons as if to fit a wooden figure above (Figure 2.14).[94] While the idea of the excavators that this was a *xoanon* is suggestive, we of course do not know how the figure may have appeared; but its probable scale does make it distinctive from what has gone before, and it seems a reasonable assumption, given other Neopalatial evidence, that it could have depicted a deity. Another example of clay feet, though a little different, comes from a Neopalatial shrine in the palace of Malia, where the roughly half life-size feet appear to have broken off at the top, suggesting they formed part of a figure.[95] Can we speculate from the size alone that this too could have shown a divinity?

At the same time as this elaboration of larger-scale figures, there is a marked reduction in the production of clay figurines, with bronze and ivory seeing more use – with more than one hundred bronze human figurines known from Crete dating to the Neopalatial period.[96] Even though some of these bronze examples are not exactly carefully modelled, they do represent a lot more investment in production than did the clay examples of the Protopalatial period, and overall one might say that figurine production sees more care. Nonetheless, bronze figurines are still probably depicting worshippers, like their clay counterparts.

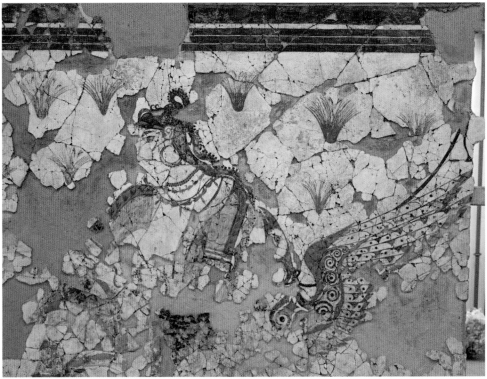

2.13 The 'goddess' from Xeste 3, Akrotiri Thera. Courtesy of the Akrotiri Excavations.

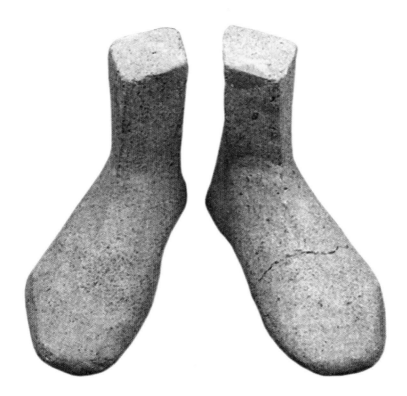

2.14 Pair of clay human feet, ht. 17cm, Anemospilia, Inv.no Π2224 a, b. Archaeological Museum of Heraklion, Hellenic Ministry of Culture and Sports, TAP Service.

These representations seem to contravene the basic idea of substitution and 'misdirection' in almost all other Minoan cultic imagery: they seem to be a very specifically Neopalatial phenomenon. Interestingly, some of these figures come to a quite dramatic end. Is it just coincidence that the snake goddesses were found broken, quite possibly deliberately so, and ritually deposited in the Temple Repositories;[97] and the Palaikastro kouros was dramatically smashed in a destructive event that burnt the entire town? If these figures are indeed representations of deities in human form, it seems quite at odds with the prevailing tendency in Minoan art – and was it perhaps then their ensuing power that rendered them dangerous in some sense, and thus inviting harm? May this be at least partly why they were destroyed? They contravene any sense of a withheld epiphany.[98] We also arguably see a shift towards anthropomorphic representations on seals and finger rings that could be deities – though they are often small and hovering, and hardly unequivocal – their ambiguity and very small-scale offering perhaps less of a challenge to the 'principles' of epiphany.

These rather exceptional and powerful pieces aside, we appear to see another important transformation in the Neopalatial period – a change towards

the assembling of miniatures to form microcosms. We have already seen a version of this logic in the Neolithic, but it receded somewhat during the intervening centuries. A key piece in this puzzle is the apparent increase in 'house' or shrine models. Such models are much rarer than either figurines or miniature vessels, but they can provide us with a strong idea of how reduced-scale objects may have functioned as sets. In an important study, Ilse Schoep groups together the few that are known, including the clay models from the Kamilari tomb, the Archanes house model, a model from the Juktas peak sanctuary, a series from the east Cretan site of Piskokephalo, and the models from the Loomweight Basement at Knossos.[99] She shows that there are different categories: first, the fully elaborated multi-room building model, which is really an architectural model, the only example being the one from Archanes; second, the fully elaborated single-room building model (Monastiraki and Menelaion); third, the back-stage model, which formed a kind of frame in front of which figurines could have been placed to form a ritual microcosm (see the examples from Loomweight Basement and Piskokephalo); and fourth, the fully elaborated action model, which actually shows figures in action, with relatively little attention given to architectural detail, as with the Kamilari cases.[100] One might note how the figurines in the Kamilari models are quite roughly made and hence effective substitutes, for all their 'poverty'.[101] The discovery at the Juktas peak sanctuary of two miniature clay pillars just like the pillar in the Monastiraki example suggests a cult function for such models too.[102] Moreover, the Piskokephalo model was found alongside human and animal figurines.[103]

Some of these examples in Schoep's typology date to the end of the Protopalatial period, such as those from Monastiraki and the Loomweight Basement at Knossos. Nevertheless, it does seem that they come into their own during the Neopalatial period, becoming more clearly associated with cultic performances at peak sanctuaries. One must surely imagine that figurines and miniature vessels too were used in groups of this kind – the construction of microcosms to elicit some kind of effect on the macrocosm. While the Piskokephalo and Juktas finds suggest an association between model shrines and figurines, a relatively recent find provides an even clearer context: excavation of the peak sanctuary at Gournos Krousonas, on the way up to the Idaean Cave, produced a shrine model, figurines, bronze double axes[104] and miniature vessels dating to the Neopalatial period.[105] Further evidence for the connection between models and cult comes from the peak sanctuary of Kophinas, which has produced two kinds of models, rectangular models and façade models.[106] The former type, of which there are 150 fragments, consists of a low rectangular dish with figures attached, often aligned along the walls (as if in a procession), while the latter type, much rarer, just presents an architectural façade showing ashlar blocks. There are also shrine models at a peak sanctuary

in the Pediada region, Kephala Lilianou, with horns of consecration added.[107] Cult activity seems, as described, to have moved here from the nearby Middle Minoan IB peak sanctuary, Stou Mameloukou. Rethemiotakis sees such models as offering backdrops for cult scenes and considers this to be a new development in the Neopalatial period (despite the sporadic earlier examples in the Protopalatial).[108]

Indeed, this sense that architectural models are most often designed and used as cult accessories – rather than representations of specific buildings – seems quite widespread across the Near East.[109] We might justifiably view animal and human figurines and miniature vessels in much the same way. Rather than seeing them as stand-alone artefacts in their own right, we might better conceive them as players in a scene. Certainly, for miniature vessels, there are good grounds for casting them in the same microcosmic terms as architectural models, since so many are indeed associated with tombs, peak sanctuaries, and other cult contexts. Quite illuminating here is Tournavitou's discussion on the quantities and contexts of (mostly Neopalatial) miniature vessels at the peak sanctuary of Ayios Georgios on Kythera.[110] She shows how few they are in number compared to normal-sized vessels – although she does not explicitly recognise that this ought not to be too surprising if one thinks of them as probably playing a role in constructing microcosms, rather than used as votives by every single sanctuary worshipper. That is to say, we should try to make sense of them as accessory artefacts, rather than as capable of bearing a specific semiotic load by themselves (i.e. as standing in for an individual worshipper, let us say).[111]

Critically, these examples occur at the end of the Protopalatial period (Loomweight Basement), or into the Neopalatial period. The depiction of built space in miniature is encountered in other media now too, providing further evidence for this general trend. The Town Mosaic, probably dating to Middle Minoan IIIA, i.e. the beginning of the Neopalatial period, was found by Evans within the palace at Knossos; it consists of a number of small faience inlays (Figure 2.15). As many of these inlays show houses, the Town Mosaic is often interpreted as signalling the greater architectural elaboration and planning that is seen in the Neopalatial period. However, the inlays are not only architectural, but also include 'abundant remains of inlays of another class, trees and water, goats and oxen, marching warriors, spearmen and archers, arms and equipments, the prow apparently of a ship, and curious negroid figures'.[112]

Lyvia Morgan assembles some of these graphically into zones to show how they may have been arranged to form a scene, with the buildings at the top, a zone of trees below that, followed by goats and humans, and then in the lowest zone the sea with men swimming or drowning.[113] She does this in order to show its connection with the Siege Rhyton from Shaft Grave IV at Mycenae, a link that Evans himself made,[114] and also with the shipwreck scene in the

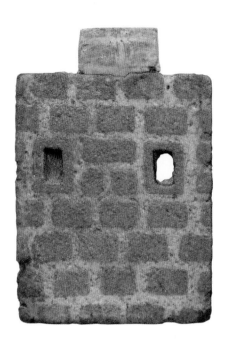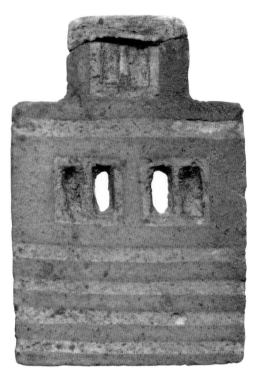

2.15 Two faience house plaques from the 'Town Mosaic', Palace of Knossos, Inv.no Y1. Archaeological Museum of Heraklion, Hellenic Ministry of Culture and Sports, TAP Service.

miniature wall paintings from the West House at Akrotiri, Thera. The details of how Morgan assembles the zones in the Town Mosaic are very tentative, 'merely to facilitate comparison'.[115] She suggests that if the plaques were inlays for the panels of a wooden box, then perhaps the buildings covered the top, with different scenes then covering each of the four sides.

Clearly, given this evidence from Thera, the Neopalatial period also sees depictions of architecture in miniature wall paintings. Sara Immerwahr had made the interesting observation that in such representations architecture is 'shown somewhat like a stage background'.[116] This fits very well with the argument developed so far that in the Neopalatial period we see the elaboration of models as microcosmic scenes, in which architectural models play an important framing role. The brief mention above of the Siege Rhyton from Mycenae indicates that such scenes are also being depicted in other media and at small scale, in this case in relief on a silver vessel.[117] Also in relief and on a rhyton, but in this instance in stone, an example from a Minoan-type peak sanctuary at Epidauros (close to Mycenae) bears an identical scene.[118] Further examples of stone rhyta from this period with relief depictions of architecture in association with cult activities are the 'Boxer' rhyton from Haghia Triada,[119] and the

'Sanctuary' rhyton from Zakros (Figure 2.16).[120] This use of architectural models, whether in two or three dimensions, to frame cult activity, is a very interesting development – and one might tie it both to the apparent rise of cult shrines within settlements in the Neopalatial, as well as the increased use of built structures on those peak sanctuaries still in use, such as Juktas.

What happens after the end of the Neopalatial period on Crete, during Late Minoan II–III? The Neopalatial period ends with widespread destructions in Late Minoan IB; only the palace of Knossos is untouched. Subsequently, there are major changes in material culture – the Linear A script completely disappears, but it is used as the basis for a new script, Linear B, deciphered and shown to be an early form of Greek. We see other changes also associated with the Greek mainland, such as new kinds of 'warrior' burial, and various innovative pottery forms.[121] It appears, however, that in the periods immediately following this major transition, i.e. Late Minoan II–IIIA1, Knossos is still very powerful on a regional scale, and there is a good deal of continuity in fact with earlier periods. What does this mean for the use of figurines, miniatures and models, and their association (or not) with cult practice and religion? We could quite reasonably anticipate some major changes.

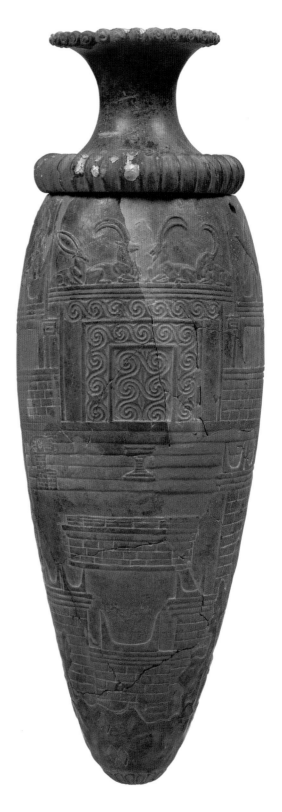

2.16 Relief stone rhyton ('The Sanctuary Rhyton') ht. 31 cm, Zakros palace, Inv.no Λ2764. Archaeological Museum of Heraklion, Hellenic Ministry of Culture and Sports, TAP Service.

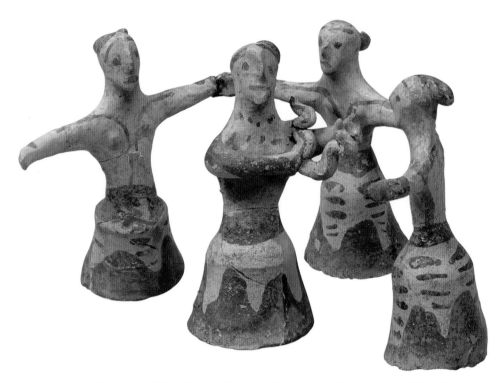

2.17 Clay model of four figurines (group of dancers and a lyre-player); height of figurines 13 cm; from Palaikastro settlement (Block D), Inv. no Π3903. Archaeological Museum of Heraklion, Hellenic Ministry of Culture and Sports, TAP Service.

It seems that Cretan figurines do change, becoming more schematic in comparison to the naturalism of the Neopalatial period.[122] In the Late Minoan II and IIIA1 periods, part of this schematism involves rather standardised cylindrical bases; note too that they often have painted decoration that draws on pottery motifs – an example from Late Minoan II at Knossos, in the Minoan Unexplored Mansion, shows the beginnings of this development, and a group of dancers from Palaikastro, datable to Late Minoan IIIA1, is also decorated (Figure 2.17).[123] This group scene is one indication that microcosmic scenes may remain important in the functioning of Minoan miniatures and models. One might also note that shrine models continue on Crete (though they are largely unknown on the mainland). They are cylindrical in form, with conical roof and a rectangular opening, and some are quite late – one from the Spring Chamber at Knossos is from the eleventh century BC, and contains a goddess with upraised arms; and very interestingly so does a later example (eight century BC) from Archanes – indeed, they continue into the Archaic period.[124] One striking exception to the cylindrical form of later models is a very large rectangular one from Quartier Nu, Malia, dating to Late Minoan

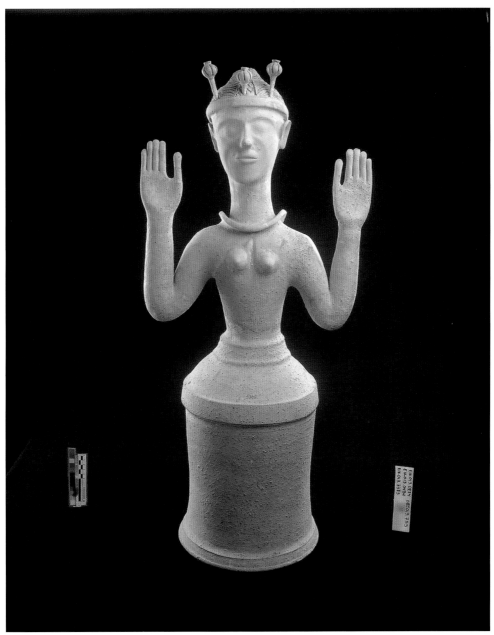

2.18 Clay female figure with upraised arms, ht. 79 cm, Gazi, sanctuary; Inv.no Π9305. Archaeological Museum of Heraklion, Hellenic Ministry of Culture and Sports, TAP Service.

IIIB; its purpose as a shrine model is unclear,[125] though it does have a possible visual association with nearby shrine equipment.[126]

A further aspect of this continuing tradition of microcosmic scenes on Crete is seen in the Minoan goddesses with upraised arms (Figure 2.18).[127] These occur in the advanced Late Minoan IIIB to LM IIIC periods, and often with

other artefacts that together form a set of shrine equipment, such as ceramic plaques and snake tubes. It is interesting that slightly earlier, in Late Minoan IIIA–B, we also find sets of shrine equipment but without these figures: Gaignerot-Driessen gives examples from a number of Cretan sites, and they may combine snake tubes (or tubular stands without 'snakes'), triton shells, kalathoi, and rhyta, among other finds. This practice of combining ritual objects to form sets is specifically noted by Salapata as a comparison to later, Classical examples in which sets of objects are grouped together as dedications.[128] Perhaps, then, we can see here a further aspect of a continuing tradition in using models to create microcosmic scenes for cult practice.

If microcosmic scenes appear to continue from the Neopalatial period, what about the other key feature of that period – the apparent move to depict divinities in anthropomorphic form? On the one hand, the very use of the term 'Minoan goddesses with upraised arms' (MGUAs) for the cult figures discussed above would seem to strongly suggest that this practice continues. On the other, the schematism of Late Minoan III figures and figurines would seem to suggest a break from the Neopalatial, and perhaps a different meaning for these depictions – even if the MGUAs do share the same pose as the 'snake goddesses' from the Temple Repositories. The argument made by Gaignerot-Driessen that these MGUAs are more likely to be votaries than goddesses fits well with the wider arguments made here. It is also consistent with the idea expressed by Driessen that much of Minoan religion seems to be basically aniconic, with a resistance to direct anthropomorphic depictions of deities, except during the Neopalatial period when we see some likely exceptions.[129] Along with the plaques and snake tubes, they form part of the cult equipment the aim of which is to elicit the appearance of (rather than directly display) the deity. It is 'withheld epiphany'.[130]

What is the situation elsewhere at this time, for example on the Greek mainland? Here a very widespread tradition in the use of figurines develops during the Late Helladic III period. They first seem to appear at the end of Late Helladic IIB and into Late Helladic IIIA1 – though they owe a great deal to Cretan influence, this does not entirely explain their origins, which remain somewhat obscure.[131] The small female figurines only really become very common in Late Helladic IIIA2[132] – the earliest 'Phi' type have their hands folded to the chest, much like the earlier Minoan ones with 'symmetrical hands to torso gesture'.[133] These gradually give way to the 'Psi' type, which draw on another typical gesture in Minoan figurines, the upraised arms (as discussed above). There is also the rarer 'Tau' type, with arms crossed on the chest. These small female figurines are often found in burials (of all kinds), though they also appear discarded in domestic refuse.[134] They seem to be used singly rather than in sets with other equipment, and so have a quite different function to figurines on Crete at this time. There also exist larger figures in the

Mycenaean world (c.25–30 cm), usually with arms upraised like Psi figurines. These typically occur in shrines, as at Phylakopi, Tiryns and Mycenae, together with shrine equipment – so perhaps here one might argue that we do see a handful of examples of microcosmic scenes. Both these and the small figurines have attracted a number of interpretations, with many scholars arguing that they do represent deities.[135] Given what we have argued above, following Gaignerot-Driessen,[136] it seems that we might best see these figurines and figures as votaries or worshippers of various kinds, while direct anthropomorphic depictions of deities are largely withheld.

MICROCOSM AND MACROCOSM

How, then, are we to interpret the meanings of reduced-scale models in the Aegean Bronze Age? We have identified quite a range of patterns, with the use of different materials – clay, marble, bronze, faience, gold and ivory; different scales, from the miniature to c. 1:2, though little at life-size and nothing monumental; and varying levels of detail, from quite crudely modelled figurines to more detailed renderings such as the Palaikastro kouros. Nonetheless, the general tendency is towards a stark reduction in scale and detail and the use of clay in the generation of models. What does seem to change significantly over time is the use of models in isolation or in groups. The apparent move in the Neopalatial period towards the elaboration of microcosmic scenes is a fascinating innovation – and I think one can see how it builds on what has come before. How might we interpret this? In other words, what added power do models and miniatures gain when combined in sets?

We could return to the argument outlined above concerning surrogate situations.[137] Are models assembled in microcosmic scenes in order to provide some traction on an intractable 'target situation', in other words, the macrocosm? We can turn to some ethnographic studies here by way of further support. Perig Pitrou describes miniaturisation as an important component of ritual offerings (called *mesas*) made by the Mixe of Oaxaca (Mexico).[138] A *mesa* is a representational device ('dispositif figuratif') through which different natural powers are activated and encouraged to interact. The aim is for the microcosm thus enacted to have some impact on events at the level of the macrocosm.[139] But Pitrou qualifies this by saying that it is not just about hoping that events will play out in a favourable way at the wider level – it is also about aligning different ontologies through the ritual – specifically by reducing sowing and rainfall to counting and distribution respectively.[140] He also refers to this in terms of 'condensation'.[141] In effect, miniaturization creates an abstraction through which heterogeneous parts are assembled in order to work together:

> En définitive, l'action rituelle figure des caractéristiques appartenant à
> deux ordres d'activité, non pour les représenter, mais pour produire une
> action synchronisée entre les humains et les agents de la nature.[142]

Miniature worlds thus at least offer the elusive possibility of wholeness, or at
least alignment of human action with the wider phenomenal world, through
condensation.[143]

An important aspect of the *mesa* that Pitrou describes is that a number of
miniature objects are gathered together.[144] This combination of models in
groupings would seem to enhance the sense of coordination between human
and non-human agents, or what Pitrou also calls 'co-activity'.[145] While
Pitrou's focus is on Mesoamerica, he notes that similar rituals are observed in
the Andes. There Catherine Allen has described 'pebble play' with miniature
objects, a process that also sees the grouping together of these objects in
microcosmic scenes.[146] A further feature that Allen highlights about such
groupings is that they use temporary miniatures; she contrasts this with another
Andean phenomenon that uses permanent miniatures, within which two
forms can be identified, *inqaychus* and *alasitas*.[147] An *inqaychu* is often a stone
in the form of an animal and is cherished as a source of vitality; it is typically
kept concealed within the home. An *alasita* is a mass-produced object that is
purchased, symbolising commercial aspiration, anything from a computer to a
car. It appears that neither *inqaychus* nor *alasitas*, as permanent miniature
objects, are designed to be used in sets, unlike temporary miniatures. How-
ever, in Sillar's account of contemporary Andean offerings, he describes *illa*
(equivalent to *inqaychus*) as both permanent (and indeed in some cases
inherited) and used together in sets.[148] Nonetheless, we can perhaps begin to
see some differences here in the effects that miniatures can have when used
individually or in sets. Pitrou, citing Laugrand, also makes reference to Inuit
miniatures, perhaps also used individually like *inqaychus*; in this context, mini-
aturization emerges as a quite different figurative device, Pitrou suggests, more
based on substitution and transformation than condensation.[149] Indeed, he
points out that miniatures are often seen in Inuit society not as images of real
objects, but as the actual origin for them – again, rather like *inqaychus*. Still, as
Laugrand warns, we must guard against an essentialist view of miniatures, as
they take on their power relationally.[150]

Given this relationality, it should perhaps come as no surprise that miniatures
bring many ontological possibilities. Pitrou suggests that in a Mixe context the
microcosm can be manipulated to have effects on the macrocosm. Laugrand
argues that in an Inuit setting, the microcosm is not a model of the 'real' but is
actually its source. Weston discusses the ancient belief in Western medieval
cosmology that the same patterns repeated themselves at different scales, with
the macrocosm being 'the greater sacred order of the universe' and the

microcosm the world of man.[151] In other words, man in the image of god, reproduces the same geometries; and so one should recognise this beauty, in a sense, by making architecture and the world of man as harmonious as possible. So, we have here three quite different cosmologies, or ontologies. We might then realise that when it comes to the Aegean evidence, we are probably faced with a particular view on how the microcosm interacts with the macrocosm. Were microcosmic scenes designed to reprise, generate or manipulate the macrocosm? Although an answer to this question may be beyond us, we can at least place this change within the wider socio-political developments of the Neopalatial period. This is a time when one palatial site on Crete, Knossos, becomes very large and powerful, and Cretan influence becomes quite pronounced over a wide area of the southern Aegean. Scholars also agree that palatial elites seem now to be manipulating and centralising religion much more than before (Driessen 2015, 36). Perhaps we might cite here an important voice on miniatures, that of Gaston Bachelard:

> Such formulas as: being-in-the-world and world-being are too majestic for me and I do not succeed in experiencing them. In fact, I feel more at home in miniature worlds which, for me, are dominated worlds. And when I live them I feel waves of world-consciousness emanating from my dreaming self. For me the vastness of the world had become merely the jamming of these waves.[152]

Is it that microcosmic scenes, then, offered a heightened sense of control for palatial elites looking to centralise religion? It is interesting that for Bachelard the miniature also seems to offer something almost religious – as if the possibility it provides for grasping the whole all at once has an epiphanic dimension – which is of course quite relevant for Minoan religion, with its apparent emphasis on epiphany, especially in the Neopalatial period. Perhaps here, in discussing the role of models in epiphany, we might refer to comments by Ludmilla Jordanova on the revelatory aspect of models in general: 'models purport to reveal a reality without being the real thing themselves'.[153]

CONCLUSIONS

Miniatures and models exist from the Upper Palaeolithic, are made and used quite intensively through the Neolithic and Bronze Age, as we have seen here, and continue into the Geometric and Archaic periods, and indeed the later Graeco-Roman world, before later appearing in the medieval, Renaissance and early modern periods. We have also briefly encountered their prevalence in a range of non-Western cultures.[154] Furthermore, they make some interesting appearances in modern and contemporary art, ranging from Slinkachu's miniature microcosms of real-life scenes (Figure 2.19),[155] and the miniature

2.19 A miniature scene by the artist Slinkachu. Courtesy of the artist and the Andipa Gallery, London. Above: wider scene with model barely visible at lower right. Below: close-up of the model.

everyday worlds full of tiny plastic figures composed by Kim Adams,[156] to Joel Shapiro's atomistic tiny metal sculptures of quotidian objects placed alone in a vast gallery space,[157] and Charles LeDray's intricate miniature stepladder carved from human bone placed alone in a bell jar.[158] Similar feelings may,

conversely, be evoked by the oversizing of artefacts, as exploited by artists such as Claes Oldenburg and Ron Mueck.

A much wider comparative study, combining the historic and the ethnographic, would no doubt bear fruit. What emerges through the various examples presented in this chapter is that the material process of modelling produces a wide range of semiotic possibilities. Particularly when modelling entails a quantitative reduction of scale and a qualitative simplification, quite strong scaffolding effects are produced; through their substitutive and performative affordances, models are used to reflect on and affect time. Reduced-scale material models offer immensely rich heuristic and creative possibilities.

The potential of a 'deep history' for such a phenomenon is very elegantly indicated by George Didi-Huberman in the context of *imprinting*[159] – which is the subject of the next chapter. With imprinting too, as we shall see, there are some fascinating issues around temporality, creativity – and especially, indeterminacy.

THREE

IMPRINTING

In the previous chapter we considered 'modelling' as an artistic process capable of capturing some aspect of a prototype, often but not always through the creation of a reduced-scale stand-in. Use of the idea of 'capture' here implies that the prototype is somehow affected by its substitute – and this sounds almost magical. It is a principle (the 'Law of Similarity') that lies at the root of Frazer's account of sympathetic magic: that by making a likeness of something one might gain some power over it. This is taken further by Michael Taussig in his work on mimesis.[1] However, as Taussig underlines, Frazer identified not only a Law of Similarity, but also a Law of Contact or Contagion. That is to say, things that have been in contact may continue to act on each other even when separated. In terms of contagious magic, this is often described as the magic that can be performed using a person's exuviae, such as fingernails or hair – once in contact with and part of the person, but still capable of being acted upon to gain some power over the person even at a distance. Taussig uses a different example, that of a horse's hoofprint, required in the magic performed to change the mind of the horse's owner.[2] The hoofprint is an interesting case because, although it does follow the principle of contact, it is at the same time an image of (part of) the horse. Taussig goes on to argue that 'in many, if not in the overwhelming majority of cases of magical practices in which the Law of Similarity is important, *it is in fact combined with the Law of Contact*'.[3]

3.1 Allora and Calzadilla, *Land Mark (Foot Prints)*, 2002. 24 colour photographs, each 20 × 24 inches (50.8 × 51 cm). Copyright Allora & Calzadilla. Courtesy the artists and Gladstone Gallery, New York and Brussels.

The use of a hoofprint in Taussig's example allows for the introduction of 'imprinting' as a praxeology with a particular semiotic capacity for capture. Many other forms of imprint bear this doubling up of similarity and contact. The connection between forms is made explicitly by Susan Sontag, who likens footprints (Figure 3.1)[4] to both death masks and photographs, in how they are all 'directly stenciled off the real'.[5] Unlike other images, then, these signs not only resemble their referents, they are also caused by physical contact with them.

Of course, it is photographs rather than death masks or footprints that have occupied most of the attention of theorists in thinking about the coconstitution of similarity and contact in imprinting. When we consider the impact that photography had in the late nineteenth century as a means for directly reproducing the real, we might well consider another technology of imprinting that developed in parallel and was considered complementary: plaster casting.[6] Sculpture and architectural fragments were reproduced in plaster through a process of casting, with a mould made directly from the original and the plaster imprinted from the mould. The notion of a direct stencilling

from the real holds true for such plaster casts even more so than for photography. Furthermore, these plaster reproductions can be viewed as more perfect than the originals – Mari Lending conveys the wonderful example from Marcel Proust's *In Search of Lost Time* of young Marcel being enthralled by the plaster copy of a medieval church portal in the Trocadéro Museum, but ultimately disappointed when viewing the original some time later. As Lending puts it, 'the actual church seemed arbitrary, while its plaster version in Paris appeared perfect, universal, and timeless'.[7]

However, this idea of reproduction actually adding value has by no means been universally shared. Lending recounts the fluctuating fortunes of the Yale Cast Collection, dramatically in and out of favour through the course of the twentieth century.[8] The dismissal of the imprinted copy as irretrievably inauthentic is most famously tied to Walter Benjamin's critique of the photograph as an example of 'mechanical reproduction'. What technologies like photography, engravings and woodcuts allow is repetition and replication, which are a threat to the 'authentic' artwork produced with creative input by an artist.[9] Although this contrast between authentic artworks and the mechanically reproduced is often attributed to Benjamin first and foremost, it is arguably a distinction that goes much further back, to Vasari in the sixteenth century, in his efforts to distinguish more or less creative forms of artistic production.[10] Vasari's decision to downgrade imprinting as a dubiously creative production, as belonging to the mechanical rather than the liberal arts, has had a lasting impact – so much so that Didi-Huberman calls the imprint the forgotten paradigm in the history of art.[11]

ANCIENT IMPRINTING

While it is perhaps natural to become preoccupied with photography, plaster casting and other relatively recent technologies of imprinting, there is quite a deep history to this praxeology, as Didi-Huberman is indeed at pains to point out. He takes us back to Palaeolithic hand painting that implies a stencilling from the real, through to the Pre-Pottery Neolithic moulded skulls from Jericho.[12] One imprinting technology to which he devotes less attention[13] – hardly a criticism, as his scope is already vast, from prehistory to Duchamp – is that of seals and their sealings. Seals are small personal items usually made of stone and carved with intaglio patterns that, when the seal is impressed into a malleable material, typically wet clay, will leave a patterned mark in relief, or 'sealing'. They are known from the sixth millennium BC in the Near East but become especially numerous when the first administrative systems come into being together with the earliest urban centres in the fourth millennium; initially seals are stamps, with cylinder seals invented a little later.[14] Although

the iconography of the patterns carved into seals is at times incredibly intricate, these objects have an economic function as much as an aesthetic value, used to secure (seal) various kinds of documents and containers.

Seals and sealings have an incredible history in the Aegean too, made and used almost throughout the entire Bronze Age, spanning some two millennia. Aegean seals come in a range of forms, such as ivory or bone stamp seals with one face, stone prisms with three to four faces, and gold finger-rings (Figure 3.2). Adding up all the impressions, and the various faces from these different seals, we now have a corpus of some 11,000 images, or 'seal-types'.[15] These seal-types are themselves incredibly varied, from simple geometric motifs to intricate narrative scenes depicting mythical creatures or cult epiphanies.

Most scholars accept that the idea of sealing must have found its way to the Aegean from the Near East, where the practice is known much earlier.[16] Sir Arthur Evans was in part drawn to the study of the prehistoric Aegean by his encounter with seals on Crete in the 1890s;[17] these objects, with their Near Eastern roots, must have fed into his belief that the development of Minoan civilisation owed much to Near Eastern influence. Subsequent scholars may have tried to temper or indeed refute the extent of this influence, with Renfrew especially advocating for the significance of local developments in the Aegean.[18] However, scholars have more recently been finding new ways to reconsider mobility and culture contact beyond the narrow assumptions of diffusionism – and here the work of David Wengrow is especially interesting and illuminating, not least because seals do feature prominently in his account.[19] He identifies a fascinating spread of composite motifs (or 'monsters') from the Near East to the Aegean, with Taweret one example: an Egyptian goddess combining elements of a hippopotamus, a lion and a crocodile, that is transmitted to Crete and transformed there into the Minoan 'genius' (Figure 3.3).[20]

While such image transmission can occur across a range of media, it does very often see a close link to seals. Indeed, Wengrow notes that:

> ... the subsequent proliferation of composites during the Bronze Age follows closely the spread, to neighboring parts of the Old World, of mechanical modes of image production, and of the palace and temple institutions where they were used to promulgate officially sanctioned signs.[21]

What is especially intriguing here is that Wengrow presents sealing as a means of transmitting images across space and time with a certain degree of fidelity. Indeed, he conveys this process as one of replication, and makes a direct connection to Benjamin's idea of mechanical reproduction, beginning his book with the claim that 'the first age of mechanical reproduction belongs

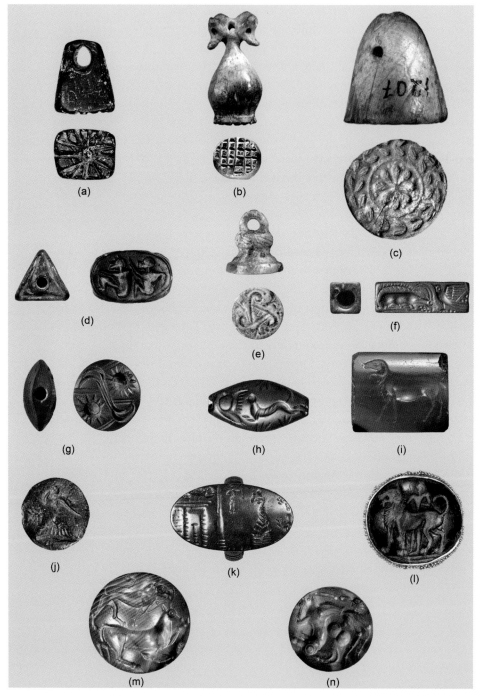

3.2 Selected Minoan seals: (a)–(b) EM II: steatite pyramid, bone theriomorph; (c) EM III–MM IA: hippopotamus ivory conoid; (d)–(f) MM II: steatite prism; blue chalcedony *Petschaft*; green jasper prism; (g)–(i) MM III–LM I: red jasper lentoid; haematite amygdaloid; carnelian cushion; (j)–(l) LM I: serpentine lentoid; gold signet ring; lapis lazuli lentoid in gold mount; (m) LM II–IIIA1 lapis lacedaimonius lentoid; (n) LM IIIA1 agate or chalcedony cushion. Scale c. 3:2. Photographs: Dr Olga Krzyszkowska.

to Mesopotamia ...'.[22] This may not seem particularly controversial. Many current approaches to seals and sealings in the Near East do not question the replicative power of the seal.[23] Moreover, the idea finds support in recent ground-breaking accounts of seals and sealings in other cultural contexts. Verity Platt, in a thought-provoking article on Graeco-Roman seals, contends that 'seals have the power to produce a chain of "copied" images which are directly connected to an original through their isomorphic properties'.[24] She too draws on Benjamin's idea of mechanical reproduction, placing the seal as a kind of ancient counterpart to the photograph, with a seal able to replicate an image. But there is a further dimension that Platt adds, which is the personal intimacy of the seal, worn on the person and closely connected to the person. As she states:

3.3 A Minoan 'genius' on a sealing from Phaistos. Image courtesy of CMS Heidelberg.

> [T]his combination of material intimacy with the semiotic power expressed by the act of mechanical replication is what makes seals so 'good to think with'.[25]

Turning to yet another cultural context, to medieval seals of the twelfth century, some quite similar observations are made by Bedos-Rezak in her seminal study:

> With the diffusion of sealed charters in the eleventh and twelfth centuries, human beings bounded by flesh and consciousness were now engaging in strategies of deferred representation so that, where they had previously operated as their own empirical self-representing agents, they now came to coexist with, indeed relate to, a 'double', their representative image (imago).[26]

Here the notion of 'deferred representation' seems quite close to what Platt is describing – the capacity of seal and sealing to mediate between personal intimacy on the one hand and a more distributed self on the other. Bedos-Rezak also indicates that it is the replication of the sign quality of the seal through its sealing that enables the dissemination of a person, as a social role:

> To be recognized and to be functional as a person, the individual had to become something else, a sign. Through signs, the individual acquired

definition and was constituted as an effective site for the production of symbolic activity.[27]

Thus, despite the differences between ancient Near Eastern, Graeco-Roman and medieval settings, there is in each of these accounts a similar sense of the replication of images that seals allow. For Platt and Bedos-Rezak, part of the power in this replicative process comes from the capacity of seals to extend personal agency and identity beyond the peripersonal and across a much wider spatio-temporal frame. Wengrow also notes for Egypt that 'media of personal presentation' become the focus of new forms of depiction for emergent elites in early states.[28] However, where seals are concerned, there is relatively little sense that there is much that can go wrong in the replication that the seal performs – it is as if it were a controlled process of reproduction, indeed a mechanical one. One major problem with such a conception of sealing is that it assumes all of the dynamic power is condensed in the seal itself, and its design and artistry is where creativity lies; the process of imprinting is then a relatively straightforward and mechanical replication in a malleable medium. This perspective, though, is a result of the imprint having been excluded from the narratives of art history.[29] The notion of mechanical reproduction being 'merely' replicative cannot even be fully overturned by these innovative studies that seek to put the study of seals on a new footing.[30]

IMPRINTING INDETERMINACY

The imprint has been so forgotten that Didi-Huberman feels compelled to turn to neighbouring disciplines, anthropology and archaeology, in his deep history of imprinting. What his appeal to these disciplines allows him to do is conceive of imprinting gesturally, drawing on the likes of Marcel Mauss, André Leroi-Gourhan and Gilbert Simondon. One significant outcome of this reorientation towards imprinting as gesture, other than to reinstate a haptical counter-model to the optical, is the realisation that it is anything but a mechanical, predictable process. When a fingerprint is taken, it is quite difficult to create a clean print – there is a certain technique to it, and attention needs to be paid to ensuring an even distribution of ink, correct angle of the forearm, rolling the finger from one side to the other, etc.[31] A footprint in the snow may seem mechanical and multiply repetitive, but no two are likely to be absolutely identical, with slight differences in the density of the snow, in angle and pressure of the foot falling etc. Certainly, there are cases – such as the mass production of bricks by imprinting in a mould – where predictability and repetition do seem to be generated; but they result from a high regulation of the process, not as an inevitable outcome of the mere action of imprinting itself. One of the scholars on whom Didi-Huberman draws, Gilbert Simondon, uses the example of the brick in the mould to discuss imprinting. He has

the very interesting observation that, with such moulds, the artisan can never quite see what is going on at the interface between mould and form, observing that 'le centre actif de l'opération technique reste voilé'.[32] The artisan does not control the imprint, or what Simondon calls 'la prise de forme'. The artisan prepares the clay substrate as best he or she can, and designs and carves the mould; but after that, it is the system of clay-mould that accomplishes the task. As Ingold puts it, also drawing on Simondon, the brick 'results not from the *im*position of form onto matter but from the *contra*position of equal and opposed forces immanent in both the clay and the mould'.[33]

That there is this indeterminacy at the heart of the imprint, then, goes rather against the idea of the imprint as mechanical reproduction. We can see a similar sentiment expressed to that of Simondon in work on photography. André Bazin postulates that 'all the arts are based on the presence of man, only photography derives an advantage from his absence'.[34] Geimer cites Bazin in the context of developing further this notion of the contingency inherent in photography, which he illustrates with an example from 1870 of a photograph of a Cairo skyline by Antonio Beato, in which a fly has inserted itself (Figure 3.4). Geimer suggests that one would typically see this accidental

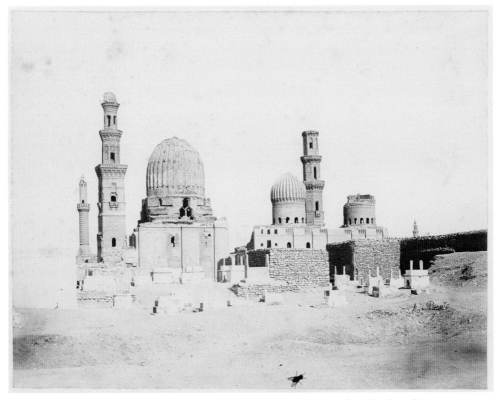

3.4 Photograph of a scene from Cairo, Antonio Beato, 1870. Fotosammlung Ruth und Peter Herzog im Jacques Herzog und Pierre de Meuron Kabinett, Basel.

inclusion as a distraction, but he argues that in many kinds of photography (e.g. scientific) this contingency is of value. In such instances, photographic traces are not just produced, documenting what can already be seen; rather they are exploratory, making visible 'a microbe, a radioactive substance, a galaxy . . .'.[35] So the photograph is the condition of vision: and its epistemic value therefore requires some pragmatic contingency or indeterminacy.

A further commentary, on the contingency of photography is found in the work of Kris Paulsen on the importance of the viewer's relation to the photograph – rather than define a photograph in terms of its indexical relationship to its referent, as physically caused by the latter, one should instead focus on its deictic character (or what Barthes calls the punctum), whereby it reaches out and touches the viewer.[36] There is indeterminacy in the reception of the photograph because sometimes its deictic character might be quite immediate and performative, but on other occasions it may require rather more abduction, i.e. interpretation.[37]

Part of this indeterminacy in the imprint as index lies in the indirect relationship between the gesture of imprinting and the form generated. When one presses together two surfaces, the process of 'pressing' or indeed 'stamping' does not itself relate directly to the resulting brick (because the artisan is on the outside). Compare, for example, to drawing in the sand, also a process of making marks in relief, and so perhaps with some similarities – and see Jennifer Green on the semiosis of such mark-making.[38] But with such 'inscribing', the gestures of the artisan relate much more closely to the marks being made – the process is not 'veiled', between two surfaces out of sight to the inscriber.

Although this notion of the indeterminacy of the imprint comes largely from thinking through anthropological concerns and interests, or through twentieth-century art production, with a common conflation of imprint, index and photography, the insights are surely transferable to our thinking about seals and sealings. We have already mentioned how Didi-Huberman uniquely shows the deep history of imprinting, from the handprints in Palaeolithic cave painting, to Mycenaean death masks, to Roman coins.[39] We can certainly include seals and sealings more fully in this story, as they have a remarkable presence and persistence in many ancient cultures, as we have already seen, with our brief examples thus far taken from the ancient Near East, the Graeco-Roman world and medieval Europe.[40] We have only mentioned a handful of scholars working in these areas. If we bear in mind the considerable weight of research on Near Eastern sealing practices, for example, we cannot do justice here to its complexities. We might briefly note, however, that in the wider scholarship there is some recognition of partial legibility and imperfection in sealing practices in ways perhaps not anticipated in Wengrow's general treatment. We can see this, for example, in the important work on the

Persepolis Fortification Archive, where the question of sealing legibility is certainly to the fore.[41]

However, we already have our work cut out dealing with our main focus, the seals and sealings of the Aegean Bronze Age, with its corpus of some 11,000 seal-types. Indeed, discussion of the art of the Aegean Bronze Age makes little sense without serious consideration of this corpus, with objects spanning Early to Late Bronze Age, found all over the Aegean in many different contexts (albeit with many lacking good contexts too), with a stunning range of materials, shapes and iconographies.

CONTINGENCY AND INDETERMINACY IN AEGEAN BRONZE AGE SEALS

Despite this variability, there is one feature that these seals from the Aegean Bronze Age share – their very small scale and, by inference, their intimate association with the human body. It is not only the imprint that has a tactile quality, but the seal itself – it may very well have been more felt than seen, worn on the person, close to the skin, whether on the wrist as a bracelet, around the neck as a necklace or on the finger as a ring. Indeed, some Aegean Bronze Age seals seem so strongly connected to the body that they may have had more of an amuletic function, never used sphragistically at all – although their ever-present sphragistic potential must surely have affected the way they were perceived. With their small scale – and we should not forget that many are only 1–2 cm in size – we should consider their relationship to the reduced-scale models that were the subject of the previous chapter. However, the seals themselves are not reduced-scale versions of some larger prototype. They are artefacts that are only ever at this scale (though the imagery upon them does often involve a scale reduction). Nonetheless, their size does mean that they are prone to being viewed as banal or playful, as little more than toys. While this has sometimes led to their under-appreciation, there are also occasional examples of art historical scholarship making a positive feature of this playful-ness in interpretation, as in Pointon's work on the playful quality of eighteenth-century miniature portraits, and the consequent psychoanalytical implications.[42]

Pointon makes an interesting observation with regard to miniature portraits as transitional objects – they imply a sociability, an attempt on the part of the user to negotiate their selfhood in a wider social space.[43] Seals also create a relationship between the immediacy and intimacy of personal identity, and a wider social world – but they do so perhaps even more strikingly because of their capacity to leave multiple imprints across both spatial and temporal distance. Even though the motifs on the seal itself may only be observable to a select few, the imprints generated by a seal have the potential to be very

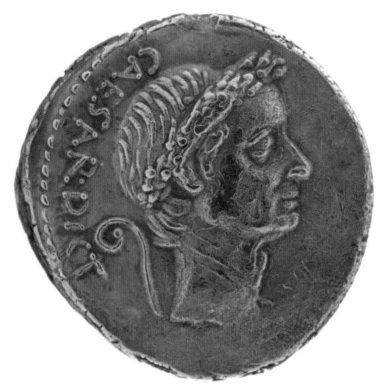

3.5 Roman silver denarius depicting Julius Caesar, 44 BC. With permission of the Royal Ontario Museum. © ROM.

widespread. This creates an interesting tension between close control and loose dissemination. But to what extent would the wide release enabled by imprinting have jeopardised the seal's association with an intimate personal identity? Didi-Huberman discusses this in connection with Roman coins, with Julius Caesar the first Roman leader to put his own image on a coin (Figure 3.5).[44] Was the identity of Caesar in any way undermined by the proliferate reproduction of his portrait on coins across the empire? As long as the image was controlled – in other words, as long as the minting process was secure with minimal possibility of fraudulent copying – then its power remained with Julius Caesar.

In this case one would also expect that the reproduction of his image on coins would be as careful and 'mechanical' as possible, with contingency reduced to a minimum. Didi-Huberman, in contrast to Benjamin, sees something magical in this capacity of the imprint to remain connected while at the same time widely disseminated.[45] He draws a link with Frazer's idea of contagious magic, an idea with which we began this chapter, wherein a powerful link remains between two things that have been in contact;[46] he cites Frazer specifically on the magical power of footprints, which Frazer says is nearly universal.[47]

This power that printed images can have is exploited in many other contexts, not least in the ancient Near East, where Wengrow suggests it is no accident that we usually see powerful images on seals.[48] His argument is that this is because of the multiplicity of imprinting – providing the power to widely disseminate – like the printing press, or indeed Roman coins. Again, this power is dependent on the control over the means of reproduction, which ought presumably to be as mechanical as possible. Seals would have been carefully controlled – both through the use of rare, exotic materials and restricting access to the skilled artisans with the know-how to carve intricate images. Given the close connection between Near Eastern seals and those of the Aegean Bronze Age, it should come as no surprise that the latter also often bear bold images carved intricately in exotic stones. They are rarely indecisive or indeterminate.

But from our earlier discussion on the contingency in imprints, especially but not only photographic ones, we should perhaps recognise that, despite such efforts at control, seals offer as much contingency as they do certainty. Perhaps elites could control both raw materials and craft knowledge, but impressing seals into clay does not have the mechanical certainties that we might imagine for, let us say, a printing press or a mint. Imprinting a mark into clay is a not a straightforward business – it requires a certain amount of bodily skill. The gesture to be used (rolling, stamping, etc.) demands a particular pressure and angle, and the wetness of the clay also comes into play. The seal itself may have one or multiple faces, may be convex or flat, hard or soft, and more or less graspable and easy to manipulate. Impressing into clay is thus inevitably somewhat tactile, meaning that the creation of an image engages senses other than the visual, lending it a degree of immediacy. Indeed, the tactility of the impression reinforces the 'punctum' of the index (see Paulsen above) – the way in which a sealing, like a photograph, announces a 'here–now', its deictic quality. So, the very gestural process of transferring immediacy to distance is quite significant. When one engages with an index or imprint, one recognises not only its current deictic quality, but also its having been created in a past that is no longer accessible.[49] Nagel and Wood call this the 'double temporality' of the imprint.[50] But crucially, this space means an openness to quite variable interpretation – we might refer again to the distinction made by Sonesson between performative and abductive indices.[51] Indeterminacy in the imprint comes not only from its double temporality, the fact that it rolls together a here–now and a there–then,[52] but also from the uncertainty about the geographical and temporal distance between these two phases. Was the impression made yesterday, a month ago or a year ago? Is the person with the seal still present, or long gone? To interpret the impression, then, might well require a level of abduction that goes well beyond the performative deixis of pointing, for example. Moreover, some protagonists

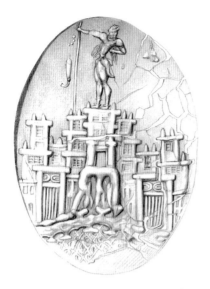

3.6 A Minoan sealing from Chania (the 'Master Impression'). Image courtesy of CMS Heidelberg.

might be much better equipped than others to infer accurately from the impression – presumably bureaucrats in the administration would be best able to abduct from the impression, while other non-specialists might be able to say very little other than someone impressed this with a seal at some point in the past. Figure 3.6 shows one of the most striking of Minoan sealings, the so-called Master Impression, found at Chania in west Crete and almost certainly made by a gold finger ring.

This level of indeterminacy might then seem to run counter to what one would assume of an administration – that consistency and predictability in seal impressions ought to be of paramount importance to its smooth operation. Would not the institutional authority of the mark be compromised by its illegibility, its imperfect registration? This is more or less what is implied by Wengrow who, because of his use of a framework influenced by ideas on cultural transmission and epidemiology, is susceptible to treating seal images as *representations* of deities or cult figures. They contain important information, and that information needs to be faithfully transmitted. For this reason, he is not attuned to the possibility that perhaps their power may lay in the very conditions of their imperfect replication, in their contingency. If we turn to work by Pentcheva, and Kumler, admittedly in rather different contexts,[53] on how relief images are more presentations than representations of the numinous, then perhaps it is the process itself of imprinting that offers a different kind of access to the divine, one that is imperfect and indeterminate, and hence more 'alive' than the controlled mechanical reproduction

implied by Wengrow. When we turn to some of the subjects of many of these Aegean Bronze Age seals, we will see an abiding concern with the otherworldly.

EARLY BRONZE AGE SEALS IN THE AEGEAN

Seals are very rare at the beginning of the Early Bronze Age, in Early Bronze I, though they do increase noticeably in Early Bronze II, with some fifty seals known from mainland Greece.[54] They are in clay, or soft stones, never in bone or ivory; bronze and lead seals are exceptionally rare, and it seems likely that some were in wood. Sealings are more numerous, with one hundred from the House of the Tiles at Lerna (with seventy different motifs) and, also in the Peloponnese, more than 250 from Petri. Motifs are typically geometric and curvilinear, with triple C-spirals and quadruple spirals featuring in the House of the Tiles assemblage.[55] Figurative motifs are rare. Seals and sealings also occur in the Cyclades at this time, principally decorated with spiraliform motifs. Crete is rather different, because there are many seals known (in the hundreds), but very few sealings. The seals in soft stone (steatite) tend to have simple linear motifs, while those in bone are more varied, with meander or star motifs, while some (from Haghia Triada) are carved in the shape of animal heads.[56] Some scholars argue that the absence of sealings on Crete suggests that seals were being used as amulets and not sphragistically;[57] others maintain that we can hardly use the absence of evidence for Early Minoan sealings as evidence of absence, since we simply do not have enough settlement contexts with fire destructions from the Early Minoan period.[58] Whatever the case, it does seem that in their first periods of use, the affordances of seals are not being universally exploited across the different regions of the Aegean. If seal and sealing technology does owe its emergence to contacts with the Near East and Anatolia, as seems likely,[59] then perhaps the contacts were not entirely direct, which could explain a certain degree of local selectivity in how to use the technologies.

The Near Eastern connection becomes quite apparent in the final period of the Early Bronze Age, on Crete at least; seals largely disappear from use on the Greek mainland and in the Cyclades during Early Bronze III. The connection is made manifest in the use of hippopotamus ivory, probably imported from Egypt, to make rather large seals decorated with figurative motifs. Particularly prevalent in the Mesara, and belonging to the Early Minoan III and Middle Minoan IA periods, one notable group is called 'Parading Lions'. An example from Platanos depicts on one of its faces seven lions 'passant' parading around a central frieze of six spiders; on its other face, three scorpions make a whirling pattern.[60] The combination of exotic material and imagery marks quite a departure from earlier seals.

3.7 Ivory squatting-monkey seal, ht. 3.6 cm, Platanos, tholos tomb; Inv.no Σ-K1040. Archaeological Museum of Heraklion, Hellenic Ministry of Culture and Sports, TAP Service.

Some ivory seals are even zoomorphic, such as a series in the form of squatting monkeys (Figure 3.7), which imitate Egyptian amulets.[61] Emily Anderson has undertaken a detailed study of these seals, notably the Parading Lions group, and finds that they differ from earlier Cretan seals not only in their exotic origin, but also their fuller sphragistic function; she has some interesting observations on what this means for the negotiation of individual and community identity in the Mesara at this crucial time of emergent social complexity.[62] Why would making impressions in clay with a personal item have been a useful strategy for establishing social identity? Only a small group could be aware of the association between an individual and a given seal with a simple design, especially if worn on the person and barely used sphragistically. But with a more complex design and a fuller sphragistic use, then a distinctive identity can come to be more widely distributed – which could be strategically useful at a time when social networks were expanding in their reach.[63] This tension between the intimate and the distributed, and this capacity to evoke identity through presentational rather than representational means, are enduringly powerful features of sealing.[64] Semiogenesis unfolds on the basis of these material supports.

MIDDLE BRONZE AGE

The decline in seal production and use on the mainland and in the Cyclades after Early Bronze II continues into the Middle Bronze Age, with barely a single example known; on Crete, however, thanks to the emergence there of the palatial system and administration, glyptic develops apace.[65] One of the principal points of reference is the sealing archive from Phaistos vano 25, with thousands of impressions, showing the active use of many kinds of seals in bureaucratic practices.[66] Another concerns the sealstone workshop at Quartier Mu Malia, and associated stylistic group of seals; though they are used in administration too, we have very few sealings compared to actual seals.[67] There are also many seals from the Mesara tombs; these indicate that seals continued to be valued for their close association with personal identity, suggesting their amuletic quality continued to be important alongside their sphragistic function. A problem with these tomb contexts is that they cannot be very closely dated within the Middle Minoan period.

Of the changes we see during this period, one of the first is the disappearance of ivory, and indeed the short-lived Early Minoan III–Middle Minoan IA phenomenon of 'white pieces' – a man-made composite material seemingly produced to mimic Egyptian imports, especially in the creation of local versions of scarab seals.[68] Bone seals also gradually disappear. It is as if the external influence that stimulated this creative output has diminished considerably. They are replaced mainly by stone stamp seals. Some of these do pick up on what has come before, mimicking the forms of bone seals and white pieces. Others are new types, such as three-sided round or oval prisms, and four-sided rectangular prisms, most commonly in steatite (especially prisms) and serpentine, a stone that is readily available in parts of the island (Figure 3.8).

These soft stones would have been relatively easy to carve – with the corollary being that this softness made it hard to create clean lines that could make sharp impressions. Then in the course of Middle Minoan II we start to see hard stones used: jasper, chalcedony, carnelian, agate and occasionally rock crystal and amethyst.[69] The carving of these harder materials was enabled by a technological innovation, the lapidary lathe.[70] This in turn enabled the creation of cleaner lines for impressing sharp images in clay. A new form is typically made in these new materials, and that is the Petschaft, which has a circular face and a stalk-shaped grip. By the end of the period we can tell from impressions at Petras and Phaistos that metal rings occur too (thanks to oval and convex bezels, not found in stone). Thus, in the course of Middle Minoan II we see some quite significant innovations in seal forms and materials, seemingly very closely tied to their sphragistic function and use.

At Phaistos the corpus is largely composed of sealings and not seals, which provides us with an opportunity to think about indeterminacy in seal

CMS V Suppl.3 no. 21 CMS II,1 no. 418 CMS XII no. 90

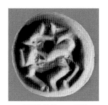

CMS V Suppl.3 no. 21a CMS V Suppl.3 no. 21b CMS II,1 no. 418 CMS II,2 no. 78c

CMS XII no. 90 CMS II,2 no. 174b CMS III no. 173b CMS XI no. 11a

3.8 Seals of the Malia Steatite group (after Anastasiadou 2016b, fig. 3). Courtesy of Dr Maria Anastasiadou. Images courtesy of CMS Heidelberg.

impressing. On the other hand, the corpus has not in fact been published, although much discussed. What we can say nonetheless is that stamp seals with circular face (discoids, 'boutons', Petschafte) create most of the impressions. While many motifs are ornamental, showing similarities with the contemporary Kamares pottery (i.e. curvilinear, geometric), others are very naturalistic, with birds, quadrupeds, lions in flying gallop, and indeed fantastic animals too such as griffins, sphinxes and Minoan genii, though few humans (Figure 3.9).[71]

Some of these depictions come from metal rings, which will go on to become a significant seal form in the following period. Although the considerable iconographic interest in this material means that any contingency in impressions is often overlooked, Krzyszkowska does mention that one quarter of the sealings from Phaistos vano 25 are illegible, which is quite remarkable.[72] Relaki in her work comparing Early Minoan and Middle Minoan sealing practices in the Mesara also discusses the vano 25 archive, citing work by Enrica Fiandra documenting that, of the c.6,586 direct object sealings, 2,202 preserve clear seal impressions, while 1,705 seem to show they were removed

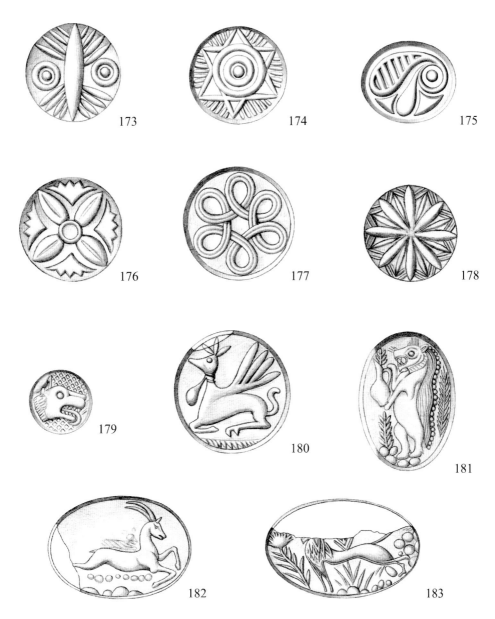

3.9 Selected motifs on sealings from Vano 25, Phaistos. Courtesy of Dr Olga Krzyszkowska (drawings of impressions © CMS Archive).

while the clay was still wet, thus damaging the impression.[73] The practice of multiple sealing that is used in this archive, stamping with the same seal over and over, would also seem to suggest a high level of indeterminacy, a lack of faith in the absolute authority of a single act of impressing.

As is the case in various other forms of material culture in the Protopalatial period, seals show some strong regional differences. So whereas we see mostly stamp seals in the Mesara region, in east Crete it is three-sided prisms in steatite, often carved quite roughly, that predominate.[74] Centred around the so-called Malia workshop (Figure 3.8), the corpus consists of more than 600 examples across east Crete, from Malia to Palaikastro, with motifs borrowed from earlier seals, such as the Parading Lions group of Early Minoan III–Middle Minoan IA. We see swirls, rosettes, quadrupeds, water-fowl, scorpions and spiders, schematic human figures and sometimes boats.[75] The motifs are often very stylised, with a head sometimes just shown by a simple hole. Given that we have a lot of seals and hardly any sealings, however, the situation is quite different from that in the Mesara, which makes it difficult to say very much about the level of contingency in sealing practices. What we can perhaps say is that with three-sided prisms, it is probably unlikely that all three sides would have been used in the authorisation of a commodity or document – so if just one side would have been used to make any given impression, we can suggest that this 'choice' of face constitutes a degree of contingency. We can also refer to the recently published Middle Minoan IIB archive from Petras, with its seventy-two impressions, or possible impressions; of these, only one is completely preserved with all its details, so the archive is quite fragmentary.[76] We might also note one imprint for which there was 'plenty of space to imprint the entire motif, but it was done in a way that only two thirds were actually impressed'.[77] This again suggests, as at Phaistos, that neat and perfect imprinting was not a requirement.

NEOPALATIAL PERIOD ON CRETE AND BEYOND

Turning now to the Neopalatial period, more than 2,000 seals and several hundred sealings are known from this period on Crete.[78] This impressive corpus shows some radical changes from the preceding period, in materials, motifs, shapes of seals and in technologies of sealing. In terms of how seals were increasingly adapted to effective sealing, Krzyszkowska notes that now seal faces are invariably convex – on lentoid, amygdaloid and cushion seals – whereas previously they tended to be flat, as on prisms and Petschafte.[79] She suggests that now seals had to be controlled by pulling the string tight, to form a handle: 'to make a good impression – and to remove the seal cleanly from the clay – a convex face offered a clear advantage'.[80] With an increasingly complex set of supports in sealing practices too, such as roundels, noduli, flat-based nodules and hanging nodules (Figure 3.10),[81] one might imagine that now

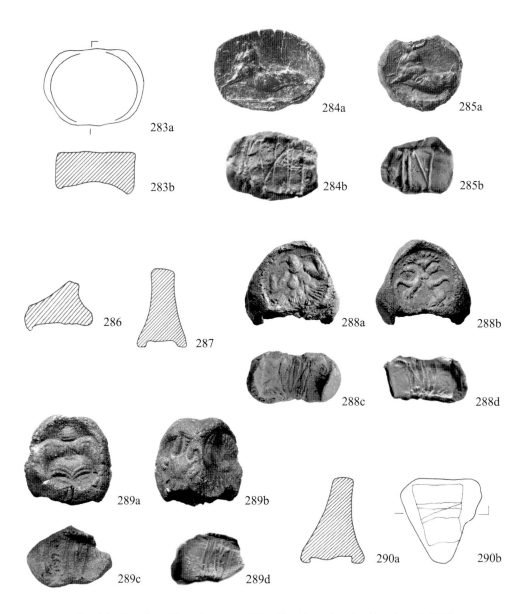

3.10 Neopalatial flat-based nodules. Courtesy of Dr Olga Krzyszkowska (drawings © CMS Archive).

there was less contingency in sealing and that seal impressions were more accurately made. This would make perfect sense, given the apparent heightened concern with administrative control, and the considerable centralised power of Knossos in the Neopalatial period. However, although Hallager has surprisingly little to say on the subject, given his focus on sealings,

Krzyszkowska does indicate that in the Neopalatial there are still incomplete impressions as a result of carelessness, and some partial ones because the seal was too big for the clay support.[82] Indeed, she finds this altogether puzzling: 'In other cases impressions were so carelessly made that the motifs are preserved only in part or are sometimes too blurred to read at all. If recognition proved difficult how on earth did the system work?'[83] It does seem curious in the context of what we assume about palatial power in this period; yet on the other hand, we should expect indeterminacy as a normal feature of any sealing practice.

When we move beyond Crete to the islands, then the Cyclades, coming under considerable influence from Crete, do show similar patterns of use in seals and sealings. Akrotiri on Thera has a corpus of sealings very similar to those found on Crete in the Neopalatial period. There is even an impression with a chariot scene from a ring that also made impressions on nodules at Ayia Triada and Sklavokambos.[84] The Akrotiri sealings are the subject of a study recently published by Artemis Karnava, showing that the sealings, which are in Cretan clays and so indicate the movement of sealed parchments from Crete to Thera, may not even have been opened, and thus the documents remained unread.[85]

The mainland, however, sees a very different pattern. The mainland may not itself have had any workshops during the time of the Neopalatial period on Crete. Moreover, the lack of sealing impressions at this time on the mainland implies that seals may not have had an administrative role there before the Mycenaean palaces are founded.[86] And yet, there are some wonderfully rich seals, especially gold finger-rings from burials at Mycenae, such as the 'Battle in the Glen' ring, and another showing a deer hunt with an archer from a chariot, both from Shaft Grave IV in Grave Circle A.[87] Now these rather unique finds are joined by the remarkable gold finger-rings from the incredible recent discovery at Pylos of a warrior tomb with a whole array of rich burial goods; a plan of the burial and one of its four gold finger-rings are illustrated here (Figure 3.11).[88]

Seals seem to be solely prestige objects on the mainland at this time – further underlined by the lack of soft stone seals, common on Crete, but seemingly of lower value and prestige. Moreover, some of the earliest known mainland seals are actually conceived as jewellery – as with the two talismanic seals imported from Crete found in Grave Circle B at Mycenae as necklace beads.[89] Although efforts have been made to distinguish local mainland products from Cretan imports, it is incredibly difficult, and ultimately perhaps more sensible to simply talk of many of these seals as 'Creto-Mycenaean'.[90] Any workshops that may have existed on the mainland, and this seems unlikely for much of the Neopalatial period (and its equivalent on the mainland), would surely have been set up under the

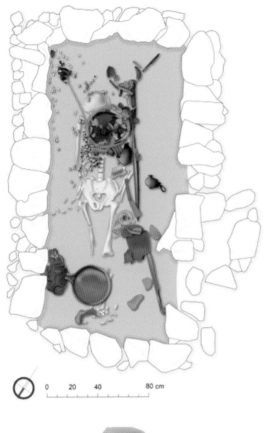

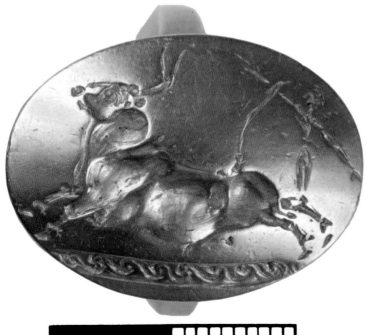

3.11 'Griffin Warrior' burial and one of the gold finger-rings. Courtesy of the Department of Classics, University of Cincinnati.

guidance of Cretan artisans, as this is not a craft that can be straightforwardly copied. Although the inspiration does seem very largely Cretan, one can see a few signs of some expression of mainland preferences, such as the use of amber for an amygdaloid seal found in tomb 518 at Mycenae,[91] and a reworked amethyst amygdaloid seal from Pylos with a lion depicted quite distinctly as compared to contemporary Cretan examples. Indeed, as Poursat stresses, we should not completely deny the possibility that Mycenaean preferences might have had some effect on Cretan artisans at this time,[92] as this direction of influence, long under-appreciated, can be discerned in other media, such as pottery.

One might well imagine that this situation only holds for the initial period of the mainland's borrowing of this Cretan tradition. This is, however, not the case. Slightly later in time, in the Final Palatial period (Late Minoan II–IIIA1, on Crete), it remains largely impossible to distinguish Cretan from mainland seals.[93] Not only do they circulate between these different regions, but they are also all made with the same techniques. Their value is still more for the prestige they convey, and they are deposited to this end in wealthy tombs. On the mainland it is not until later in Late Helladic IIIB that any sealings survive on the mainland, which makes it very difficult to ascertain the origins of Mycenaean sealing practices.[94] Certainly, it is curious that the sealings at Pylos, as indeed at other palatial centres such as Mycenae, Thebes and Tiryns, are sealed with antique finger-rings that went out of production c.1370 BC with the destruction of the palace at Knossos, and seals of semi-precious hard stones whose production lasted barely much longer.[95] Stranger still, the same can be said for the sealings at Knossos,[96] where the latest sealings date to c.1300 BC. It would seem then that even on Crete there is a period (say between 1370 and 1300 BC) when seals were not dynamically linked to sealing – and this presages their total disappearance soon after. A curious footnote in the history of Aegean Bronze Age sealing is the occurrence on the mainland of seals in soft stones and in glass – with neither used at all sphragistically.[97] The soft stone seals form the 'Mainland Popular Group' (Figure 3.12), and are of relatively poor quality; they seem to be quite derivative of earlier styles, and with quite simplified motifs – not what one might call especially innovative.[98]

The glass seals are mould-made, which is quite a departure, but was a technique typically used for manufacturing jewellery. This suggests that per-haps making seals in this way was considered as an extension of jewellery-making. Moreover, the style of the motifs, with rather heavy lines, suggests a possible link to ivory carving.[99] Thus, although these last florescences in glyptic art might at first sight seem innovative, they actually owe more to develop-ments in other crafts. Indeed, as Poursat puts it, 'paradoxalement, c'est à l'apogée des palais mycéniens que l'art de la glyptique perd son statut d'art

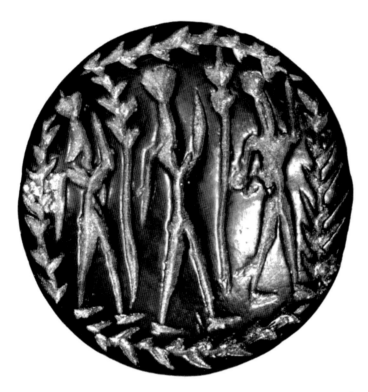

3.12 Seal from the 'Mainland Popular Group', Mycenae. Image courtesy of CMS Heidelberg.

principal du relief'.[100] And for Poursat, it is other relief arts, especially ivory, that take its place.

So, the relative lack of innovation in mainland seals contrasts very strongly with the creativity seen in Cretan seals. This difference can surely be tied to the active sphragistic use of seals on Crete, and the quasi-total absence of such uses on the mainland. If the logic of the seal is worked out and revealed through the many gestures of imprinting, and if such acts are intrinsic to its 'life', then the absence of this dynamic is surely going to produce an artefact that is lifeless, to all intents and purposes. They become relics, trapped in time: 'Bagues et sceaux en pierres semi-précieuses sont désormais des reliques de valeur du passé'.[101] They are substitutional, and hence backward-looking artefacts.

In other words, the contingency of the seal-to-sealing relationship and the indeterminacy that comes with the uncertainty at the interface between the two, placed against the need for consistency and accountability in sealing practices, generates a dynamic and creative tension. Using seals is a material and semiotic strategy for creatively exploring the world and gaining purchase on it. The indeterminacy of the sealing is useful on the one hand in administration, because it shows deictically that a person was present (like a signature); and it is simultaneously useful for capturing the ineffability of the numinous.

(a) (b)

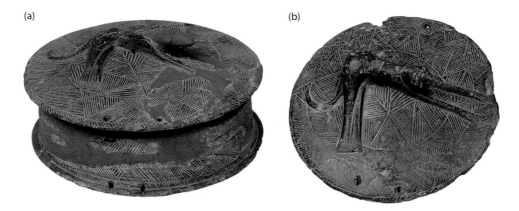

3.13 Stone pyxides with reclining dogs as handles of lids: (a) pyxis with lid, ht. 6 cm, Zakros, Gorge of the Dead, Inv.no Λ2719; (b) lid, ht. 3 cm, Mochlos, cemetery, Inv.no Λ1282. Archaeological Museum of Heraklion, Hellenic Ministry of Culture and Sports, TAP Service.

Indeterminacy is thus doubly good to think with. The indeterminacy of the imprint is perhaps not unlike the incompleteness of the miniature, which inevitably 'fails' to capture all detail in its likeness – but in this 'failure' offers space for creativity and imagination. The point here is that this 'space' is not a mental space, but is a locus or a series of loci that spread across minds, bodies and materials.

We mentioned above the idea put forward by Poursat that on the mainland in Late Helladic IIIA–B glyptic is replaced as a relief art by ivory. What can we say more broadly about relationships between glyptic and other relief arts? For the Early Bronze Age, one could pick out the occasional relief depiction, such as serpentine pyxis lids from Zakros and Mochlos depicting reclining dogs (Figure 3.13),[102] but there is not much else to report. The Middle Bronze Age is also quite sparse, although the acrobat on the gold pommel of a sword from Malia springs to mind,[103] and one might include some of the relief metal vases from the Tôd or Aegina treasures, though their provenance and date are debatable. On the Greek mainland and in the islands the situation is even more meagre, Poursat summarising as follows: 'Les arts du relief sont peu représentés en Grèce à cette époque'.[104]

It is really in the Neopalatial period that we see remarkable developments in relief arts – not only with the dramatic changes in seal carving, but also the emergence of relief frescoes – indeed the first figurative frescoes are arguably in relief.[105] Consider the life-size relief bulls from Knossos, in all likelihood from the very beginning of the Neopalatial period. Then at the same time we see relief bulls in other media, such as pottery – an example on a polychrome conical pithos from Anemospilia;[106] and a large lentoid flask from Akrotiri, Thera, almost certainly an import from central Crete, depicts a lion attacking a bull, in low relief with added white paint (Figure 3.14).[107]

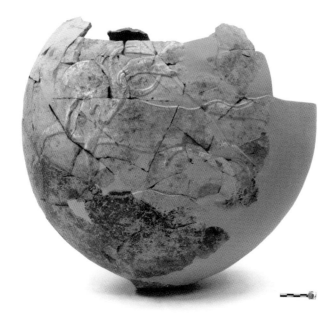

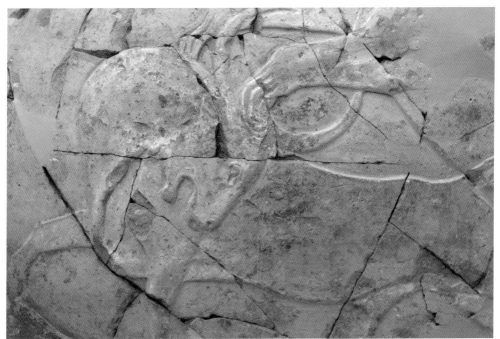

3.14 Flask with relief bull and lion scene, from Akrotiri Thera. Courtesy of the Akrotiri Excavations.

Then a little later we have the stunning relief stone vases, many of them rhyta, with intricate narrative scenes carved in relief, such as The Harvester Vase (Figure 3.15), the Boxer rhyton, and the Chieftain's Cup, all from Ayia Triadha.[108] The Sanctuary Rhyton from Zakros is another astonishing piece

3.15 Stone rhyton called 'The Harvester Vase', restored height 18cm, Haghia Triadha, Inv.no Λ184. Archaeological Museum of Heraklion, Hellenic Ministry of Culture and Sports, TAP Service.

(see Chapter 2), showing architectural elements as backdrop, as indeed does the Boxer rhyton (see Chapter 2 on microcosms). Another extraordinary piece, in yet another medium, is the ivory pyxis from Mochlos, with fabulous relief carving of a goddess in an epiphany scene.[109] We might further add the fine relief faience plaques from the Temple Repositories of Knossos, one of a bull, one of a wild goat suckling her young;[110] and the gold straight-sided cups from Vapheio, also with relief scenes of bulls.

We cannot liken these 3D art forms to seals as such, because seals were carved in intaglio, while these are all in relief – so what they can be compared to are actually the relief impressions created by seals. How does relief in and of itself hold a kind of power? We might draw here upon the interesting observations of Pentcheva in connection with Byzantine relief icons, and the kind of power they hold.[111] She says that relief images create shadow and movement – they seem more alive than a flat image. In motion themselves, so to speak, they draw the moving, perceiving body and eye towards them. So, they are more bodily and gestural then a flat icon – they invite tactility. Together with the play of light and sound, and the scent of incense, Pentcheva suggests this sense of tactility contributes to a more multi-sensorial, and hence more powerful, religious experience.[112] But surely there are many other ways of achieving this effect. Using models in a microcosm – as discussed in Chapter 2 – would also arguably produce a three-dimensional and tactile experience. Why then show an image in three dimensions in the form of a relief icon? Pentcheva says that 'in Byzantine image theory as it emerged in the 9th century, the icon is the imprint (in Greek, *typos*) of Christ's visible characteristics (appearance) on matter'.[113] So the icon gains power and aura from the sense of it having been created through direct physical contact with the divine. There is no reason why this should be solely a Christian concept, and indeed the wider anthropological relevance of 'contagious magic' was emphasised at the start of this chapter in our use of Taussig's ideas on mimesis, and in the context of Didi-Huberman's use of Frazer in discussing imprints as 'formes auratiques'.[114] Might such a concept then also be embedded in the relief images we see proliferate in the Neopalatial period? Given the power of the relief created by a seal – the combined power of delegated authority and of divine presence, no less – might not this logic have then been transferred to other (larger scale) media? So that when confronted with the relief imagery on stone vases, wall paintings, or ivory pyxides, the viewer would in all likelihood think of these reliefs as having been made through contact, as indeed most relief images had been up to that point, for generations? Interestingly, Pentcheva also makes a connection between relief images and seals in ninth century Byzantium, as sealing would have been a common practice for letters. She further references the work of Herbert Kessler on the *acheiropoietos* of Christ, created like a coin or seal, such that 'Christ's body functions like an intaglio impressed on the material surface'.[115] So in a culture in

which seals and impressions were common currency,[116] it would have made good sense to consider icons in similar light, given the close association of *graphe* and *sphragis*.[117] Returning to the Aegean context, we might recall the different opinions of Panagiotopoulos and Blakolmer (see Chapter 1) on the locus of creativity in the Neopalatial period – in three- or two-dimensional art. The current line of argument is much more consistent with Panagiotopoulos' argument that three-dimensional art is pivotal, and not with Blakolmer's idea that novelty is actually driven by wall paintings once this 'major art' emerges as a medium of expression.[118]

It is also significant in Pentcheva's account that relief icons are often in materials with specific qualities, be they technological, as with enamel, or in their radiance, as with gold. Perhaps it is the case that gold creates a shimmer that enhances the sense of movement inherent in relief art. We do see an association between relief and gold in the Aegean world too, with at least one of the relief rhyta mentioned above, the Sanctuary Rhyton from Zakros, preserving traces of gold leaf on its surface. And then, of course, we should not forget the most famous gold reliefs of all – the death masks from the Shaft Graves of Mycenae. Here, the direct physical presence causing these images demands a recognition of the necessary absence that is implied – the loss caused by the death of these notable individuals.[119]

We do need to think about the different materials involved, and how they relate to the religiosity of the scenes. Do some materials contribute to epiphany and transcendence? And with seals, there are so many more materials than gold to think about: from lapis lazuli. to rock crystal, to carnelian, to amethyst – some opaque, some transparent, some hard, some soft. We may not be able to determine their meanings in our protohistoric Aegean contexts, but the selection of materials for relief impressions appears not to have been trivial.

Might we usefully open this up to consider various kinds of artefacts in the Aegean Bronze Age created through casting or moulding? This would include many metal objects, like double axes, swords, etc. There are often magical connotations with such technologies, not to mention a definite indeterminacy in the creative outcome. But, as Platt points out, the seal is different, because the replication can be carried out by anybody with a gem or ring, unlike casting or moulding, occurring in a craft workshop.[120] Moreover, casting a metal object in a mould does not feel like an image is being directly stencilled from the real, as Sontag put it, in the sense of a death mask, or a footprint. There is not the same 'gesture' of imprinting in the casting of a fluid, molten medium until it sets.

CONCLUSIONS

We have seen in the above discussion, as also was the case in the previous chapter, how the specificity of a material process can be used in scaffolding

meaning. What is especially potent in the process of producing a likeness through imprinting is the conjunction of similarity and contact. The notion of similarity arising through contact may have informed at least some Aegean imagery, especially when one acknowledges the apparent primacy of seals in the development of figurative imagery. It is an idea that has arisen repeatedly, from Frazer of course, but also since in Taussig, Didi-Huberman and Pentcheva, across variant ontologies. If we just pick up on Didi-Huberman's usage, he has an interesting conception of the imprint, which takes him not only back to the Jericho skulls, but even back to the Upper Palaeolithic. He talks of 'la forme empruntée, la forme empreintée, et la forme sculptée' – and the Jericho skulls are all of these in one form, because the skull is transposed, or 'borrowed' ('empruntée'), from the body proper; the form is then moulded, with the skull as the container-imprint ('empreintée'); and then sculpted too ('sculptée'), with the addition of paint.[121] His Upper Palaeolithic example concerns the collecting together at Lascaux of actual shells (borrowed), fossil shells (geological imprints), and carved stones in shell form (sculpted). His deep historical approach should serve as an inspiration for any archaeologist; and his insistence on the 'anachronic' effects of imprinting practices applies equally well to the previous chapter on modelling, with its evident effects on time. It is a message that can also be readily carried forward into the following chapters, first on combining, then on containing. We have seen already how some of these relief images combine different materials, and so are composite in nature. Moreover, many also draw on the skeuomorphic logic that will feature centrally in the next chapter on combining. And, of course, when we turn to the theme of containing, many of these imprints already discussed double up as containers of one sort or another, from the Jericho skulls, to the Mycenaean death masks, to the various rhyta of Minoan Crete.

FOUR

COMBINING

INTRODUCTION: COMPOSITION IN THOUGHT AND DEED

In Chapters 2 and 3 I described *modelling* and *imprinting* as techniques that, through the transformations they impose, serve to prompt a creative outlook on the real. By viewing material technologies in this way, a range of ancient materialities, such as figurines, models, miniatures, seals, sealings and relief stone vases, can be made to appear in a new light. What I want to do in this chapter is develop a framework for looking anew at a creative phenomenon that is quite common in the Aegean Bronze Age, and in many other ancient, and indeed modern, settings. This creative mode entails the combining or 'blending' of heterogeneous elements – putting pieces together that might not seem to belong together at all. But the composite that is thereby generated can be quite powerful. It may be counterintuitive, but that is very much the point – the counterintuitive combination of parts feeds the imagination.[1]

Just putting one thing next to another is in itself insufficient to provoke the imagination. Interestingly, despite using various experiments to explore the nature of physical reasoning in infants, developmental psychologists do not have children place objects side by side – perhaps because there is no particular 'violation of expectation' to be investigated in so doing.[2] However, in some contexts it seems that placing objects next to one another, in different kinds of formation, does incite certain kinds of reasoning. After all, there are games based on physical juxtapositions, such as jigsaw puzzles and Scrabble. Often

placing puzzle pieces next to one another, or Scrabble letters side by side, leads nowhere at all – the pieces do not fit, and the letters seem not to suggest any words at all. But then there is that 'click' when a join is made, or a word forms.[3] There is a process here whereby the physical juxtaposition does, at some point become a mental operation – or, as Kirsh and Maglio might put it, pragmatic action becomes connected to epistemic action.[4] There is a scaffolding process at work whereby material structure provides the scaffold for semiotic manipulation – as we have seen for both substituting and imprinting too, in Chapters 2 and 3 respectively. As Ed Hutchins discusses in his work on material anchors for conceptual blends, bodies placed next to one another in a line do not in and of themselves make a queue.[5] There needs to be a concept of temporal sequence added, which is really to say that the line needs to be interpreted, to become a sign. The potential of bodies to form a line provides a material anchor, but this potential needs to be married with the concept of temporal sequence. Hutchins is working here with the idea of conceptual blends.[6] Interestingly, Turner recognises some of the content of what we discuss in this chapter in terms of conceptual blends: 'blending jumps out when we look at arresting and pyrotechnic monsters, gods, chimera, and therianthropes like the lionman'.[7]

In art history, Barbara Stafford is unique in drawing extensively on cutting-edge cognitive science to develop theories on how images work.[8] Indeed, she argues for a kind of isomorphy of structure between the mind and the world – as the mind (she argues) works by cobbling together 'conflicting bits of information', so we often see such processes of combination or coalescence – what she refers to as 'intarsia' – in the creation of art.[9] The physical cobbling together of things in this way, as in the emblems of early modern European prints, is a compositional mode that allows semiosis to piggyback on the material structure in the world. Stafford suggests that 'this dual process of first prying apart and then patching together into a novel unit yields ill-sorted and fantastic objects demanding to be noticed and thought about'.[10] So these composites that Stafford has in mind work by being counterintuitive; presumably some emblems are more effective than others in that their juxtapositions wreak transformation on some aspect of the real more eloquently or starkly. One question we will ask through this chapter is whether these juxtapositions can, over time, become blends. Stafford indicates that she is concerned with inlaying, not blending, which is no doubt appropriate if one is interested principally in the creative moment of composition. Here she seems to imply that with a blend one loses the separateness of the different elements. This is not how Turner portrays blends, however, as a key point of conceptual blends is that they can be used to compress and then expand ideas: a blend allows for the tight packing and 'transport' of an idea, which can then be 'unpacked' when needed (and then repacked).[11] It is worth asking, though, if

over the long term, the centuries of use of blends that we will explore below, a composite or blend may come to be somewhat fossilised, with this dynamic transportability fading away, as its semiotic power wanes (or is transformed).

Forms that juxtapose heterogeneous elements are known under other names too – they are monsters, or chimeras. Carlo Severi has written on the powerful role of chimeras in the generation of memory and imagination. Indeed, he shows how the idea of the chimera was fundamental in much of Warburg's reasoning on the power of images.[12] In an archaeological context, David Wengrow introduces the idea, focusing particularly on the Near East, that monster imagery only really proliferates with urbanism.[13] He also works with the notion of the counterintuitive, as discussed above in Stafford's work, though he draws more explicitly from the French cognitive anthropologists Dan Sperber and Pascal Boyer,[14] as well as arguing that counterintuitive images are quite mobile (a point on which Stafford would probably concur). However, he introduces the important revision that they are not contagious in their spread, in the sense of being indiscriminate; their transmission is instead highly selective and historically contingent.

AEGEAN MONSTERS

This we can see well enough in the spread of various monster images of Near Eastern origin into the Aegean. Composites such as griffins and sphinxes undergo a cultural transmission that is quite variable. Here we might usefully consider five categories of such composites, beginning with griffins.

Griffins

The griffin is a bird–lion composite of Near Eastern invention that 'travels' to the Aegean towards the end of the Middle Bronze Age and has a long life thereafter through much of the Late Bronze Age. However, we should not imagine that this journey is entirely one way – the transmission is complex, with Aegean-style griffins, which have distinctive characteristics, also depicted in Egypt, for example at Tell el-Daba.[15] As Morgan states, 'the Aegean griffin has the beak of a vulture, raised wings in profile (one behind the other), and often bears a crest and spirals'.[16] Griffins appear on seals, wall paintings, metal (in the Shaft Graves), ivory (Mycenaean examples) and pottery. One of the earliest depictions is on a sealing from vano 25 in the First Palace at Phaistos.[17] While this example is couchant, a slightly later one from Tholos Tomb B in the Fourni cemetery at Archanes, probably dating to Middle Minoan IIIA, is in the flying gallop pose, with a female deity hovering behind; the depiction is on a striking round gold finger-ring (Figure 4.1).[18]

4.1 Gold ring with a griffin and female figure, Archanes, Phourni cemetery; Inv.no X-A1017. Archaeological Museum of Heraklion, Hellenic Ministry of Culture and Sports, TAP Service.

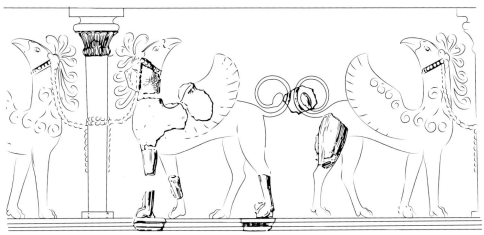

4.2 Relief fresco griffins from East Hall, Knossos. After Evans 1930, fig. 355. Redrawn by Isabella Vesely.

This is the first phase of the Neopalatial period, when figurative art booms across multiple media. Indeed, alongside these small-scale griffins on seals we also find some quite large-scale depictions on frescoes, such as the large relief examples from the Great East Hall in the palace at Knossos (Figure 4.2),[19] and a large-scale griffin

on a wall painting in Xeste 3 at Thera accompanying a female deity.[20] A further example from Thera in possible association with a female deity comes from the 'Porter's Lodge', just south of Sector A.[21] However, not all Neopalatial fresco depictions of griffins are at such scale: we also see them in miniature frescoes, both at Knossos and at Thera, the latter hunting in a Nilotic landscape in the West House.[22] While their representation on seals and frescoes is quite well documented, somewhat less well known is their appearance on Middle Cycladic pottery at Akrotiri on Thera,[23] as well as Ayia Irini on Kea and Phylakopi on Melos.[24]

The association between a griffin and a female deity in the Xeste 3 wall painting and the Archanes gold ring is developed further in later periods. In Late Minoan III, griffins depicted on seals show this close association, with the female deities flanked by griffins also often bearing so-called snake frames, most probably representing, initially at least, the horns of sacrificed bulls and goats.[25] The griffins flanking the throne in the Throne Room at Knossos (see Figure 4.3) are difficult to date, but could also be Late Minoan II;[26] and if one links the symbolism to the seals with griffins flanking a goddess mentioned above, it may be that the Throne Room representations are placed as an

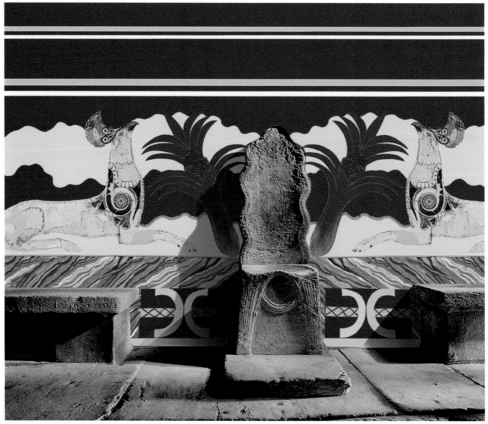

4.3 Griffins in Throne Room, Knossos. Prepared by Ute Günkel-Maschek. Courtesy of Yannis Galanakis, Efi Tsitsa, Ute Günkel-Maschek; and the British School at Athens.

evocative backdrop for the performance and actions of a female protagonist, be that queen, priestess or 'impersonated goddess'.[27] One might even imagine that the griffins are thus located to evoke an absent seated female deity who might be induced to appear epiphanically. A further association between important females and griffins is found on the Ayia Triadha sarcophagus, where a griffin is depicted pulling a chariot with two women.[28]

Sphinxes

Sphinxes are composite creatures that combine a human head with a lion's body; they also sometimes sport wings, an aspect of the composition that has generated different explanations. Sir Arthur Evans himself recognised the existence of both wingless and winged variants in Minoan iconography, and considered the winged type to be truly Minoan (albeit inspired by Near Eastern prototypes), and the wingless type to be of Hittite derivation.[29] Evans found examples of both types, he thought, in the Treasury Deposit of the Domestic Quarter at Knossos. He reconstructs a winged sphinx made of ivory,[30] and a wingless one based on steatite locks of hair, which he thought would have fitted onto a body of ivory (Figure 4.4); that this sphinx would

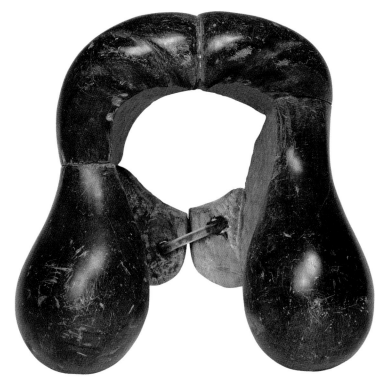

4.4 Stone headdress, perhaps of a sphinx, ht. 23 cm, Palace of Knossos, Inv.no Γ352. Archaeological Museum of Heraklion, Hellenic Ministry of Culture and Sports, TAP Service.

have been wingless is seemingly based on comparisons with a steatite sphinx from Hagia Triada.[31] However, as Lapatin points out, it is quite speculative that these stone coiffures belonged to a sphinx; on the basis of the Palaikastro kouros, with its coiffure in a similar stone, Lapatin suggests the composite figure may actually have been anthropomorphic.[32]

Notwithstanding Evans' ideas on the different sources of winged and wingless sphinxes, this composite 'monster' clearly first travels to the Aegean from somewhere in the Near East in the Middle Bronze Age, with the first occurrence about the same time as the griffin in Middle Minoan IIB – in this case, a wingless, 'Egyptianising' form on a clay appliqué from the Quartier Mu complex at Malia (Figure 4.5).[33]

Nota Kourou also notes two equally early examples from seals, one of which, a green jasper example from Archanes, is also mentioned by Evans.[34] It is also further argued by Kourou that the winged type then first appears in the Neopalatial period – the ivory example found by Evans would appear to

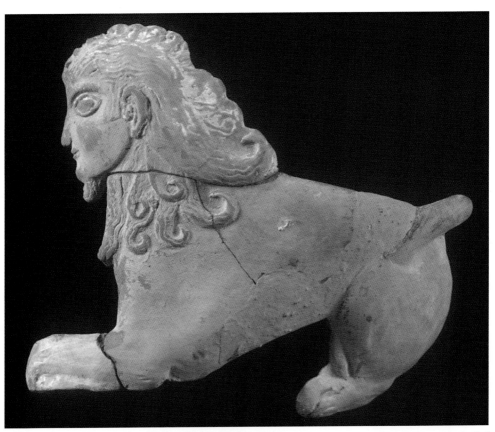

4.5 Egyptianising sphinx appliqué from Quartier Mu, Malia (see Poursat, J.-C. 1980, Reliefs d'appliqué moulés, in Mu II, 116–132; and Poursat 1992, Quartier Mu guide). Courtesy Ecole Française d'Athènes. Photograph Ph. Collet.

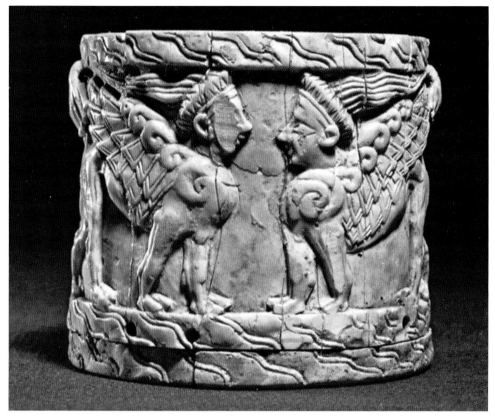

4.6 Winged sphinxes on an ivory pyxis from Thebes, Boeotia. With permission of the Ephoreia of Boeotia. Photo credit: Sp. Tsavdaroglou (Catalogue du Musée de Thèbes, *Dimakopoulou-Konsola, pl. 26 en bas*). Image courtesy of Jean-Claude Poursat.

date to this period. It seems that winged sphinxes are more associated with Syria than with Egypt.[35] A recently discovered example of a winged sphinx from the Neopalatial period comes from Palaikastro, where it forms the handle on a small decorated lid. It fits with the idea that the sphinx in the Aegean almost always appears as an 'isolated, emblematic figure in a crouching position'[36] The sphinx continues its life in the Aegean in Late Bronze III, with examples in ivory from Mycenae, Thebes (Figure 4.6), and Spata (in Attica),[37] and cylinder seals from Thebes.[38] Depictions of sphinxes seems quite different to those of griffins, not least in being singletons, while griffins often appear in pairs; and in the consistent crouching position, contrasting to the different poses taken up by griffins.[39]

Minoan Genius

A third kind of fantastical composite creature is Taweret, a hippo–human–crocodile hybrid in Egypt, and a fertility god, transformed in the Aegean into a

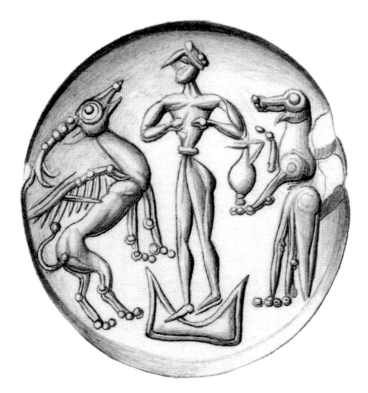

4.7 Minoan genius on a seal from an unknown location on Crete, now in the Benaki collection. Image courtesy of CMS Heidelberg.

specifically local kind of monster, the Minoan genius.[40] An early example in the Aegean comes from a sealing in vano 25 at Phaistos, dating to Middle Minoan IIB, where we also see the first griffin depiction, and at the same time that the sphinx appears at Malia. A fabulous example is also on a stone triton from Malia,[41] which we will consider further below. There are also those on a seal from Vaphio on the Greek mainland, a little later of course; and a famous gold finger-ring from Tiryns with a whole procession of genii. A seal from an unknown location on Crete (now in the Benaki collection) has a marvellous scene with a genius on one side of a male figure in arms-to-torso pose (atop horns of consecration), and a griffin-goat composite on the other (Figure 4.7).[42]

Bes/Beset

A fourth, rarer 'monster' is derived from the Egyptian Bes, with the only Aegean example known so far on a sealstone from the cemetery at Petras in east Crete (Figure 4.8). In Egypt, Bes combines human features, in dwarfish proportions, with the mane and tail of a lion. It is often depicted frontally, as is

the Petras example, 'with outsized head, pendulous breasts, hairy legs, and a tail possibly dangling in between'.[43] The date is Middle Minoan II, like the first appearances of the griffin, sphinx and Minoan genius. However, it does not seem to gain any kind of traction in the Aegean, with no 'afterlife' in subsequent periods.

Zakros 'Monsters'

Also in east Crete is an assemblage of rather remarkable and unique 'monsters', on Neopalatial sealings from Zakros (Figure 4.9). There is a human–goat–bird figure, and various bird–ladies.[44] The Zakros composites raise an interesting issue. Anastasiadou says that some are put together cohesively such that they look like living creatures – i.e. head, body, limbs, etc. These with an 'organic' set-up she contrasts with examples that seem to be created 'inor-

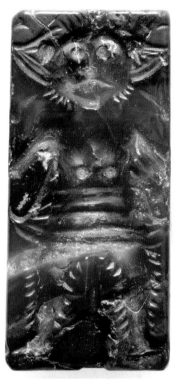

4.8 Seal from Petras (east Crete) with image of Bes (or Beset). Courtesy Metaxia Tsipopoulou and Petras excavations.

ganically' – the different parts do not join up to form a coherent 'living' whole. It is hard to think of these composites as 'creatures'. This point that Anastasiadou makes is quite significant because, indeed, there is no necessary relationship between 'composite' and 'creature' – composition and recombination can surely be done non-organically. Why can we not apply a general notion of 'composite' recombination to the blending of different inorganic things? If we think this is a reasonable assertion, it paves the way for looking at certain kinds of artefactual recombination under this broad umbrella of the 'composite'.

ORGANIC AND INORGANIC CHIMERAS? FROM MONSTERS TO SKEUOMORPHS

Let us take an example here from the Aegean Bronze Age that serves to show this connection of organic chimeras with inorganic chimeras. In Figure 4.10 we see an image carved in relief of two Minoan genii, derived from the Egyptian goddess Taweret, a composite creature with hippopotamus head, lion claws and feet and crocodile back and tail.[45]

4.9 A Zakros monster sealing. Image courtesy of CMS Heidelberg.

The stone object on which this image is carved is in the shape of a triton shell.[46] Actual triton shells were also used for cult purposes, and in some cases were themselves carved and painted.[47] In this case, however, we have a stone imitation of a triton shell.[48] So this too is a composite – perhaps not as chimeral as the Minoan genius, but nonetheless we have an organic form (sea shell) rendered in an inorganic material (stone), arguably a counterintuitive blending. Such combinations are not typically described as chimeras, but rather as skeuomorphs. We will now discuss this phenomenon of skeuomorphism – while keeping in mind that perhaps skeuomorphs are more chimeral than typically realised.

The word 'skeuomorph' may come from the Greek 'skeuos', for 'vessel', and 'morphos', for 'form', but it is a neologism, seemingly first coined in English in the late nineteenth century.[49] A skeuomorph is a form that takes a prototype and mimics it in a different material. While mimicry and imitation are certainly key to skeuomorphism, they are not in themselves sufficient to explain the phenomenon. As Tanya McCullough points out, salt and pepper shakers made to look like batteries, or bars of soap imitating Lego, are not skeuomorphs because they do not make any attempt to duplicate the function of either batteries on the one hand, or Lego on the other.[50] There has to be

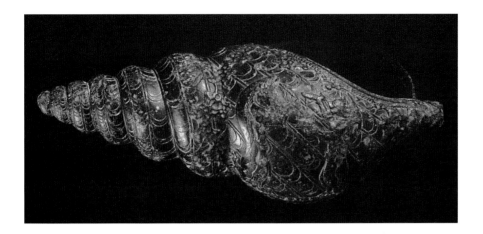

4.10 Stone triton from Malia with scene of Minoan genii carved in relief. Courtesy Ecole Française d'Athènes. Photograph Ph. Collet; drawing I. Athanassiadi.

some sense of commonality of function for the term 'skeuomorph' to have any purchase, and not to extend to all forms of imitation. After all, as McCullough so nicely puts it, a painting of a banana is not a skeuomorph of a banana because it is not attempting to replicate the real world 'purpose' of a banana as foodstuff. Paintings are rarely skeuomorphic – except when they are doing a functional job, as when a painted marble-veined dado does the job of an actual marble dado. Here we might usefully cite McCullough's definition:

> Skeuomorphs ... are substitutive proxies made from different materials and/or by different manufacturers that meaningfully emulate another valued object of the same function for the purpose of evoking the properties of the original through the use of specific markers inherent to the prototype.[51]

With this definition, one can see how the imitative salt and pepper shakers are not skeuomorphs, because they are not emulating 'another valued object of the same function'. What is meant by 'function' though requires some further unpacking. McCullough draws on the idea of 'affordances' from the work of J. J. Gibson in ecological psychology.[52] The advantage of this idea is that it provides a relational perspective on function, such that an artefact's function is not somehow entirely inherent but depends on the action context. A screwdriver may be designed for particular actions, but it has some flexibility in use depending on the requirements of the user – for example to open a tin of paint.[53] But as well as these physical affordances, some artefacts might be said to have 'cognitive' affordances.[54] A cognitive affordance may be a 'design feature that helps ... thinking and/or knowing about something'. Typically, as McCullough indicates, this sense of affordance has been developed in relation to computer software design, with icons for particular electronic operations, like cut-and-paste, depicting actual physical artefacts associated with these processes (i.e. scissors as icon for 'cut'). Here some aspects of McCullough's definition ring true, in that the skeuomorph is a proxy emulating an original of the same function; yet, it would be difficult to say that the scissors are a 'valued object'. McCullough mentions other, more material examples of specific markers acting as visual cues, such as the vestigial handle on some maple syrup bottles – presumably an index of the heritage value of the product. Such examples are perhaps not all that different from those cited long ago by Colley March,[55] such as when a Classical Greek temple made of marble included carved depictions of timber beam-ends – these would have been essential structural features in the earlier timber-built temples but become visual cues in the stone temple to its heritage and origin in earlier form. Thus, this architectural feature may not have a physical affordance per se, but it can be argued to have a cognitive affordance, in that it uses 'specific markers inherent to the prototype' to facilitate thinking about the object in an appropriate manner.

In effect, McCullough is here providing a functional interpretation of 'ornament'. Although McCullough does not dwell on the theme of ornament in her account, for much of the discussion of skeuomorphs in the late nineteenth century 'ornament' was an overriding preoccupation. Scholars then considered timber beam-ends as ornamental – in that they did not make any physical contribution to the integrity of the building. That such features persisted was seen as a sign of a lack of progressive thinking on the part of the craftsman – almost as if the power of long-established materials (such as wood) was such that they imposed themselves on the artisan's mind, simply unable to shake them off.[56] This logic was also seen to operate in the preservation of basketry patterning in ceramic vessels, for example. It was only with Riegl that the selection of antique features harking back to the past was entertained as possibly being a conscious selection – although this too was then taken as a sign of the relative lack of creativity in 'primitive' technologies, if compelled to maintain nostalgic links to earlier (outmoded?) technologies, when compared to modern technology. Thus, either way, ornament was detrimental to truly creative production. The modern view of cognitive affordances, however, does explain how ornament can provide functionality in its capacity for offering visual cues. That said, there surely comes a point where ornament lingers and even its function as a marker becomes dubious – is the 'survivance' (to take a term from Warburg) of the 'le voleur' base in a wine bottle really still a necessary marker, or is it nothing more than nostalgia?[57] Initially in the first stages of the innovation of making corks for wine bottles from plastic, one can see the utility in making them resemble cork. But how long does this need to persist once the innovation has been successfully adopted? McCullough does quite usefully urge us to consider chronological factors in assessing the degree of similarity between skeuomorph and prototype, which can diminish over time. Yet there is also the issue of whether the (cognitive) functionality of the skeuomorph degrades over time, as the context of understanding changes.

Time is indeed an integral facet of McCullough's approach, notably in her important distinction between 'aspirational' and 'preservational' skeuomorphs.[58] The former, on the one hand, are those types that emulate valuable, prestigious, and/or exotic artefacts, using materials that are more readily attainable. So, for example, if there is a cup made from silver, and this is difficult to obtain because of the rarity of silver, and/or restricted access to the skills of the craftsman, then it may be that those aspiring to own such a luxury object and to share in the status it implies will seek to make and use their own versions, in ceramic, for example. This phenomenon of clay imitations of metal prototypes not only fulfils all of the requirements of McCullough's definition of a skeuomorph, it has also attracted most of the scholarly attention on skeuomorphism, as in Vickers and Gill's well-known study of

Greek metal and ceramic vases,[59] and studies of Bronze Age examples too.[60] On the other hand, the logic of preservational skeuomorphs is to 'preserve some aspect of the past or to evoke some idealized qualities associated with traditional technologies and methods'.[61] McCullough argues that such examples are typically brought up in the literature concerning times of transition, for example when clay vessels start to be made in the Neolithic, seemingly imitating basketry, textiles or other organic forms, like wood or gourds;[62] or when stone forms transition to metal;[63] or indeed when timber-built structures start to be made in stone. In this last case, McCullough brings up again the case of Greek temples, which when made in marble sometimes maintain specific markers from their wooden predecessors in a 'preservational' nod to the past. She uses this case to also argue that in preservational cases the skeuomorph may occur in more expensive materials than the prototype.

McCullough's analysis is valuable in setting out a broader framework for understanding the dynamics at play in skeuomorphism, getting away from some of the specific interpretations encountered in the archaeological literature that can only account for some instances. She quite correctly identifies the need for us to think more clearly about how value is established relationally and how it may change over time as circumstances and relations shift. The focus on skeuomorphs as substitutive proxies is also very helpful, resonating quite strongly with many of the arguments made earlier in Chapter 2. Yet by placing emulation at the heart of her definition, McCullough perhaps restricts herself more than she needs. Another recent contribution to the literature on skeuomorphism also identifies a range of phenomena at play but comes at it rather differently.[64] One of the main arguments Houston makes for skeuomorphism in the Maya world (though more broadly too) is that the directionality of mimicry is often from an impermanent (organic) material to a more permanent one (ceramic, stone). This has more of a metaphysical flavour to it by way of interpretation when compared to McCullough's approach (though it is consistent with her 'preservational' logic). He also discusses the idea that skeuomorphs embody a transfer of essence, 'by means of *claimed transubstantiation*'.[65] Interestingly, here he cites George Hersey, who argues that Greek temple ornament embodies a kind of transubstantiation whereby elements of sacrifice become the temple.[66] This idea of a kind of transubstantiation or ontological transfer is also found in Conneller's study of possible Upper Palaeolithic skeuomorphs.[67] Although her preoccupation with 'deception' detracts from her main points, one can see here how McCullough's focus on emulation perhaps limits her from opening up the topic further still.

However, these are not the main reasons why I think McCullough ultimately plays it too safe in sticking with emulation as the underlying process of skeuomorphism. While it is admittedly difficult to get away from the idea of a

prototype being copied, I would like to approach the phenomenon a little differently, in a way that can hopefully illuminate its creative aspects more fully. By bringing to bear some of the above ideas on combining and blending, we might usefully reconceive skeuomorphism as a combination or blend between form and material – often, though not always, metal form with clay material. Moreover, the blend need not join together just two elements, as we see some examples where three elements are combined, such as metal form, stone decorative effect and clay material. If we see a skeuomorph as a composite, then we perhaps put ourselves in a position to go beyond their characterisation in terms solely of emulation or imitation – terms that do not begin to capture the skeuomorph's creativity.[68]

Returning to the striking example we introduced above, that of the stone triton vessel bearing imagery of two Minoan genii, how does viewing it as a composite enhance our understanding? After all, it does fit well into McCullough's definition of a skeuomorph. The stone triton could 'function' in much the same way as the shell triton – perhaps for 'the pouring of liquid offerings during ceremonies'.[69] And it does seem to be clearly emulating the shell original. But what is the logic in choosing to imitate a shell triton in stone? Neither the 'preservational' nor the 'aspirational' logics proposed by McCullough seem to make sense here, because there is little indication that stone tritons are replacing shell ones and maintaining visual cues to the shell originals; and it is not as if stone is evidently inferior to shell and can only emulate this more valuable material (as is often argued for ceramic skeuomorphs of metal prototypes). The rich imagery engraved on the stone 'skeuomorph' marks it out as *more* aesthetically charged, not less. It is a creative, innovative artefact that stretches the idea of emulation and suggests that something else more dynamic is going on.

Perhaps this is an outlandish case, unique such that we cannot use it as in any way exemplary. We should, one might argue, stick with more canonical scenarios for skeuomorphism, which in the Aegean Bronze Age seems typically to have been the ceramic imitation of metal prototypes. Indeed, there are the examples cited more than a century ago by Sir Arthur Evans, finding fine ceramics at Knossos reminiscent of striking gold and silver vessels from the Shaft Graves of Mycenae.[70] Gordon Childe too discusses skeuomorphs, saying they are objects 'aping in one medium shapes proper to another', though mentioning in particular wooden objects copied in pottery or metal, or ceramic copies of gourds.[71] A very apposite set of examples come from the Neopalatial tombs at Kythera, where a series of ceramic vessels are found that would typically have been made in either stone or metal on Crete itself – such as ring-handled basins (Figure 4.11).[72] That the original bronze examples on Crete would have had special ritual meaning is further indicated by the depiction of exactly the same form on a wall painting from Xeste 3 at Akrotiri, Thera (Figure 4.11) – and here we assume it is the bronze prototype depicted,

(a)

(b)

(c)

4.11 (a) Bronze ring-handled basin, Knossos, diameter 34 cm, Palace of Knossos, Inv. no. X2068. Archaeological Museum of Heraklion, Hellenic Ministry of Culture and Sports, TAP Service; (b) ceramic skeuomorph, Kythera courtesy of the British School at Athens; (c) depiction of same type on wall painting, Akrotiri Thera, courtesy of the Akrotiri Excavations.

not the ceramic imitation. Ceramic versions of these forms are not found on Crete itself. So, there is a narrative here that the community on Kythera was not able to access the 'richer' materials and so made do with poorer imitations. We should bear in mind, however, that we are dealing here with grave goods – and it may be that the residents had perfectly good access to the stone and metal forms, but just deemed it unnecessary to deposit them as grave goods. Still the overriding impression is of the ceramics being the poor skeuomorphic imitations. It is this kind of view that has carried over to later periods too, with the major treatment by Vickers and Gill on later Greek pottery also asserting that clay is the poor copy of metal.[73]

But I wonder if even with these kinds of examples it may not be so cut and dry. Going back to Evans, it is not just clay imitations of metal that he identifies, but also clay imitations of stone – notably some with what he identified as 'breccia' and 'conglomerate' effect in Middle Minoan IIA,[74] and some with white-dotted decoration mimicking stone vases with white inlays.[75] Is there really such a hierarchy of materials here, from stone to clay? He also then illustrates a tall jug with this white-dotted decoration that also blends metallicizing ridges at its mid-body (Figure 4.12).[76] Other ceramic vessels from this Middle Minoan IIIA period also blend these features – both some metallicizing features, such as ribs or grooves, and stone features – especially the white-dotted style, reminiscent of Yiali obsidian.[77]

Moreover, some of the earlier Kamares forms that are so often discussed as metallicizing often integrate other crafts too – MacGilllivray in his work on these wares from Knossos even describes some as 'Early Woven Style', indicating their apparent connections with textiles (Figure 4.13).[78] So rather than a straight emulation, that is directional from one material to another, perhaps we might benefit from viewing this phenomenon as a more creative blending of various effects of forms, surfaces and materials.

Let us now see how this approach, which takes a lot from the work of McCullough and others on skeuomorphs

4.12 Three-handled jug in white-dotted style, Knossos, palace; Inv.no Π2397. Archaeological Museum of Heraklion, Hellenic Ministry of Culture and Sports, TAP Service.

4.13 Polychrome bridge-spouted jar, combining textile and metal features, ht. 16.6 cm, Knossos, palace; Inv. no Π4390. Archaeological Museum of Heraklion, Hellenic Ministry of Culture and Sports, TAP Service.

but with a greater focus on creative blending, might help us understand the innovations we see in the combinations of material and form from the Neolithic to the end of the Bronze Age in the Aegean.

NEOLITHIC SKEUOMORPHISM

The appearance of ceramic vessels at the beginning of the Neolithic is one of the most significant innovations in human history. The Early Neolithic of the Aegean sees this innovation in a number of regions, both on the Greek mainland and the island of Crete. Following the logic outlined by some scholars, one might expect to see the first ceramic vessels piggybacking on prior forms, i.e. organic containers made of wood, gourds or basketry.[79] The logic here is the 'preservational' one outlined by McCullough, such that innovations may more easily become accepted if developed within existing idioms. The innovation of the ceramic vessel may have been more palatable and easier to take on board cognitively if presented in the terms of existing

traditions and technologies. McCullough suggests that preservational skeuomorphs may indeed be utilised at times of technological transition – though she warns that they may also have relevance at other times too, and that aspirational skeuomorphs might as easily appear too.

If we review discussions of some of the earliest pottery in the Aegean, they do not seem especially concerned with the debt that pottery owed to preceding technologies. Tomkins suggests that some of the first pottery vessels at Knossos in the Early Neolithic may have been skeuomorphic of two preexisting traditions in wood and basketry,[80] though not many examples are adduced in support of this. We observe further cross-fertilisation among crafts a little later in the Neolithic too. For example, Middle Neolithic pottery from Sesklo I seems to imitate basketry or textile patterns,[81] while Late Neolithic pottery from Dimini (Arapi) might also be imitating basketry designs.[82] This is perhaps more in line with the decorative influences from basketry that Wengrow identifies further east in Mesopotamia, on Samarran and Halaf pottery from the late seventh and sixth millennia BC.[83] This skeuomorphism is thus occurring some two millennia later than the first pottery in the area, so, as McCullough argues, it hardly seems to be following a preservational logic. Rather, she suggests, ceramic skeuomorphs of basketry 'did not appear until there was something deemed worthy enough to emulate', i.e. specialised drinking sets.[84]

EARLY BRONZE AGE SKEUOMORPHS

With the onset of the Early Bronze Age c. 3000 BC, we might expect another phase of preservational skeuomorphism, as the introduction of metal forms was sufficiently challenging cognitively to have justified piggybacking new metal types on existing stone ones. This does seem to occur to a certain extent, with early copper axes seemingly mimicking stone forms, from the end of the Neolithic in the late fourth millennium BC.[85] However, it is not until midway through the third millennium BC that we see an explosion of metal artefacts, a 'Metallschock'.[86] This term refers principally to the proliferation of metal vessels and their skeuomorphic ceramic counterparts for use in feasting ceremonies – consider in Anatolia the Alacahöyük and Troy gold and silver examples and the spread of this aesthetic to ceramic vessels such as tankards and depas cups.[87] From Anatolia these forms are also taken up in certain Aegean contexts, in the so-called Lefkandi I/ Kastri group. Nakou has argued that the ceramics of this group are a 'direct emulation of Anatolian metal tableware'.[88] She then considers that this influence carries forward into the fine grey burnished ware of the following period Early Helladic III.[89] However, at the same time Rutter has noted the influence of basketry and textiles on Early Helladic III pattern-painted, incised and impressed wares.[90] So perhaps these different influences merge in the skeuomorphic pottery of Early

Helladic III – which would fit with a model of combination and blending rather than straightforward emulation. Here we might draw a useful parallel to an argument put forward on flint daggers in Bronze Age Scandinavia.[91] Such daggers have typically been interpreted as skeuomorphs of bronze prototypes, presumed to be more valuable; but Frieman argues that both flint and bronze daggers are symptoms of broader social and technological currents, rather than one being emulative of the other. Perhaps ultimately one might argue something similar for all the metal and ceramic vessels that form this broader complex – that they speak to broader concerns in which both are implicated, rather than metal necessarily being primary over ceramics.

That there exists a broader aesthetic that involves the (often counterintuitive) combination of different forms and materials can be traced in other examples too that are not immediately caught up in this 'Metallschock'. We might just take, for example, some of the more emblematic vase types of the Early Cycladic period, such as the incised pyxides. These appear to mimic similar stone shapes, the more globular of which in turn seem to owe something to the shape of sea urchins, though their decoration is more connected to basketry or textiles.[92] Another of the most distinctive Cycladic vases from the Early Bronze Age is the so-called frying pan, which is sometimes copied in marble; two bronze examples have even been found at Alacahöyük in Anatolia.[93] So here we see rather multi-directional connections that do not seem to show neat emulative flows from one material to another.[94]

MIDDLE BRONZE AGE SKEUOMORPHS: METAL WINS

What changes do we see in the Middle Bronze Age? Certainly, these multi-directional flows identified in the Early Bronze Age are present too. But now there does seem to be a particular emphasis on the emulation of metal forms and styles in pottery – at least on Crete. This development is in no small part attributable to the major social changes on the island at this time, with the emergence of powerful palatial centres at Knossos, Malia and Phaistos. The elites at these urban centres appear to have used metal artefacts as signs of their prestige and status – both in weaponry, it would seem, though the evidence is slim (such as the famous acrobat sword from Malia), and in vessels that could be used in conspicuous consumption. Though these are thin on the ground, due to the inherent value and recyclability of metals such as gold and silver and metal alloys like bronze, we do encounter the occasional piece, such as the silver kantharos from Gournia. Faced with the relative absence of direct evidence from Middle Minoan Crete, we can employ two tactics. The first is to look to the incomparable contexts from the Shaft Graves on the Greek mainland, where many metal vessels are preserved. This is not only a different region, but quite a bit later than the appearance of the first palaces on Crete;

nonetheless, it is still the Middle Bronze Age, albeit its very end. Further justification lies in the fact that a lot of these vessels are almost certainly imports from Crete – so they do tell us something, presumably, about the forms used on Crete during the latter part of the Middle Bronze Age. We see, for example, handle rivets, repoussé mid-ribs, torus rings and both vertical and horizontal fluting. The second tactic takes another indirect route – and that is to study the pottery forms and styles that we think are skeuomorphing these 'missing' metal prototypes. McCullough combines these two tactics in her thesis.

McCullough provides numerous examples in the Middle Minoan pottery from both Knossos and Phaistos of clear metallicizing features. Torus rings placed at the collar of closed shapes such as jugs and ewers would have been quite necessary on metal vessels to hide the join between the main body and the neck. However, in clay they do not make much structural sense, as indeed there are numerous examples of these types that work perfectly well without such a ring. A torus ring on a ceramic shape then looks to be quite clearly a gesture towards a metal prototype. They become quite common in the later MM period, typically on ewers. There are various examples, especially together with white-on-dark retorted spirals – a combination that appears on a silver ewer from Grave Circle A at Mycenae.[95] The repoussé mid-rib on straight-sided cups is characteristic of the so-called Vaphio type, and is again an adaptation that makes structural sense for metal vessels but not for pottery. It is, nonetheless, simulated in ceramic straight-sided cups.

Crinkly or multi-lobed rims seem peculiarly metallic too, and to see them in clay is again clearly skeuomorphic. There is a wonderful example from Malia's Isle of Christ that McCullough picks out as one of the few very direct simulations we know of, with its close similarities to the silver kantharos from Gournia. Yet, there is a much wider corpus of multi-lobed pottery vessels from Malia, and indeed from Myrtos Pyrgos, testifying to a rather more creative rendering of multi-lobed rims in the medium of clay. There is the quite famous example from Myrtos Pyrgos of the crinkly rimmed kantharos containing multiple self-same miniatures (Figure 4.14);[96] in addition, a series of broad carinated bowls with multi-lobed rims seem to be experimenting in a way that goes beyond any straight copying of a metal prototype.[97]

The point to impress is that indeed we do see strong connections between metal and ceramic in Middle Minoan material culture, and surely McCullough is correct in thinking that the relationship is directional and emulative. We might, nonetheless, note that there are other cross-media flows at play too. For example, as mentioned earlier, vessels that are otherwise quite metallicizing might include references to stone, as with the white-dotted wares of Middle Minoan IIIA that mimic Yiali obsidian.[98] Returning again to Myrtos Pyrgos, we can see also simulations of stone without any apparent reference to metal, as with a ceramic tumbler that is very close in both shape and surface treatment

4.14 Kantharos with miniatures, Myrtos Pyrgos. Courtesy of the British School at Athens.

4.15 Stone tumbler (left) and ceramic skeuomorph (right), Myrtos Pyrgos. Courtesy of the British School at Athens.

to a stone tumbler made of serpentine, with its distinctive flecking (Figure 4.15).[99] At both Malia and Palaikastro there are, admittedly rare, ceramic basket skeuomorphs, actually imprinted from basket moulds; while at Phaistos, a basket-shaped vessel has a squashed elliptical rim, upturned handles as if one might carry it like a basket, and wavy line decoration in dark paint.[100] There is then also the question of textile designs that may be

integrated into the designs of metallicizing ceramic vessels – McCullough suggests that 'there could have been some interplay between the designs used in textiles and metal work', and this could be reflected in Kamares ware.[101] So although the dominant direction of flow may be from metal to clay in this period, there are still other cross-media borrowings in play.

These strong gestures towards metal prototypes in pottery forms are not universal across the whole Aegean world in the Middle Bronze Age. In the Cyclades, we see quite different tendencies in the pottery, what we might call a 'theriomorphic' rather than skeuomorphic tradition. That is to say, the pottery does employ a kind of blending logic, but it involves wild animal forms, and especially birds. Many Middle Cycladic jugs are bird-shaped, with necks that are tucked back, and even 'eyes' either side of the 'beak'. The blend is accentuated still further by the painted depiction of birds on such vessels too (Figure 4.16). When the metallicizing pottery of Minoan Crete does make its way to the Cyclades, as in the imports identified in Phase C at Akrotiri, Thera, for example, they are quite strikingly different from the local wares.[102]

When we turn to the mainland (Middle Helladic), we encounter other distinct ceramic traditions – Grey Minyan and Matt Painted.[103] There is some

4.16 Jug with bird features and decoration, from Akrotiri Thera. Courtesy of the Akrotiri Excavations.

debate as to whether Grey Minyan is metallicizing or not. Its typical form, the kantharos, with its carination and stem, would seem to mimic metal, though we do not have any contemporary metal vessels on the mainland with which to compare.[104] Hence Matthäus' caution in warning against the reconstruction of lost Middle Helladic metal forms on the basis of Grey Minyan ware.[105] The ware has a lustrous sheen to it, and its grey colour may mimic silver, with its red and yellow variants representing copper and gold, according to some scholars.[106] As Reeves notes, Furumark was rather more circumspect about the ware's metallic debts.[107] She argues though that taking the surface treatment and shapes together we should see Grey Minyan as skeuomorphic of metals, and probably of an indigenous Middle Helladic tradition of silver vessels.[108] Sarri also admits, a little reluctantly, that 'Minyan ware might have been inspired by plating techniques'.[109] It is interesting, however, that the lack of decorative surface treatment means the effect is quite different from the contemporary Kamares ware on Crete. Matt Painted ware shapes seem to draw on the metallicizing range of Grey Minyan, with kantharoi again featuring, though the simple dark-on-light motifs evoke textiles or basketry, if anything.

LATE BRONZE AGE: MULTI-DIRECTIONAL SKEUOMORPHIC FLOWS

On Crete the final phases of the Middle Bronze Age and the first phase of the Late Bronze Age are often treated together, because they all fall in the Neopalatial period, and this marks a series of important technological, social and political changes on the island – notably with the rise to power of Knossos as the major palatial centre on the island. There is a conspicuous change in aesthetic in the pottery, with white-on-dark pottery (largely associated with metallicizing tendencies) replaced by dark-on-light styles. In Middle Minoan III, white-on-dark styles continue but, as Poursat notes, there is a general feeling that the quality of production decreases, with the finest products of Kamares ware no longer visible.[110] This has long been attributed, since Evans, to the increased wealth of elites in the Neopalatial period, especially at Knossos, meaning that they had better access to luxury metal vessels and hence less need to create skeuomorphic imitations thereof.[111] While there may be some truth to this, new forms do still look towards metal, such as the Vaphio cup. In some instances, the Vaphio cup is paired with a new decorative style known as 'tortoiseshell ripple', characteristic of the early Neopalatial period (and particularly Middle Minoan III). One recent study on skeuomorphism suggests tortoiseshell ripple is imitative of gold,[112] and the occurrence of incised vertical lines on a Vaphio cup from Grave Circle B at Mycenae might appear to back this up. The motif does often occur on other metallicizing shapes too,

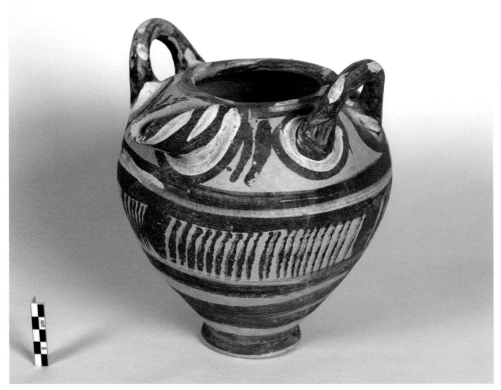

4.17 A jar with tortoiseshell ripple decoration. Courtesy of the Akrotiri Excavations.

such as ewers and rhyta, and so could very well be referencing the vertical fluting on metal wares.[113] However, in the initial description of tortoiseshell ripple by Sir Arthur Evans,[114] who indeed coined the term, he thought it was reminiscent of some Neolithic rippled wares, inspired presumably by an organic material – perhaps wood grain (Figure 4.17). This recognition of the multiple sources in skeuomorphism is taken up by Hatzaki, who rather sees connections with stone veneering, which was a prominent feature of the Knossian palatial built environment during Middle Minoan III.[115] Though there may well have been increased access to metals in this period, it does not follow that skeuomorphism would naturally decrease – especially if we see skeuomorphism as more than just the imitation of valuable materials.

Perhaps some other process is at work too. Could it be that, as metallicizing references in pottery became more and more regularised, artisans looked to other media for inspiration, to set their work apart? The dark–on–light styles that emerge in this period do seem to have reference points other than metal, with relatively naturalistic renderings of plant motifs becoming popular, and figurative imagery in general coming more and more into play (having been quite rare in Kamares pottery). Tortoiseshell ripple does fade away quite

quickly, relatively rare already in Late Minoan IA, and absent by Late Minoan IB.

The obvious development occurring exactly at this time that we cannot ignore is the emergence of figurative wall painting. Arguably the first examples appear in Middle Minoan III,[116] where previously frescoes had consisted of spirals and similar geometric motifs. Blakolmer argues that this change makes wall painting into the premier art form, with glyptic art, which had long used figurative depictions, taking its lead from fresco.[117] Whether glyptic or fresco is the prime mover in this change, it provides pottery with a new point of reference. This is not to say that pottery abandons metal references, because it clearly does not; but that the flow of cross-media referencing is now more multi-dimensional, perhaps more like it was in the Early Bronze Age, before metals became such a powerful aesthetic in the Middle Bronze Age.

The multi-dimensionality of some of this referencing is well attested in a form that takes off in popularity from Middle Minoan III onwards – the rhyton. The conical rhyton, for example, occurs in stone, metal and ceramic. Stone examples often have torus rings, borrowed from metal,[118] or elaborate laid-on handles mimicking those in metal, which must have been difficult to make in stone, such as on the Boxer rhyton from Ayia Triada (Figure 4.18).[119] Of course, this rhyton has relief scenes of boxing and bull-leaping, equally at home in another medium, that of fresco. Ceramic conical rhyta from Gournia have the same type of laid-on-handles.[120] The Siege Rhyton from Mycenae is made of silver and is of the same shape, it too with figurative scenes.[121] Some globular ceramic rhyta bear dark-on-light decoration of 'conglomerate' style, thought to imitate stone surface effects.[122] Similarly, a ceramic alabastron from Hagia Triadha has decoration imitating vases in limestone with banded veining.[123] Basketry has its say too – a dark-on-light vase from Pseira has the baggy shape of a basket, albeit combined with figurative decoration of multiple double axe motifs.[124]

With all these cross-cutting currents, it is difficult to maintain that there was a clear emulative trend from metal to ceramic. Indeed, Reeves has argued that skeuomorphism is somewhat attenuated in the Late Bronze Age.[125] As she puts it, 'the influence of metal vessels can be characterized as having become fainter as the references become more generalized. . .'.[126] That is to say, the metallic references are still there, but they are not quite as direct as they were in the Middle Bronze Age. But why should this have occurred? Reeves cites an idea from Davis that perhaps the decorative motifs were now generated from within the ceramic craft itself.[127] However, we need to also consider, as suggested above, the likely influence of other arts such as glyptic and fresco.

Despite its possible primacy in influencing various trends in artistic expression,[128] wall painting itself is not immune to some of these cross-craft flows.

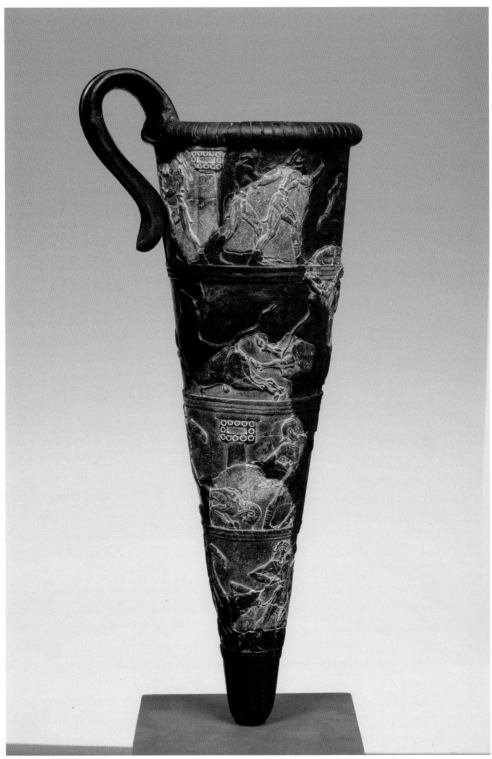

4.18 Relief stone rhyton ('The Boxer Rhyton'), Haghia Triadha, villa; Inv.no Λ342.
Archaeological Museum of Heraklion, Hellenic Ministry of Culture and Sports, TAP Service.

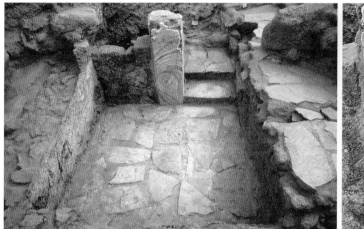

4.19 Frescoed lustral basin, Chania. Courtesy of the Ephorate of Antiquities, Chania Archaeological Museum; and the Hellenic Ministry of Culture and Sports.

There are some fascinating cases of skeuomorphism in Neopalatial frescoes. One of the most striking examples is the Neopalatial lustral basin from Chania in west Crete, which sees the use of painted plaster to mimic the look of a marble dado (Figure 4.19).[129]

Similar 'marbling' effects are also found in the Minoan-style frescoes at the Egyptian site of Tell el'Daba. Here Johannes Jungfleisch has been studying the architectural imitations in the frescoes, and identifies patterns that mimic timber beam-ends, already noted for the Aegean in miniature frescoes by Morgan.[130] This skeuomorphism is of particular interest because it compares to that seen in later Greek temples, in which timber beam-ends were mimicked in marble, for example in the Parthenon (as discussed). Here the idea was to harken back to valued ancestral forms; moreover, the marble version was more enduring than the timber, an important theme in much skeuomorphism.[131] However, neither of these points can be applied to the Tell el'Daba case: painted plaster is hardly more enduring than timber, and the referencing does not seem to have been to some anterior palace made of timber. Instead, as Jungfleisch notes, it may be that the Aegean timber-framed buildings had some cachet in the Nile delta, with mudbrick architecture more the norm. As for the relative longevity of plaster vs. timber, it may be simply that timber was not an option in this environment, and so their relative permanence was a moot point.

Although the mimicking of both stone and timber architectural features in wall paintings is a fascinating phenomenon, it is hardly the most conspicuous feature of Aegean wall painting. A more general point concerning their connections to other crafts is that they may have been skeuomorphic of textile hangings,[132] this hinted at by the depiction of tassels in some wall paintings,

and the detailed depiction of textile motifs, as in the Procession Fresco at Knossos (Figure 4.20).[133]

Although rather speculative as an idea, it does at least indicate that the LBA aesthetic seems to be much more multi-directional in its cross-craft connections than that of the MBA, which was more metal-focused. An apposite example comes from Emily Egan's observations on the decorative motifs of the kilts worn by the men in the Late Minoan II Procession and Cupbearer frescoes.[134] She argues that their decorative patterns are actually taken by the painters from Palace Style jars at Knossos (datable to Late Minoan II–IIIA). The decoration of these vases may in turn have mimicked textiles; which, as we have discussed, may have been the inspiration for palatial wall paintings. The use of textile motifs in ceramic decoration is also apparent at Knossos in fine tableware such as rounded cups, and particularly so in this

FIG. 450. SUCCESSIVE GROUPS (A, B, C) OF 'PROCESSION FRESCO'. FROM RESTORED DRAWING BY MONSIEUR E. GILLIÉRON, FILS.

4.20 Detail from the Corridor of the Procession fresco, Knossos.

same Late Minoan II–IIIA1 period.[135] So, we see rich cross-craft interactions: textiles to wall paintings; textiles to ceramics; and ceramics to wall paintings.

Tracing the story later into the Late Bronze Age, when a new phase of strong Mycenaean influence is witnessed across the Aegean, we can identify further changes. Mycenaean pottery seems to separate itself from other crafts, with metallic models in particular having little direct influence.[136] One of the only exceptions to this, as noted by Reeves, is the phenomenon of tin-coating ceramic vessels. Otherwise, Mycenaean pottery decoration carries on the logic of Minoan decorative schemes. Although Reeves may not see any metallic influence, there are a few signs of connections with other crafts – the Pictorial Style is one of the few categories in the pottery that seems to owe a debt to wall painting.[137]

FROM COMPOSITES TO BLENDS?

Let us now bring our discussion full circle back to composites and blends. Stafford talks about composition in which the different pieces remain distinct; and for Turner too, the point of a blend is no different from a composite – it

should have the capacity to be packed, carried and then unpacked – which implies that the different pieces should remain separable.[138] This may hold true in the early stages of innovation for much of the skeuomorphic composition we have discussed here. But then there are subsequent stages, as the meaning of the composites evolves. Can we argue that the composite/blend changes over time such that it is difficult to pick apart the heterogeneous elements that went into its making? Why might this happen? Well, one angle is to think of the cognitive advantages gained. In the initial moment of creativity, when the elements are first juxtaposed in the composition, there is arguably a degree of 'interpretative flexibility'.[139] That is to say, there may not be consensus on the status of what has been created – some user groups may view it as positive, and others as negative. Over time, however, this flexibility decreases as the meaning of the object is settled upon – in one of Bijker's examples, this is what happens with the invention of the bicycle, which goes through an initial stage of uncertainty and flexibility, until a common ground is located. Many heterogeneous elements, technical and social, are conjoined in the bicycle, and it eventually becomes more cognitively efficient to take these for granted through the stabilised artefact, than to question them constantly. The technology in the artefact then becomes 'black-boxed' to some degree, such that users stop thinking about it consciously. While this may be a handy cognitive trick, it has a downside – it means as analysts we too easily fail to think about the inner sociotechnical workings of these 'naturalised' technologies. Similarly, with skeuomorphic blends, as time passes some of the links between heterogeneous elements may be masked and naturalised, so that the evident connection in the moment of creation between, let's say, metal form and clay material, fades. The composite can no longer be 'unpacked' because its very nature ceases to be transparent.

CONCLUSIONS

What are we to make of this prevalence of composition and blending in the Aegean Bronze Age, whether the combination of animal elements to make monstrous forms, or the melding of forms and materials to create skeuomorphs? It is tempting to take this phenomenon and link it to what we might see as the prevailing cosmology or ontology of the time. If we take Descola's fourfold ontological scheme, then we can observe that Minoan Crete has been associated with at least three of the four ontologies Descola identifies – Evans interpreted the Minoan evidence within a 'naturalist' framework; Herva sees an 'animist' conception of the world in the same evidence; and Shapland has recently argued that 'analogism' is the best fit.[140] Certainly, one could argue that composition and blending fit well within an analogist ontology. Shapland employs Wengrow's arguments on monsters to argue that

what we are seeing with the cultural transmission of the iconography of composite beings from the Near East to the Aegean is the feeding of a local analogist ontology with new content.[141] However, the argument in this book is that the combination of heterogeneous elements is just one among a number of creative strategies for transforming the 'real'. We must also take into account those strategies discussed in the two previous chapters, modelling and imprinting, and those now to be covered in the chapters ahead, containing and fragmenting. When all of these are considered side by side, can we say that they indicate analogism? Perhaps, although our first task is to work through these various strategies, or praxeologies, and their various gestures and materialities, before we can begin to wonder about a possible shared ontology linking them together.

In the following chapter we turn to **containing** as a process of 'capture', of doing something to some forms of materiality that reconfigures them and allows them to be thought of creatively. Initially we will examine the various modes of containment represented in burial practices, before then extending our analysis to houses as containers, and then certain forms of ceramic container.

FIVE

CONTAINING

WHAT DOES IT MEAN TO CONTAIN?

The range of facilities in human societies that act to contain matter is truly vast. We spend much of our lives inhabiting, transporting, making, filling, emptying and discarding containers. Houses, vehicles, silos, shopping carts, laundry bags, milk cartons – the list is almost endless. We are contained in the womb, we are wrapped as soon as we are born, and when we die we are once again contained – in a coffin, an urn or the earth.

Containing may therefore seem to differ from the praxeologies discussed in the preceding chapters in being more immediately functional. I will argue, however, that acts of containing entail decisions that are just as aesthetic and potentially creative as those found in modelling, imprinting and combining. Admittedly, this creative dimension has rarely been integrated with some of the more functional accounts, and this is an issue we will have to address through the course of this chapter.

Yet, this separation of the functional from the aesthetic is far from the only problem facing us. We should not assume that either aspect, even in isolation, has received proper scholarly treatment. If we start with the functional aspect of containing, we might admit that the broad range of containing strategies, hinted at above, could seem quite daunting for any kind of overarching analysis. Even so, the lack of effort to offer any kind of systematic treatment of containing or containers is still quite striking.[1] Archaeology is perhaps an

exception, with many archaeologists spending much of their lives sorting through the remnants of ancient containers, in the form of pottery sherds.[2] Moreover, archaeologists have begun to foreground containers in their enquiries into the long-term development of materials and technologies.[3] Nevertheless, even these accounts do not provide some of the basic observations on containing that are required as we attempt to think through the kinds of material engagement that containing entails.

THE PHYSICS OF CONTAINMENT

One very useful (and somewhat overlooked) account is offered by Rosalind Hunter-Anderson (Figure 5.1). Though mostly concerned with house form, she has some very pertinent observations for containers in general. At a general level she talks of 'facilities' – which are 'devices that contain or restrain the motion of matter'.[4] Here a potentially two-way process is revealed: a container may prevent the dispersal of whatever is contained or protect the contained from 'environmental interference'.[5] Containing sets up a barrier between inside and outside, and its design may be focused on inclusion (keeping matter in) and/or exclusion (keeping matter out).

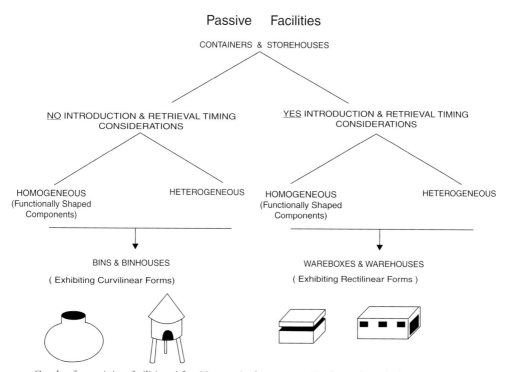

5.1 Graph of containing facilities. After Hunter-Anderson 1977. Redrawn by Isabella Vesely.

Hunter-Anderson further defines 'passive facilities', those which are concerned with keeping matter in an 'idle' state. Here she is not addressing houses, or at least residential houses, in which there is movement and activity within the container. She has in mind various facilities of containment in which the matter is contained and kept idle between activities – say, for example, a laundry bag, or a suitcase. But here she identifies a further important variable that can help us to understand containment as material engagement: 'the degree of content homogeneity-heterogeneity'.[6] That is to say, if the contents of a container are homogeneous – as they would be in a jar full of grain, or water – then 'all content components have an equal target value'.[7] Thus, if one is looking to retrieve some of the matter that is contained, then one handful or scoop is no different from any other. However, if the contents are heterogeneous then retrieval may be targeted, which in turn may necessitate containers allowing for a structural separation of the contents. Quite sensibly, Hunter-Anderson suggests the use of different terms for containers with homogeneous and heterogeneous contents: 'bins' for the former, and 'wareboxes' for the latter. She further argues that such facilities of containment tend to develop different forms – round in the case of the former, and rectangular in the latter. While a sphere may be the most efficient shape for containing unsorted, homogeneous matter, it is not a shape that lends itself to efficient compartmentalisation, which wareboxes often require. Cubes can be much more efficiently packed together, as they can share walls in all directions.[8] With bins and wareboxes, Hunter-Anderson has in mind passive facilities that are portable, though she also extends her logic to fixed facilities – bin is to storehouse as warebox is to warehouse.

It also matters for storage whether contents are solid or non-solid. 'Liquid or gaseous matter must be contained under any circumstances'.[9] Solid forms do not necessarily have to be contained to be stored – they can simply form piles (of grain, for example). For liquids or gases, 'the walls of the structures designed to house such material must touch it'. This fact implies that such facilities, confronted with liquid or gaseous matter that strongly resists containment, face particular design demands – in circumstances that range widely, from the extensive levees that help contain the waters of the Mississippi,[10] to the laboratories that contain lethal pathogens. Indeed, air- and water-borne viruses offer special challenges to disease prevention. In the UK foot-and-mouth crisis of 2001, it was not the virus that was directly quarantined, but rather the sheep, to minimise their exposure to infectious carriers.[11] This is to turn containment around and focus not on preventing the dispersal of one kind of matter, the virus, but on protecting another kind of matter, the sheep. The virus is recategorized as environmental interference, like rain or wind, elements that cannot be easily contained, but which can be mitigated by the protective envelope of containment. The sheep were 'housed', a form of containment

designed to protect inhabitants rather than prevent their dispersal. By the same logic, oxygen and moisture (non-solids), which accelerate the spoiling of perishable foods, are difficult to contain; the focus falls on containing the foodstuffs (whether liquid or solid) to minimise their exposure and delay spoilage. As for matter that is not solid, gas or liquid, like fire (a plasma), then this too needs containment – it 'requires containers of all sorts such as hearths, pits, kilns, ovens, and firebreaks'.[12]

With the foot-and-mouth crisis, it was another kind of container, the truck, that contributed to the prolific movement of sheep to market and exposed them uncommonly to the virulent spread of the virus. While facilities may be 'passive' insofar as their contents are kept in an idle state between introduction and retrieval, this does not mean that the facility itself might not move. Shipping containers are of course a key facilitator of contemporary global trade.[13] In their case, containers serve to separate the goods from environmental interference, but also to gather together segments of 'break-bulk cargo' with a shared destination.

In contrast to mobile containers with passive contents, we must also consider immobile containers with active 'contents' – in other words, residential houses. Hunter-Anderson recognises this difference and calls such containers 'activityhouses', in contrast to the 'storehouses' that are passive facilities.[14] She distinguishes between two classes of activity in activityhouses: 'living aspects' and 'role aspects'. This distinction broadly corresponds to one we will make below when we come to discuss Minoan houses: occupation and accessibility.

This distinction among facilities between activityhouses and storehouses raises an issue that is not directly addressed by Hunter-Anderson – the nature of the opening or sealing of a container. Using the shipping container again, these are designed as sealed containers that are not to be broken until they reach their destination. We might also consider a tomb as a kind of sealed container.[15] Other forms of storage facility, though, engender a form of retrieval that is less 'final' – many containers have an outlet, whether it be a tap, a spout, a spigot or a mouth.[16] These openings in turn imply stoppers and lids. For Hunter-Anderson's activityhouses, however, we perhaps have to imagine containers that must perform both roles: 'sealed', so to speak, on some occasions (as when the house is closed up at night), and with porous openings on others. Some house openings may be like stoppers or lids, easily removed to allow flow; others may be much more like the blocking of a tomb or the tightly sealed door to a shipping container.

CONTAINING AS PSYCHOLOGICAL FACILITY

However, we also need to recognise that storehouses and activityhouses alike entail more than just physical considerations. Each of the above examples of

containing could hardly be more functional. One could easily form the impression that containing is a necessity of economics, whether it concerns the containing of commodities or of people. Certainly, people contain themselves for pragmatic reasons to restrict environmental interference from water, wind and wild animals. Even in death, when our bodies are also contained, functional reasons exist. Yet, the reasons for containing bodies in life and death are as much psychological as physical. Containing as a means of restricting access to others – other people as well as other physical entities – is a way to separate ourselves as individuals, to isolate ourselves. While this antisocial move may seem negative, it takes on a positive quality in Gaston Bachelard's classic 1964 work, *The Poetics of Space: The Classic Look at How We Experience Intimate Places*. Bachelard suggests that solitude is an important condition because it allows us to gather our thoughts and most intimate memories. These memories can be hard to locate, however, and so Bachelard argues that we need intimate spaces where we can place, retain and possess them – with the house acting as the archetypal intimate space.[17] We contain ourselves within houses for shelter, but houses also contain our memories and dreams. Indeed, it is not just past memories that can be gathered here; it can also serve as a secure locale from which the imagination can take flight. It is as if, on the one hand, the body alone is too limiting as a storehouse for memories and dreams, while on the other, the cosmos is too infinite and overwhelming. The house constitutes an in-between space that sets limits that are at a comprehensible scale.

When put in these terms, it becomes easier to see how containing might hold within it both an aesthetic dimension and a creative potential, rather than being a merely functional necessity.[18] If containers can then serve as repositories for intimate memories, and even as spaces for the release of the imagination, then their artistic elaboration follows naturally. Intimacy might be further accentuated by a shrinking of scale to encapsulate the body, or parts of the body (as in hair within lockets), even more completely. This conjunction of containment, intimacy, and scale reduction is observed by Hanneke Grootenboer in her fascinating study of late–eighteenth-century miniature portraits. She too draws on Bachelard, who wrote not only of houses, but also other, more confined, domestic spaces, 'such as attics and cellars, as well as baskets, boxes, nests, and even shells, regarding these as intimate places where we find solitude'.[19] She goes on to note that 'Bachelard observes strong connections among architecture, furniture, and smaller containers—all spaces that, when opened, cancel out the exterior world'.[20] With the mention here of 'smaller containers', one might recall, thinking back to Chapter 2, that Bachelard also has a chapter on miniatures in *The Poetics of Space*. Miniatures have this intimate quality and can alter our perception of time. Marianne Koos, writing on late–sixteenth-century English miniature portraits, further underlines the connection between containment and intimacy,[21] as does Dagmar Weston in her treatise on

miniaturization, seen as 'a demonstration of the rule of containment and encapsulation, which was a governing principle of cabinets of curiosities'.[22]

Containment as an artistic strategy may, as these examples suggest, often go together with scale reduction, as a means for enhancing feelings of intimacy. However, to associate containing with intimacy alone constitutes a limited outlook on the condition. It assumes the individual psyche as the core phenomenon around which containing is subsequently elaborated – with the body as its container that, somehow insufficient in this role, then requires further layers of containment (the house, for example) to strengthen its isolation in order to protect it and its memories. This suggests that the body is a kind of psychic arch-container; and that this feeling, this basic metaphor, is extended out into the world as a mechanism for enveloping and protecting our intimate selves – albeit alongside the more adventurous brief of extending and scaffolding our imaginations. Some support for this sense of the body as the inevitable source of all containing metaphors appears across different domains. From developmental psychology, we learn that infants at a very young age do develop a kind of physical reasoning whereby they can discern that an object might interact with another by being placed within it.[23] Through manipulating the object world, the infant comes to differentiate, for example, between a container and a tube. In ethnography, there are plentiful examples of house forms modelled metaphorically on the body, perhaps most markedly shown in a study of Batammaliba houses in Togo and Benin.[24] And in archaeology, the deep history of the evolution of house forms and other kinds of container is also argued to stem from basic bodily metaphors.[25] It is as if there is a psychic inevitability to conceiving of our bodies as containers.

However, we might recognise that containment is not an end in itself, and that the psychic well-being of an individual is not assured by containment alone – many of the memories that are collected and protected by intimate containment surely accrue in social, collective settings. So, containment must be in tension with release – the individual may require solitude, but this is an intermittent need, to gather oneself psychically, before then entering into society again. The boundaries that are thus set up between inside and outside are there to be broached – containers are not hermetically sealed but have entrances and exits. Returning to the example above of eighteenth-century miniature eye portraits, these were often mounted in lockets, and in certain situations would have been shown quite publicly. Grootenboer describes the case of the Prince of Wales, who had apparently entered into a relationship with a certain Mrs Fitzherbert.[26] There was much speculation as to whether they had married, no doubt exacerbated by the Prince's display of the eye portrait to his companions while at the opera (as reported in a letter written by Lady Spencer). As Grootenboer notes, the portrait was probably mounted in a locket, and so its display would have 'involved unclasping the locket to present what was concealed inside' (Figure 5.2).[27]

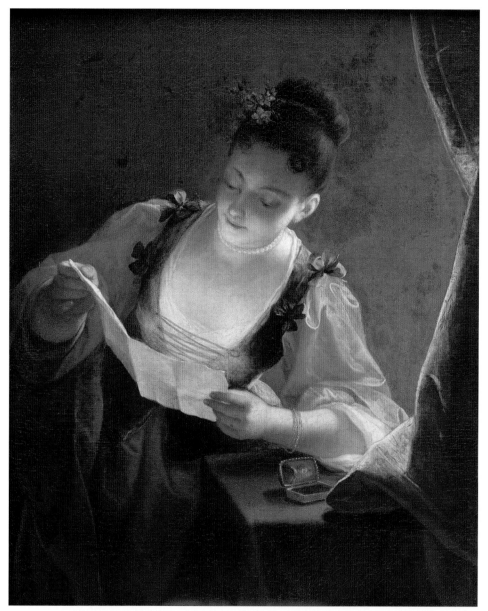

5.2 *Young Lady Reading a Letter*, by Jean Raoux, showing miniature portrait in locket. Credit: Scala / Art Resource, NY. Location: Musée du Louvre.

ETHNOGRAPHIES OF CONTAINMENT

Although the above examples from the Early Modern period can serve as a useful indication of how containing may act as an artistic strategy, now I shall turn from art history to anthropology to gain a broader outlook on containing practices. Containing has not received widespread attention, but there are three ethnographies that provide ample food for thought.

The first to be discussed here is by Jean-Pierre Warnier, who identifies containing as a key 'technology' of kingly power in the Cameroonian high-lands.[28] The king's body is 'a container of ancestral substances such as breath, saliva and semen'.[29] His power is periodically 'released', shared with his people – 'he disseminates the aforementioned substances by projecting his breath and speech upon his subjects, by spraying them with raffia wine from his drinking horn and his mouth'.[30] The metaphor of the king's body is extended further outwards, such that his palace and city are also the 'bodies' of the king. Yet, containing is more than just a technology of power imposed from above – it is also a fundamental technology of the self that is practised by the king's subjects. In everyday life, containers of various forms are given special treatment. One might say that containers feature prominently in all societies, but in this Cameroonian context there is an 'over-investment' in containers and their surfaces. One example can be found in how mothers wash their babies. With the body as the 'arch-container', the skin then becomes key to the maintenance of the body and its boundaries as a container of the self. When babies are bathed, a daily event, mothers devote plenty of time to rubbing and massaging the baby's skin with lotion or oil (Figure 5.3).[31] Although this is now typically done with commercial products, in the past it was palm oil that was more commonly used, and each newborn was given an oil pot for this purpose.[32] It is not just babies that have their skin worked on in

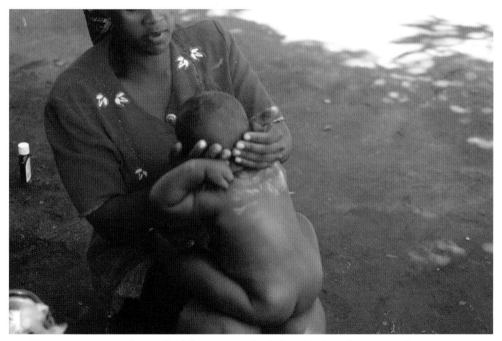

5.3 Human container surfaces – the daily massage of an infant, Mankon, Cameroon. Courtesy of Jean-Pierre Warnier.

this way – adults too use palm oil, often mixed with camwood paste, to massage their skin, especially as a means of invigorating tired limbs.

As the oil pot suggests, these technologies of the self reach beyond the skin and are 'propped up' on various artefacts. Warnier also describes houses in the Cameroonian grassfields, and how they are built as containers that create a particularly pronounced difference between inside and outside. All external walls have double lining, the thatched roof is thick and there is a single opening that is difficult of access. Doorways have high thresholds (30–40 cm) and low lintels (<160 cm), making it difficult for an adult to enter, without both raising up the legs and bending the back, a contorted gesture that causes anyone entering to put down their things and pause before entering.[33] The opening is also quite narrow, such that it is almost impossible to get through without brushing against the doorframes; these are often decorated with dead elders or certain animals (e.g. chameleons) that can spray their saliva, and so any potential intruder would have to reckon with these protectors. And there are many other forms that are caught up in this materiality of containing:

> The technologies of power and technologies of the subject focus on the treatment of skin, containers, openings, surfaces, actions of receiving, storing, closing down, opening up, pouring out, expelling, etc. The corresponding bodily conducts are propped against an abundant material culture by which the king, the notables and the ordinary subjects are surrounded. It diversifies and multiplies the opportunities of bodily storage and containment: drinking horns, calabashes, wooden or clay bowls for mixing oil and camwood, oil drums, bags, houses, the enclosure of the palace and the city, hedges, fences and gates of all kinds.[34]

What is also apparent in this quote is how Warnier sees this containing logic as inextricably both about personal identity and political power.[35]

The second ethnography, by Laurence Douny, is directly inspired by Warnier's work.[36] It too is situated in west Africa, focused on the Dogon people of Mali. Douny portrays containment as a microcosmology or philosophy that informs the way Dogon people live, offering them a feeling of security against scarcity. As in the grassfields case outlined by Warnier, containers take a range of scales, from the territory, to the village, to house compounds to the body. However, Douny argues that containing as a material practice is less important than containing as a metaphor: 'material forms of containers do not really matter so much as the idea of the container as a means for people to contain substances, matters, people, activities, and ideas'.[37] Thus in her ethnography, Douny emphasises the kinds of things that are frequently contained, such as millet in granaries, and the kinds of things that need to be expelled, like waste. Materials have to move in and out of containers, and so their 'porosity' is a quality that has to be reckoned with, particularly in a semi-arid Sahelian landscape where key resources like millet and water are scarce.

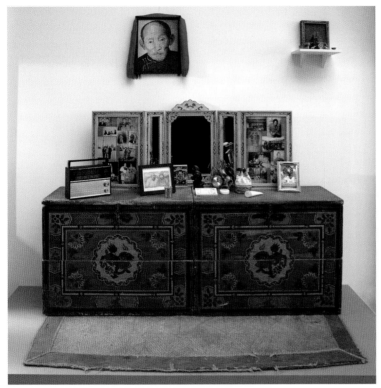

5.4 A Mongolian chest. Courtesy of Cambridge Museum of Archaeology and Anthropology, and Rebecca Empson.

The social context does appear to be quite different from that of the grassfields, where containing is a technology of power for sustaining kingship, with Warnier describing the 'governmentality' of containers. Here, in the Dogon context, containment seems to be much more of a collective set of values, creating 'a sense of cohesion, unity, and solidarity among Dogon villagers through their shared embodied knowledge'.[38] In terms of forms of material culture that one might call art, the Dogon are famous for their masks used in masquerades. Douny does touch on these, though only briefly as they are treated more fully in other accounts. Masks may be understood as containers, and so it would be interesting to explore further the degree to which these objects are conceived as such in Dogon society.

Containing also features prominently in our third exemplary ethnography, Rebecca Empson's study of Mongolian chests (Figure 5.4).[39] She identifies 'fortune' as a particularly central idea among the mobile pastoralists she studies in Mongolia. The well-being of the herd is a constant concern, and one never quite knows where the fortune resides in maintaining a herd healthy and safe. So, if an animal is traded from the herd, a piece of that animal is kept back, in the form of a tuft of hair, and this tuft is then placed in the household chest.[40]

This practice guards against bad luck – what if the herd's fortune all lay in that one animal? One cannot isolate and keep the whole herd together forever – there has to be movement. But this technique of separating a small part from the whole helps to 'harness' fortune while permitting mobility. It is something of the same logic that informs the taking of a baby's umbilical cord, wrapping it carefully and placing it too in the chest – it guards against the dissipation of family relations.[41] Importantly, for Empson, these parts that are stored away in chests are then not permanently removed, isolated – they may be immobile, but they ensure mobility.[42]

These three ethnographic cases, full of detail though only very briefly sketched here, derive from quite different environments and social contexts, with striking variations in the degree of hierarchy and mobility. And yet, it emerges that containing as a material metaphor can find powerful uses in widely divergent circumstances. Although the goals of containing may be psychological and social, they are achieved within material parameters of the kind outlined by Hunter-Anderson. We will further see the material and metaphorical adaptability of containing across contexts now that we turn our attention back towards art history.

CONTAINING IN ART HISTORY: FROM SARCOPHAGI TO RELIQUARIES

Containment in the above ethnographies concerns the custodial storing of parts of things; the movement of human bodies through 'activityhouses'; and the status of the human body itself as container. While burials and the ancestors did briefly arise, in the art-historical cases we will now discuss they feature more prominently. And in turning to the containment of dead bodies, we might also remind ourselves of the distinction made by Hunter-Anderson between homogeneous and heterogeneous contents – if a body is enclosed in a container, is it the former or the latter? While a dead body, when introduced into a tomb of whatever kind, may be 'one' thing, as the dead body decays it fragments – although wrapping in a shroud, or 'cartonnage' as in Egyptian coffins, may minimise this process.[43] If this transformation from one whole thing to many things thus occurs between introduction and retrieval, then the contents are hardly 'idle'. We might take this observation into account as we think through how wholes or parts are contained, particularly in relation to how they have been treated in discussions of burials and relics in art history.

Jas Elsner, in his study of Roman burial sarcophagi, gives us a perspective on containment that is not too far removed from the accounts offered ethnographically. Certainly, the subject is now how to contain the dead rather than the living, but the methods of containment in question do delimit whole

bodies using rigid, solid surfaces (not unlike houses, albeit at a smaller scale).[44] What Elsner does in his analysis is foreground the tension between concealment and display in these burial forms – which is not unlike the tension between sealed and porous that Douny highlights. Elsner argues that the creativity in the complex decorative schemes on these sarcophagi is mediated by the objects' dual functions – to conceal the dead body at the same time as displaying it. That is to say, it must conceal in a way that does not hide – the dead body is the focus of a burial ceremony, and so must be present while also being absent. This twofold function creates a tension, and it is this tension that Elsner says inevitably creates the 'decorative imperatives' of the sarcophagus.[45] One might add that the sarcophagus seems to perform a transformation of the dead body from a homogeneous whole to fragmented parts between introduction and what may be a future retrieval – it is hardly performing a simple custodial role in which the contents are kept idle. In the case of sarcophagi for married couples, the custodial question takes on extra import: as Zanker states, 'both partners don't usually die at the same time'.[46] On some sarcophagi, such as the one pictured here in Figure 5.5, the iconography depicts mythical love stories, in this case Selene and Endymion. If the mortal partners are likened to those from myth then, as Zanker suggests, 'the surviving partner, as long as he or she lived, would be drawn into the mythological discourse of the tomb'.[47] In such circumstances, the decorative imperatives are surely further affected by this ongoing relationship between the dead and the living.

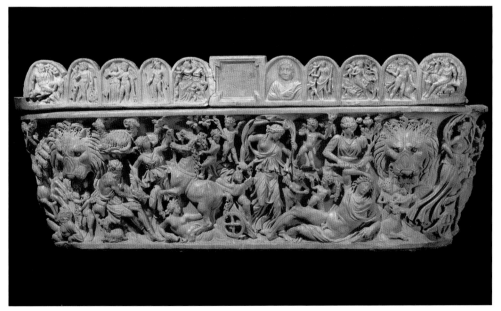

5.5 Roman marble sarcophagus, early third century AD, Metropolitan Museum of Art, Rogers Fund, 1947. Accession no. 47.100.4a, b. Creative Commons.

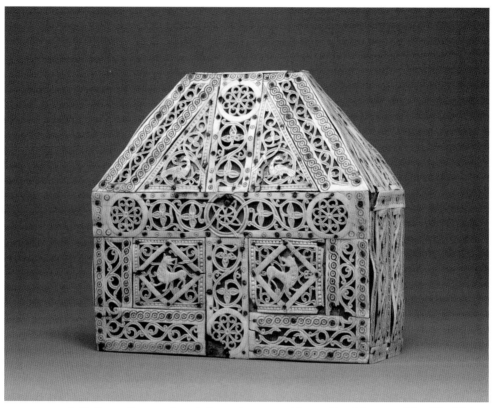

5.6 Reliquary from northern Italy, tenth century. Metropolitan Museum of Art, The Cloisters Collection, 1953. Creative Commons.

If we fast-forward from the Roman period to the mediaeval, here it is the phenomenon of relics and their reliquaries that has instigated discussion on what containing does, in terms of both the separation it creates, but then also the promise of eventual release or reembodiment (Figure 5.6). The question of what is being contained has now shifted, because the relics that are contained within reliquaries are parts of bodies, not wholes. Insofar as they have already undergone the active process of fragmentation, they are no longer apt to disintegration and transformation – and so their storage in reliquaries is more custodial, it would seem. This partibility also creates the potential for a reduction of scale, which in turn can afford greater portability. This potential portability then becomes a factor in the degree to which the relic is destined for display. Nonetheless, despite all these interesting variables in their potential to contain, reliquaries have, according to Cynthia Hahn, typically been viewed in art history as static containers – presumably with this 'custodial' function to the fore – not even artworks; so she asks: 'what do reliquaries do for relics?'[48] She recasts reliquaries as active participants in relating the story of the relic to the faithful; in describing them as 'restless', Hahn conveys the feeling of tension that is inherent in the reliquary's dual role of isolation and display.

This sense is further underlined in a study on the ornamental character of reliquaries by Ittai Weinryb.[49] With reliquary ornament 'an active agent in the apprehension of belief', mediating between a relic and its audience, Weinryb argues that the choice of dense arboreal foliage as ornament has particular metaphysical underpinnings (reflected also in the ornament adorning manuscripts). Weinryb says that reliquaries offered the sensory experience of glimpsing. He also draws connection between dense arboreal foliage (making up the ornament of the reliquary in question) and manuscripts, delving into some of the metaphysical reasons for ornamenting reliquaries. One particular eleventh-century reliquary he describes has an open 'rinceau-work' structure of foliate motifs that appears to allow viewing of the relic within, though he suggests the latter may have been further contained, perhaps within a cloth bag, thus allowing 'only limited visual access to the sacred objects, creating a sensory experience of glimpsing'.[50]

This idea of partial viewing or 'glimpsing' is further developed in Massimo Leone's semiotic account of reliquaries.[51] Here it is argued that the relic as index operates semiotically through a process that highlights the 'intrinsic incompleteness, and therefore the intrinsic completability, of the interpretant'.[52] In other words, the fragmentary nature of the relic introduces a desire for that which is beyond, transcendent and complete, even though that desire cannot ultimately be fulfilled. What the reliquary does is accentuate this tension even further by allowing only an incomplete vision of the relic. Leone suggests that the relationship between reliquary and relic thus provides a 'material simulacrum' of the relationship between the relic and what it signifies, a more perfect whole.[53] Thus, Leone links the idea of glimpsing to that of completeness and incompleteness, the transcendent and the worldly. As mentioned above, the fact that reliquaries contain parts, not wholes, in contrast to other kinds of containers, is quite relevant to their materiality.

Leone's study may focus on reliquaries, but he has in mind a much broader semiotic inquiry into the nature of 'wrapping' and the transformations it effects. He differentiates between various kinds of wrapping, some of which maintain the form of the object wrapped, while altering it 'chromatically' (the effect of tight black leather trousers, is one example he gives), while others may encapsulate in such a way that the hidden form is masked. Although he does not take his discussion in this direction, there are interesting parallels with some recent work in ethnography and archaeology on wrapping and 'bundling'.[54] Here there is an emphasis on sacred objects that are wrapped and unwrapped, thus more or less visible at different moments. This fits very well with one of Leone's observations, that 'there is no revealing without re-veiling',[55] pointing clearly to the dynamic between containing and releasing with which we began. But there is another aspect to the wrapping effect of sacred bundles that Leone does not touch on – and that is how different objects can be

combined and juxtaposed when bundled together. This is apparent not only in these studies of sacred bundles found in the archaeology of the Americas,[56] but also in Empson's ethnographic study of chests in Mongolia.[57] With the dynamic between reliquary and relic, an elaborate outer container shields an index, a small part of a whole, a single bone of a saint; and the contents of sacred bundles may also be largely indexical in similar ways, though the juxtaposition of quite distinct kinds of index creates complex associations.[58] At the same time, bundles cannot wrap liquids or gases like solid containers can; and they do not, as a corollary, have the same kinds of openings.

Wrapping, veiling and bundling – each of these terms suggests not only the soft surfaces of textiles, but also the kinds of surfaces that may follow the contours of the similarly soft and yielding human body. Does this then indicate, somewhat in line with the arguments of Bachelard we have cited, that the body is always and inevitably the arch-container metaphor? One might think so. However, not all forms of containing are quite so compliant and soft. Some can be much more rigid, hard and unyielding, and not mimic the body's contours at all – as with the Roman sarcophagi as described, or various house forms that contain living bodies. Perhaps some container metaphors resist the psychic inevitability of the body as source, with more creative material strategies. I have argued elsewhere that externalised containers may provide us with new kinds of semiotic resources for thinking about revealing and concealing, and that these may have been turned towards the body, rather than always stemming from it.[59]

It is too simplistic to associate soft wrapping with the organic and hard cladding with the inorganic, but it is nevertheless the case that methods for bundling, wrapping or veiling an object would use textiles, and these do not survive at all well from most ancient contexts, with the obvious exception of ancient Egyptian burials. On the other hand, the inorganic hard claddings of sarcophagi, for example – in marble, metal or ceramic perhaps – are much more likely to survive from antiquity. Thus, there is a kind of practical, material logic to following Elsner's initiative, as a lot more evidence is of the kind he describes with Roman sarcophagi. Though, as we shall see, the equivalent containers in the Aegean Bronze Age are invariably ceramic, not marble, and are painted or plain rather than with relief carvings. Nonetheless, a functional and aesthetic tension between concealment and display in these burial containers can be traced, with some significant shifts over time. In some periods, there appears to be minimal concern with burial containment; in others, the concern is largely functional; and in others still, there is considerable elaboration and ornamentation around containment. It is with these burials that I now begin a discussion of the evidence of containment from the Aegean Bronze Age, as they introduce quite well the problem around passive facilities and their custodial function. From there I will go on to treat other kinds of container, including houses.

BURIALS AS PASSIVE FACILITIES IN THE AEGEAN BRONZE AGE

Burial containers have a custodial role – they are charged with keeping the dead still and at rest. Bodies decay and fragment, and some burials serve to contain this process; while others may find themselves involved in the second-ary partitioning of the body's fragments. Despite these basic functional con-cerns, the methods employed in prehistory and history for containing the dead are immensely variable and almost endlessly creative, and this no less so in the Aegean. On top of this variability, we are also faced with an uneven record: in some periods it can be quite difficult tracking exactly how the dead were treated, as burial rites are not always especially conspicuous in terms of the material traces they leave.

Beginning with the Neolithic, this is one of those periods when the dead seem unusually elusive across the Aegean.[60] On Crete, for example, Neolithic burial practices are poorly understood.[61] Some burials have been found in caves, which we may perhaps view as a ready-made form of natural container, albeit minimally intimate – both because caves are relatively open, and the multiple interments in such settings. It seems that there may not have been much emphasis on formal containment of the dead in this period – unless containment was achieved through organic means that we can no longer identify, such as wrapping in textiles.

In the Early Bronze Age, there are significant changes. Chris Mee notes that in the Cyclades the cist-grave becomes a common form of burial in the Early Cycladic period, pointing to a certain level of investment in containment, because they are stone-lined, for individual interments.[62] This may suggest a relatively intimate and indeed sealed form of containment, especially when compared to the Neolithic; and it does contrast with the picture on Crete. Here we also see major changes from Early Minoan I, with 'more cemeteries, new types of tombs, more significant deposition of material in tombs, and the creation of lasting architecture'.[63] Containment of the body clearly becomes important in these new rites, and with regional variations: in the east of the island we see rectangular house tombs, as here at Mochlos (Figure 5.7), while in the south central area, circular tholos-tombs are the norm, appearing in the Asterousia from Early Minoan I.[64] These built tombs are a major investment in 'containing' the dead, though they do so less intimately than cist-graves – they are shared communally, and often contain multiple bodies. If we take up the idea of bins and storehouses, then we might speculate that the separation of heterogeneous contents through compartmentalization was not a primary concern in these circular tholoi.

Towards the end of the Early Bronze Age on Crete we see another change, with pithoi and larnakes now used to contain the body more intimately, visible especially at the cemetery of Phourni at Archanes in central Crete (Figure 5.8),

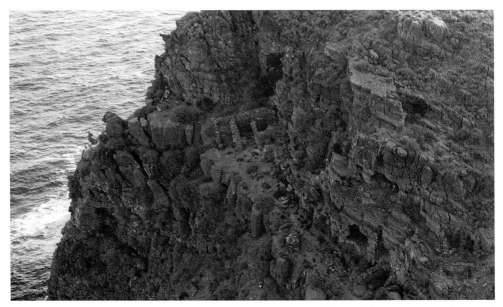

5.7 Rectangular house tombs at Mochlos. Courtesy of the Mochlos Excavations; photograph by Doug Faulmann.

but also at Pachyammos in the east.[65] This shift towards the use of sarcophagi, or clay coffins, is typically interpreted as a move towards greater individualism; and its timing, at the end of the Early Bronze Age and continuing into the Middle Bronze Age, just when the first palatial centres emerge, is seen as significant, part of a change from relatively egalitarian communities to much more hierarchical ones in which individual status came to the fore. But pithos and larnax burials still occur in a communal setting; and these new forms of containment hardly bear the elaboration one might expect if the primary motivation were signalling individual status. Indeed, Dickinson has made an important observation on funerary pithoi: that they are perhaps less about stressing the individual, and more about isolating burials from one another.[66] This then becomes a question of compartmentalization, and we might look at the techniques chosen for this process. One might expect that the circular tholoi would form a natural focus for such activity, but it is reported that both these and the rectangular tombs see container burials within them.[67]

As for the kinds of clay sarcophagi used, it does not appear that there is any simple association between 'bins' (pithoi) and 'storehouses' (tholoi), or 'wareboxes' (larnakes) and 'warehouses' (rectangular tombs). A lot of pithoi used in burials are little different from those used in domestic contexts, and some may well have been appropriated from the latter for use in the former. Clay larnakes of this period may be made specifically for burials, but they share many features with pithoi, and are similarly unelaborated – they are 'domestic vessels slightly altered'.[68] We might further note that some of these early

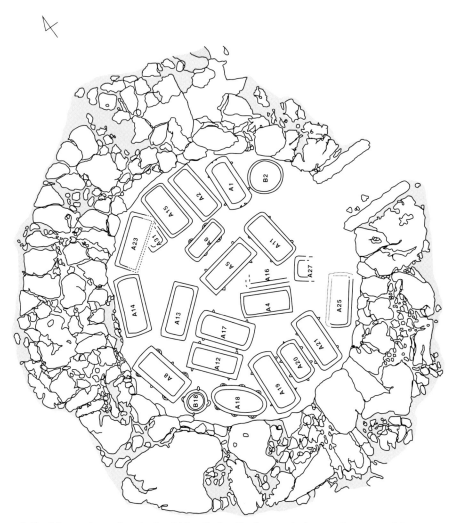

5.8 Burial containers (larnakes) within Tholos Epsilon at Archanes. Courtesy of Diamantis Panagiotopoulos. Redrawn by Isabella Vesely.

larnakes are not exactly rectangular, but rather have rounded corners – as if they are a kind of compromise between bin and warebox. Whatever the social and cultural changes were behind the use of containers in burials, it seems that there was a growing concern in Middle Minoan I, at least at Archanes, to separate and isolate the dead more intimately (rather than to mark individual prestige and status). Philosopher Peter Sloterdijk calls such burial pithoi from ancient Greece and the Bronze Age Aegean 'uteromorphic' – implying a crawling back into the intimacy of the womb at death.[69]

These trends continue into the Protopalatial period, through the early part of Middle Minoan II certainly, although their status in Middle Minoan IIB is debatable. Certainly, many cemeteries do appear to have gone out of use before the end of Middle Minoan IIB.[70] This development presages a curious

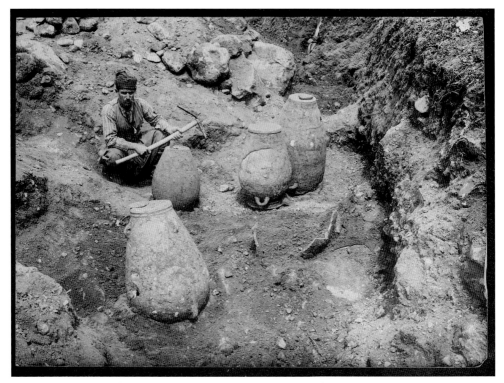

5.9 Pithos burials at MM III Pachyammos. Courtesy of Penn Museum.

phenomenon in the subsequent Neopalatial period (Middle Minoan III–Late Minoan I), when burials decline at the same time as population seems to increase.[71] Built tombs in particular decrease in number, though a handful of multi-chambered tombs are known from Poros and Knossos.[72] Pithos and larnax cemeteries do carry on though, at least into Middle Minoan III, as notably in east Crete at Sphoungaras and Pachyammos (Figure 5.9), though even this burial evidence tails away in Late Minoan I.[73] Devolder comments on the relatively small size of the pithoi in the Sphoungaras and Pachyammos cemeteries, and the likelihood that many may have been child burials; while Girella comments on the placement of the pithoi upside-down in pits,[74] which implies a lack of concern with retrieval. Given the very dense settlement pattern in this period, it is strange that, these burial 'bins' aside, we see such little investment in burial containment.[75] Why do the dead now become so uncontained? We will return to this below, once we have brought in other container modes, such as houses and artefacts.

Nevertheless, it is at this time on the mainland that we see some of the most remarkable burial containers ever found – the Shaft Graves of Mycenae. In these burials, the sense of containment is more absolute, as the graves are sealed. They can be and are reentered for subsequent burials, but their very nature – vertical shafts into the earth – hardly facilitates this. So, there is a very

specific dynamic of display and concealment. The body once buried may be fully concealed and hidden from view; which means that any display has to come first. The bodies were probably dressed and may have been available for viewing before being taken in a procession to the grave.[76] Some of the more elaborately arranged bodies were adorned with dozens of ornaments, including many gold foil cut-outs, which were probably sewn onto garments or a shroud and made exclusively for the burial.[77] Some males (and one child – Figure 5.10) were also conspicuously concealed with gold face masks. The richest burials were effectively covered in gold.[78] This 'wrapping' of the dead in exquisite materials creates the kind of active dynamic between concealment and display noted by Elsner. Moreover, the associated grave goods are also unequivocally dramatic displays of wealth and prestige. And yet, this display at the grave site itself was probably short-lived, confined to the immediate moments of the burial rite. The bodies were inhumed in deep shafts (up to 3.5 m), which were filled with earth and covered with a ceiling of wooden beams and then stone slabs or branches and marked on the surface by a heap or circle of stones, and perhaps a grave stele.[79]

That these burials were sealed in this way and subsequently quite inconspicuous is perhaps best shown by the lack of looting in the intervening millennia. With the new 'Griffin Warrior' burial from Pylos, intact with spectacular finds, the excavators had no idea initially that they had begun excavating a tomb.[80] With a richly decorated sarcophagus, the tension between concealment of the dead body, and its 'display' in some sense, can continue indefinitely, if the sarcophagus remains in view. With these Shaft Grave burials, however, the dynamic is quite different – not so much a tension between display and concealment, as a temporal sequence of display *then* concealment. Containing conveyed a quite different kind of transcendence – perhaps much more directed to the

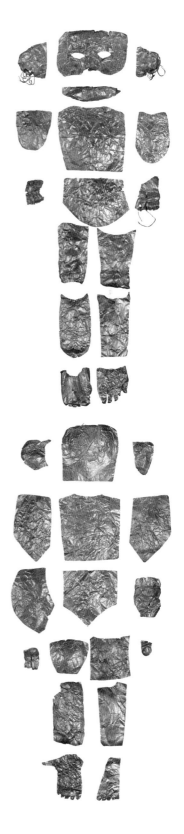

5.10 Infant's gold shroud from Grave Circle A, Tomb III (Karo 1930, pl. LIII, no. 146; see Latsis NAM, p.114. Arithmos Evrimata Π146). National Archaeological Museum, Athens. © Hellenic Ministry of Culture and Sports/ Archaeological Receipts Fund.

afterlife than the world of the living. Such a tomb is much more of a passive, custodial facility, it would seem, than the revisitable house and tholos-tombs of Crete, where secondary treatment of the body and rearrangement of bones was common; perhaps the wrapping of the body is a sign of the importance of keeping it intact.

The mainland Shaft Graves were gradually superseded by chamber tombs, which created a quite different dynamic of containment. Accessed horizontally rather than vertically, these containers could now contain both the dead and the living in the moment of the interment rites; as Boyd puts it, interment becomes a qualitatively different act.[81] Moreover, with the opening to the tomb much less 'sealed' than in a Shaft Grave, the chamber tombs also lent themselves to multiple revisitings for rearranging the chamber's contents.[82] There was not a pattern of more intimate, individual containment, it seems, unlike on Crete: clay coffin use is seldom found beyond Crete; although in the Middle Helladic period on the mainland pithos burial was common, it diminishes to the point of scarcity from Late Helladic I onwards.[83]

This trend of conspicuous burial on the mainland does spread to Crete where, from the Late Minoan II period, at Knossos and Chania notably, we find 'warrior graves' with elaborate display of finds and display/concealment in built forms. Moreover, Crete sees the introduction of burial containers too, or in some cases, the reintroduction, as there is a revival of earlier forms known from Early to Middle Minoan.[84] Pithos burials are revived in Late Minoan IIIA2, and clay larnakes now appear in two main forms, the tub larnax, which is closest to the Early and Middle Minoan forms (which were, however, much more varied in shape), and the chest larnax.[85] Chest larnakes are lidded, while the tub form is unlidded; and chests are thought to have been skeuomorphs of wooden prototypes.[86] Pithoi, tubs and chests imply quite different logics of containment. Pithoi are closed shapes without lids, so it would presumably have been possible to glimpse the dead body within (unless a cloth or textile covering was affixed). Note too that their cylindrical shape puts them in the category of 'bins' in domestic use, such that retrieval of contents is untargeted; can this be taken to mean that retrieval in death, of returning to the corpse, was not a factor?[87] Tub larnakes are low, open shapes without lids, almost designed to display while only very partially concealing (Figure 5.11). It hardly seems coincidental that tub larnakes are also often decorated on their interiors as well as exteriors. Chest larnakes (Figure 5.11), however, usually have taller sides, legs and a lid – features that place more of a premium on concealment of their contents, rather than display.[88] They are, however, quite often elaborately decorated, though only on the outside; with their four distinct sides with panels, they possess a different kind of decorative logic to the continuous surfaces of tub larnakes.

There are some regional preferences for different forms of container. For example, within east Crete, tub and chest larnakes are the preferred types at

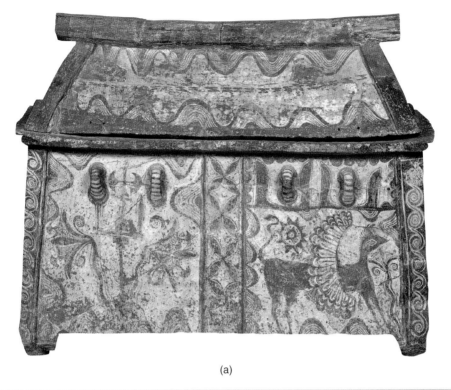

(a)

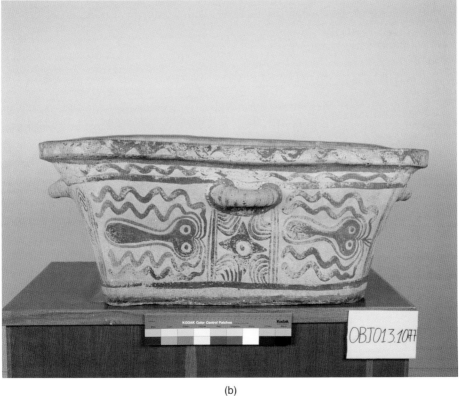

(b)

5.11 (a) A chest larnax from Palaikastro, ht. 1.8 m, Inv.no Π1619; (b) a tub larnax from Episkopi Ierapetra, ht. 40.5 cm, Inv.no Π7624. Archaeological Museum of Heraklion, Hellenic Ministry of Culture and Sports, TAP Service.

sites on the Isthmus of Ierapetra, whereas a little further east, at the site of Mochlos, pithoi seem to be slightly favoured.[89] At Mochlos chest larnakes do exist, and Smith suggests they are associated with wealthier burials than were pithoi, which we might think makes sense in terms of the level of care and retrieval that the different forms afford. At a broader level, it is difficult to say what this renewed emphasis on intimate containment in Late Minoan IIIA2–B society might signal – though comparison with patterns in the levels of display and concealment in architecture might be informative.

These Late Minoan III burial containers – pithoi, tubs and chests – are all portable, even though they may have required two to four people to carry them. In the mediaeval period, reliquaries were portable – partly enabled by them holding only small parts of bodies, allowing for a kind of miniaturization, or distillation. We hardly see this in the Aegean – the veneration of just parts. Body parts are sometimes separated and set apart in collective burials that are reused, but they are rarely isolated and recontained – though Smith does mention that small bones have been found in some cases in cylindrical pyxides, much smaller kinds of container.[90] Nonetheless, we can pick up this theme of portability – and containing and releasing – with containers that move and circulate to varying degrees. Portability may range from the movement of storage and transport jars at different scales across the Aegean and east Mediterranean, to the movement of drinking and other vessels within and between buildings. And in most cases, it is the movement of liquid commodities that is particularly targeted.

CONTAINING AND MOVING

We can start with the pithos, as it has already been discussed in the context of burial containers. Though the pithos may in some periods have been reappropriated for burial, it is primarily a container for the storage of commodities such as oil, wine and cereals. In terms of passive containing facilities, it is a classic 'bin' – a large cylindrical storage unit for homogeneous contents, into which items can be introduced for subsequent retrieval in the knowledge that they will remain 'idle' in the meantime (Figure 5.12). With homogeneous contents of equal target value,[91] their retrieval is usually indiscriminate (in that any handful or scoop retrieved is much like any other). Pithoi might contain for quite long periods, perhaps even years at a time.

The pithos is a mainstay of the Aegean Bronze Age. Examples are known on Crete from the very beginning of the Early Minoan period,[92] with well-published examples also from the Early Minoan II period, and then throughout the Middle and Late Bronze Age.[93] Two aspects of their decoration, which is relatively constant over time, speak to their contents and manoeuvrability respectively. Trickle decoration would seem to mimic the marks that might be

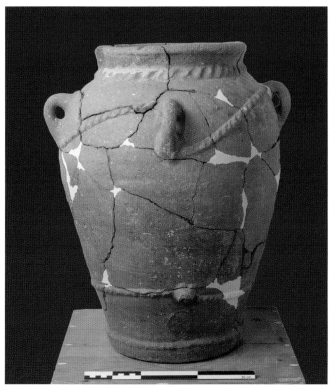

5.12 A storage pithos from Crete (Palaikastro), Neopalatial period. Courtesy of the British School at Athens. Photograph by Kostis Voutirakis.

made from oil; and rope cords suggest that such vessels were often bound with ropes to help move them around. While their discovery in specialised rooms (magazines) suggests relative immobility, there is plenty of evidence from fabric studies of their mobility – with, for example, imported examples from Crete found at Akrotiri on Thera, and at Miletus in coastal Anatolia. We cannot say if such vessels would have travelled empty or full, but the latter seems more likely – why move empty pithoi over such distances? Despite such mobility, they do remain relatively stable in form over long periods, seemingly not attracting the same kinds of creativity as seen in some other kinds of vessels discussed below.

Other containers that travel seem much more suited to this purpose – they are smaller, much more portable, and with narrower necks that could be more readily stoppered. The main kind of transport jar, at least on Crete, is the oval-mouthed amphora. Neither this form, nor an early equivalent, the collared jar – both grouped under the term 'maritime transport container' (MTC)[94] – has quite such a long history as the pithos. The collared jar makes an appearance in the southern Aegean in the Early Bronze II period, but there are no definite transport jars in Early Minoan I or Early Cycladic I.[95] By the Middle

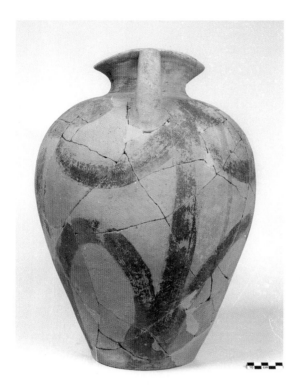

5.13 An oval-mouthed amphora (early 'MTC'), from Quartier Mu. Courtesy Ecole Française d'Athènes. Photograph Ph. Collet.

Bronze Age the oval-mouthed amphora has established itself as the main kind of MTC: it has an ovoid-conical shape, and a mouth that narrows to an opening of around 6 cm (Figure 5.13). The oval shape of the rim that opens up above the mouth would have facilitated pouring, as would the two vertical handles attached to either side. A few ceramic stoppers have been found for these amphoras.[96] Though the capacities of oval-mouthed amphoras vary quite a lot,[97] we can suggest that 15–20 litres is fairly typical. The outer surfaces are often decorated, usually with simple dark-on-light bands, though in east Crete we also see slightly more complex motifs, such as discs and loops or linked discs, while those from the Mesara have yet more complex designs.

Such jars perform like pithoi in that their contents must remain idle in these 'passive' facilities, albeit while the container itself may be highly mobile. The timeframe of introduction and retrieval is rather shorter than that for pithoi, as the transport jar is set to contain only so long as the product within needs transporting, with emptying of its contents into larger containers upon arrival at its destination.[98] We should also note that these jars also are relatively unchanging over time. Still they are not quite so invariant as the pithos. While the oval-mouthed amphora continues to be made and used in the Neopalatial

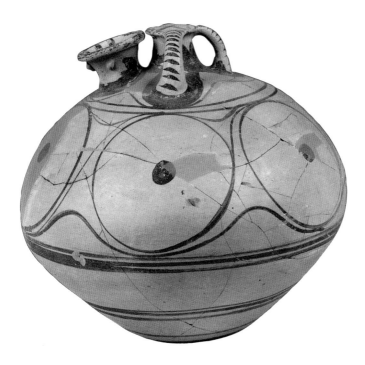

5.14 Stirrup jar, ht. 30 cm, Knossos; Inv.no Π15045. Archaeological Museum of Heraklion, Hellenic Ministry of Culture and Sports, TAP Service.

period, a new kind appears, the stirrup jar.[99] This vessel type has a similar ovoid-conical profile and is of a similar size – it seems it would have contained about the same amount of product as an oval-mouthed amphora. However, its mouth is much narrower, and even more significantly, it is a false mouth – it is completely blocked. Just to the side of this false mouth is a side spout that serves as the only means for filling and emptying the vessel. Being placed to the side, this would have made pouring easier, presumably, just by tipping the vessel; while the much narrower opening would have allowed for easier stopping and sealing of the contents while in transit. Neopalatial examples have two further characteristics, which appear to be designed for two functions: pierced holes to afford the attachment of labels, and 'spout horns' to help secure the stopper (Figure 5.14).[100] If we pause to consider what this innovative form tells us about how containment was conceived, it does look as if there was an increased concern with concealing and securing contents. The stirrup jar becomes even more common in later periods, and is a widespread type by Late Minoan IIIA2–B. As Catherine Pratt suggests, its popularity testifies to a 'certain desire to carefully control the contents of transport stirrup jars and clearly mark their ownership'.[101]

Perhaps, then, a particular kind of commodity called for a standardised container in the Neopalatial period, such that the contents could not only be readily identified from the container, but also more effectively controlled. It is tempting to connect this new Neopalatial concern with the argument I will make about houses as containers, and the degree of control exercised over the movement of residents and visitors within them, particularly at a time of increased population and greater regional mobility. Indeed, the Neopalatial stirrup jar is found mostly in palaces, elite villas and major coastal settlements.[102] With the proliferation of stirrup jars in the following periods (Late Minoan IIIA2–B), we can see how this might connect with the ever-increasing importance of trade networks, with stirrup jars and other kinds of standardised container – such as Canaanite amphoras – moving widely across the east Mediterranean. Some archaeologists see in this development an early example of 'commodity branding', with consumers able to spot the likely source of a product just from its packaging.[103] This connection between a container and its contained product would have held particular advantages in an international trading environment such as that of the Late Bronze Age east Mediterranean.[104] We should also recognise the kinds of products being transported in such containers, from the pistacia resin or sesame oil in Canaanite amphoras, to the oil and wine of stirrup jars. These are products that needed to be parcelled up and shipped in relatively small batches, as 'break-bulk cargo', rather than pooled together – perhaps an issue of scale, relating to what might be easily portered. These Bronze Age practices of using ceramic containers for the transport of liquid presage a much longer history of 'Mediterranean containerization'.[105]

However, many containers in the Aegean Bronze Age were designed for much shorter periods of containment – perhaps very momentary where the myriad drinking vessels of Bronze Age Crete are concerned. It is such vessels – and those connected with them in use, the pouring vessels such as beaked jugs and bridge-spouted jars – that see far more typological and decorative variability than do storage and transport containers. This feature is usually attributed to their social visibility in acts of conspicuous consumption, though this alone does not necessarily mean that they should be variable and innovative rather than standardised and unchanging. Another reason often given is that they would have broken more often, being more fragile and handled daily; and that this need for frequent replacement would have encouraged changefulness. Perhaps we should give due attention also to the temporality of their use – it is hard to claim either pouring or drinking vessels as 'passive' facilities with a custodial function. They may have had homogeneous contents with equal target value, which helps explain their cylindrical form – but they are hardly 'bins' in the passive sense implied by Hunter-Anderson's formulation. They are more active – like houses.

We could present countless examples of Aegean drinking vessels. But perhaps the container type that best epitomises this instant or non-custodial temporality is the 'rhyton' (Figure 5.15). This is a remarkable type of vessel that releases while containing, as there is always a hole through which any liquid that is introduced can flow straight out. The hole is always a strikingly standardised 0.5 cm, presumably to elicit a particular speed of flow. In other words, it behaves much more like a tube, though masquerading as a container. Thus, the containing function is only short-lived, as the rhyton is set up for the almost immediate release of its contents – and in this it does have some similarity to drinking vessels.

Moreover, rhyta are often in quite striking designs or conspicuous materials. They occur in expensive materials, as with the gold lion head's rhyton and the silver 'Siege Rhyton' from Shaft Grave IV in Grave Circle A at Mycenae.[106] Those that are made from stone can have elaborate relief scenes carved into them, as with the Sanctuary rhyton from Zakros, or the Boxer rhyton from Ayia Triadha.[107] When made in ceramic they typically have quite striking decorative schemes, whether in polychrome, as some Middle Minoan examples,[108] or in dark-on-light, with spirals, or Marine Style.[109] And of course they come in shapes that attract attention – most obviously in the shape of bull's heads, or lion's heads, but also ostrich eggs, with a couple of examples each from Akrotiri and Mycenae actually made of this material.[110] If we just think of one of the most iconic rhyta from the Aegean, the bull's head rhyton in stone (with restored gilt wooden horns) from the Little Palace at Knossos,[111] this is an object that must have drawn the eye – particularly if it had liquid dripping from its lower lip, where the secondary opening was drilled – all the more if this liquid was perhaps wine. Was it supposed to evoke bull's blood, even sacrifice? One can imagine, then, the powerful effect on the beholder, and the capacity of the rhyton to draw attention to itself. For this reason, for their theatricality, scholars do not find it difficult to accept that they were used in ritual ceremonies. Moreover, this performative aspect was probably enhanced by movement, with rhyta held aloft while carried short distances from one space to another, as implied in the Corridor of the Procession fresco mentioned above.

Rhyta have a long history stretching back to the Early Bronze Age.[112] However, they proliferate during the Neopalatial period. Rhyta create a very particular connection between containing and releasing as metaphors in space with a specific temporal unfolding. In this, like cups, they can be likened to Neopalatial residential houses, though they instantiate the idea of controlling flow and movement even more exquisitely. Indeed, rhyta are strongly linked to architectural space in terms of both where they were stored and how they seem to have been used in processions through buildings.

Another form of container that does not fully contain also comes into its own in the Neopalatial period – the strainer-pyxis (Figure 5.16). This differs

(a)

(b)

(c)

5.15 Three rhyta from Gournia settlement, (a) conical, ht. 30 cm, Inv.no Π2830, (b) conical, ht. 28.5 cm, Inv.no Π2831, (c) globular, ht. 22 cm, Inv.no Π2837. Archaeological Museum of Heraklion, Hellenic Ministry of Culture and Sports, TAP Service.

5.16 A strainer-pyxis from Crete (Palaikastro), Neopalatial period. Courtesy of the British School at Athens. Photograph by Kostis Voutirakis.

from the rhyton in having multiple holes rather than a single one, and in standing on a base like a regular piece of tableware. Its exact function remains elusive, however, with theories ranging from perfume production to sponge-holder.[113] However, as Platon notes, the pyxis form is typically for storing solids; so perhaps the strainer-pyxis was for containing solid contents that had been introduced to the vessel from a liquid mixture, with the liquid component supposed to drain away upon introduction to the pyxis (not unlike a colander).[114] That the remaining contents were then to be kept within the vessel is indicated by the shape of the form's lip, evidently designed to take a lid, though only sometimes actually present. The often-elaborate decoration on the pyxis indicates a tableware role, as the motifs are akin to those seen on cups and jugs; so perhaps the contents were foodstuffs for the table.[115]

This phenomenon of containers that do not fully contain – and hence which have active rather than passive contents – returns us to the distinction Hunter-Anderson makes between passive and active containing facilities.

HOUSES AS ACTIVE CONTAINING FACILITIES

Houses for the dead may be containers in the sense of passive facilities, with a custodial function. But residential houses see internal movement – which is why Hunter-Anderson distinguishes between storehouses and activityhouses.

This is not to say that houses of the living and the dead do not see metaphorical connection – after all, tomb structures and house structures may share certain properties, as in the long houses and long barrows of Early Neolithic Europe.[116] But residential houses contain otherwise: as mentioned in this chapter, they often have to be alternately sealed and porous. Hunter-Anderson defined two roles that houses fulfil, 'living aspects' and 'role aspects'.[117] These correlate broadly with a distinction in architectural studies between occupation and accessibility – the former concern being more about concealment and protection, and the latter with social display. Do some house forms, in terms of their interior arrangement, signal an overriding concern with concealment (i.e. the protection and isolation of those inside)? Can we see particular patterns of access and permeability that, on the contrary, might show more of an interest in display? If the exterior of a house has embellished entrances and surfaces – through colour, texture and scale, for example – are these also oriented more towards display than concealment? Is it possible to think of a house as more inward or outward facing? Fortunately, studies applying space syntax analysis to Aegean architecture, particularly that of Minoan Crete, give us a means to address some of these questions.[118]

House forms in the Aegean no doubt saw substantial changes through the course of the Neolithic and the earlier part of the Bronze Age. However, the evidence is relatively limited, and is typically not sufficient to provide the relatively complete floorplans needed for space syntax analysis. We do have just about enough evidence from the Middle Bronze Age, however, to identify some striking shifts that occur in the latter part of this period, when houses become much more 'articulated' in plan, as opposed to a more 'agglutinative' structure before.[119] Different spaces within a house become more clearly articulated, in the sense that rooms are assigned different functions, and these functions are themselves more explicitly segregated.[120] In order to achieve this separation, Letesson shows that corridors were deliberately incorporated into building plans, introducing greater control of movement in the transition from one functional space to another. Moreover, transitions from exterior to interior spaces also saw greater attention through the use of stoas, porticoes and vestibules; while these changes might have begun in Middle Minoan II, they really come to the fore in Middle Minoan III and Late Minoan I, i.e. during the Neopalatial period.[121] This is also when we witness an increased emphasis on exterior surfaces, with the use of fine ashlar masonry seeing much more widespread use; and the use of colour in building materials, such as green serpentine, or red schist, in Neopalatial architecture.[122] The Neopalatial house, then, is made into a new kind of aestheticized container, in which intimate spaces become more segregated and differentiated, and articulated in more complex ways by spaces of movement such as corridors and vestibules (Figure 5.17).[123]

5.17 The articulated space of a Neopalatial house, Delta Alpha at Malia. Courtesy of Quentin Letesson.

What factors might we invoke as contributory to these changes? If we connect the *occupational* function (or 'living aspects') of the house with residents, and the *accessibility* function ('role aspects') to visitors, does the heightened concern with access mean that houses from the late Protopalatial period onwards, and most prevalently in the Neopalatial, were increasingly expected to serve visitors as well as residents? Although speculative, might we then suggest that this change could be a result of the rise in regional and interregional connectivity and exchange that begins in late Middle Minoan II and becomes well established from Middle Minoan III?[124] Such changes surely in turn would have meant more population mobility, and hence more diverse populations, at least at some sites, not least Knossos and Akrotiri. Just to raise one example, such a pattern would explain quite well a change we see at the east Cretan site of Palaikastro at the transition from the late Protopalatial to early Neopalatial period. Here a Minoan hall is constructed in Block M, in the

heart of the settlement, and this is an architectural form that is quite clearly Knossian.[125] The hall would have been entered from just off the main street in the settlement, and moving through a rather grand entrance hall, a visitor to the building would then have stepped into a fine portico, from which a ceremonial room off to the left could have been accessed through a pier-and-door partition – a novel architectural arrangement at the site. This hall could have taken quite a large number of guests, way beyond the number of residents of this complex. Moreover, there were hundreds of conical cups found in storerooms just off the entrance, suggesting their use in some sort of welcome ceremony upon entering the building – it has been argued that such cups could have been used in a ritualised reception ceremony, to offer a 'token' of hospitality.[126] Such cups are found in large numbers in buildings all across the island at this time, and it is tempting to see them as connected to a standardised welcome ritual that helped to smooth the mobility of visitors from place to place. Thus, accessibility is not just achieved through an architectural aesthetic, but also through such items of portable material culture.

We might bring in an interesting observation here by Donald Haggis, who uses a distinction between 'static' and 'dynamic' to differentiate between various settlement structures, principally those on Crete and the Greek mainland during the Bronze Age.[127] He sees a 'static' structure as quite prevalent on Crete, with ample evidence for constancy in how buildings show 'agglomerative or agglutinative arrangements that do little to alter dramatically the overall experience of the form or visual experience of the original building'.[128] He draws examples from both the beginning and end of the Bronze Age to demonstrate his point; from Early Minoan II Myrtos Fournou Korifi and Vasiliki on the one hand, and Late Minoan IIIC Kavousi Vronda on the other. Haggis further links this kind of structure with the Lévi-Straussian 'House' idea that has recently been suggested as a structuring principle for Minoan society.[129]

But can we take the apparent existence of static structures in Early Minoan and Late Minoan III to mean that the same continued uninterrupted throughout the Bronze Age? If we return to Letesson's observations mentioned above on the substantial changes in house form that occur in the Neopalatial period, we can argue that from Middle Minoan III to Late Minoan I a rather different logic came into play, one that compromised the prevailing static structures by introducing a new dynamic, in which the stress was much more on display and access, rather than isolation and occupation. If this is the case, what then does it also imply for the 'House' society – can we take it to mean that the Neopalatial period saw some transformations on this front as well?[130] If the material house in a House society should promulgate protection and intimacy, then the houses of the Neopalatial period, in many cases, appear to be informed by a rather different logic, more predicated on enabling controlled access for visitors.[131]

The creative forms of architecture in the Neopalatial period – and their aesthetic that enables a clear differentiation of space for visitors and residents – appear to be supplemented by the use of figurative wall paintings placed quite strategically within the built environment. On the one hand, some wall paintings are located in relatively intimate spaces,[132] such that they could not have been stumbled upon by visitors – though there is the question of whether some of these may have been visible from outside streets too.[133] There are clearly some frescoes, however, that are precisely placed in areas of transition and access, such as vestibules, corridors and lustral basins – one need think only of the relief bulls from the North Entrance Passage at Knossos, the Corridor of the Procession, or indeed the frescoes from Xeste 3 at Akrotiri adorning both a lustral basin and staircases. But Letesson suggests that these are not the norm, and it is no accident that we find them at sites like Knossos and Akrotiri.[134] Is it that these sites were especially significant trading centres, with a more diverse population than many sites, and thus especially in need of architectural and iconographic frames at the transitions between public and private spaces? This raises the question of the nature of these settlements as 'containers'. If houses themselves can be conceived as containers then cities become containers of containers, as Lewis Mumford intimated.[135] If the Neopalatial house saw a new kind of differentiation of space, should we then imagine that the Neopalatial town was reconfigured too? It seems quite possible, if we assume that sites like Knossos and Akrotiri were likely to have had a lot more visitors in a time of increased interregional trade. The signalling of different kinds of spaces in the built environment, with frescoes particularly communicative, might then have been especially necessary (Figure 5.18). That some architectural forms may themselves in the Neopalatial period have come to take on an iconic, and even symbolic, role within the built environment is further suggested in the incorporation of standardised architectural forms into the wall paintings themselves, such as in the miniature Sacred Grove and Grandstand frescoes at Knossos, and in the Flotilla fresco from Akrotiri. Moreover, architecture appears in other media too, such as the faience inlays from the Town Mosaic at Knossos, and in some stone rhyta, such as the Sanctuary rhyton from Zakros.

It seems that frescoes of different kinds are strategically integrated within spaces according to their degree of public accessibility, and that they have an active role in signalling norms of access (which would be especially useful in a diverse population). Another form of installation that may perform a similar role is the kernos. This is a kind of stone feature with multiple 'cupules' or rounded depressions, whose enigmatic function has led to various speculative interpretations. However, Letesson has analysed their position (and that of hearths) in terms of Neopalatial architectural configurations and concludes that most of them are 'embedded in or close to transition spaces or passages'.[136] He also cites the earlier work of Chapouthier on the palace of Malia, associating

5.18 A Minoan fresco in a transitional public space – relief bull scene in the North Entrance Passage. Photograph by the author.

kernoi with rites of passage involving libations. That liquid libations might well be connected with movement and passage from one space to another is further suggested by the apparent connection between rhyta and ritual processions along corridors – as indicated, at least, by the depictions in the Corridor of the Procession fresco, and clusters of rhyta found together in 'cult repositories', as for instance in Late Minoan IA the 14 rhyta in room 58 of House Cm at Gournia, seemingly destined for use in a nearby public space rather than within the house itself.[137] The association of rhyta – vessels that are anything but passive containing facilities – with processions through porous architectural spaces can be taken as an indication of a very particular containing logic at play during the Neopalatial period – at both the level of individual house 'containers' and indeed in the urban 'container' of the town more broadly.[138]

CONCLUSIONS

We have seen in the above how we need to differentiate between passive and active containing facilities. Hunter-Anderson draws a rather fast line between them, but perhaps it is not that easy. Built tombs may seem like the ultimate passive facility with a custodial function – yet even these houses of the dead, when they are not fully sealed, can see a kind of dynamic containing that is not totally separate from the houses of the living. Some burial containers seem the

epitome of the passive facility, not least when they use storebins from store-rooms, namely pithoi. Other containers though, like chest and tub larnakes, are much more like the Roman sarcophagi that Elsner says embody a tension between concealment *and* display. And when we turn to containers designed for a much briefer lag between content introduction and retrieval, such as drinking and pouring vessels, and rhyta especially, we can begin to see how these sorts of vessel have such a different relationship to time (compared to pithoi and transport jars) that it does not really make sense to see them as passive facilities. Indeed, they behave more like the active facilities that Hunter-Anderson calls activityhouses, of which residential houses are one subcategory – especially those of the Neopalatial period that seem so oriented towards accessibility. Changes in resident–visitor dynamics might have come about as a corollary of the increasing urbanisation in this period, and perhaps also heightened mobility of populations in trade networks.

Turning to burial containers, however, to assess the degree to which mortuary customs may also have been affected by these broader changes, we are confronted with the problem of a lack of evidence, with Neopalatial burials quite elusive.[139] But is this reduced visibility of funerary rites something real – perhaps reflecting the inappropriateness for such intimate practices to also be subjected to these moves towards visibility and accessibility? If such rites are strictly for residents and not visitors, as one could expect, then monumentality and display might have been selected against.

If so, then how can we explain what happens after the Neopalatial period, when burial does again become quite conspicuous and an arena for display? The Final Palatial and Postpalatial periods do present very different social and political circumstances, with Mycenaean cultural practices now having quite some influence on Crete, even though we need not stretch to the epithet 'Mycenaean Crete'. Population mobility must surely have been just as preva-lent in these periods as in the Neopalatial, and the circulation of stirrup jars points to a very ready flow of commodities; and yet the architecture, on Crete at least, does seem to revert to a more agglutinative pattern, as had been seen previously, before the Neopalatial period, which arguably means the dynamic between resident and visitor is now balanced back to the former.[140] Clearly, social circumstances have changed, and we do not have all the answers – what this new way of looking at houses, burials and pottery vessels has done, however, is open up new lines of enquiry concerning the presence of different containing logics in different domains of life.

At a broader level, we have to ask what these dynamics of containing imply for creativity and change in Aegean Bronze Age art. Elsner has argued that the tension between concealment and display informed the artistic choices in sarcophagus iconography. Much as the dynamic between seal and sealing in processes of imprinting creates artistic potential, or the dialectic between

forward- and backward-looking models engenders different approaches to scale reduction and its relationship to the 'real', so the materiality of containing has generated various innovative strategies for reimagining the world as lived. With its complex imbrication of physical and psychological dimensions, containing further reveals more of the complexity of how materiality can scaffold meaning. We will explore in the following chapter our final example of how material processes can provide semiotic resources for creative thinking – in this case through the paradoxically destructive act of fragmenting.

SIX

FRAGMENTING

BREAKAGE AS OBLITERATION

In Ai Weiwei's 1995 '*Dropping a Han Dynasty Urn*', the artist lets go of the vase he is holding at shoulder height and remains impassive as it hits the pavement and breaks into dozens of pieces (Figure 6.1). This deliberate and provocative act does not just fragment the object, but also shatters our perception of value. The worth of such a vase (or 'container', thinking back to Chapter 5) is instantly transformed. We might at first glance take this transformation to be one that diminishes value, and yet the artist maintains that some new value is generated, or released, from this act – that it is as creative as it is destructive. The old Maoist adage of having to destroy in order to create is often cited in connection with this act.[1]

Ai Weiwei has disrupted the value of Han Dynasty urns in other ways. He painted the Coca-Cola logo on one such urn (*Han Dynasty Urn with Coca-Cola Logo*). A Swiss collector, Uli Sigg, subsequently bought this piece, and in 2012 was photographed by Manual Salvisberg, a Swiss artist, dropping the urn to the ground in much the same way as Ai Weiwei had done in 1995 (Figure 6.2). This photographic work is called '*Fragments of History*'.[2]

A third instance of a Han Dynasty urn meeting a similar fate occurred in 2014 – again featuring the art of Ai Weiwei. His '*Colored Vases*', on display at the Pérez Art Museum Miami, consisted of sixteen Han Dynasty urns repainted by the artist in bright colours to resemble modern containers.[3]

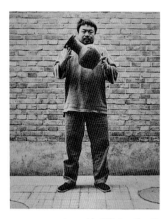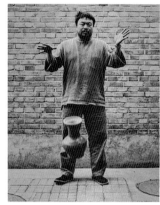

6.1 Ai Weiwei's *Dropping a Han Dynasty Urn* (1995). Courtesy: Mary Boone Gallery, New York.

6.2 *Fragments of History* (Uli Sigg dropping an Ai Weiwei piece). Courtesy of Manuel Salvisberg

A local artist, Maximo Caminero, on visiting the show, took exception to what he perceived as the museum's privileging of international over local artists. In protest, he picked up one of the sixteen urns and dropped it on the floor, smashing it into dozens of pieces. Beside him on the gallery wall Ai Weiwei's 'Dropping a Han Dynasty Urn' was displayed next to 'Colored Vases'. Captured in amateur video footage, Caminero clearly mimics Ai Weiwei's gesture. In Figure 6.3 we see the aftermath, the pieces scattered across the gallery floor.[4] Caminero was arrested, pleaded guilty to criminal mischief, and received an eighteen-month probationary sentence.

These three acts are physically very similar. They involve the collision of two objects – brittle urn, propelled by gravity, meets hard pavement (or gallery floor). The brittle urn, upon collision with the immovable object, smashes into dozens of pieces. Object collision is an event that we can grasp at a basic level – even very young infants develop physical reasoning about the behaviour of

6.3 Breakage of one of Ai Weiwei's 'Colored Vases' in the Pérez Art Museum Miami.

inert objects when in contact.[5] But why do two objects collide? In the three cases described above, there are quite distinct motivations, and they may not even be fully articulated. One might imagine other possibilities – indeed Ai Weiwei initially understood that his Miami urn had been broken accidentally.[6] In much the same way as in the preceding chapters, we are faced here with a process that is relatively straightforward in physical terms but that can support quite a range of semiotic content. As the three protagonists have demonstrated with such clarity, the seemingly simple act of dropping a pot and allowing it to smash can be deceptively creative.[7]

Let us reflect on these three acts from a slightly different angle. The collisions are quite unpredictable – the act of fragmentation creates a particular pattern of breakage that will differ each time it is performed. According to William Tronzo, 'fragment presumes fragmentation, an action whose results can never be entirely foreseen, in contrast to other, more deliberate forms of partitioning or division'.[8] When we consider further examples of fragmentation that seem comparable, we might initially agree that volatility does seem necessary for an understanding of fragmenting. The explosive obliteration of the monuments at Palmyra by ISIS, or the Bamiyan Buddhas by the Taliban, clearly fit within the same schema of fragmentation. These acts, which are unequivocally labelled as iconoclastic, may be included in a much deeper history of iconoclasm stretching back to the Reformation, and still earlier the

eighth–ninth-century Byzantine iconoclasms, and even the *damnatio memoriae* of antiquity.[9] And although the breaking of the Miami urn was iconoclastic, the impassive expression of Ai Weiwei in '*Dropping a Han Dynasty Urn*' may make us hesitate over reading this as iconoclasm. Gamboni makes the interesting observation that the artist may actually have been more interested in generating an 'iconoclash' (in the sense developed by Latour) rather than iconoclasm – the point being to create an image that is ambiguous in its meaning, with the viewer welcome to see it as iconoclastic if they so wish.[10]

PICKING UP THE PIECES

Although the aim of these acts might have been obliteration, fragmentation always leaves fragments. The fragments of the urn from '*Colored Vases*' lay on the floor of the Miami museum for some period of time – seen in the photograph taken after the fact in Figure 6.3 – as an evidentiary trace of the perpetrator's crime. But they were at some point cleared up, though their subsequent fate is unclear – held as evidence, returned to the artist, or discarded? Was there an attempt to piece them back together? We do not hear about the afterlife of the urn in this story, any more than we learn what happened to the pieces of Ai Weiwei's '*Dropping a Han Dynasty Urn*'.[11] The volatile act was obliterative, and so the fragments are literally neither here nor there. What happened to all the fragments of the Bamiyan Buddhas? Some remained in situ for study by specialists, who have been able to learn new things about the artworks in the process; though there are also stories that some made their way to the bazaars of Peshawar for sale to tourists, like pieces of the Berlin wall (another fragmented monument). After their obliteration, the fragments were, it seems, of little concern to those who enacted the destruction. This state of affairs is unsurprising if we recognise that the 'twin logic' of iconoclasm – destruction and reportage – can do without the fragments.[12] That is to say, the destruction is meaningless if it is not reported upon or disseminated. In the contemporary cases of Palmyra, or the Bamiyan Buddhas, the reportage is more or less instantaneous.[13] In ancient cases, such as those of *damnatio memoriae* in the Roman world, the public announcement may have seen a delay, but there are inscriptions that record the destructive acts.[14] In some cases, though, the monument itself also acts as its own record of the obliteration, with the missing parts quite clearly displayed in their absence.[15]

If methods of reportage such as text and film are at hand for bearing witness to the iconoclastic act, then perhaps there is no place for the fragments themselves. Equally, some forms of destructive violence leave little trace. However, even some of the more explosive acts of fragmentation do generate fragments that can be the subject of some kind of afterlife. One modern

artwork that throws light on this with great effect is Cornelia Parker's '*Cold Dark Matter*', in which the artist blew up a shed with explosives, collected the pieces and then had them hung in a gallery (Figure 6.4).[16] This collection and care for the fragments of an obliterative fragmentation explicitly makes afterlives for fragments that would normally be forgotten.[17]

Such a careful treatment of fragments is more typically associated with a gentler detachment of part from whole. Such a process would go against Tronzo's definition, but perhaps we *can* conceive of fragmentation without the volatility on which he insists. Jacqueline Lichtenstein quotes the Oxford English Dictionary in defining a fragment: 'a part broken off or otherwise detached from a whole'.[18] This indicates that volatility need not be part and parcel of fragmentation. Indeed, as Lichtenstein notes, the word *fragment* in French is associated with the Catholic ritual of breaking the Host. So, detachment from the whole can surely be careful – as in the yak hair in the Mongolian case study described previously in Chapter 5. A piece that is so carefully separated can surely also be a fragment.

A fragment, then, has creative potential because of the possibilities for being taken in different ways. The physical fragment has a semiotic life, in that, as a sign, it 'stands to somebody for something in some respect or capacity'.[19] What kind of trace is it, if a trace at all? Is a fragment an index of some performative act of fragmentation, and was that act volatile or careful? Perhaps it is the broad potential for interpretation that creates a perception of fragments as dangerous and powerful if they are not properly contained or handled. Sometimes the fragments in question may seem relatively insignificant, as Arnaud Halloy describes in his study of an Afro-Brazilian possession cult called the Xangô cult.[20] Halloy recounts the occasion on which he had been invited to help clean up after a sacrifice at some local saints' altars. This meant disposing of rotten food, and gathering up various offerings such as stones, iron pieces, old coins and bracelets. Although he had been warned not to throw away any of the permanent objects, he inadvertently did just this with a small stone that had been part of the offering. Once his mistake was recognised, there ensued 'an emotional and dramatic treasure hunt'.[21] Disposing carelessly of any small part in this way was so troubling because these parts do not just represent the saint, they *are* the saint. Halloy goes on to make the intriguing argument that what we often see in ritual is a kind of inversion so that inanimate objects are imbued with living qualities, and living entities are treated as objects.[22]

The idea that the whole may be fully contained in any single part – and hence that the loss of any small part may be troubling – also helps us make sense of attitudes to relics in mediaeval Europe. The relics of saints were potentially unsettling because of the powerful notion that partition and fragmentation amounted to decay. As Bynum puts it, 'the threat to be warded off is the threat that fragmentation constitutes a corruption of being – a corruption

6.4 Cornelia Parker's *Cold Dark Matter, An Exploded View*, 1991. A garden shed and contents blown up for the artist by the British Army, the fragments suspended around a light bulb. Dimensions variable. Photograph by Hugo Glendinning. Courtesy the artist and Frith Street Gallery, London. Photo Credit: © Tate, London 2018.

that not only destroys but also pollutes'.[23] So for the body parts of saints to be powerful, they had to somehow overcome these ideas of decay and corruption. Evidently, the anxiety about the pollution and putrefaction implied by decay was successfully countered, as fragmentation was taken up as a potent process. Pieces of the true cross were spread across Europe, and 'monasteries created networks of affiliation by sending bits of their own precious relics to daughter houses as gifts'.[24] Bynum also notes secular cases, with the aristocracy leaving instructions in their wills to have their bodies divided and scattered widely. Division and separation came to find acceptance through the synecdochal notion that the part is the whole – or what Bynum describes as the doctrine of concomitance.[25] In other words, Christ lives, even if his blood is both in heaven and on earth; and a saint is no less a saint if his body parts are relics in different locations.[26] This concomitance assumption resonates with the account provided by Halloy of the rituals in the Xangô cult.

If uncontrolled or uncontained, fragmentation bears risk, bringing with it the dangers of corruption, decay and pollution. To counter the unsettling forces that are released in the performance of fragmentation, the fragment needs to be harnessed and controlled in some way. If one considers death as the most powerful form of decay and partition, then many mortuary rites come into focus as means to overcome death's unsettling fragmentation. They may harness containment in order to resist decay and partition, as with Egyptian mummification; or the aim may be to minimise pollution by caring for the bodily fragments that are ultimately produced, with the parts carefully framed as substitutes.[27] And it is not just the death and decay of the body that can be viewed in these terms, but also, arguably, the death and decay of communities and their structures. If the fragments of such ruins as Detroit, Chernobyl or post-Katrina New Orleans signal death and decay, then we might similarly talk of the unsettling 'ghostly' feeling that occurs when structures are abandoned and allowed to rot and decay.[28]

So, fragmenting may be a volatile action, or a more careful act of partition; and it may create fragments that are forgotten, or fragments that are attended to and nurtured. One might surmise that in volatile fragmentation it is the performance itself and its reportage that are significant; while in the more careful versions, the fragment itself is what matters. What we might recognise here, as in the previous chapters, is the relevance of an approach that is broadly 'praxeological' in scope – one that pays attention not only to the materialities in question, but also to gestures and bodily conduct, and their sensory and emotional context. Within the French traditions of praxeology and the anthropology of techniques that underscore the approach taken here, we might pick out the work of Naji and Douny, who emphasise the need to think not only about making and doing, but also 'unmaking' and 'undoing'.[29] Unmaking is akin to the volatile fragmentation outlined above, while undoing is closer to the more careful versions of fragmentation. The care of undoing

allows for the fragment to be reincorporated into another object or ensemble. These different praxeologies produce quite divergent semiotic potential.

FRAGMENTATION THEORY IN ARCHAEOLOGY

Although archaeology quite evidently works with incompleteness, with remains that are almost always parts of wholes, the fragmentary nature of the material record has generally been seen as a deficiency for which archaeologists must compensate in some way.[30] But one can only compensate for loss, not for absence. Nativ argues that herein lies a serious problem within archaeology – the conflation of loss with absence, or indeed the systematic treatment of absence as loss. In other words, much of what is supposedly missing from the archaeological record was never there and was always absent – and so cannot be considered as lost. To see fragments as powerful signs in their own right rather than as little more than frustrating remnants of what was once complete requires a change of perspective.[31] One archaeological approach that does succeed to some degree in taking fragments as a positive presence rather than as symptomatic of loss is the 'fragmentation theory' developed by John Chapman.[32] This theory recognises the role of the 'deliberate fragmentation' of objects in prehistory, thus taking the fragment as in and of itself inherently meaningful. Though one might imagine such acts of deliberate breakage might have been quite common, it is quite difficult finding clear evidence, and the case studies that Chapman presents are far from numerous. It is quite possible that Nativ would think Chapman does not go far enough, in that he picks out a special class of deliberately fragmented objects, while leaving the rest of the archaeological record to suffer under notions of loss and residue.

Chapman always stresses that it is not so much the act of fragmentation that is of interest – after all, we barely ever see the act itself in prehistoric contexts – but more what happens to the pieces subsequently. A key and rather novel part of his theory is the linkage he creates between fragmentation and what he calls 'enchainment' – and we may regard this as the equivalent of reportage in iconoclasm.[33] A story he uses from the opening pages of 'Parts and Wholes' provides a very nice illustration of the idea.[34] The occasion is the funeral of Leslie Grinsell, a British fieldwalker who recorded ancient monuments such as long and round barrows. His instructions for his own funeral were quite particular – especially regarding what should happen to his ashes. He asked that they be contained in a replica collared urn (a type from the Bronze Age) and taken to a specific hilltop. There his twelve closest friends were to smash the pot, letting the ashes disperse. The most interesting part for us here is then what he specified should happen to the pieces – that each friend should take a fragment home as a token of their love for the departed. What this particular act of fragmentation served was the reinforcement of a set of social relations.

The performative sequence of breakage and then separation creates a chain of relations between the landscape, Grinsell's prior actions in that landscape, his bodily remains, material culture and the individuals present. Enchainment is thus this process whereby social relations are enacted through material sequences. Some of these ideas are perhaps present in the scholarship mentioned above concerning relics, though the fragments that have social effects in these cases are hardly the result of deliberate fragmentation. Moreover, the idea of enchainment introduces an anthropological angle that helps to formalise some of the thinking around these social effects, with Chapman drawing principally on Marilyn Strathern's work on dividual personhood.

This connection that Chapman makes between fragmentation and enchainment has been recognised for its utility in a number of contexts in British prehistory, evidenced not least in its adoption by Clive Gamble in his ambitious theoretical framework for understanding Palaeolithic social worlds.[35] However, Gamble offers a revision, as he feels Chapman confuses matters by using fragmentation and enchainment interchangeably. Gamble puts forward a model in which social practice is differentiated from social action; while the distinction between the two is not all that clear, the former appears to be more structural while the latter is more rooted in the material world. Gamble sees accumulation and enchainment as two quite different social *practices*, while the corollary social *actions* are consumption and fragmentation respectively.[36] Thus, rather than running enchainment and fragmentation together, as Chapman does, Gamble proposes a separation whereby enchainment is a broader social practice (read 'principle'; or 'ontology'?), while fragmentation is its social action. The necessity of the connection between fragmentation and enchainment is further questioned by Brittain and Harris.[37] They argue that enchainment can occur without fragmentation, as is the case in Melanesia; and fragmentation need not be enacted for the sake of enchainment. If we just return momentarily to the Ai Weiwei examples with which we started, all three cases see deliberate breakage, or fragmentation. But none of them can be linked in any sense to a process of enchainment – except to the degree that they are then subsequently reported on through text or photography. The Ai Weiwei breakages show there can be quite different semiotic content piggybacking on the material process. Why should fragmentation necessarily be aimed at creating pieces to extend social relations? In other cases, one can also query the motivation and doubt whether breakage has anything to do with such a social process – as in the examples of *damnatio memoriae*, which do have a social purpose, but more one of disenchainment, if anything.

FRAGMENTING IN THE AEGEAN

The Aegean evidence does feature quite prominently in the development of Chapman's thinking. He habitually cites the work of Lauren Talalay on Greek

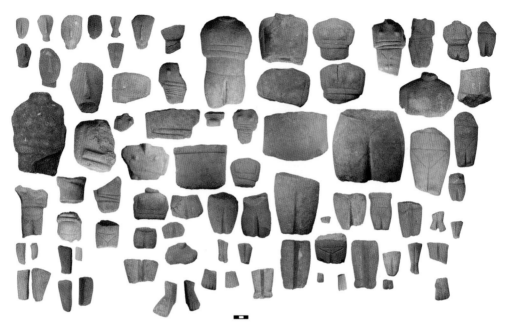

6.5 Fragmented folded-arm figurines from Keros. Courtesy of the Cambridge Keros Project.

Neolithic figurines as influential (and of course his own work is in the Balkans, which is not so very far away). Chapman has more recently done a brief survey of the evidence for fragmentation in the Aegean.[38] We will come back to this below, but what it does not include, however, is the evidence from Early Bronze Age Keros, also a case of deliberate breakage of figurines (Figure 6.5).[39]

The Keros case is quite remarkable. This island in the Cyclades had been known for some time as an important findspot for Cycladic folded-arm figurines of the Early Bronze Age, due to looting activities. Excavation subsequently confirmed the site's significance, with Colin Renfrew then launching a sustained fieldwork campaign in the 2000s. The settlement site has been excavated, along with two 'Special Deposits', North and South. These deposits have yielded large numbers of figurine fragments: Renfrew reports 553 sculptural fragments from the Special Deposit South and 283 from the North, though this had also been looted.[40] However, none is complete, and there are hardly any joins. Despite the care taken with sieving during the dig, there were no tiny fragments or 'smithereens' found on site either. This means that the fragmenting of these figures happened elsewhere, and then only pieces were brought to this spot. Given the prevalence of these figures at sites across the Cyclades, for example on Naxos and Syros, and the small size of the Dhaskalio-Kavos community compared to these other settlements, it seems likely that the figurine fragments were brought to Keros from these other islands. Renfrew wonders if they would have been used on ritual occasions, until a point at which they reached the end of their use life and had to be

properly disposed of (and not just thrown away).[41] He suggests that ritual breakage might have been deemed an appropriate path of action. How then it became custom to take one of the fragments to Keros as some sort of ritual discard, or indeed rededication at what Renfrew interprets as the first maritime sanctuary, is of course likely to remain unknown. What can we actually say about ritual performance of any kind at the Keros Special Deposits? We should not forget that there were many other fragments found here too, not least nearly 2,500 fragments of marble vessels,[42] which presumably were transported along with the broken figures, and fragmentary pottery vessels, most of which appear to also have been brought in, not only from the neighbouring islands of Kouphonisi, Naxos, Amorgos and Ios, but also from Melos, Thera, Syros and Siphnos.[43]

We do not know what happened exactly in the destruction of the Keros fragments on their 'home' islands. However, we might speculate about the whole figurine accompanying, presumably, the whole body at the time of burial; and then as the body decayed and fragmented, perhaps there was some sense that the figurine should mirror this transformation, and itself be transformed into pieces. Of course, such fragmenting does not explain the journey that individual pieces subsequently took to Keros. But if just one piece of a fragmented figurine from a given island was dispatched to Keros for ritual deposition, and joining fragments from numerous other locales similarly dispatched, then these fragments could be thought of as creating enchained relations.[44] Linking enchainment to reportage, we might then also see the itineraries that brought them to Keros, and then the ceremonies presumably accompanying their deposition, as a version of the reportage discussed earlier in relation to the Roman *damnatio memoriae* and the Palmyra destructions of ISIS. These journeys were an extended reportage, drawn out over both time and space; they may have mirrored the funerary journey of the deceased. Whatever the precise meaning, they created a particular kind of networked community in the Early Bronze Age Cyclades.[45]

This tradition of figurine production and use dies away in the Cyclades at the end of the Early Bronze Age. For figurines in the Middle Bronze Age, it is to Crete that we must turn, which sees a flourishing tradition of its own emerge.[46] The figurines are quite different in many ways – they are smaller, more roughly modelled and of clay – and they occur not only in human form, but also animal, especially cattle, sheep/goat and pig. They are rarely found in burials or settlements, but rather are overwhelmingly found, in their thousands, on peak sanctuaries and in caves. It is the peak sanctuaries of Juktas and Petsophas, above the Minoan towns of Knossos and Palaikastro, respectively, that provide the best-known examples.[47] Although the figurines are clearly not always complete, little has been made of this as possibly resulting from deliberate breakage.[48] This is presumably because of the find contexts of such

figurines – they are typically found exposed to the elements in rock crevices. It would seem that the taphonomy of peak-sanctuary deposition would make it hard to argue that missing pieces were definitely not present – especially in the absence of thorough sieving.

However, excavations at one peak-sanctuary, Atsipadhes, where activity is concentrated in the Middle Minoan II period, offer hope of establishing if and how figurines were incomplete, with careful plotting of all fragments.[49] The excavators found that when fragments did join up, they had usually been found in close proximity to one another, indicating that they were broken at the time of deposition; they further entertain the idea that this may point to the ritual breakage of offerings.[50] However, that such finds were often in crevices, in the open air, and that the site also suffered intermittent robbing, suggest that one cannot easily attribute any missing fragments to deliberate removal from the site in a process of fragmentation and enchainment. Chapman, however, is less cautious, optimistically stating that Peatfield carefully shows post-depositional factors to be minimal (wishful thinking at an open-air sanctuary). He then allows himself to argue that 'one part of the performance at the sanctuary may well have been the smashing of the figurines, with one part deposited on the Terrace and other part(s) removed for their return visit to the lowland site(s)'.[51] Not only is it difficult to support the idea of removal for enchainment purposes on the basis of the actual patterns in the evidence at Atsipadhes, but we also have very little evidence for figurine pieces back at settlements.[52]

Rather than trying to find fragmentation everywhere, however overlooked and neglected, we can perhaps take the view that in the Middle Bronze Age we encounter very few indications that fragmenting was a praxeology used creatively. One possible episode from a Middle Minoan settlement context has recently been published, from the site of Ayia Triadha in the Mesara.[53] Here the heads of four ceramic bull rhyta were found in a deposit seemingly commemorating new building activity. The bodies of these vessels were absent, suggesting that the rhyta may have been ceremonially smashed, with only the heads then included in the deposit. The finds can be dated to the Middle Minoan IB period, i.e. the very beginning of the Protopalatial period. It is not until centuries later, however, at the end of the Middle Bronze Age, after the transition to the Neopalatial period, that we find any further examples of apparent fragmentation, all of which, perhaps not coincidentally, concern figurative sculptural pieces. The first case involves the famous 'snake goddesses' from the palace of Knossos (Figure 6.6). Sir Arthur Evans discovered these faience figurines in the west wing of the palace, in two stone-lined cists that he dubbed the Temple Repositories, owing to the apparently religious character of their contents.[54] These cists might in their original use have served as repositories for cult equipment; but the nature of the finds does not reflect

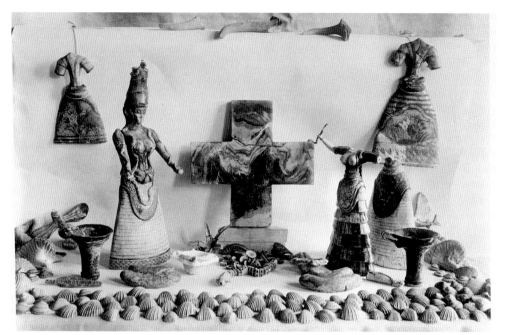

6.6 Finds from the 'Temple Repositories', Knossos. Arthur Evans Archive (AN.C.1490), Ashmolean Museum. Image © Ashmolean Museum, University of Oxford.

this primary function. Instead, what we see is a set of artefacts that have been carefully deposited as part of the closing of these repositories, a kind of ceremonial disposal.[55] While it may have been the case that some of these artefacts were accidentally broken during an earthquake destruction, Hatzaki suggests that they were more likely deliberately broken as well as deliberately deposited. Indeed, not all the items deposited are broken – there are forty to fifty whole ceramic storage jars, for example. It is the figurines, in particular, that are most fragmented, and Hatzaki believes they may have been deliberately smashed, a view in part supported by what must have been the deliberate separation of the snake goddess figurine, with its lower body placed in the West Repository, away from the rest of the faience fragments in the East Repository.[56]

Of the thousands of artefacts found in the Temple Repositories – with at least 6,340 marine shells from the East Repository, for example[57] – only a handful appear to have been deliberately fragmented. The incompleteness of some of the broken faience figurines has been taken to indicate that some pieces may have been held back, or circulated using the logic of enchainment – Chapman argues that they were most probably broken as part of a rite of passage, 'with small fragments of the figurines taken away from the palace as "tokens" of the participation in the exceptional ritual by other ritual specialists or related elites'.[58] This very speculative argument for enchainment aside, what

other reportage might have been at work? Again, quite hypothetically, there may have been oral history commemorating the event, creating the twin logic of destruction and reportage.[59]

Our second case finds some connection with the first – it also features figurative sculptural forms, and the possibility of fragments being taken away as tokens of participation.[60] And while the artefacts in question – stone bull's head rhyta – recall the ceramic bull rhyta from Middle Minoan IB Ayia Triadha described above, they are just as emblematic of Knossos as the snake goddesses. One of the most complete (and widely reproduced) examples comes from the Little Palace at Knossos; another relatively well-preserved example is from the palace of Zakros in east Crete (Figure 6.7). However, their completeness is relative – in neither case does more than 50% of the artefact survive.[61] Most of the other examples – and Rehak catalogues twenty-three in all – are in an even more partial state. Rehak takes this absence of complete examples as an indication that these stone vessels, which after all were presumably quite robust, may have been deliberately broken. He observes one particular pattern, which is that the upper half of the bull's muzzle is always missing. If bull's head rhyta acted as simulacra of sacrificed bulls, then perhaps they were acted upon as if they were bulls. A blow to the muzzle to stun the actual bull before sacrifice may have been reenacted as a blow to the stone bull's muzzle, causing it to smash into pieces.[62] If this ritual breakage took place, then perhaps some of the pieces were left as part of the ritual act (hence the <50 per cent of pieces we find deposited), while others were 'distributed as symbola among the participants in the ceremony'.[63] Rehak further notes that the condition of stone relief rhyta, such as the Harvester Vase and the Boxer Rhyton, are little different. Indeed, only the stone triton from Malia is complete, while the Treasury Rhyton from Zakros was almost complete, but was found smashed, its pieces scattered through four rooms of the palace; unfigured stone rhyta are much more frequently complete.[64] As with the faience figurines from the Temple Repositories, the breakage and preservation patterns are suggestive; but we have neither direct evidence for the nature of their breakage, nor for any enchainment practices.

The third case, the Palaikastro kouros, is different again. This is another figurative sculptural artefact, made principally of ivory, though it also incorporates stone (of the same kind as the bull's head rhyta, i.e. serpentine) and gold.[65] It is hence often described as a lithochryselephantine piece. The artefact itself – which we have described in Chapter 1 (see Figure 1.3) – is a quite remarkable work of art, with astonishing detail in the rendering of the veins on the arms, and in the carving of the headdress (this in stone). It is also utterly unique in its scale, standing 50 cm tall. However, what is even more surprising is the context of its discovery, as it was found smashed into many pieces in the heart of the Minoan settlement at Palaikastro (Figure 6.8). Moreover, it was

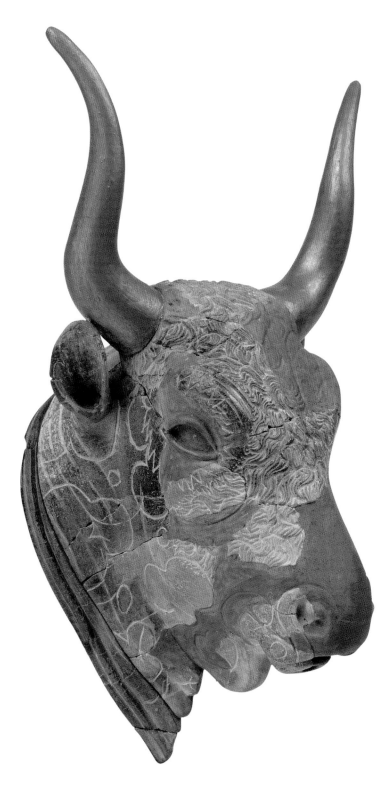

6.7 Stone bull's head rhyton, ht. 15 cm, Zakros palace; Inv.no Λ2713. Archaeological Museum of Heraklion, Hellenic Ministry of Culture and Sports, TAP Service.

6.8 The dispersed findspots of the Palaikastro kouros. Photograph Jan Driessen. Courtesy of the British School at Athens.

not all found in one place – the lower body was found inside a building that suffered a severe fire destruction, Building 5, while the upper body was found just outside this same building, in a small square.[66] This peculiar distribution is interpreted as resulting from a violent destructive act, with the figure taken, presumably from its spot within the shrine of Building 5, smashed against the doorframe of the entrance to the building, with the aggressor holding the legs and targeting the head, with the legs then tossed into the burning building.

Unlike the previous two examples, here we truly see the moment of destruction, in what would seem to be a clear-cut case of iconoclasm – especially if the figure represented a male god, perhaps a local variant that was frowned upon by Knossos (if we can assume Knossian aggressors were responsible). However, there is nothing to indicate that any pieces were taken and used in enchainment; nor do we know of any reportage. Though we might speculate that news of this dramatic act travelled by word of mouth and was commemorated in some way, it is equally possible that no such reportage occurred, given the upheavals at this time, at the end of the Late Minoan IB period when sites across east Crete may subsequently have suffered decline and temporary abandonment. If iconoclasm requires the twin logic of destruction and reportage, here the second facet is anything but certain.

MAINLAND GREECE AND THE LATE BRONZE III PERIOD

If we turn to the Greek mainland, the presence of bull's head rhyta fragments at Mycenae and Pylos could suggest that fragmentation was a cultural process there too.[67] We do see other forms of evidence that have been discussed within the framework of fragmentation – namely the broken swords from the Shaft Grave burials.[68] Though there are a number of complete swords from the Shaft Graves, notably in graves IV and V in Grave Circle A, many are also fragmented (Figure 6.9). While some of these are in pieces within the graves, the majority consists only of isolated fragments, suggesting that they were deliberately broken before being deposited, with some of the pieces held back.[69] Harrell argues that the cutting of these swords was probably the work of a metalsmith; and the metalsmith might then also have taken charge of the withheld fragments and recycled them, perhaps to make new swords. This suggests a different kind of enchainment: 'casting a "second generation" from sword fragments sustains ties between individuals through time, bonds capable of even surviving death and burial'.[70] So that rather than being ritually 'killed', as some scholars have previously argued, Harrell's argument is that fragmentation revivifies.

6.9 Broken sword from Grave Circle A, Tomb V (Karo 1930, pl. LXXXI, 723). National Archaeological Museum, Athens. © Hellenic Ministry of Culture and Sports/ Archaeological Receipts Fund.

With these phenomena during the Shaft Grave period there is always the question of the extent of Minoan influence – especially where the bull's head rhyta are concerned. However, this question becomes much less salient in the subsequent Late Helladic III period; and yet, some possible indications of fragmentation are still observed. Many Mycenaean chamber tombs have deposits of multiple stemmed drinking vessels called kylikes seemingly smashed deliberately as the final moment in a funerary ceremony; this was noted long ago by Carl Blegen in his excavation of the tombs at Prosymna in the Argolid.[71] It is hard to know if such vessels were deliberately broken though,[72] as they would surely not have survived intact even if left whole in this exterior space; neither is there any evidence to suggest that pieces were removed to then 'enchain' relations or create reportage. A rather more intriguing case of possible fragmentation is reported from Hagia Triada (Klenies) near Tiryns, another site in the Argolid, by Klaus Kilian.[73] It consists of a group of c. 100 figurines found 'more or less on the surface in an area without any surrounding walls', and since argued by Robin Hägg to be from an open-air sanctuary.[74] These pieces are all just fragments (Figure 6.10), and none has the

6.10 Assemblage of fragmentary figurines from Tiryns. With permission of Joseph Maran, Tiryns excavations.

distinctive shoulder parts that would allow for the ready definition of the figurine type (i.e. Phi or Psi). Malafouris sees this as particularly significant, as it could indicate the deliberate retention of those fragments that are the most diagnostic and identifiable.[75] In this instance, we can perhaps imagine a deliberate breakage of figurines at this possible sanctuary location, with subsequent enchainment along the lines envisaged in Chapman's theory of fragmentation.

Few instances of fragmentation have been documented on Crete in the Late Minoan III period, though at Mochlos there are examples of what has been described as 'ritual killing'.[76] These occur in a particular Mycenaean burial, Tomb 15, which contained four objects treated in this manner: a bronze dagger snapped in half, and three ceramic vessels missing key features such as handles and spouts.[77] The partial and selective removal of these features, on vessels that otherwise remain intact, is seen as a means of taking the objects out of circulation and denoting their association with the deceased. This action is perhaps comparable to the possible smashing of kylikes in the dromoi of tholos-tombs, as a kind of final act; but it seems unlikely that the missing spouts or handles then took part in acts of enchainment. Perhaps fragmenting here nonetheless does have a semiotic value.

CONCLUSIONS

I argued in this chapter that a fragment has considerable creative potential because of the possibilities it offers for being interpreted in many different ways. Was the fragment deliberately removed, or is it just accidental? If deliberate, was it a violent or a controlled act? In the Bronze Age examples we have catalogued here, this ambiguity is certainly to the fore. But to suggest that fragmentation was a significant semiotic or artistic strategy in the Bronze Age Aegean is to overstate the case. Whitley frames fragmentation as a distinctively Bronze Age phenomenon that seems 'very odd indeed' from a Homeric perspective.[78] And while this contrast may work for the purposes of drawing out the particularities of Iron Age materialities, it fails to capture the rarity of the phenomenon within the Bronze Age itself. The case of Early Cycladic Keros is quite remarkable in and of itself, and hints at a practice with echoes around the Cyclades – but we have very few other indications of this kind from the Early Bronze Age, a period spanning one millennium. We can find very little positive evidence from the Middle Bronze Age, until the Temple Repositories at the end of the period; and even here it is not entirely clear that we are viewing either deliberate breakage or indeed enchainment. The case of the bull's head rhyta is similarly speculative; and while the Palaikastro kouros was patently smashed, we can say little to nothing about any associated reportage. As for the Late Bronze III period, there are some suggestive instances of smashed kylikes and figurines, but relatively little to convincingly show deliberate actions that incorporated reportage or enchainment.

When compared to outbursts of iconoclasm in Byzantium, and during the Reformation, the material process of fragmenting seems semiotically under-exploited in the Aegean. We might even speculate that this seeming resistance to partibility is ontologically and aesthetically consistent with the emphasis on containment that we saw in the previous chapter, as manifest in various forms of evidence, from burials as containers to houses as containers. After all, the Middle Minoan period on Crete, for example, with its house-tombs and tholos-tombs, seems particularly invested in the containment of the dead and the integrity of the body (with partibility a very controlled secondary process). Cremation, one of the most dramatic means to break up the dead body, is all but unknown. In terms of houses for the living, one might argue that these always contain – and yet the argument for the importance of the long-maintained house in House societies does place special emphasis on the integrity of the house as container. Interestingly, one of the few periods on Crete when we do see signs of an increase in fragmenting, i.e. the Neopalatial period, is also when burial practices seem comparably uncontained, and when houses become more open of access – suggesting a conjoined change in the aesthetics of containment and partibility.

SEVEN

MEANING ON THE MOVE?
MOBILITY AND CREATIVITY

THE HOW AND WHY OF CREATIVITY

In the opening chapter we broached the question of not only how creativity
works but also why. It was argued that our method, a developmental approach
centred on scaffolding, could offer both description and explanation. We
phrased this in terms of combining the strengths of *Verstehen* on the one hand
and *Erklären* on the other; and in terms of a medium-viscosity approach that
could steer between thick and thin description. In the intervening chapters,
however, we have mostly focused on the *how* – that is to say, how different art
processes work, and how meaning emerges in the making. Now, in this final
chapter, it is time to give some thought to the why. To what extent can we
explain the creativity of Aegean Bronze Age art?

The way I will tackle this issue is to stretch the limits. That is to say, I want
to examine how far Aegean art can travel, to test its mobility beyond a
particular locale. While we have been quite wide-ranging – moving from
the folded-arm figurines of the Early Bronze Age Cyclades, to the icono-
graphic monsters in the seals and wall paintings of Minoan Crete, to the burial
containers of the Mycenaean mainland – we have not given too much
attention to how any one of these art processes may have itself been mobile
across the Aegean, from one setting to another. After all, folded-arm figurines
are found on Crete too, quite far from their Cycladic 'home'; in the other
direction, griffins appear in the wall paintings of the Cyclades, and burial

containers of Mycenaean type travel to Crete and beyond. Although such processes of mobility are sometimes dubbed 'international', whether in the 'international spirit' of the Early Bronze Age Aegean or the 'international style' of the Late Bronze Age east Mediterranean, exactly what is mobile in these cases is not especially clear. So, I would like to expand into this macro-scale in this last chapter. It will provide a 'stress-test', so to speak, through which we might reveal some of the local logics of artistic creativity in ways that will move us closer to explaining why creativity exists in terms of the effects it produces.

Extending our analysis to this macro-scale is not altogether straightforward. Our more local focus up to now is quite natural given the overall aim of identifying 'meaning in the making', a bottom-up process whereby semiosis emerges through the pragmatic, grounded ways in which humans use bodily gestures and conduct to engage with things. Broadly similar approaches, inspired by Gell's *Art and Agency*,[1] among others, have been quite effective at showing the localised agency of artworks, but have fared less well when confronted with the macro-scale of artistic creativity. Yet, objects *can* have effects over distance, though recognising this capacity requires an acceptance of the important role of iconography. Peter Stewart suggests that while Gell's sidelining of iconography perhaps suited his primary concern with localised relationships, it did nothing for the appreciation of how 'the iconography of gods makes them easy to represent and recognize in different places and circumstances'.[2]

THE MACRO-SCALE OF AEGEAN ART

The Aegean offers numerous examples of iconography working in this way – of objects travelling and having wider effects. In addition to those mentioned above we could call on many more, not least the recent striking discovery of Minoan seals of exquisite beauty in the Griffin Warrior burial at Pylos (see Figure 7.1).[3] These form part of 'Minoanization', one of the most striking cases of artistic transfer from the Aegean Bronze Age. This phenomenon saw significant cultural and probably political influence flow from Crete across the southern Aegean during the late Middle Bronze Age and early Late Bronze Age. A number of characteristically Minoan forms 'travel' from Crete not only to the Greek mainland, as we see with the Pylos burial and indeed the Shaft Graves at Mycenae, but also to the Cyclades, the Dodecanese and coastal west Anatolia.[4] It involves more than just exquisite forms like finely carved seals and metal rhyta; there are many different kinds of imported objects, not least various types of pottery that make their way from Crete to communities across this wide area. Furthermore, a number of these forms (and their decorative styles), though by no means all, find themselves locally imitated.

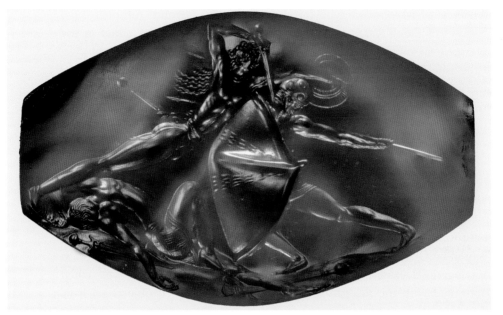

7.1 Combat Agate seal, Pylos. Courtesy of the Department of Classics, University of Cincinnati.

A further intriguing process is then a shift in orientation of these communities, particularly those in the Cyclades, Dodecanese and coastal west Anatolia. In the mid-fifteenth century BC Crete's power is compromised, with the mainland emerging as the dominant region and a concomitant shift in the direction of interregional influence. Now many of those sites that were 'Minoanized', such as Kea, Akrotiri and Phylakopi in the Cyclades, and Miletus in coastal west Anatolia, are instead 'Mycenaeanized', with their material culture showing these new affinities.[5] For fine wares with particular decorative styles to be mobile presumably demands a certain degree of aesthetic appreciation for them to be consumed. But this mobility, not only in the sense of the actual products, but also their styles, such that they are then imitated locally, has some limits – despite the prolific typological and stylistic borrowing, these regional cultures do retain much of their local character.

These interregional patterns have been interpreted in a variety of ways, ranging from colonisation to acculturation.[6] Most recently, ideas borrowed from globalisation studies have led to notions of hybridity and entanglement being mobilised to bring such patterns to life in new ways, particularly for the east Mediterranean Late Bronze Age.[7] Figure 7.2 shows the east Mediterranean, to provide some sense of the scale involved. The material appropriations that come about in moments of transcultural encounter might range from the inclusion of Mycenaean drinking vessels into local Levantine assemblages to the incorporation by local potters of details of Mycenaean pottery shapes into

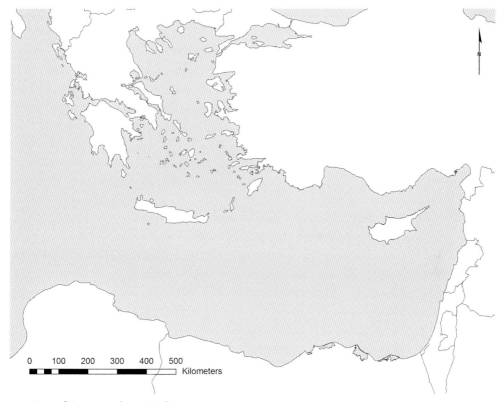

7.2 Map of Aegean and east Mediterranean.

their wares; Stockhammer calls these different kinds of entanglement 'relational' and 'material' respectively.[8] It seems that these entanglements could work to alter the makeup of the individual cultures concerned, though the idea of an international style conveys more the sense of a zone of interaction in a space between cultures. A more extreme version of this perspective appears to see such interactions as a powerful driver of change. For example, Kristiansen and Suchowska-Ducke see not only significant mobility across much of Europe during the Bronze Age, but also 'a shared Indo-European Bronze Age tradition', in which 'the shared use of sword types among Scandinavia, Central Europe and the Aegean during this period' led to "similarities in the social institutions linked to warriors'.[9]

MOBILE STYLES AND IMMOBILE ONTOLOGIES

However, there is certainly scope for questioning how transformative such cultural encounters really are. After all, the adoption of particular features of material culture does not presuppose any real depth to cultural translation. We can find support for this idea in a fascinating treatment of the art of ancient Mesopotamia. Zainab Bahrani argues that although ancient Mesopotamia and

ancient Egypt shared some elements of their artistic traditions, images behaved quite differently in these two societies, having a distinct 'ontological presence'.[10] She too discusses the Late Bronze Age east Mediterranean's 'international style' (as already mentioned), in which a common artistic idiom was created that allowed for different cultures to 'communicate'.[11] And yet, despite this apparent hybridity, the arts of Egypt and Mesopotamia remain largely separate. One might say something similar about the Greek mainland, the Cyclades, the east Aegean, and Crete during a slightly earlier period – yes, there is some hybridity, but the arts of these areas do remain distinct. The artistic strategies themselves, derived from ontological presences, just do not 'up and move'.

Bahrani's argument might inspire us to look at Aegean art in a similar light. What if the cultural translations and entanglements observed in Minoanization and Mycenaeanization do not involve any significant aesthetic or ontological transformation? This would indeed constitute a useful shift of perspective on these phenomena. The seals found in the Griffin Warrior burial at Pylos, for example (see Figure 7.1), do not indicate a high degree of knowledge of seal use (i.e. for sealing). It is as if the objects have been transposed into a different socio-cultural context in which their uses have not been learnt. Here we can return to Chapter 1, where we discussed 'scaffolded' learning – the way in which enskilment (in craft, for example) happens within a structured socio-cultural environment. If this environment is left far behind as the object travels, it is unsurprising to then see such objects take on a quite different meaning. Another way to put this is that what scaffolding does is create a kind of 'infrastructure'; when objects travel outside of this infrastructure, they can become untethered, or 'unscaffolded'. Ironically, 'entanglement' might be an entirely appropriate term to use here to describe the kinds of relations that are thereby created. It can imply a kind of disorganised, non-infrastructural mesh in which an object becomes bound.

Yet, these kinds of stylistic entanglements in material culture are only part of the picture. What we also observe, especially in Minoanization, is a mobility of technological knowledge such that some technologies *are* learnt and adopted; in the Cyclades, in particular, the potter's wheel, wall painting techniques and weaving are all taken up. These adoptions presumably involve rather more intense and frequent contact than does sharing of objects. Learning to make pottery on the wheel, for example, is not something that can be achieved overnight, but typically requires quite a long apprenticeship. In this case, then, it would appear that there was scaffolded learning; this is not a haphazard entanglement. Would Cretan potters have spent long periods of time in the Cyclades, for example, showing local Cycladic potters how to use the potter's wheel? This is of course difficult to say, but just considering what it would take for such a technology to really catch on in a completely new area should make

us aware of the inherent problems, and perhaps even unlikeliness, of such innovation. Technologies can travel, but quite often they do not travel particularly well. In other cases where the potter's wheel has been introduced into new areas, it has often not bedded in at all – used for a few generations perhaps, by a minority of potters, before fading away.[12] Certainly, the introduction of the potter's wheel to Thera does not meet with universal enthusiasm, as potters continue to use handmaking techniques for some generations; but it does seem to have had some degree of infrastructural support. Turning to weaving, the mobility of this technology in the early Late Bronze Age seems very tightly connected to human mobility, in the form of skilled female labour.[13] We should perhaps presume, then, that there was also an infrastructure for textile production and trade that supported this mobility. As for the lime-plaster technology used in wall paintings, this is not used in the Cyclades during the Middle Cycladic period, only to be introduced under Minoan influence in the early Late Cycladic period. The high quality of the lime plaster in many of the Theran frescoes might point to a strong connection with Knossos, with artisans travelling between these centres and the technology transferred through such close contacts.[14] While we can show that such technological practices exhibit mobility – and scholarship is increasingly focused on such movement[15] – we should also be alert to the difficulties faced in adopting 'foreign' technologies. Perhaps we might speculate that the long-term success of such transfers depends on the technology's compatibility with local ontologies and the degree to which this facilitated the transmissibility of scaffolded learning.

Perhaps, then, if there are these seemingly more profound kinds of cultural interaction contributing to phenomena like Minoanization, we might imagine that Bahrani's argument is of limited application and that actually in this context (and perhaps also Mycenaeanization) we do see ontological and aesthetic transformation wrought by transcultural contact. The recent focus on technological mobility in everyday practices is certainly consistent with the approach pursued in earlier chapters focusing on art *processes*. However, when we consider many of the praxeologies we have discussed so far – modelling, imprinting, combining, containing and fragmenting – then indeed most do not seem to transfer at all well to neighbouring 'cultures' even in seemingly thoroughgoing episodes of influence and acculturation, like Minoanization. We have discussed each of them in very grounded, immediate ways, in relation to bodily conducts and gestures. When we come to examine their spread beyond immediate and proximate 'communities of practice' to wider 'constellations',[16] we find something quite surprising. They do *not* appear to be at all mobile. Minoan practices of *modelling*, with the widespread use of figurines, miniatures and shrine models, find little uptake in the Cyclades, for example, or anywhere else for that matter. *Imprinting* seems similarly immobile – yes,

sealings do turn up off-island, at Akrotiri for example, but here the cache of seventy sealings is composed of actual imports from Crete.[17] Seals move too, of course, as recently displayed most spectacularly by the incredible group from the Griffin Warrior burial at Pylos on the Greek mainland (for an example, see Figure 7.1). But, as mentioned earlier, it is doubtful that they were accompanied by an embedded understanding of imprinting as a creative process. The artistic strategy of *combining* also seems to lack mobility. Yes, composite monsters (griffins) do crop up in the Cyclades almost as early as they do on Crete. These are composites already formed in the Near East though, and they are travelling as ready-made combinations. As we will discuss, these might be quite good examples of immutable mobiles, or black-boxed transfers. As for the actual logic of composition, which seems to be dynamic on Crete with its extensive skeuomorphism, this does not seem to transfer with much success. Admittedly, we see in the Cyclades some attempts at tortoiseshell ripple decoration, in imitation of Cretan forms; but it is not done with a great deal of understanding of its skeuomorphic intentions.

Does the artistic logic of *containing* spread with any kind of conviction? If we argue, as in Chapter 5, that the articulated Neopalatial house on Crete constitutes an innovation in ideas of containing, then the appearance of similar structures in the Cyclades, for example at Ayia Irini on Kea and at Akrotiri on Thera,[18] could be seen as the transfer of this praxeology. It is difficult to say too much about the mobility of Cretan burials as containers in the Neopalatial period, as we know so little about them on Crete itself; though in the later 'Mycenaeanizing' phases, mainland burial-containing practices do seem mobile. In terms of ceramic containers, both rhyta and strainers do travel to the Cyclades, and are quite common at Akrotiri. Does this mean that containing as a praxeology may be more mobile than others? Finally, the praxeology of fragmenting does not see much mobility, though it is relatively uncommon in the first place.

But the flipside of mobility is immobility. Not everyone and everything was mobile. As Greg Woolf has argued, in all the new work on mobility in the ancient Mediterranean, we have to remember that there were 'stayers' as well as 'movers'.[19] Furthermore, as well as less mobile individuals there were more localised cultures with resistance to mobile cultural elements. During the process of Minoanization there are many local features that persist in the Cyclades, such as Cycladic cups, nippled jugs and iconographic elements such as swallows.[20] Turning to Mycenaeanization, the impact of Mycenaean culture on Minoan Crete is often thought to be quite extensive in the Late Minoan II–III periods, with the appearance of Greek and Linear B, and striking warrior burials, especially at Knossos. However, in the face of this

7.3 LM II Palace Style jar, ht. 26 cm, Knossos, Isopata Tomb; Inv.no Π6495. Archaeological Museum of Heraklion, Hellenic Ministry of Culture and Sports, TAP Service.

apparently overwhelming influence, typically thought to be generated by actual Mycenaean presence, there is still some considerable continuity in Minoan 'aesthetic'. Gypsum is used in Knossian architecture in Late Minoan II, in ways quite reminiscent of its earlier Minoan uses; rosettes are incorporated into new artistic schemas, as in the Throne Room; wall paintings are redone in ways that very clearly reprise earlier ones, as in the West Porch; and in pottery, the Late Minoan II Palace Style continues Minoan iconography (Figure 7.3).[21] Although Driessen and Langohr talk more of culture than aesthetics, it looks like Knossos actively retains a Minoan aesthetic in Late Minoan II–III, even while politically and administratively mainland in character. It is an intriguing example of continuity where we might have assumed ontological/aesthetic transformation.

AESTHETIC AND EVERYDAY TECHNOLOGIES

Why should such art technologies be so locally resilient? And why should the indeterminacy of imprinting not travel to the Greek mainland, no more than the logics of substitution translate to the Cyclades? How is it that other kinds of technology do somehow manage to move with at least some degree of success across the Aegean? What is different about art technologies and practices?

What is it about the ways that artistic meaning scaffolds from the bottom-up in particular locales and communities that makes it too dependent upon local ties and local agencies to be transported elsewhere? Just being locally embedded is not enough – one might easily say the same of other practices, like use of the potter's wheel or the warp-weighted loom. We need to find something that distinguishes art practices from other technologies.

In finding answers, we can return to some of the language we used earlier in this book. We described art as a means of material engagement that enables a 'capture' and creative reimagining of the world, and as part of a process of meaning-making whereby material resources are converted into semiotic ones. We might build on this by arguing that what art practice does is gather up different domains – an idea that has some similarities to the idea of 'condensation' developed in social anthropology.[22] While this was initially conceived in studies of ritual, Lemonnier has taken it and applied it to the study of techniques more broadly. Due to the various and varied parts that are brought together in the process of technological action – building a fence, for example, or making a trap – an artefact can come to have strategic importance for its capacity to encapsulate different social dynamics.[23] These strategic artefacts, Lemonnier argues, tend to be quite resilient to 'marginal change', for the very reason that they bundle together different domains. This bundling – or what Lemonnier also calls *blending*[24] – could explain why aesthetic technologies in particular are locally resilient. This point raises the question whether Lemonnier himself considers strategic artefacts to have an aesthetic dimension – and we might suggest that he does see them in this way.[25] The aesthetic dimensions of technical action are also brought out in the work of Ludovic Coupaye on yam production in Papua New Guinea.[26]

Yet, Lemonnier's main concern is with local dynamics rather than regional or global ones. So, the degree of mobility of a strategic artefact beyond its local context is not of concern. We might *imagine* that the local resilience of an artefact, due to its gathering up and condensing multiple domains, could make it quite immobile; but this aspect is not addressed in Lemonnier's analysis. A contrary interpretation also presents itself, however. It derives from Latour's idea of 'inscription practices', which has some similarities with condensation and blending.[27] One example Latour evokes of an inscription practice is cartography: a map is a model of the world, an abstraction that succeeds in condensing various domains into one 'perspective'. But he does also argue that his idea applies to visual culture and artistic practices – insofar as they too seek to condense multiple domains into one perspective. Latour makes particular reference to Svetlana Alpers' work on Dutch visual culture of the seventeenth century. If art is, in part, a practice for enlisting others to one's own vision, then art's effectiveness can be linked to the success of the inscription practices in play. This is where the approaches of Latour and Lemonnier really start to

differ. While Lemonnier is largely concerned with the local success of strategic artefacts, Latour has in mind wider, transcultural processes. So, in his eyes, for an inscription practice to be 'successful', 'you have to invent objects which have the properties of being *mobile* but also *immutable, presentable, readable* and *combinable* with one another'.[28] Here, mobility clearly means beyond local settings.

What does it mean for the objects that are generated by inscription practices to be 'immutable'? Above all, it implies a predictable relationship to time. If we take here the example of the late fifteenth- and sixteenth-century Portuguese ships that John Law presents as immutable mobiles,[29] then we can recognise that with this kind of transport technology its mobility, and hence success in effecting long-distance control, depends on its immutable properties – i.e. its properties have to come together in predictable and reliable ways. A rather interesting feature of many technologies, in fact, is that they have to be somewhat invisible to be workable. From a simple technology, like a hammer, to a more complex one, like a ship, the person(s) using it cannot be constantly worrying about what is happening. Action just has to happen and carry forward – in other words, with a particular and predictable temporal unfolding. Of course, hammers break and ships are grounded, and at that point the technology is anything but invisible, and time stands still.[30] A technology has to be a kind of black-box, whose inner workings do not concern us most of the time, as long as they are predictable and reliable. This black-boxing is arguably of benefit cognitively, easing computational loads – imagine if one had to think about and check all the parts of a car every time one turned the ignition. We should not have to worry what a technology is for. With familiar technologies, there is a kind of a stabilisation not only of meaning and functionality,[31] but also of time (i.e., immutability).

Yet, technologies are not immutable when they come into the world. When they are first innovated they undergo a complex process of negotiation as the meaning of the new technology is up for grabs, so to speak, in a phase of 'interpretative flexibility', as has been very elegantly shown with the first stages of the bicycle in the late nineteenth century.[32] During this phase the technology is still quite mutable, which means that its functional, semiotic and temporal attributes are yet to be determined. With such mutability, the technology does not yet have much mobility. But once stabilised, it does. Which means, in effect, that the mobility of a technology requires its ontogeny, its coming into being, to be rendered opaque, inscrutable, and invisible. This is a particular kind of relationship between ontology and ontogeny.[33]

Still, these are, arguably, everyday technologies. I certainly do not want to make a radical distinction between these and aesthetic technologies – not least because the everyday can have an aesthetic, and because artworks are

technological too.[34] Indeed, the kind of attention to an object or technology that occurs when it breaks, or when its meaning is still open to interpretation, is arguably not unlike the attention one devotes to a work of art. Bence Nanay has argued that this kind of attention is distinctive because it is 'distributed'.[35] That is to say, one attends to multiple properties of the object at once. This mode of attention is not typical of how one perceives the everyday world, in which one normally only attends to very specific properties of any individual object, while perceiving multiple objects simultaneously. As Nanay indicates, the kind of distributed attention brought to bear on an artwork can also occur in the midst of everyday life – as with his barber who recounts how one day he saw from his shop an 'old man walking very slowly, holding a yellow umbrella and wearing a stripy three-piece suit and a baseball bat', and that it was 'like seeing the world in slow motion—as if it were a film'.[36] If this kind of attention, distributed across several properties of a single thing, is what one might call 'aesthetic', then we can also recognise, with this sense of time slowing down, that it has temporal effects too. Attending to a broken hammer may not have an aesthetic quality, but it is a form of attention that arguably shares this quality of temporal disruption. Distributed attention is not enough in itself to make an experience aesthetic, as Robert Hopkins, in a review of Nanay's book, underlines;[37] though what it may do is affect the experience of time.

Distributed attention might be one way in which everyday and aesthetic technologies are implicated in some of the same perceptual processes. And yet, as Hopkins indicates, we still have to recognise some differences. With regard to the art of the Aegean Bronze Age, the reason for this is simply empirical: some everyday technologies are mobile across the Aegean, while artistic ones are not. There is, I think, a crucial aspect of artistic practice that renders it much less mobile than other kinds of technology. The creativity of artistic practice is more indeterminate, ambiguous and shifting than in other technologies. It is therefore inherently incompatible with the immutability demanded by the immutable mobile. Creating a technology that is sufficiently robust and immutable to be mobile over space and time (like the Portuguese ship, the bicycle or the car) is difficult enough. The challenge is even greater when one of the essences of a practice is to be shifting and maintain an unstable relation to time – as the creativity of the artwork necessarily demands.

Nevertheless, artistic processes *do* create products, products that can have great mobility. Some aspect of aesthetic practice is rendered transportable and separable in the product. But how is this possible when the creative acts of modelling, combining or imprinting, for example, are only partially encapsulated in the object? Isn't the ontogeny of the object critical to a full understanding of its aesthetic? Perhaps, but something does travel in the object so that it can have useful effects over distance, even able to enlist others to the

vision it encapsulates. We have seen this in Chapter 3, where we saw that seals can travel over distance and have effects, but that their impact is lessened by the immobility of the logic of imprinting.

The processes whereby different domains are condensed within an object surely need more attention. How do certain products of artistic praxeologies manage to be mobile? I intimated above that the only requirement would be some degree of commonality in aesthetic appreciation of certain kinds of artefacts. However, this hardly recognises how rare it is for exotic artefacts to actually find acceptance. Even if we have argued that an artefact travels more readily than an aesthetic, we should still try to explain how and why some styles seem more mobile than others. What *can* travel? One of the more intriguing examples from the Aegean is the griffin (along with other composite creatures discussed in Chapter 4). This composite being originates in Syria and the Levant and finds its way not only to Crete from the late Protopalatial period, but also to the Cyclades and then later the Greek mainland.[38] While the iconography is clearly introduced, it quickly becomes internally adapted, with the griffin's beak noticeably longer and more like that of a vulture than the short, falcon-like beak of the Near Eastern prototypes.[39] Furthermore, the symbolism of the griffin changes. In Syro-Levantine art it was predominantly a protector, a role that certainly translates to certain contexts in the Aegean, as in the famous Xeste 3 example from Akrotiri. However, in the Aegean it is also often depicted as a predator in flying-gallop pose. Curiously, both the details of the Aegean iconography and the creature's symbolism then return east and are found in Egyptian art, as at Tell el-Daba (Figure 7.4).[40] The geographical and

7.4 Griffin iconography – the Aegean type in Egypt, at Tell-el-Daba. © Lyvia Morgan, Egypt and the Levant, and ÖAW.

symbolic mobility of this icon are perhaps tied to its inherently composite status. One might say the same for the Minoan skeuomorphic vessels that make their way to the Cyclades in the early Neopalatial period, and indeed the conjoined iconography of bulls and double axes.

EMPIRE AND ICON

What is interesting with these Aegean cases is that although there is some degree of mobility generated by inscription practices and the condensation into an icon, the artefact does not really hold its meaning very effectively over time and space. In other cultural circumstances, iconic artefacts do seem much more capable of consistent effects over distance. For example, the standardised iconography of Roman gods helped to create a sense of familiarity upon their distribution in far-flung locales.[41] But what are the conditions under which inscription practices can create such icons with valence over considerable distances? In the Roman case, it is probably connected with the nature of imperial power and its intervention in art processes to produce standardised iconography that has sufficient 'immutability' to be mobile and effective over distance. Such direction of inscription practices towards immutability for the sake of control is, it would seem, rather at odds with the principles of creative flux and mutability in artistic practice. We might look for other examples in imperial conditions – say, for example, in Lori Khatchadourian's work 'Imperial Matters'.[42] Khatchadourian describes different kinds of things in empires: delegates, proxies, captives and affiliates. Delegates are the objects that mediate 'the practices that reproduce a sovereign's prerogative to rule'.[43] An example she provides is the marble in the architecture of the Roman Empire. Proxies emulate delegates, but the process of emulation is imperfect and deviations occur – and because of this 'proxies encourage and invite human efforts at gentle play in the arts of production and consumption'.[44] Captives are objects brought into imperial capitals – such as 'the spoils marched through the streets of Rome during triumphal processions'.[45] Lastly, affiliates are the everyday things that largely outside of the power machinations of empires. For the Aegean Bronze Age, I think there is sufficient political direction in the Neopalatial period to create some approximation of an 'immutable mobile', but it is not actually that strong, and certainly not imperial. It would be difficult to argue that anything like a delegate really existed, even in those moments, such as Minoanization, when we do see some degree of regional political influence and the implication of objects in that process.

Is there something, then, about political intervention in creative processes that is particularly adept at rendering the relationship between art process and product opaque? Opacity promotes immutability, which in turn seems to be a condition for mobility. If the link between process and iconographic output is

obscured, the consumer only gets to use or apprehend the technology in particular ways (with seal imprinting again a good example). Such an observation may seem more fitting for many modern technologies, which are so black-boxed that users can only use them in set ways. That said, people do of course find ways to be subversively creative with technologies – with one example being the workarounds devised to bypass the ethics (and temporalities) imposed by the Berlin key.[46] We arguably see a similar dynamic in ancient art technologies too – with empires making opaque the relationship between technology and power, but users nonetheless sometimes able to be creative and subversive.[47]

This dynamic between the global opacity of technologies and local creative responses inheres not only in the consumption of technologies but also their production. In the moments when innovative technologies are coming into being, they are largely localised before they become stabilised and mobilised. And it is in these moments that they are mutable and shifting – as in the case of the bicycle, while its technology was in development. Thinking more specifically about art technologies and processes, then arguably they need to remain local if they are to remain mutable and creative. If we put these observations into the language of wider ensembles, we can extend the argument further.[48] When a technology is stabilised for wide dissemination it can be said to enter into a particular set of relations that serve to stabilise the innovation – and this is what we might call 'infrastructure'.[49] While infrastructural stability might be seen as a positive quality, it also has a rigidity that can stymie further creativity. At the local level, the mutability of technological processes produces a resistance to the formation of rigid connections – or to put it another way, any movement towards infrastructural stabilisation is countered by the inherent mutability of the entanglements, the contingency of which means they can disentangle and entangle in equal measure.[50] If we can thereby associate the local scale with creativity and entangling/disentangling, and the global scale with infrastructure and stability, we must ask the question of how these scales interact. Clearly, innovation does periodically ripple through the global scale, in response to localised inventions.[51] Somehow, then, these scales are connected such that infrastructure is from time to time subject to contingent forces of entanglement that then allow innovations to spread.

THE IMMOBILITY OF CREATIVITY CROSS-CULTURALLY

So, unexpectedly, creativity in aesthetic production may have very limited mobility. The gathering together of different domains – what we might call a process of condensation, or even inscription – creates a dynamic temporal mutability between process and product that is not amenable to transcultural movement. Admittedly, the artistic product is in some circumstances rendered

mobile, especially with striking and standardised iconographies that have imperial forces behind them. And yet in the black-boxing that renders such artefacts or icons portable, their ontogeny is necessarily rendered invisible. Seals may travel across the Aegean, but the aesthetic of imprinting does not very easily accompany them; skeuomorphic iconography may be mimicked in the Cyclades, but the combinatorial logic does not travel easily from Crete. When a thing travels and only its ontology is encountered at a foreign locale, then that absence of ontogeny makes the thing's aesthetic difficult to fully grasp. What is maintained locally is the mutable relationship between ontology and ontogeny. Since neither ontology nor ontogeny alone can fully encapsulate what is essential to this local character, we need another term – and 'aesthetic' seems quite capable of capturing their conjunction. It is the aesthetic of place that is localised and keeps places different. This is what Bahrani argues for Mesopotamian and Egyptian art: even though they may be in contact and sharing iconography, their aesthetics remain separate.

If we then accept that a local aesthetic is dynamic and mutable, then it will presumably be both hard to pinpoint and resistant to naming. But should we not try to characterise it nonetheless? John Baines describes an ancient Egyptian concept of decorum.[52] Zainab Bahrani suggests Mesopotamian art has a different ontology, one that sought to break out of temporal limits and make the image 'infinite'.[53] We can assume that the world of the Aegean had yet another ontology – or perhaps several, given the differences between Cretan, Cycladic and Mainland artistic traditions. This idea of regional difference within the Aegean also raises the question of variation over time. While Bahrani, for example, does suggest that in Egypt the art of the Amarna period behaves differently,[54] there is a danger of reducing any of these ontologies to a single unchanging tradition enduring over millennia.

What about further afield? Have other ancient arts been characterised in this way, in terms of their underlying aesthetic? Bahrani does mention ancient Greece and Rome and is clearly thinking about their art ontologies too. One might also mention studies in Chinese art, such as that of Lothar Ledderose on Chinese art in which he identifies a modular aesthetic.[55] In the study of the pre-Columbian art of the Americas, there have also been significant efforts to define particular ontologies. For Mesoamerica, there is the wonderful book by Stephen Houston, already referred to earlier in Chapter 4. Here he is trying to get at a sense of Maya ontology, describing the consistent preoccupation with the dynamic between permanence and impermanence.[56] In the Andes, the art of the Moche shows a particular attention to decay, disintegration and death, with Lisa Trever arguing for a Moche aesthetic worldview.[57]

If each of these ancient aesthetics or ontologies merits its own unique description – ranging, for example, from decorum to modularity – then one might quickly see how such terms might proliferate, complicating comparison.

With this in mind one can understand the attraction of a comparative frame-work in which any ontology can be assigned to one of a limited number of categories – as has been presented by Philippe Descola.[58] For example, Des-cola's fourfold system has been applied in an Aegean Bronze Age setting, with Andrew Shapland characterising its art as analogist.[59]

These two approaches are essentially bottom-up and top-down respectively. By approaching any ancient art with four categories of ontology in mind, one is obliged to make the ancient ontology fit for the sake of comparison. It is inevitably reductive – which is arguably true of any kind of model. On the other hand, the bottom-up approach is more led by the material – so that then one tries to identify the aesthetic in local terms, so to speak, whether that seems best described by a term like modularity, or decorum; or perhaps an ancient term. This approach is more compatible with Holbraad's post-posthumanism, in which he recommends approaching 'the thing' without any ontological predetermination whatsoever (see Chapter 1).[60] Interestingly, neither Baines nor Bahrani is put off by the lack of an ancient word for what they see as the guiding aesthetic in Egyptian or Mesopotamian art respectively. For Minoan Crete (and Aegean more generally) we have no such guidance anyway and so are obliged to rely on the materials. The 'Homo ludens' of Groenewegen-Frankfort may sound dated;[61] but is there an aesthetic of playfulness? How else might we characterise it? Can we try to describe some coherent logic that captures Minoan, or even Aegean, art overall? Is it even feasible to propose a single ontology or aesthetic encompassing all of the praxeologies we have described – modelling, imprinting, combining, containing and fragmenting – or are they too diverse to be assimilated under a single rubric? And is the search for a single defining ontology not further frustrated by the temporal range with which we are faced? Is it likely that Late Bronze Age containing practices are guided by the same logic or aesthetic as Early Bronze Age ones, separated by a millennium?

The process of following the materials taken up in the ontological turn may have the advantage of being bottom-up. But do we not risk, in defining an ontology or an aesthetic in this way, undoing all the good work when we come to investigate new phenomena? That is to say, is it not tempting to let this ontology lead us, rather than starting from scratch each time? With the idea of 'meaning in the making' it is important to resist the sense that ideas are already formed in the mental domain and are then materialised: but we risk just this as soon as we start to talk about Minoan art's playfulness, or the decorum of ancient Egyptian art. Such assignations can all too easily stop us from recognising the local mutability and creativity inherent in a constant engage-ment with things in their making and use.

I think what we can say about Aegean Bronze Age aesthetics or ontologies is that they appear to use creativity as a means for affecting or transforming time.

Bahrani talks of Mesopotamian art as seeking to break out of temporal limits; and Houston identifies impermanence as a particular concern in Maya art. In our discussion of modelling in the Aegean Bronze Age, we saw that the dual performative and substitutional status of models creates a particular orientation to time; and imprints have a double temporality too, both 'here–now' and 'there–then'. The skeuomorphs presented in Chapter 4 can also have both backward and forward-facing properties, in being 'preservational' and 'aspirational' respectively. Time also looms large in the custodial function of containers brought up in Chapter 5; while the fragmenting processes introduced in Chapter 6 create their own temporal dynamics. It is perhaps these various kinds of localised temporal effects that are anything but immutable and which therefore resist mobility beyond the local scale.

Such observations move us from the how of creativity towards the why. But within the Aegean it is not as if creativity emerges uniformly throughout the Bronze Age. There are moments where aesthetic creativity seems to be more intense. If the aim is somehow to channel aesthetic attention to reflect upon time, both future and past, then why might this be more intensely felt in certain periods? In periods of pronounced social change does a community's understanding of time come under pressure? One perspective on this is to see creativity in relation to memory – in the sense that memory is not a static process of recovery but rather a dynamic process of imagining.[62] Perhaps, then, bursts of creativity may be in part explained by moments when social memory comes under some kind of existential threat. To explore what these pressures and threats may be in the Aegean Bronze Age would require further examination of particular contexts. My intention here is simply to indicate ways in which we might begin to account not only for the how but also the why of creativity.

GLOBAL AESTHETIC HISTORIES?

If we study each aesthetic or ontology locally and bottom-up, then what is the scope for being global and comparative? If what I have identified here for the Aegean is somehow distinctively protohistoric, then is there any sense in seeking similar phenomena in other protohistoric contexts? Global comparison would be rendered far more feasible if Descola's scheme for ontological identification were followed.[63] The latter path would presumably make for a more systematic history of ancient aesthetic worlds. Descola's anthropological outlook may be comparative, and in that sense global, but it is not art *historical*. Perhaps the closest equivalent we might find in art history is the 'Real Spaces' project of David Summers.[64] While Summers does not seek to identify local ontologies or aesthetics within a comparative framework, his approach is nonetheless 'global' in seeking to establish a series of processes – such as facture,

planarity and virtuality – that are sufficiently universal to have valency for non-Western as well as Western art. Moreover, Summers does range across time periods, and includes numerous instances of ancient art, especially when they can contribute to his global aims, as with Mesoamerican art, which features quite prominently.[65] This methodology is, as for later periods of art, quite closely tied to deciphered texts; prehistory does find some brief mention, as when Palaeolithic female figurines are discussed, or Neolithic tombs such as Newgrange. Protohistory, in the guise of the Aegean Bronze Age, receives only passing mention.[66] Summers' patchy use of the ancient to create a global reach is motivated by methodology rather than a desire to tell long-term aesthetic histories. Indeed, the idea of creating a deep history of facture, for example, may be inconsistent with the aims of world art, which, epistemically speaking, as Jas Elsner puts it, entails the 'death of history'.[67]

If Summers' approach can be characterised not as defining ontologies, but as seeking patterns in art processes that might cross-cut ontologies, then arguably my approach has some commonalities. My attention to processes of modelling, imprinting, combining, containing and fragmenting can quite readily be extended to later periods – not least the Greek Iron Age – and to other contexts entirely. I see the attention that Summers gives to themes like planarity and virtuality as of a similar kind; and my focus on 'modelling' in Chapter 2 has certain similarities with his theme of 'substituting'. None of these praxeologies is exhaustive though. Others that are very suggestive, I think, are the motility of powder and sand, and the viscosity of oil. For the former, we might refer to the fascinating work of Jennifer Green on aboriginal sand drawings in central Australia,[68] as well as Martin Holbraad's ethnographic study on Cuban divinatory powder as power.[69] For the latter, Sophie-Ann Lehmann has argued for the importance of oil's affordances, not least its viscosity, as mediatory in the visual realism of early Netherlandish painting.[70] In line with Lehmann, I agree that materials can and should be theorised. Nevertheless, my aim here has primarily been to use art processes as a means of approaching Aegean Bronze Age society anew. Working in this protohistoric context we are faced with a particular relationship to art, finding no dialogue with texts but challenged by a prolific and abundant corpus. The approach is, therefore, in many ways more archaeological and anthropological than what we find in global art history. It necessarily has to engage fully with the range of materials encountered in the archaeological record; and it pays attention to production as well as consumption. Hence the choice of the term 'meaning in the making' for this book's title – it conveys the essential archaeological quality of context.

NOTES

CHAPTER 1

1 Concerning the status of ancient art as art, particularly in Greece, see Tanner (2006) and Porter (2010).

2 Smith and Plantzos 2012, 8.

3 Smith and Plantzos 2012, 4.

4 Smith and Plantzos 2012, 8.

5 Which is not to say that small-scale ornaments were not marginalised in scholarship at the expense of cave paintings – see White (2007).

6 E.g., Summers (2003) and Didi-Huberman (2008).

7 Neer 2012; Stansbury-O'Donnell 2015.

8 Polychronopoulou 2005, 347.

9 Polychronopoulou 2005, n. 5.

10 Schnapp 1996.

11 Basu 2013.

12 Basu 2013.

13 Donohue 2005; Basu 2013.

14 Colley March 1889; Haddon 1914; see also discussion in Houston (2014).

15 A to-and-fro between the mental and the material can arguably be traced in the early-twentieth-century approaches to the prehistoric cultures of the Aegean too. Cathy Gere, in her study of Evans's work at Knossos (Gere 2009), identifies an oscillation between the pragmatic concerns of industrialism and more utopian spiritual considerations, a tension she sees as quite typical of modernism.

16 Papapetros 2010; Payne 2012; Basu 2013.

17 Rampley 2000; Wood 2014; Severi 2015.

18 E.g., Rodenwaldt (1927), Matz (1928) and Snijder (1936).

19 Ingold 2013, 20–21; Malafouris 2013.

20 von Rüden 2013.

21 Blakolmer 2010.

22 Panagiotopoulos 2012.

23 Hood 2005.

24 Nikolakopoulou 2010.

25 Knappett 2005; Malafouris 2013.

26 MacGillivray et al. 2000.

27 Morris 2009, 183.

28 Though see Sofaer (2015, 15–39) on techniques for manufacturing figurines and miniatures, and the 'thinking hand'. Céline Murphy (2018) suggests that Minoan figurines were well constructed, even if of simple design.

29 Rutkowski 1991.

30 MacGillivray et al. 2000.

31 Gell 1998.

32 Hamilakis 2014, 70.

33 Poursat 2008; 2014.

34 E.g. Solso (1996) and Zeki (2003).

35 Onians 2008.

36 Slingerland 2008, 256.

37 Slingerland and Collard 2012.

38 Slingerland and Collard 2012, 11.

39 Rampley 2017, 4–5.

40 Onians 2008.

41 Freedberg and Gallese 2007.

42 Rampley 2017.

43 Tallis 2011.

44 One of the few art historians to pursue an explicitly cognitive approach and avoid the trap of reductionism is Barbara Stafford. Her book *Echo Objects* examines the 'cognitive work' that images perform (Stafford 2007).

45 See review in Abadia and Nowell (2015).

46 White 2003; 2007; D'Errico et al. 2005; Kuhn and Stiner 2007.

47 Farbstein 2011.

48 Malafouris 2013; Garofoli 2015; Iliopoulos 2016; Kissel and Fuentes 2017.

49 Though for an exception, see Holbraad (2011), as discussed hereafter.

50 See Scott 2013, 862. Manuel DeLanda speaks of 'flat ontology' in contrast to the hierarchical ontology that separates individuals from species as of distinct ontological status. In a flat

51 ontology, species are 'just another individual entity, one which operates at larger spatio-temporal scales than organisms, but an individual entity nevertheless' (DeLanda 2002, 47). On flat ontology, see also Bryant (2011).
51 Scott 2013; 2014.
52 Scott 2014, 34.
53 Costa and Fausto 2010; Salmond 2014.
54 Viveiros de Castro 1998; Salmond 2014, 161.
55 Latour 2009, 2.
56 Descola 2010b; Salmond 2014, 164–165.
57 Scott 2014, 34.
58 Henare et al. 2007; for further commentary, see Holbraad (2011) and Salmond (2014).
59 Henare et al. 2007, 3.
60 Holbraad 2011. See also Holbraad and Pedersen (2016).
61 Holbraad 2011, 17.
62 Bennett 2010; Coole and Frost 2010.
63 Harman 2010; see also Bogost (2012).
64 Brown 2003.
65 Holbraad 2011, 22; Witmore 2012.
66 E.g. Alberti et al. (2011), Witmore (2014), Hamilakis (2014) and Fowler and Harris (2015).
67 E.g. Barrett (1994), and Dobres and Robb (2000).
68 E.g. Bradley (2009), Garrow and Gosden (2012), Robb (2015), Jones (2017) and Jones and Cochrane 2018.
69 Sofaer 2015.
70 Sofaer 2015, 16–17, and 166; drawing substantially on Pallasmaa (2009). See also Bender Jørgensen et al. (2018).
71 Renfrew 2003; 2004.
72 E.g. Renfrew (2012) (note influence of Malafouris on his later position).
73 In his foreword to the 2007 edited volume Image and Imagination, he does assert that 'figuration has traditionally been one of the principal component fields of cognitive archaeology' (Renfrew 2007, xvi). See also Renfrew (2009), in which he does consider Upper Palaeolithic art from a cognitive angle – although cognitive here consists of a rather broad evolutionary viewpoint. See also his 1985 The Archaeology of Cult where his cognitive focus is directed towards religion.
74 E.g. Jones (2007) and Barrett (2013).
75 Hodder 2012.
76 Holbraad 2011.
77 E.g. Jones (2012), Hamilakis (2014) and Witmore (2014).

78 See Jones (2012), for example; critique in Scott (2013); also Kohn (2013, 41). The reliance on phenomenology is limiting because, according to Warnier (2006), to make the body into the social and cultural fact, rather than the techniques of the body, leads to an epistemological dead-end.
79 See Pauketat, in his book An Archaeology of the Cosmos: 'There remains a pervasive Western, rationalist bias in archaeology that predisposes some researchers—even those who advocate various social-archaeological, landscape-based, or post-colonial approaches—to be suspicious of inferences about patterning that suggests cultural order and alignments realized at scales larger than the immediate and everyday' (Pauketat 2013, 5).
80 Zoe Crossland comments on this problem of presence and absence, citing Severin Fowles on the effects of 'thing theory and its kin . . .' which have 'overprivileged a crude notion of presence . . . as if the only meaningful relations were those between things that can be seen, smelt or felt' (Crossland 2014, 19; Fowles 2007, 25). See also Miller (2005).
81 See Rose (2011).
82 On the question of novelty in organisational form, see Padgett and Powell (2012). On ideas of 'correspondence' see Spuybroek (2016).
83 See Holbraad (2011), Pedersen (2011) and Kohn (2013).
84 Holbraad 2011, 18.
85 Though see Pedersen (2007).
86 See Jordan (2014).
87 Wimsatt and Griesemer 2007, 227.
88 Wimsatt and Griesemer 2007, 227.
89 Wood et al. 1976.
90 Vygotsky 1978.
91 Downey 2008, 206.
92 Stout 2002.
93 E.g. Wendrich (2012).
94 Knappett and van der Leeuw 2014.
95 See also Caporael, Griesemer and Wimsatt (2014).
96 Clark 1997.
97 Clark 1997, 46.
98 See review by Chemero (1998).
99 Robbins and Aydede 2009.
100 Theiner and Drain 2017, 857. 4EA stands for embodied, embedded, extended, enactive and affective cognition.
101 Lakoff and Johnson 1999; Goodwin 2010.
102 Hutchins 1995; 2005.

103 Wheeler 2005; Noë 2012.

104 E.g. Cole (1996), Wertsch (1998) and Sinha (2005).

105 Baillargeon et al. 2012; see also, for example Spelke et al. (1992) and Xu and Carey (1996).

106 Gauvain 2013, 21.

107 Hutchins 1995.

108 Hutchins 2005.

109 Lemonnier 2012.

110 Naji and Douny 2009.

111 Gowlland 2011.

112 Warnier 2001; 2006; 2007.

113 Warnier 2006, 187. We have charted a set of connections here via the idea of scaffolding from Wimsatt and Griesemer, via Clark, Hutchins and Lemonnier to Warnier. But although the ideas of the Matière à Penser school of Warnier, with its focus on the 'praxeological' role of material culture, are quite consistent with some of the above scholarship on scaffolding, there seems to be less of an emphasis on learning, and developmental questions in general.

114 Knappett 2005; Boivin 2008; Malafouris 2013; Overmann 2013; Iliopoulos 2016.

115 See Sofaer (2011). And in contrast to Warnier, we might stress that Ingold's approach (see Ingold 2000) is very explicitly developmental in focus; and cites the likes of Gibson, Bateson, Clark, etc.

116 See also Sofaer (2015).

117 Cf. Renfrew and Zubrow (1994).

118 Cf. Hamilakis (2014).

119 See Gosden and Malafouris (2015), Ingold (2016) and Coupaye (2018).

120 Warnier 2007.

121 Baillargeon et al. 2012.

122 Malafouris 2013.

123 Kirsh and Maglio 1995.

124 Bonnot 2014, 30. We might translate as follows: 'So we always have to deal with a subtle blend of sensori-motor routines and planned or reflexive actions.'

125 Gauvain 2013.

126 Except for brief consideration of 'wrapping' – see also Harris and Douny (2014).

127 Stafford 2007.

128 Wengrow 2014.

129 And a spectrum in meaningfulness of physical gestures, from gesticulation to sign language – Green (2014).

130 Kohn 2013.

131 Kohn 2013, 33.

132 Note though that this hierarchy, argued by Deacon (1997), has come under strong criticism from semiotician Goran Sonesson (2006). See Iliopoulos (2016).

133 See his discussion of the Amazonian rubber economy, and how different materialities are implicated (Kohn 2013, 153–168).

134 Interestingly, Sterelny (2010) has argued that Clark's extended mind framework is a subset of a much broader process whereby cognition is supported by environmental scaffolds.

135 Keane 2005; also Hull (2012) and Fehérváry (2013).

136 Gell 1998.

137 Bauer 2002; Knappett 2005; Preucel 2006; Watts 2008; Crossland 2009; 2014; Wallis 2013.

138 One could say that Lemonnier is pursuing the kind of 'empirical ontology' advocated by Holbraad (2011).

139 Or semiogenesis – see Iliopoulos (2016); see also Holbraad (2011) on the conceptual affordances of things.

140 Elkins 2008.

141 Stafford 2007, 3.

142 Hutchins 2005; Williams et al. 2009.

CHAPTER 2

1 Belting 2004; Kuijt 2008; Knappett 2011; Croucher 2012; 2018.

2 Croucher 2012, 94.

3 On plastering in PPNB, see Clarke (2012).

4 Croucher 2012, 94; see also stunning examples from Tell Aswad – Stordeur and Khawam (2007).

5 Croucher 2012, 109.

6 Warnier 2007.

7 Vernant 1991; see also Gaifman (2012) on aniconism and xoana; and Platt (2011, 92–93).

8 Neer 2010; and note other accounts of this subject matter, such as by Tanner, Stewart, R. Smith and Sourvinou-Inwood (cf. Dillon 2012).

9 Neer 2010, 21.

10 Neer 2010, 22.

11 Vernant 1991, 153.

12 Belting 2004. Originally 'Bild-Anthropologie' in the German.

13 David Summers also makes substitution a significant component of his work 'Real Spaces' (Summers 2003). He links substitution to what

he calls 'real metaphor', which is '*the most basic means by which substitution is effected*' (257; original italics). In metaphor, he states, we may put a lion in place of a person, but in real metaphor 'we actually *do* put something at hand in place of something else ... real metaphor thus makes the absent present by the transfer of what is already at hand' (257).

14 Stewart 1993.

15 Nagel and Wood 2010. It is interesting how this influential work in current art-historical theory owes so much to Hans Belting, as Moxey (2011) underlines: 'If Belting [in *Likeness and Presence*] frames an account of the history of European art in terms of cult images (whose power lies in their capacity to make present the divine), that are replaced in the course of time by works of "art" (whose fascination derives from their indexical relationship to the exceptional personal gifts of their creators), Nagel and Wood articulate the mechanisms by means of which these transactions are enacted and analyze the development from one model to another.'

16 Nagel and Wood 2010, 30.

17 Note the example used by Nagel and Wood of Theseus's ship – supposedly maintained by the Athenian state for centuries, even though all the original wood would have long rotted away. Krauss calls this type of artefact a 'structural object'.

18 Moxey 2011.

19 Lévi-Strauss 1962, 35.

20 'La connaissance du tout précède celle des parties' – Lévi-Strauss (1962, 35). Laugrand (2010) also cites Lévi-Strauss at length; and much of Bailey (2005) is inspired by Lévi-Strauss too; see also Evans (2012, 382).

21 For the idea that the creation of miniatures has a gestural rooting in bodily conducts, see Kohring (2011).

22 Mack (2007) too in his book on miniatures talks about smallness as an attempt to access an *ideal* invisible world. See also Garfield (2018).

23 Lévi-Strauss 1962, 34.

24 Kiernan 2009; Gimatzidis 2011.

25 Pilz 2011; Salapata 2018.

26 Morris 2006, 9.

27 Wiseman 2007; see also Wiseman (2003, 185–192) and Descola (2012).

28 Wiseman 2007, 1.

29 On models of and models for, see Keller (2000) and Griesemer (2004, 435).

30 Morris 2006.

31 See Weston (2009, 44) citing Gadamer (1986).

32 Pointon 2001.

33 Winnicott 1971.

34 Winnicott 1971, 2.

35 Winnicott 1971, 4.

36 Pointon 2001, 68.

37 Grondin 2001.

38 Grondin 2001, 46.

39 See Gadamer (1986).

40 Platt 2011, 2.

41 As suggested in Neer (2010), concerning the generic physiognomies of Archaic sculpture.

42 Clark 2010, 24.

43 DeLoache 1991.

44 Clark 2010, 25. Bailey (2005, 36) talks of temporal compression too, particularly in relation to Disneyland (achieved through a subtle miniaturism), and Delong's (1983) work on the proportional compression of space and time.

45 Day 2004.

46 Bailey 2005, 32.

47 Evans 1921; Ucko 1962.

48 Gimbutas 1974; Bailey 2005.

49 Nanoglou 2008; see also Perlès (2001).

50 Nanoglou 2008, 8–9.

51 Marangou 1992; 1996a; 1996b.

52 Marangou 1996a.

53 Bailey 2005, 91.

54 Bailey 2005, 170–171.

55 Talalay 1993.

56 Poursat 2008, 42.

57 Nanoglou 2009.

58 Renfrew 2007, fig. 10.2.

59 Renfrew 2007, 121.

60 See Marangou (1992) for details on occurrences of miniatures and house models in EBA Greece, though predominantly from the mainland.

61 Poursat 2008, 71–73.

62 Pullen 1992.

63 Fragments of eleven house models were discovered in a likely foundation deposit. See Todaro (2003).

64 Simandaraki-Grimshaw 2013.

65 Simandaraki 2011.

66 Warren 1969, 71–74.

67 Warren 1969, 71.

68 Bevan 2007, 88.

69 Girella 2002; though Girella here is principally focused on normal-sized vases that have miniature elements attached, largely in LM III.

70 Tzonou-Herbst 2010.

71 Rethemiotakis 1997; 2001; Morris and Peatfield 2002; Morris 2009.

72 Peatfield 2001, 53.

73 On Minoan religion being polytheistic, see Gulizio and Nakassis (2014).

74 Zeimbekis 2004.

75 Bosanquet et al. 1902–1903, 377; Rutkowski 1991.

76 Zeimbekis 2004.

77 Poursat 2008, 102, 126–127; Rethemiotakis and Christakis 2011, 212.

78 Schoep 1994; Kanta et al. 2001; Poursat 2001; 2008, 102.

79 E.g. Knossos MM IB, Macdonald and Knappett (2007).

80 Poursat and Knappett 2005.

81 Macdonald and Knappett 2007.

82 Bosanquet et al. 1902–1903, 374.

83 See discussion in Laffineur (2001), Peatfield (2001), Thomas and Wedde (2001) and Krzyszkowska (2005, 142–143).

84 Gesell 2004.

85 Driessen (2015, 36), citing Peatfield (2016).

86 Driessen 2015, 41.

87 Platt 2011, 102.

88 Dimopoulou and Rethemiotakis 2004.

89 Soles and Davaras 2010.

90 Thomas and Wedde 2001.

91 Doumas 1992.

92 Evans 1921.

93 MacGillivray et al. 2000.

94 Sakellarakis and Sakellaraki 1991.

95 Gesell 2004, 133.

96 Tzonou-Herbst 2010; note Tyree (2001) – many from caves now are in bronze.

97 Hatzaki 2009.

98 And see what Platt (2011, 108) similarly has to say about Phidias' Parthenos.

99 Schoep 1994; see also Lefèvre-Novaro (2001) on Kamilari.

100 Schoep 1994, 207–210.

101 See Lefévre-Novaro (2001, pl. XXVI.)

102 Poursat 2001, 486.

103 Poursat 2001, 489.

104 NB the cache of miniature double axes from Juktas–Karetsou (1981); see also Haysom (2010).

105 Rethemiotakis 2009.

106 Rethemiotakis 2014, 153.

107 Rethemiotakis and Christakis 2011, 212; see also Poursat (2008, 102, 126–127). Note horns of consecration on the Monastiraki model and one of those from the Loomweight Basement (Poursat 2001, 486; 2008, 102).

108 At the peak sanctuary of Traostalos, a number of tiny shoes were found (Chryssoulaki 2001, 62), though it is unclear if they are of Proto-palatial or Neopalatial date; while the sanctuary site of Kato Symi has produced a foot model of Neopalatial date (Muhly 2012). These could be further examples of accessories used in microcosmic scenes.

109 Shrine models are found all across the ancient Near East, as is shown in Muller (2016), *Maquettes Antiques D'Orient*, and the contributions to the edited volume *Maquettes Architecturales de l'Antiquité* (Muller 2001). In the concluding comments to this volume, Jean-Claude Margueron observes how he is struck by how simple the models often are, and how they must surely have worked as accessories, rather than as representations in and of themselves (Margueron 2001, 544). This fits with the argument put forward here that shrine models served as backdrops in microcosmic scenes.

110 Tournavitou 2009.

111 This interpretation is broadly compatible with the argument put forward by Briault (2007) on sets of equipment defining peak sanctuaries (rather than the sanctuary's physical location). And what then about miniatures in settlements in the Neopalatial period? Simandaraki-Grimshaw (2012) presents some examples from Petras that would appear to come from both Proto- and Neo-palatial periods, though this is not specified.

112 Evans 1921, 302 and fig. 228.

113 Morgan 1988, 150 and pl. 190.

114 Evans 1921, 311–312.

115 Morgan 1988, 151.

116 Immerwahr 1990, 67.

117 See also Poursat (2014, figs 34a, b).

118 Koehl 2006, no. 818; Poursat 2014, 45.

119 Poursat 2008, fig. 323.

120 Poursat 2008, fig. 327; see also Koehl (2006, no. 204). Poursat (2014, 45) draws a parallel with the Chania Master impression too.

121 Driessen and Langohr 2007.

122 Rethemiotakis 2001.

123 Poursat 2014, 124.

124 Poursat 2001, 487–489. Further research is needed to establish the degree to which miniature vases in LM II–III Crete are associated with microcosmic scenes.

125 Driessen and Farnoux 2011.

126 Gaignerot-Driessen 2014, 496.

127 Gesell 1985; 2004; 2010; Gaignerot-Driessen 2014.

128 Salapata 2015, 188.

129 Driessen 2015.

130 Platt 2011, 102.

131 Poursat 2014.

132 Poursat 2014, 203.

133 Morris 2009, 183.

134 Gallou 2005; Tzonou-Herbst 2010.

135 See Gallou (2005, 52–58) for review; also Poursat (2014).

136 Gaignerot-Driessen 2014.

137 Day 2004; Clark 2010.

138 Pitrou 2012.

139 Pitrou 2012, 87.

140 Pitrou 2012, 97.

141 Following Houseman and Severi (1998); see also use of this concept by Lemonnier (2012, 144).

142 Pitrou 2012, 99. My translation: 'Ultimately, ritual action does not incorporate aspects from two domains of activity in order to represent them, but to generate synchronicity between humans and nature.'

143 See also Halloy (2013).

144 Pitrou 2016, 465.

145 Pitrou 2016.

146 Allen 2016.

147 Allen 2016, table 2.

148 Sillar 2016; and see his figure 3, showing a ritual bundle of *illa*.

149 Laugrand 2010.

150 Laugrand 2010, 59; see also Laugrand and Oosten (2008). One might also mention in this regard the Andean miniatures called *inqaychus* – see Allen (2016). Hamilton (2018) provides another perspective from the Andes, focusing on the Inca, in which miniatures are viewed from a relational perspective.

151 Weston 2009, 43. Also see in Andean and Mesoamerican contexts the idea of fractality to understand the relationship between scales (Allen 2016; Dehouve 2016).

152 Bachelard 1964, 161.

153 Jordanova 2004, 449.

154 E.g. Laugrand (2010).

155 Slinkachu 2012. They are highly detailed scenes, and quite performative; but they are also set up in public spaces such that they may or may not endure – in all likelihood though they will be quickly trampled by a passer-by, or swept away as soon as it rains. Their combination of the ephemeral and performative, with the detailed and timeless, is quite jarring.

156 Verge 1997, 42.

157 Rugoff 1997, 25.

158 Rugoff 1997, 25. One could also consider Charles Simonds's 'dwellings' as miniature microcosms.

159 Didi-Huberman 2008.

CHAPTER 3

1 Taussig 1993, 47.

2 Taussig 1993, 53.

3 Taussig 1993, 55; italics in the original.

4 Note, however, how even the imprint can be subverted – here in the figure from the work of Jennifer Allora and Guillermo Calzadilla, customised soles were produced to create footprints with political messages.

5 Sontag 1977, 154; see also Paulsen (2013).

6 Lending 2017, 12.

7 Lending 2017, 4.

8 Lending 2017, 183–221.

9 Benjamin 1936. Lending (2017, 102) notes that, for some reason, Benjamin did not include plaster casting among the media of mechanical reproduction.

10 See Didi-Huberman (2008).

11 Didi-Huberman 2008.

12 Didi-Huberman 2008.

13 Didi-Huberman 2008, 73 and fn. 4.

14 Collon 1997; Pittman 2012, 319; see also Porada (1980) and Matthews (1993).

15 See Krzyszkowska (2005, 16–17).

16 Krzyszkowska 2005, 24.

17 MacGillivray 2000, 129–130.

18 Renfrew 1972.

19 Wengrow 2014.

20 Wengrow 2014, 63; see also Weingarten (1991).

21 Wengrow 2014, 80–81.

22 Wengrow 2014, 1.

23 For example, from Ameri et al. (2018, 10): 'The mechanical replication of the seal design as it is impressed on a soft surface allows for the production of large quantities of precise and identical images, and eliminates the possibility of error in the reproduction of these images.'

24 Platt 2006, 238.

25 Platt 2006, 241.

26 Bedos-Rezak 2010, 156.

27 Bedos-Rezak 2010, 157.

28 Wengrow 2014, 54.

29 Didi-Huberman 2008.

30 Though Platt does recognise the instability of the seal, it is in the sense of their potential for being undermined by fraudulent copying, not in the sense that the replication is in anyway problematic or contingent.

31 E.g. instructions at www.fbi.gov/about-us/cjis/fingerprints_biometrics/recording-legible-fingerprints

32 Cited in Didi-Huberman (2008, 35). See Simondon (1958).

33 Ingold 2013, 25.

34 Cited in Geimer (2007).

35 Geimer 2007, 20.

36 Paulsen 2013, 93.

37 Paulsen 2013; but see also Sonesson (1989) on performative and abductive indices.

38 Green 2014.

39 Didi-Huberman 2008.

40 Wengrow (2014), Platt (2006) and Bedos-Rezak (2010), respectively.

41 Garrison and Root 2001; Root 2008.

42 Pointon 2001.

43 Pointon 2001.

44 Didi-Huberman 2008, 71–72.

45 Didi-Huberman 2008, 73, in response to Benjamin, states: 'Ce n'est pas la reproduction en soi qui fait "disparaître" l'aura, comme on l'affirme trop souvent; plutôt la perte de contact qui supposerait une repetition sans matrice et sans processus d'empreinte'. We can translate as follows: 'contrary to what is often asserted, it is not reproduction in itself that makes the aura "disappear"; it is rather the loss of contact that a repetition without mould and without imprinting process would imply'.

46 Didi-Huberman 2008, 74. See also discussion at beginning of this chapter on Taussig's use of Frazer's Laws of Similarity and Contagion.

47 Frazer 1890–1915, I, 133–135.

48 Wengrow 2014.

49 See Platt (2006) and Knappett (2011).

50 Nagel and Wood 2010.

51 Sonesson 1989.

52 Platt (2006, 242), citing Barthes.

53 Pentcheva 2006; Kumler 2011.

54 Poursat 2008, 58.

55 Poursat 2008, 59.

56 Poursat 2008, 60.

57 Anderson 2015; 2016.

58 Krzyszkowska 2005, 78.

59 Poursat 2008, 59–60.

60 Poursat 2008, 61.

61 Poursat 2008, 61, fig 61.

62 Anderson 2015; 2016.

63 See Anderson (2015; 2016), Sbonias (2012), and Relaki (2012).

64 See Relaki (2012, 320).

65 Poursat 2008, 107.

66 Poursat 2008, 107.

67 Anastasiadou 2011.

68 Krzyszkowska 2005, 72–74.

69 Krzyszkowska 2005; Poursat 2008.

70 Krzyszkowska 2005, 83–85.

71 Poursat 2008, 110–112.

72 Krzyszkowska 2005, 108.

73 Relaki 2012, 301.

74 Anastasiadou 2011.

75 Poursat 2008, 110; Anastasiadou 2016b.

76 Tsipopoulou and Hallager 2010, 195.

77 Tsipopoulou and Hallager 2010, 195.

78 Poursat 2008, 203.

79 Krzyszkowska 2005, 124.

80 Krzyszkowska 2005, 124.

81 Hallager 1996.

82 Krzyszkowska 2005, 126.

83 Krzyszkowska 2005, 155.

84 Krzyszkowska 2005, 190.

85 Karnava 2018.

86 Poursat 2014, 50.

87 Pini 2009; Becker 2018, 371–375. The Battle in the Glen ring is Becker's cat no. R33, while the chariot and deer hunt ring is R32. See also Karo (1930, pl. XXIV, 240 and 241).

88 www.griffinwarrior.org; Davis and Stocker 2016.

89 Poursat 2014, 51.

90 Pini 2009; Poursat 2014, 50. For an extended discussion concerning the question of stylistic differentiation between 'Minoan' and 'Mycenaean' in relation to gold finger rings, see Becker (2018, 287–311). See also Becker (2015).

91 Poursat 2014, 51.

92 Poursat 2014, 51.

93 Poursat 2014, 108. Younger (2010) suggests that nearly all (bar the Mainland Popular Group) were probably made on Crete.

94 Krzyszkowska 2005, 279. On Mycenaean sealing practices see also Panagiotopoulos (2010; 2014).

95 Poursat 2014, 178.

96 Poursat (2014, 178), citing Krzyszkowska (2005, 229).

97 Poursat 2014, 178–179; Younger 2010.

98 Poursat 2014, 179.

99 Poursat 2014, 181.

100 Poursat 2014, 178. 'Paradoxically, it is at the height of the Mycenaean palaces that glyptic art loses its status as the main form of relief art.'

101 Poursat 2014, 178.

102 Poursat 2008, 76.

103 Poursat 2008, 118.

104 Poursat 2008, 137.

105 Evans 1921; Hood 2005.

106 Sakellarakis and Sakellaraki 1997.

107 Knappett and Nikolakopoulou 2008.

108 Poursat 2008, 235.

109 Soles and Davaras 2010.

110 Poursat 2008, 41–43.

111 Pentcheva 2006.

112 Note that Hamilakis (2014) has adopted Pentcheva's work, and that of James, to highlight the need for multi-sensory approaches to materiality and corporeality.

113 Pentcheva 2006, 631.

114 Didi-Huberman 2008.

115 Pentcheva 2006, 635.

116 See also coins; and indeed Kumler (2011) on communion wafers as imprints.

117 Pentcheva 2006, 635.

118 Blakolmer 2010; Panagiotopoulos 2012.

119 See also Pentcheva (2006) on the absence implied in imprints.

120 Platt 2006, 238–239.

121 Didi-Huberman 2008, 41.

CHAPTER 4

1 See Severi (2015), citing Boyer (2000).

2 Baillargeon et al. 2012.

3 For archaeologists familiar with the process of sorting pottery sherds, the joy of finding a join between two sherds, sometimes after hours of searching, may also come to mind.

4 Kirsh and Maglio 1995.

5 Hutchins 2005.

6 Fauconnier and Turner 2002; also Turner (2014).

7 Turner 2014, 16.

8 Stafford 2007; also Stafford (2011).

9 Stafford 2007, 43; on isomorphy, see also Gell (1998).

10 Stafford 2007, 45.

11 Turner 2014, 23.

12 Severi 2015, 36–38.

13 Wengrow 2011; 2014.

14 E.g. Sperber (1996) and Boyer (2000).

15 Morgan 2010.

16 Morgan 2010, 304.

17 Krzyszkowska 2005, 106, no. 180; Morgan 2010, fig. 9.

18 Sakellarakis and Sakellaraki 1997, 651–653, figs. 718–719.

19 Evans 1930, fig. 355.

20 Doumas 1992, pl. 128; Vlachopoulos 2008.

21 Vlachopoulos 2007; Morgan 2010.

22 Morgan 1988; Doumas 1992.

23 Papagiannopoulou 2008.

24 Morgan 2010, 304.

25 Hägg and Lindau 1984.

26 Hood 2005; Galanakis et al. 2017.

27 Galanakis et al. 2017, 44.

28 Burke (2005) for iconographic connection with the Archanes gold ring, see Sakellarakis and Sakellaraki (1997, 652).

29 Evans 1930, 420–421.

30 Evans 1930, 417.

31 Evans 1930, 421.

32 Lapatin 2001, 29.

33 Poursat 1980, 116–118.

34 Evans 1930, 418, fig. 28; Kourou 2011, 166; 3.

35 Kourou 2011, 166.

36 Blakolmer 2016, 64.

37 Poursat 2014, 183–188.

38 Porada 1981/2.

39 For more on sphinxes see Dessenne (1957) and Karetsou et al. (2000).

40 See Weingarten (1991) and Rehak (1995a).

41 Baurain 1985.

42 CMS V, 1 no. 201; Rehak 1995a, 227.

43 Krzyszkowska 2012, 153.

44 Anastasiadou 2016a.

45 Wengrow 2014, 123, fn. 39; for Minoan genius, see Weingarten (1991) and Rehak (1995a).

46 Baurain 1985.

47 Sanavia 2014.

48 Note too ceramic imitations, e.g. at MM II Phaistos – Sanavia (2014). There are also faience imitations of triton shells – for example at Myrtos Pyrgos (Cadogan 1977–1978, fig. 26) and Shaft Grave III at Mycenae (Foster 1979, 137–138, pl. 44). A faience argonaut was found at Zakros. See Panagiotaki et al. (2004, 158).

49 Colley March (1889), and also Haddon (1915).

50 McCullough 2014, 48.

51 McCullough 2014, 40–41.

52 Gibson 1979. See its wider adoption in archaeology too: e.g. Sinclair (2000), Knappett (2004; 2005) and Gillings (2012).

53 McCullough 2014, 46.

54 McCullough (2014, 46–47), citing Hartson (2003); see also Holbraad (2011).

55 See Houston (2014).

56 See the discussion in Chapter 1, where we showed the roots of this discussion in Gottfried Semper, resonating subsequently in Conze, Riegl, etc. It has significant repercussions for the question of form, as also discussed by Warburg – see Severi (2015); and then taken up by Nagel and Wood (also via Didi-Huberman, Belting) of similar themes concerning the promulgation of form over time in antiquity through a model of substitution.

57 Taylor 2010, 153.

58 As an aside, it might be useful to think of aspirational examples as forward-looking and performative, and preservational ones as backward-looking and substitutional, in the sense of Nagel and Wood (2010).

59 Vickers and Gill 1994.

60 E.g. Knappett (2002), Reeves (2003) and McCullough (2014).

61 McCullough 2014, 54.

62 See Wengrow (2001) and Knappett et al. (2010).

63 Frieman 2010.

64 Houston 2014. It may be that differences between Old World and New World literature on skeuomorphs play some role here. Nonetheless, Houston does engage more directly with the nineteenth century European tradition of thought on ornament than does McCullough.

65 Houston 2014, 58.

66 Hersey 1980. This could explain the transfer to wood, and then to marble.

67 Conneller 2013.

68 It also allows for a useful connection to Arthur's (2009) idea of 'combinatorial evolution', which he sees as a key process in many instances of technological innovation.

69 Sanavia and Weingarten 2016, 336.

70 Evans 1921, 242–243.

71 Childe 1956, 13.

72 See Hood (1978, 171).

73 Vickers and Gill 1994.

74 Evans 1921, 238.

75 Evans 1921, 413, figs. 297–298.

76 Evans 1921, fig. 300a.

77 Carter et al. 2016.

78 MacGillivray 1998.

79 E.g. Taylor (2010); also Hurcombe (2014, 153) and Manby (1995).

80 Knappett et al. 2010.

81 Poursat 2008, 32.

82 Poursat 2008, 34.

83 Wengrow 2001.

84 McCullough 2014, 70.

85 Phelps et al. 1979.

86 Schachermeyr 1955.

87 Wilkinson 2014a.

88 Nakou 2007, 235–236.

89 See also Pullen (2013).

90 Rutter 1988.

91 Frieman 2010; 2012.

92 Poursat 2008, 80.

93 Poursat 2008, 81.

94 Another example comes from Early Minoan Crete, where the pattern-burnishing of Pyrgos ware may be an attempt to evoke wood veining (Betancourt 1985, 27; Poursat 2008, 88).

95 Poursat 2008, fig. 348.

96 Cadogan 1977–1978, fig. 12.

97 Knappett 2015, fig. 3.

98 Carter et al. 2016.

99 Cadogan and Knappett in prep.

100 Poursat 2008, fig. 189.

101 McCullough 2014, 247.

102 Knappett and Nikolakopoulou 2008.

103 Poursat 2008, 139.

104 Sarri 2010, 607.

105 Matthäus 1980; see also Reeves (2003, 222).

106 E.g. Davis (1977, 123).

107 Reeves 2003, 222.

108 Reeves 2003, 226–227.

109 Sarri 2010, 607. In his recent study of Grey Minyan pottery from the site of Mitrou, Hale (2016) does not stress any metallic connections for the ware.

110 Poursat 2008, 253.

111 Evans 1921, 553; Hood 1978, 34–35.

112 Reeves 2003.

113 McCullough 2014, 164–167.

114 Evans 1921, 592–593.

115 Hatzaki 2013, 42–43.

116 Hood 2005.

117 Blakolmer 2010; note counter-argument from Panagiotopoulos (2012).

118 E.g. Poursat (2008, fig. 315).

119 Poursat 2008, fig. 322.

120 Betancourt 1985, pl. 17.

121 Hooker 1967; Hood 1978, 160–161.

122 See example from Myrtos Pyrgos – Cadogan (1977–1978, fig. 18).

123 Poursat 2008, fig. 367.

124 Poursat 2008, fig. 364.

125 Reeves 2003, 231–232.

126 Reeves 2003, 231.

127 Davis 1977.

128 According to Blakolmer (2010).

129 Andreadaki-Vlasaki 1988; see other Cretan examples at Knossos and Palaikastro.

130 Morgan 1988, 75–77; for Jungfleisch's work, see www.wall-paintings-ted.de/architectual-imitations-palace-g.html

131 See Houston (2014).

132 Wilkinson 2014a, 269; 2014b.

133 Shaw 2000.

134 Egan 2012.

135 Hatzaki 2018.

136 Reeves 2003, 232; Poursat 2014, 221.

137 Poursat 2014, 138 and 221.

138 Stafford 2007; Turner 2014.

139 Bijker 1995.

140 Herva 2006; Descola 2010a; Shapland 2013, 194–195.

141 Shapland 2013, 199.

CHAPTER 5

1 Shryock and Lord Smail (2018) comment on this oversight, though they do not mention Lewis Mumford's early call to include containers in histories of technology (Mumford 1934). One reason why container technologies may have been overlooked, according to Sofia (2000), is that they are seen as passive and feminine. See also Peters (2015, 142).

2 Shryock and Lord Smail 2018, 2.

3 Gamble 2007; Bevan 2014; 2018.

4 Hunter-Anderson 1977, 295.

5 Hunter-Anderson 1977, 295

6 Hunter-Anderson 1977, 296.

7 Hunter-Anderson 1977, 296.

8 Hunter-Anderson 1977, 299.

9 Hunter-Anderson 1977, 301.

10 Pickering 2010.

11 Law and Mol 2008.

12 Peters 2015, 139–140.

13 Klose 2015; Ducruet 2016;

14 Hunter-Anderson 1977, 303.

15 Peters 2015, 140.

16 Peters 2015, 140.

17 Bachelard 1964 (published in French in 1957 as 'La poétique de l'espace').

18 On the power of containing, drawing profoundly from Bachelard, see also the *Spheres* trilogy of Peter Sloterdijk (2011–216).

19 Grootenboer 2012, 12.

20 Grootenboer 2012, 12.

21 Koos 2014.

22 Weston 2009, 43.

23 Baillargeon et al. 2012.

24 Blier 1987.

25 Gamble 2007.

26 Grootenboer 2012, 71.

27 Grootenboer 2012, 71.

28 Warnier 2006, 2007.

29 Warnier 2006, 188.

30 Warnier 2006, 189.

31 Warnier 2007, 64–65.

32 Warnier 2007, 67.

33 Warnier 2007, 88.

34 Warnier 2007, 26.

35 Although, as Forni (2007) notes, there may be different layers of meaning – some containers, such as pottery vessels, are made by women, even if then appropriated by men.

36 Douny 2014.

37 Douny 2014, 30.

38 Douny 2014, 32.

39 Empson 2011.

40 Empson 2011, 77.

41 Empson 2011, 177.

42 Another example given by Empson is when someone gives away a container of cream, milk or butter – 'the giver pours the contents of their container into the recipient's container that is placed on the ground. When the recipient's container is full, the giver places their own container on the ground and pours back a little of the produce into their own container so that the "sacred portion" (*deej*), containing the fortune of one's animals, is retained' (Empson 2011, 72).

43 Cooney 2015.

44 Elsner 2012a.

45 Elsner 2012a.

46 Zanker 2012, 167.

47 Zanker 2012, 167.

48 Hahn 2010; see also Hahn (2012).

49 Weinryb 2013.

50 Weinryb 2013, 15.

51 Leone 2014.

52 Leone 2014, S52.

53 Leone 2014, S53.

54 Mills 2008; Zedeno 2008; Harris and Douny 2014; Brown Vega 2016.

55 Leone 2014, S52.

56 Zedeno 2008; Pauketat 2013; Brown Vega 2016.

57 Empson 2011.

58 E.g. swan bone, sage bundle and bison hair bundle – see Zedeno (2009, 411).

59 Knappett et al. 2010.

60 Mee 2011, 224.

61 Legarra Herrero 2014, 141.

62 Mee 2011, 225.

63 Legarra Herrero 2014, 141.

64 Legarra Herrero 2014, 142.

65 Vavouranakis 2014.

66 Dickinson (1994, 215), in Vavouranakis (2014, 199).

67 Legarra Herrero 2014, 80–81.

68 Rutkowski 1968, 222.

69 Sloterdijk 2011, 279.

70 Legarra Herrero 2014.

71 Note that the changes typically associated with the Neopalatial period do seem to start already in the middle of the Protopalatial period – much as we observed above in relation to architecture. For the significance of the transition between Middle Minoan IIA and IIB (i.e. within the Protopalatial), see Knappett (2007; 2012).

72 Ailias, Mavro Spelio, Monasteriako Kephali – see Preston (2004, 181).

73 Devolder 2010, 50–53.

74 Girella 2015, 124.

75 Devolder (2010) notes the striking decrease in monumental tomb use in the Neopalatial period.

76 Boyd 2015b, 435.

77 Voutsaki 2012, 172. See also Cavanagh and Mee (1998, 33).

78 Voutsaki 2012, 172.

79 Cavanagh and Mee 1998, 28.

80 Davis and Stocker 2016.

81 Boyd 2015b, 439.

82 Boyd 2015b, 440.

83 Preston 2004, 187. One striking exception in Late Helladic III is Tanagra – so much so that it is considered to have been heavily influenced by Crete – see Poursat (2014).

84 Preston 2004.

85 Preston 2004, 183.

86 Preston 2004, 184.

87 Note the Middle Minoan III examples mentioned above, which appear to have been buried in such a way as to limit the possibility of return.

88 On lids and containment, see Peters (2015, 140).

89 Smith, in 2019.

90 Smith, in 2019.

91 Hunter-Anderson 1977.

92 Betancourt 2013.

93 Warren 1972; Christakis 2005; Bevan 2018.

94 Demesticha and Knapp 2016.

95 Day and Wilson 2016, 19.

96 Poursat and Knappett 2005, pl. 35, 1333–1338.

97 E.g. Poursat and Knappett (2005, 202; 2006, 154).

98 On the different temporalities of storage containers in Roman houses, see van Oyen (forthcoming). Van Oyen argues that when things are contained they are removed from their entangled relations with other things. Thus, storage becomes a means of disentanglement.

99 Pratt 2016.

100 Pratt 2016, 36.

101 Pratt 2016, 36.

102 Pratt 2016, 36.

103 Wengrow 2008.

104 Knapp and Demesticha 2016.

105 Bevan 2014.

106 Koehl 2006, 298.

107 Koehl 2006, 103 and 164–165.

108 Koehl 2006, 127, cat. 350.

109 Koehl 2006, pl. 19.

110 Koehl 2006, 26.

111 Koehl 2006, 118, cat. 307 (and pl. 24). Note too example in silver and gold from Shaft Graves at Mycenae.

112 Koehl 2006.

113 Platon 2016.

114 Platon 2016, 249.

115 Platon 2016, 250.

116 Hodder 1990.

117 Hunter-Anderson 1977, 303.

118 E.g. Letesson (2009; 2014b).

119 Letesson 2009; 2014b.

120 Letesson 2015, 719.

121 Letesson 2015, 719. Also see Shaw and Lowe (2002) on stoas at Knossos; and Palyvou (2002; 2004).

122 Driessen 1989–1990; McEnroe 2010.

123 Letesson 2015, 719.

124 Knappett 2011.

125 Driessen 1999; Knappett and Cunningham 2012.

126 Rupp and Tsipopoulou 1999.

127 Haggis 2013.

128 Haggis 2013, 69.

129 Driessen 2010. We might also raise here the question of 'foundation' or 'building' deposits, discussed by Driessen in relation to House society. Does a foundation deposit create a particular relation to time that engenders building continuity? A foundation deposit is a particular kind of container, like the most sealed kind of burial, in which content retrieval is not anticipated. See Bahrani (2014, 89–94) on foundation deposits and conceptions of time in ancient Mesopotamia.

130 Letesson 2013, 345.

131 González-Ruibal and Ruiz-Gálvez (2016) provide a review of house societies in the ancient Mediterranean, in which Bronze Age Crete figures prominently. However, none of the eight features they list (2016, 403) seems particularly pertinent for the Neopalatial period, with many being quite generic to multiple periods (large size of houses, repeated building on the same spot), the antithesis of what is seen in the Neopalatial (such as house-shaped tombs), or very rare (house models in clay – really only the Archanes example is a house rather than a shrine model).

132 Letesson 2014a.

133 Paliou et al. 2011.

134 Letesson 2014a, 49.

135 Mumford 1934; Klose 2015, 128–129; Peters 2015, 144.

136 Letesson 2015, 727.

137 Koehl 2006, 288–289.

138 On the importance of thinking through the different scales of the built environment together, see Letesson and Knappett (2017).

139 Devolder 2010.

140 See Sager forthcoming.

CHAPTER 6

1 Gamboni 2010, 86.

2 http://artasiapacific.com/Magazine/78/DevastatingHistory

3 www.newyorker.com/business/currency/the-case-of-the-million-dollar-broken-vase

4 https://nypost.com/2014/02/18/artist-smashes-rivals-1m-vase-in-miami-museum/

5 Kotovsky and Baillargeon 2000; Baillargeon et al. 2012.

6 www.nytimes.com/2014/02/18/arts/design/ai-weiwei-vase-destroyed-by-protester-at-miami-museum.html

7 Eduardo Kohn in his Amazonian ethnography 'How Forests Think' (Kohn 2013) also reveals the semiotic productivity of straightforward physical acts. He uses the example of hunters cutting down a tree so that it crashes down and startles the monkeys that they are trying to shoot. This is a collision that means something – and the hunter is hoping that the monkey interprets it as a sign of danger, of whatever form, but sufficient to make it move from its perch where it cannot be reached to another perch where the shooter may gain sight of it. As with the collision between urn and ground, what does a tree colliding with the ground mean? Is it that the tree was rotten and happened to fall? Or was it made to fall and, if so, why?

8 Tronzo 2009, 1.

9 E.g. Gamboni (1997), Brubaker and Haldon (2011), Mochizuki (2013), Kolrud and Prusac (2014) and Elsner (2003; 2012b; 2016).

10 Gamboni 2010, 91. He cites Latour (2002, 14–15) on iconoclash, in which 'one does not know, one hesitates, one is troubled by an action for which there is no way to know without further inquiry, whether it is destructive or constructive'.

11 The fate of the pieces is neither covered in Gamboni's (2010) treatment in 'Dropping the Urn', nor in any other account I have encountered.

12 Elsner 2016, 135.

13 Flood 2016.

14 Elsner 2016, 131.

15 See in Mesopotamian art, for example, the selective gouging out of faces on carved relief panels at Nineveh. Bahrani (1995, 366–377).

16 See Parker (2009).

17 Sometimes fragments may take some time before they are reintegrated into something 'whole' again, as is the case with spolia – see Elsner (2000).

18 Lichtenstein 2009, 115.

19 Peirce 1931–1958 (Collected Papers 2.228; 1897).

20 Halloy 2013.

21 Hallloy 2013, 137.

22 Halloy 2013, 149.

23 Bynum 2011, 182.

24 Bynum 2011, 193.

25 Bynum 2011, 208–215.

26 'Concomitant thinking assumes that division does not destroy what was; partition does not kill; distribution does not dissolve identity' (Bynum 2011, 214).

27 See Croucher (2018).

28 See Hetherington (2004), Edensor (2005), Knappett (2011, 200–208) and Dawdy (2016).

29 Naji and Douny 2009, 422.

30 Nativ 2017.

31 On the materiality of absence (Meyer 2012). See also Buchli (2016) on immateriality and iconoclasm.

32 Chapman 2000; 2015; Chapman and Gaydarska 2007; 2009.

33 Just as Elsner sees the twin logic of iconoclasm as destruction and reportage, so might we see the twin logic in Chapman's account as fragmentation and enchainment.

34 Chapman and Gaydarska 2007, 1–2.

35 Gamble 2007.

36 Gamble 2007, 137.

37 Brittain and Harris 2010.

38 Chapman 2015.

39 Renfrew (2015) presents the argument in the same volume.

40 Renfrew 2013, 201; Renfrew et al. 2015.

41 Renfrew 2013, 207.

42 Renfrew 2013, 201.

43 Renfrew 2013, 204; see also Renfrew et al. (2015).

44 Renfrew et al. 2015, 556.

45 Renfrew et al. 2015, 556.

46 Tzonou-Herbst 2010.

47 Karetsou 1981; Rutkowski 1991.

48 See also Zeimbekis (2004) where figurines illustrated are mostly incomplete.

49 Peatfield 1992.

50 Peatfield 1992, 67.

51 Chapman 2015, 39.

52 Note also the argument recently made by Murphy (2018) that figurines may have been displayed for a time at peak sanctuaries before their eventual breakage. She bases this on the relatively good quality of their manufacture, which suggests they were not made to be immediately broken.

53 Baldacci 2014.

54 Evans 1921, 463–471, 495ff; Panagiotaki 1999.

55 Hatzaki 2009, 20.

56 Hatzaki 2009, 24.

57 Hatzaki 2009, 23.

58 Chapman 2015, 42. See also Bonney (2011).

59 Chapman 2015, 42: 'The public defacement of such remarkable objects as the faience figurines would have created enormous negative ritual energy during the dramatic performance, marking an event to be commemorated through Minoan cultural memory.'

60 See Chapman (2015, 42), who draws a link between the breakage of the faience figurines and these bull's head rhyta.

61 Rehak 1995b, 441.

62 Rehak 1995b, 451.

63 Rehak 1995b, 451. He also draws an ethnographic parallel (p. 452), saying that in potlatch ceremonies copper plaques were broken up and distributed.

64 Rehak 1995b, 442–443.

65 MacGillivray et al. 2000.

66 MacGillivray et al. 2000.

67 Rehak 1995b.

68 Harrell 2015.

69 Harrell 2015.

70 Harrell 2015, 151.

71 Blegen 1937. See also discussion in Malafouris (2005, chapter 8).

72 See Boyd (2015a, 160).

73 Kilian 1990; also Malafouris (2005, chapter 8).

74 Kilian 1990, 185.

75 Malafouris 2005.

76 Soles 1999; Morrison and Park 2007.

77 Morrison and Park 2007, 208.

78 Whitley 2013, 408.

CHAPTER 7

1 Gell 1998.

2 Stewart 2007, 168.

3 Davis and Stocker 2016; Stocker and Davis 2017.

4 Broodbank 2004; Davis 2008; Knappett and Nikolakopoulou 2008; Macdonald et al. 2009.

5 For changing patterns of Minoanization and Mycenaeanization, see papers in Gorogianni et al. (2016).

6 Macdonald et al. 2009.

7 Feldman 2006; Voskos and Knapp 2008; Maran and Stockhammer 2012; Stockhammer 2012.

8 Stockhammer 2012, 53.

9 Kristiansen and Suchowska-Ducke 2015, 371.

10 Bahrani 2014, 149.

11 On the international style, Feldman (2002; 2006).

12 Roux 2010; Knappett and van der Leeuw 2014.

13 Cutler 2016.

14 Georma 2009; Nikolakopoulou and Knappett 2016.

15 Kiriatzi and Knappett 2016; Stockhammer and Maran 2017.

16 Mills 2016.

17 Karnava 2018.

18 Letesson 2009, 308–313; Fitzsimons and Gorogianni 2017.

19 Woolf 2016.

20 Nikolakopoulou 2010.

21 Driessen and Langohr (2007) on the LM II changes in iconography in the Throne Room, with a strong continuity from Minoan Neopalatial forms, see Galanakis et al. (2017).

22 Houseman and Severi 1998. For consideration of the utility of this concept in archaeological studies of ritual, and its connection to related ideas such as bundling, see Swenson (2015).

23 Lemonnier 2012.

24 Lemonnier 2014.

25 Lemonnier 2012, 137–138; 2014, 537–538.

26 E.g. Coupaye (2018).

27 Latour 1986.

28 Latour 1986, 7; original italics.

29 Law 1986.

30 Heidegger 1971; Harman 2010; Brown 2015.

31 Lane et al. (2009) describe the 'attribution of functionality' as a key step in stabilising an innovation.

32 Bijker 1995.

33 On this relationship, see Chapter 1; Gosden and Malafouris (2015), Ingold (2016) and Descola (2016).

34 See Skeates (2017) on everyday aesthetics.

35 Nanay 2016.

36 Nanay 2016, 1.

37 Hopkins 2017. He goes on to float the idea of 'structured attention'.

38 Morgan 2010.

39 Morgan 2010.

40 Morgan 2010.

41 Stewart 2007.

42 Khatchadourian 2016.

43 Khatchadourian 2016, 69.

44 Khatchadourian 2016, 73.

45 Khatchadourian 2016, 74.

46 Latour 2000.

47 E.g. Khatchadourian (2016, 144–145).

48 Hodder 2012; 2016.

49 See Larkin (2013).

50 This understanding of entanglement as contingent and prone to disentanglement is rather different from Hodder's use of the term – e.g. Hodder (2012; 2016). The path dependencies that he would see as produced by entanglements I view here as 'infrastructure'.

51 On distinction between localised invention and disseminated innovation, see van der Leeuw and Torrence (1989) and Knappett and van der Leeuw (2014).

52 Baines 2007.

53 Bahrani 2014.

54 Bahrani 2014, 168.

55 Ledderose 2000.

56 Houston 2014.

57 Trever 2016, 273.

58 Descola 2010a.

59 Shapland 2013.

60 Holbraad 2011; Holbraad and Pedersen 2016. See also Empson (2011), who allows the materials of her study to lead her towards the indigenous Mongolian concept of fortune.

61 Groenewegen-Frankfort 1951.

62 Severi (2015), citing Aby Warburg in particular. I am grateful to Kurt Forster for alerting me to this connection between imagination and memory.

63 See Shapland (2013) for this approach in the Aegean.

64 Summers 2003.

65 His discussion of the Aztec Coatlicue of Tenochtitlan features quite prominently in the introduction to 'Real Spaces' – Summers (2003, 45–50).

66 Summers (2003, 190) – a single mention of Mycenae (the Treasury of Atreus); and on p. 440 the wall paintings of Knossos and Akrotiri very briefly feature.

67 Bahrani et al. 2014, 186.

68 Green 2014.

69 Holbraad 2011.

70 Lehmann 2014.

REFERENCES

Abadia, O. M. and Nowell, A. 2015. Palaeolithic personal ornaments: historical development and epistemological challenges. *Journal of Archaeological Method and Theory* 22(3), 952–979.

Alberti, B., Fowles, S., Holbraad, M., Marshall, Y. and Witmore, C. 2011. 'Worlds otherwise': archaeology, anthropology and ontological difference. *Current Anthropology* 52(6), 896–912.

Allen, C. J. 2016. The living ones: miniatures and animation in the Andes. *Journal of Anthropological Research* 72(4), 416–441.

Ameri, M., Costello, S. K., Jamison, G. M. and Scott, S. J. 2018. Introduction: small windows, wide views. In M. Ameri, S. K. Costello, G. Jaminson and S. J. Scott (eds.), *Seals and Sealing in the Ancient World*, 1–10. Cambridge: Cambridge University Press.

Anastasiadou, M. 2011. *The Middle Minoan Three-Sided Soft Stone Prism: A Study of Style and Iconography*. CMS Beiheft 9. 2 vols. Mainz: Philipp von Zabern.

Anastasiadou, M. 2016a. Wings, heads, tails: small puzzles at LM I Zakros. In E. Alram Stern et al. (eds.), *Metaphysis: Ritual, Myth and Symbolism in the Aegean Bronze Age*, 77–85. Aegaeum 39. Leuven: Peeters.

Anastasiadou, M. 2016b. Drawing the line: seals, script, and regionalism in Protopalatial Crete. *American Journal of Archaeology* 120(2), 159–193.

Anderson, E. 2015. Connecting with selves and others: varieties of community-making across late Prepalatial Crete. In S. Cappel, U. Günkel-Maschek and D. Panagiotopoulos (eds.), *Minoan Archaeology, Challenges and Perspectives for the 21st Century*, 199–211.

Louvain: Aegis, Presses Universitaires de Louvain.

Anderson, E. 2016. *Seals, Craft and Community in Bronze Age Crete*. Cambridge: Cambridge University Press.

Andreadaki-Vlasaki, M. 1988. Υπόγειο άδυτο ή 'δεξαμενή καθαρμών' στα Χανιά. *AAA* 21, 56–76.

Arthur, W. B. 2009. *The Nature of Technology: What It Is and How It Evolves*. New York: Free Press.

Bachelard, G. 1964. *The Poetics of Space*. Translated from the French by M. Jolas. New York: Orion Press.

Bahrani, Z. 1995. Assault and abduction: the fate of the royal image in the Ancient Near East. *Art History* 18(3), 363–382.

Bahrani, Z. 2014. *The Infinite Image: Art, Time and the Aesthetic Dimension in Antiquity*. London: Reaktion Books.

Bahrani, Z., Elsner, J., Hung, W., Joyce, R. and Tanner, J. 2014. Questions on 'world art history'. *Perspective* 2, 181–194.

Bailey, D. W. 2005. *Prehistoric Figurines: Representation and Corporeality in the Neolithic*. London: Routledge.

Baillargeon, R., Stavans, M., Wu, D., Gertner, Y., Setoh, P., Kittredge, A. K. and Bernard, A. 2012. Object individuation and physical reasoning in infancy: an integrative account. *Language Learning and Development* 8(1), 4–46.

Baines, J. 2007. *Visual and Written Culture in Ancient Egypt*. Oxford: Oxford University Press.

Baldacci, G. 2014. Pottery and ritual activity at Protopalatial Hagia Triada: a foundation deposit and a set of broken rhyta from the Sacello. *Creta Antica* 15, 47–60.

Barrett, J. C. 1994. *Fragments from Antiquity: An Archaeology of Social Life in Britain, 2900–1200 BC*. Oxford: Blackwell.

Barrett, J. C. 2013. The archaeology of mind: it's not what you think. *Cambridge Archaeological Journal* 23(1), 1–17.

Basu, P. 2013. Ideal and material ornament: rethinking the 'beginnings' and history of art. *Journal of Art Historiography* 9, 1–31.

Bauer, A. A. 2002. Is what you see all you get? Recognizing meaning in archaeology. *Journal of Social Archaeology* 2, 37–52.

Baurain, C. 1985. Pour une autre interprétation des génies minoens. In P. Darcque and J.-C. Poursat (eds.), *L'iconographie minoenne*, BCH Supplement 11, 95–118. Paris: De Boccard.

Becker, N. 2015. Attribution studies of golden signet rings: new efforts in tracing Aegean goldsmiths and their workshops. *Aegean Archaeology* 11, 73–88.

Becker, N. 2018. *Die goldenen Siegelringe der Ägäischen Bronzezeit*. Heidelberg: Heidelberg University Publishing.

Bedos-Rezak, B. 2010. *When Ego Was Imago: Signs of Identity in the Middle Ages*. Leiden: Brill.

Belting, H. 2004. *Pour une anthropologie des images*. Paris: Gallimard.

Bender Jørgensen, L., Sofaer, J. and M.-L. Stig Sørensen. 2018. *Creativity in the Bronze Age: Understanding Innovation in Pottery, Textile, and Metalwork Production*. New York: Cambridge University Press.

Benjamin, W. 1936 [1999]. The work of art in the age of mechanical reproduction. In *Illuminations*. London: Pimlico.

Bennett, J. 2010. *Vibrant Matter: A Political Ecology of Things*. Durham, NC: Duke University Press.

Betancourt, P. P. 1985. *The History of Minoan Pottery*. Princeton, NJ: Princeton University Press.

Betancourt, P. P. 2013. *Aphrodite's Kephali: An Early Minoan I Defensive Site in Eastern Crete*. Prehistory Monographs 41. Philadelphia: INSTAP Academic Press.

Bevan, A. 2007. *Stone Vessels and Value in the Bronze Age Mediterranean*. Cambridge: Cambridge University Press.

Bevan, A. 2014. Mediterranean containerization. *Current Anthropology* 55(4), 387–418.

Bevan, A. 2018. Pandora's pithos. *History and Anthropology* 29(1), 7–14.

Bijker, W. 1995. *Of Bicycles, Bakelites, and Bulbs: Toward a Theory of Sociotechnical Change*. Cambridge, MA: MIT Press.

Bille, M., Frida Hastrup, F. and Sørensen, T. F. (eds.). 2010. *An Anthropology of Absence: Materializations of Transcendence and Loss*. New York: Springer.

Blakolmer, F. 2010. Small is beautiful: the significance of Aegean glyptic for the study of wall paintings, relief frescoes and minor relief arts. In W. Müller (ed.), *Die Bedeutung der minoischen und mykenischen Glyptik. VI. Internationales Siegel-Symposium*, Marburg, 9–12 Oktober 2008. CMS Beiheft 8, 91–108.

Blakolmer, F. 2016. Hierarchy and symbolism of animals and mythical creatures in the Aegean Bronze Age: a statistical and contextual approach. In E. Alram-Stern et al. (eds.), *Metaphysis: Ritual, Myth and Symbolism in the Aegean Bronze Age*, 61–68. Aegaeum 39. Liège: Peeters.

Blegen, C. 1937. *Prosymna, the Helladic Settlement Preceding the Argive Heraeum*. Cambridge: Cambridge University Press.

Blier, S. Preston. 1987. *The Anatomy of Architecture: Ontology and Metaphor in Batammaliba Architectural Expression*. Cambridge: Cambridge University Press.

Bogost, I. 2012. *Alien Phenomenology, or What It's Like to Be a Thing*. Minneapolis: University of Minnesota Press.

Boivin, N. 2008. *Material Cultures, Material Minds: The Impact of Things on Human Thought, Society, and Evolution*. Cambridge: Cambridge University Press.

Bonney, E. M. 2011. Disarming the snake goddess: a reconsideration of the faience figurines from the Temple Repositories at Knossos. *Journal of Mediterranean Archaeology* 24(2), 171–190.

Bonnot, T. 2014. *L'attachement aux choses*. Paris: CNRS Editions.

Bosanquet, R. C., Dawkins, R. M., Tod, M. N., Duckworth, W. L. H. and Myres, J. L., 1902-1903. Excavations at Palaikastro, II. *The*

Annual of the British School at Athens 9, 274–387.

Boyd, M. J. 2015a. Destruction and other material acts of transformation in Mycenaean funerary practice. In K. Harrell and J. Driessen (eds.), *Thravsma: Contextualising Intentional Destruction of Objects in the Bronze Age Aegean and Cyprus*, 155–165. Aegis 9. Louvain: Presses Universitaires de Louvain.

Boyd, M. J. 2015b. Explaining the mortuary sequence at Mycenae. In A.-L. Schallin and I. Tournavitou (eds.), *Mycenaeans up to Date: The Archaeology of the North-eastern Peloponnese – Current Concepts and New Directions*, 433–447. Acta Instituti Atheniensis Regni Sueciae, Series In 4°, 56. Stockholm: Sweden.

Boyer, P. 2000. Functional origins of religious concepts: ontological and strategic selection in evolved minds. *Journal of the Royal Anthropological Institute* 6(2), 195–214.

Bradley, R. 2009. *Image and Audience: Rethinking Prehistoric Art*. Oxford: Oxford University Press.

Briault, C. 2007. Making mountains out of molehills in the Bronze Age Aegean: visibility, ritual kits, and the idea of a peak sanctuary. *World Archaeology* 39, 122–141.

Brittain, M. and Harris, O. 2010. Enchaining arguments and fragmenting assumptions: reconsidering the fragmentation debate in archaeology. *World Archaeology* 42(4), 581–594.

Broodbank, C. 2004. Minoanisation. *Proceedings of the Cambridge Philological Society* 50, 46–91.

Brown, B. 2003. *A Sense of Things: The Object Matter of American Literature*. Chicago: University of Chicago Press.

Brown, B. 2015. *Other Things*. Chicago: Chicago University Press.

Brown Vega, M. 2016. Ritual practices and wrapped objects: unpacking prehispanic Andean sacred bundles. *Journal of Material Culture* 21(2), 223–251.

Brubaker, L. and Haldon, J. 2011. *Byzantium in the Iconoclast Era c. 680–850: A History*. Cambridge: Cambridge University Press.

Bryant, L. 2011. *The Democracy of Objects*. Open Humanities Press. Ann Arbor, MI: MPublishing.

Buchli, V. 2016. *An Archaeology of the Immaterial*. London: Routledge.

Burke, B. 2005. Materialization of Mycenaean ideology and the Ayia Triada sarcophagus. *American Journal of Archaeology* 109, 403–422.

Bynum, C. W. 2009. Perspectives, connections and objects: what's happening in history now? *Daedalus* 138(1), 71–86.

Bynum, C. W. 2011. *Christian Materiality: An Essay on Religion in Late Medieval Europe*. New York: Zone Books.

Cadogan, G. 1977–1978. Pyrgos, Crete, 1970–1977. *Archaeological Reports* 24, 70–84.

Cadogan, G. and Knappett, C. in prep. *Myrtos-Pyrgos I. Late Protopalatial Pyrgos: Pyrgos III*. British School at Athens, Supplementary Volume, London.

Caporael, L. R., Griesemer, J. R. and Wimsatt, W. C. (eds.). 2014. *Developing Scaffolds in Evolution, Culture, and Cognition*. Cambridge, MA: MIT Press.

Carter, T., Contreras, D. A., Campeau, K. and Freund, K. 2016. Spherulites and aspiring elites: the identification, distribution, and consumption of Giali obsidian (Dodecanese, Greece). *Journal of Mediterranean Archaeology* 29(1), 3–36.

Cavanagh, W. and Mee, C. 1998. *A Private Place: Death in Prehistoric Greece*. Studies in Mediterranean Archaeology, vol. CXXV. Jonsered: Paul Åströms Forlag.

Chapman, J. 2000. *Fragmentation in Archaeology: People, Places and Broken Objects in the Prehistory of South Eastern Europe*. London: Routledge.

Chapman, J. 2015. Bits and pieces: fragmentation in Aegean Bronze Age context. In K. Harrell and J. Driessen (eds.), *Thravsma: Contextualising Intentional Destruction of Objects in the Bronze Age Aegean and Cyprus*, 25–47. Aegis 9. Louvain: Presses Universitaires de Louvain.

Chapman, J. and Gaydarska, B. 2007. *Parts and Wholes: Fragmentation in Prehistoric Context*. Oxford: Oxbow Books.

Chapman, J. and Gaydarska, B. 2009. The fragmentation premise in archaeology: from the Palaeolithic to more recent times. In W. Tronzo (ed.), *The Fragment: An Incomplete History*, 130–153. Los Angeles, CA: Getty Research Institute.

Chemero, A. 1998. A stroll through the worlds of animals and humans: review of *Being There: Putting Brain, Body and World Together Again*, by Andy Clark. *PSYCHE: An Interdisciplinary Journal of Research On Consciousness* 4.

Childe, V. G. 1956. *Piecing Together the Past: The Interpretation of Archaeological Data.* London: Routledge and Paul.

Christakis, K. 2005. *Cretan Bronze Age Pithoi. Traditions and Trends in the Production and Consumption of Storage Containers in Bronze Age Crete.* Philadelphia: INSTAP Academic Press.

Chryssoulaki, S. 2001. The Traostalos peak sanctuary: aspects of spatial organization. In R. Laffineur and R. Hägg (eds.), *POTNIA: Deities and Religion in the Aegean Bronze Age. Proceedings of the 8th International Aegean Conference Göteborg, Göteborg University, 12–15 April 2000*, 57–66. Aegaeum 22. Liège.

Clark, A. 1997. *Being There: Putting Brain, Body, and World Together Again.* Cambridge, MA: MIT Press.

Clark, A. 2010. Material surrogacy and the supernatural: reflections on the role of artefacts in 'off-line' cognition. In L. Malafouris and C. Renfrew (eds.), *The Cognitive Life of Things: Recasting the Boundaries of the Mind*, 23–28. Cambridge McDonald Institute Monographs.

Clarke, J. 2012. Decorating the Neolithic: an evaluation of the use of plaster in the enhancement of daily life in the Middle Pre-pottery Neolithic B of the southern Levant. *Cambridge Archaeological Journal* 22(2), 177–186.

Cole, M. 1996. *Cultural Psychology: A Once and Future Discipline.* Cambridge, MA: Harvard University Press.

Colley March, H. 1889. The meaning of ornament; or its archaeology and psychology. *Transactions of the Lancashire and Cheshire Antiquarian Society* 7, 160–192.

Collon, D. (ed.) 1997. *7000 Years of Seals.* London: British Museum Press.

Conein, B. 2005. 'Agir dans et sur l'espace de travail avec des objets ordinaires'. *Intellectica* 41/42, 163–179.

Conneller, C. 2013. Deception, and (mis)representation: skeuomorphs, materials, and form.

In B. Alberti, A. M. Jones and J. Pollard (eds.), *Archaeology After Interpretation: Returning Materials to Archaeological Theory*, 119–133. Walnut Creek, CA: Left Coast Press.

Connolly, W. E. 2011. *A World of Becoming.* Durham, NC: Duke University Press.

Coole, D. and Frost, S. 2010. *New Materialisms: Ontology, Agency, and Politics.* Durham, NC: Duke University Press.

Cooney, K. M. 2015. Coffins, cartonnage, and sarcophagi. In M. K. Hartwig (ed.), *A Companion to Ancient Egyptian Art*, 269–292. Chichester: John Wiley & Sons.

Costa, L. and Fausto, C. 2010. The return of the animists: recent studies of Amazonian ontologies. *Religion and Society: Advances in Research* 1, 89–109.

Coupaye, L. 2018. 'Yams have no ears!': *tekhne*, life and images in Oceania. *Oceania* 88(1), 13-30.

Crary, J. 1999. *Suspensions of Perception: Attention, Spectacle, and Modern Culture.* Cambridge, MA: MIT Press.

Crossland, Z. 2009. Of clues and signs: the dead body and its evidential traces. *American Anthropologist* 111, 69–80.

Crossland, Z. 2014. *Encounters with Ancestors in Highland Madagascar: Material Signs and Traces of the Dead.* Cambridge: Cambridge University Press.

Croucher, K. 2012. *Death and Dying in the Neolithic Near East.* Oxford: Oxford University Press.

Croucher, K. 2018. Keeping the dead close: grief and bereavement in the treatment of skulls from the Neolithic Middle East. *Mortality* 23 (2), 103–120.

Cutler, J. 2016. Fashioning identity: weaving technology, dress and cultural change in the Middle and Late Bronze Age southern Aegean. In E. Gorogianni, P. Pavuk and L. Girella (eds.), *Beyond Thalassocracies: Understanding Processes of Minoanisation and Mycenaenisation in the Aegean*, 172–185. Oxford: Oxbow Books.

D'Errico, F., Henshilwood, C., Vanhaeren, M. and van Niekerk, K. 2005. *Nassarius kraussianus* shell beads from Blombos Cave: evidence

for symbolic behaviour in the Middle Stone Age. *Journal of Human Evolution* 48, 3–24.

Daniel, E. V. 1984. *Fluid Signs: Being a Person the Tamil Way*. Berkeley: University of California Press.

Davis, E. N. 1977. *The Vapheio Cups and Aegean Gold and Silver Work*. New York: Garland Publishing.

Davis, J. L. 2008. Minoan Crete and the Aegean islands. In C. Shelmerdine (ed.), *The Cambridge Companion to the Aegean Bronze Age*, 186–208. Cambridge: Cambridge University Press.

Davis, J. L. and Stocker, S. R. 2016. The Lord of the Gold Rings: The Griffin Warrior of Pylos. *Hesperia* 85, 627–655.

Dawdy, S. 2016. *Patina: A Profane Archaeology*. Chicago: University of Chicago Press.

Day, M. 2004. Religion, off-line cognition, and the extended mind. *Journal of Cognition and Culture* 4(1), 101–121.

Day, P. M. and Wilson, D. E. 2016. Dawn of the amphora : the emergence of Maritime Transport Containers in the Early Bronze Age Aegean. In S. Demesticha and A. B. Knapp (eds.), *Maritime Transport Containers in the Bronze-Iron Age Aegean and Eastern Mediterranean*, 17–37. Uppsala: Astrom Editions.

Deacon, T. 1997. *The Symbolic Species : The Co-evolution of Language and the Brain*. New York : W. W. Norton.

Dehouve, D. 2016. A play on dimensions: miniaturization and fractals in Mesoamerican ritual *Journal of Anthropological Research* 72(4), 504–529.

DeLanda, M. 2002. *Intensive Science and Virtual Philosophy*. London and New York: Continuum.

DeLoache, J. S. 1991. Symbolic functioning in very young children: understanding of pictures and models. *Child Development* 62, 736–752.

Delong, A. 1983. Spatial scale, temporal experience and information processing: an empirical examination of experiential reality. *Man-Environment Systems* 13, 77–86.

Demargne, P. 1964. *Naissance de l'art grec*. Paris: Gallimard.

Demesticha, S. and Knapp, A. B. (eds.). 2016. *Maritime Transport Containers in the Bronze-Iron Age Aegean and Eastern Mediterranean*. Uppsala: Astrom Editions.

Descola, P. (ed.). 2010a. *La fabrique des images: visions du monde et formes de la représentation*. Paris: Musée du Quai Branly.

Descola, P. 2010b. Cognition, perception and worlding. *Interdisciplinary Science Reviews* 35 (3-4), 334–340.

Descola, P. (ed.). 2012. *Claude Lévi-Strauss, un parcours dans le siècle*. Paris: Odile Jacob.

Descola, P. 2016. Biolatry: a surrender of understanding (response to Ingold's 'A naturalist abroad in the museum of ontology. *Anthropological Forum*, DOI 10.1080/0066 4677.2016.1212523

Dessenne, A. 1957. *Le Sphinx: Étude Iconographique. Des Origines à la Fin du Second Millénaire. Bibliothéque des Écoles Françaises D'Athènes et de Rome Fasc. 186.* Paris: E. de Boccard.

Devolder, M. 2010. Étude des coutumes funéraires en Crète néopalatiale. *Bulletin de Correspondance Hellénique* 134(1), 31–70.

Dickinson, O. T. P. K. 1994. *The Aegean Bronze Age*. Cambridge: Cambridge University Press.

Didi–Huberman, G. 2008. *La Ressemblance par Contact: Archéologie, Anachronisme et Modernité de l'Empreinte*. Paris: Les Editions de Minuit.

Dillon, S. 2012. Review of Richard Neer's *The Emergence of the Classical Style in Greek Sculpture*. *Art Bulletin* 94(1), 131–133.

Dimopoulou, N. and Rethemiotakis, G. 2004. *The Ring of Minos and Gold Minoan Rings, the Epiphany Cycle*. Athens: Archaeological Receipt Funds.

Dobres, M. -A. and Robb, J. E. (eds.). 2000. *Agency in Archaeology*. London: Routledge.

Donohue, A. A. 2005. *Greek Sculpture and the Problem of Description*. Cambridge: Cambridge University Press.

Doumas, C. 1992. *The Wall Paintings of Thera*. Athens: Kapon (for the Thera Foundation).

Douny, L. 2014. *Living in a Landscape of Scarcity: Materiality and Cosmology in West Africa.* Walnut Creek, CA: Left Coast Press.

Downey, G. 2008. Scaffolding imitation in capoeira: physical education and enculturation in an Afro-Brazilian art. *American Anthropologist* 110(2), 204–213.

Driessen, J. 1989-1990. The proliferation of Minoan palatial architectural style: (I) Crete. *Acta Archaeologica Lovaniensia* 28–29, 3–23.

Driessen, J. 1999. The dismantling of a Minoan Hall at Palaikastro (Knossians Go Home?). In P. Betancourt, V. Karageorghis, R. Laffineur, and W. D. Niemeier (eds.), *Meletemata: Studies in Aegean Archaeology Presented to Malcom H. Wiener as He Enters His 65th Year*, 227–236. Aegaeum 20. Liège and Austin: University of Texas at Austin.

Driessen, J. 2010. Spirit of place: Minoan houses as major actors. In D. J. Pullen (ed.), *Political Economies of the Aegean Bronze Age. Papers from the Langford Conference, Florida State University, Tallahassee, 22–24 February 2007*, 35–65. Oxford & Oakville, FL: Oxbow Books.

Driessen, J. 2015. The birth of a god? Cults and crises on Minoan Crete. In M. Cavalieri, R. Lebrun and N. L. J. Meunier (eds.), *De La Crise Naquirent les Cultes: Approches Croisées de la Religion, de la Philosophie et des Représentations Antiques*, 31–44. Turnhout: Brepols.

Driessen, J. and Farnoux, A. 2011. A house model at Malia. In P. Militello, N. Cucuzza and F. Carinci (eds.), *Kretes Minoidos: Tradizione e identità minoica tra produzione artigianale, pratiche cerimoniali e memoria del passato. Studi offerti a Vincenzo La Rosa per il suo 70 compleanno*, 299–311. Studi di archeologia cretese 10. Padua: Bottega d'Erasmo.

Driessen, J. and Langohr, C. 2007. Rallying 'round a 'Minoan' past: the legitimation of power at Knossos during the Late Bronze Age. In M. L. Galaty and W. A. Parkinson (eds.), *Rethinking Mycenaean Palaces II*, 178–189. Revised and Expanded Second Edition. Cotsen Institute Monograph 60. Los Angeles, CA: Cotsen Institute of Archaeology.

Ducruet, C. (ed.). 2016. *Maritime Networks: Spatial Structures and Time Dynamics.* London: Routledge.

Edensor, T. 2005. The ghosts of industrial ruins: ordering and disordering memory in excessive space. *Environment and Planning D: Society and Space* 23, 829–849.

Egan, E. 2012. Cut from the same cloth: the textile connection between Palace Style jars and Knossian wall paintings. In M.-L. Nosch and R. Laffineur (eds.), *Kosmos: Jewellery, Adornment and Textiles in the Aegean Bronze Age*, 317–323. Aegaeum 33. Leuven–Liège: Peeters.

Elkins, J. (ed.). 2007. *Photography Theory.* New York: Routledge.

Elkins, J. 2008. On some limits of materiality in art history. 31: *Das Magazin des Instituts für Theorie* [Zurich] 12: 25–30.

Elkins, J. 2011. *What Photography Is.* New York: Routledge.

Elsner, J. 2000. From the culture of spolia to the cult of relics: the Arch of Constantine and the genesis of Late Antique forms. *Papers of the British School at Rome* 68, 149–184.

Elsner, J. 2003. Iconoclasm and the preservation of memory. In R. S. Nelson and M. Olin (eds.), *Monuments and Memory, Made and Unmade*, 209–231. Chicago: University of Chicago Press.

Elsner, J. 2012a. Decorative imperatives between concealment and display: the form of sarcophagi. *RES: Anthropology and Aesthetics* 61/62, 178–195.

Elsner, J. 2012b. Iconoclasm as discourse: from antiquity to Byzantium. *Art Bulletin* 94(3), 368–394.

Elsner, J. 2016. Breaking and talking: some thoughts on iconoclasm from Antiquity to the current moment. *Religion and Society* 7, 128–138.

Empson, R. 2011. *Harnessing Fortune: Personhood, Memory and Place in Mongolia.* Oxford: Oxford University Press.

Evans, A. 1921. *The Palace of Minos*, Vol. 1. London: Macmillan.

Evans, A. 1930. *The Palace of Minos*, Vol. 3. London: Macmillan.

Evans, C. 2012. Small devices, memory and model architectures: carrying knowledge. *Journal of Material Culture* 17(4), 369–387.

Farbstein, R. 2011. Technologies of art: a critical reassessment of Pavlovian art and society, using chaîne opératoire method and theory. *Current Anthropology* 52(3), 401–432.

Fauconnier, G. and Turner, M. 2002. *The Way We Think: Conceptual Blending and the Mind's Hidden Complexity*. New York: Basic Books.

Fehérváry, K. 2013. *Politics in Color and Concrete: Socialist Materialities and the Middle Class in Hungary*. Bloomington: Indiana University Press.

Feldman, M. 2002. Luxurious forms: redefining a Mediterranean 'international style', 1400–1200 BCE. *The Art Bulletin* 84(1), 6–29.

Feldman, M. 2006. *Diplomacy by Design: Luxury Arts and an 'International Style' in the Ancient Near East, 1400–1200 BCE*. Chicago: University of Chicago Press.

Fitzsimons, R. and Gorogianni, E. 2017. Dining on the fringe? A possible Minoan-style banquet hall at Ayia Irini, Kea and the Minoanization of the Aegean islands. In Q. Letesson and C. Knappett (eds.), *Minoan Architecture and Urbanism: New Perspectives on an Ancient Built Environment*, 334–360. Oxford: Oxford University Press.

Flood, F. B. 2016. Idol breaking as image making in the 'Islamic State'. *Religion and Society: Advances in Research* 7, 116–138.

Forni, S. 2007. Containers of life: pottery and social relations in the Grassfields (Cameroon). *African Arts* 40(1), 42–53.

Foster, K. P. 1979. *Aegean Faience of the Bronze Age*. New Haven, CT: Yale University Press.

Fowler, C. and Harris, O. 2015. Enduring relations : exploring a paradox of new materialism. *Journal of Material Culture* 20(2), 127–148.

Fowles, S. 2007 'People without Things.' In M. Bille, F. Hastrup and T. F. Sorensen (eds.), *An Anthropology of Absence: Materializations of Transcendence and Loss*, 23–41. New York: Springer.

Fowles, S. 2016. The perfect subject (postcolonial object studies). *Journal of Material Culture* 21(1), 9–27.

Frazer, J. G. 1890-1915. *The Golden Bough: A Study in Magic and Religion*. London: MacMillan.

Freedberg, D. and Gallese, V. 2007. Motion, emotion and empathy in esthetic experience. *Trends in Cognitive Sciences* 11, 197–203.

Frieman, C. 2010. Imitation, identity and communication: the presence and problems of skeuomorphs in the Metal Ages. In B. V. Eriksen (ed.), *Lithic Technology in Metal Using Societies. Proceedings of a UISPP Workshop*, Lisbon, September 2006, 33–44. Højbjerg: Jutland Archaeological Society.

Frieman, C. 2012. Flint daggers, copper daggers, and technological innovation in Late Neolithic Scandinavia. *European Journal of Archaeology* 15(3), 440–464.

Gadamer, H.-G. 1986. *The Relevance of the Beautiful and Other Essays*, trans. by Nicholas Walker. Cambridge: Cambridge University Press.

Gaifman, M. 2012. *Aniconism in Greek Antiquity*. Oxford: Oxford University Press.

Gaignerot-Driessen, F. 2014. Goddesses refusing to appear? Reconsidering the Late Minoan III figures with upraised arms. *American Journal of Archaeology* 118(3), 489–520.

Galanakis, Y., Tsitsa, E. and Günkel-Maschek, U. 2017. The power of images: re–examining the wall paintings from the Throne Room at Knossos. *Annual of the British School at Athens* 112, 47–98.

Gallou, C. 2005. *The Mycenaean Cult of the Dead*. Oxford: BAR Int Series 1372.

Gamble, C. 2007. *Origins and Revolutions: Human Identity in Earliest Prehistory*. Cambridge: Cambridge University Press.

Gamboni, D. 1997. *The Destruction of Art: Iconoclasm and Vandalism Since the French Revolution*. London: Reaktion Books.

Gamboni, D. 2010. Portrait of the artist as an iconoclast. In *Ai Weiwei: Dropping the Urn: Ceramic Works, 5000 BCE–2010 CE*, 82–95. Glenside, PA: Arcadia University Art Gallery.

Garfield, S. 2018. *In Miniature: How Small Things Illuminate the World*. London: Canongate Books.

Garofoli, D. 2015. Do early body ornaments prove cognitive modernity? A critical analysis

from situated cognition. *Phenomenology and the Cognitive Sciences* 14(4), 803–825.

Garrison, M. B. and Root, M. C. 2001. *Seals on the Persepolis Fortification Tablets, vol. I: Images of Heroic Encounter*. Oriental Institute Publications 117. Chicago: The Oriental Institute.

Garrow, D. and Gosden, C. 2012. *Technologies of Enchantment? Exploring Celtic Art, 400 BC to AD 100*. Oxford: Oxford University Press.

Gauvain, M. 2013. Sociocultural contexts of development. In P. D. Zelazo (ed.), *The Oxford Handbook of Developmental Psychology, vol. 2: Self and Other* 425–51. Oxford: Oxford University Press (accessed online).

Geimer, P. 2007. Image as trace: speculations about an undead paradigm. *Differences* 18(1), 7–28.

Gell, A. 1998. *Art and Agency: An Anthropological Theory*. Oxford: Clarendon Press.

Georma, F. 2009. *The Wall Paintings of Building B from the Prehistoric Settlement of Akrotiri Thera*. Unpublished PhD thesis, University of Ioannina (in Greek).

Gere, C. 2009. *Knossos and the Prophets of Modernism*. Chicago: University of Chicago Press.

Gesell, G. 1985. *Town, Palace, and House Cult in Minoan Crete*. Göteborg: Paul Åströms.

Gesell, G. 2004. From Knossos to Kavousi: the popularizing of the Minoan palace goddess. In A.P. Chapin (ed.), *XARIS: Essays in Honor of Sara A. Immerwahr. Hesperia Supplements* vol. 33, 131–150.

Gesell, G. 2010. The snake goddesses of the LM IIIB and LM IIIC periods. In O. Krzyszkowska (ed.), *Cretan Offerings: Studies in Honour of Peter Warren*, 131–139. BSA Studies 18. London: British School at Athens.

Gibson, J. J. 1979. *The Ecological Approach to Visual Perception*. Boston: Houghton Mifflin.

Gillings, M. 2012. Landscape phenomenology, GIS and the role of affordance. *Journal of Archaeological Method and Theory* 19(4), 601–611.

Gimatzidis, S. 2011. Feasting and offering to the Gods in early Greek sanctuaries: monumentalisation and miniaturisation in pottery. *PALLAS* 86, 75–96.

Gimbutas, M. 1974. *The Gods and Goddesses of Old Europe*. London: Thames & Hudson.

Girella, L. 2002. Vasi rituali con elementi miniaturizzati a Creta, in Egeo e nel Mediterraneo Orientale alla fine dell'età del Bronzo. Indicatori archeologici ed etnici. *Creta Antica* 3, 167–216.

Girella, L. 2015. When diversity matters: exploring funerary evidence in Middle Minoan III Crete. *Studi Micenei ed Egeo-Anatolici, NS* 1, 117–136.

González-Ruibal, A. and Ruiz-Gálvez, M. 2016. House societies in the ancient Mediterranean. *Journal of World Prehistory* 29, 383–437.

Goodwin, C. 2010. Things and their embodied environments. In L. Malafouris and C. Renfrew (eds.), *The Cognitive Life of Things*, 103–121. Cambridge: McDonald Institute Monographs.

Gorogianni, E., Pavúk, P. and Girella, L. (eds.), 2016. *Beyond Thalassocracies: Understanding Processes of Minoanisation and Mycenaeanisation in the Aegean*. Oxford: Oxbow Books.

Gosden, C. and Malafouris, L. 2015. Process archaeology (P-Arch). *World Archaeology* 47 (5), 701–717.

Gowlland, G. 2011. The 'Matière à Penser' approach to material culture: objects, subjects and the materiality of the self. *Journal of Material Culture* 16(3), 337–343.

Green, J. 2014. *Drawn from the Ground: Sound, Sign and Inscription in Central Australian Sand Stories*. Cambridge: Cambridge University Press.

Griesemer, J. 2004. Three dimensional models in philosophical perspective. In S. de Chadarevian and N. Hopwood (eds.), *Models: The Third Dimension of Science*, 433–442. Stanford, CA: Stanford University Press.

Groenewegen-Frankfort, H. A. 1951. *Arrest and Movement: An Essay on Space and Time in the Representational Art of the Ancient Near East*. London: Faber & Faber.

Grondin, J. 2001. Play, festival, and ritual in Gadamer: on the theme of the immemorial in his later works. In L. K. Schmidt (ed.), *Language and Linguisticality in Gadamer's Hermeneutics*, 43–50. Lanham, MD: Lexington Books.

Grootenboer, H. 2012. *Treasuring the Gaze: Intimate Vision in Late Eighteenth-Century Eye Miniatures*. Chicago: University of Chicago Press.

Gulizio, J. and Nakassis, D. 2014. The Minoan goddess(es): textual evidence for Minoan religion. In D. Nakassis, J. Gulizio and S. James (eds.), *KE-RA-ME-JA: Studies Presented to Cynthia W. Shelmerdine*, 115–128. Philadelphia: INSTAP Academic Press.

Haddon, A. C. 1914. *Evolution in Art as Illustrated by the Life-Histories of Designs*. London: Walter Scott.

Hägg, R. and Lindau, Y. 1984. The Minoan 'snake frame' reconsidered. *Opuscula Atheniensa XV*: 67–77.

Haggis, D. 2013. Destruction and the formation of static and dynamic settlement structures in the Aegean. In J. Driessen (ed.), *Destruction: Archaeological, Philological and Historical Perspectives*, 63–87. Louvain: Presses Universitaires de Louvain.

Hahn, C. 2010. What do reliquaries do for relics? *Numen* 57, 284–316.

Hahn, C. 2012. *Strange Beauty: Issues in the Making and Meaning of Reliquaries, 400–c.1204*. University Park: Pennsylvania State University Press.

Hale, C. 2016. The Middle Helladic Fine Gray Burnished (Gray Minyan) sequence at Mitrou, East Lokris. *Hesperia* 85, 243–295.

Hallager, E. 1996. *The Minoan Roundel and other Sealed Documents in the Neopalatial Linear A Administration*. Aegaeum 14. Liège and Austin.

Halloy, A. 2013. Objects, bodies and gods: a cognitive ethnography of an ontological dynamic in the Xangô cult (Recife, Brazil). In D. E. Santo and N. Tassi (eds.), *Making Spirits: Materiality and Transcendence in Contemporary Religions*, 133–158. London: I.B. Tauris.

Hamilakis, Y. 2014. *Archaeology and the Senses: Human Experience, Memory, and Affect*. Cambridge: Cambridge University Press.

Hamilton, A. 2018. *Scale and the Incas*. Princeton, NJ: Princeton University Press.

Harman, G. 2010. *Towards Speculative Realism: Essays and Lectures*. Winchester: Zero.

Harrell, K. 2015. Piece out: comparing the intentional destruction of swords in the Early Iron Age and the Mycenae Shaft Graves. In K. Harrell and J. Driessen (eds.), *Thravsma:*

Contextualising Intentional Destruction of Objects in the Bronze Age Aegean and Cyprus, 143–153. Aegis 9. Louvain: Presses Universitaires de Louvain.

Harris, S. and Douny, L. (eds.). 2014. *Wrapping and Unwrapping Material Culture: Archaeological and Anthropological Perspectives*. Walnut Creek, CA: Left Coast Press.

Hartson, H. 2003. Cognitive, physical, sensory, and functional affordances in interaction design. *Behaviour and Information Technology* 22(5), 315–338.

Hatzaki, E. 2009. Structured deposition as ritual action at Knossos. In A.-L. D'Agata and A. Van de Moortel (eds.), *Archaeologies of Cult: Essays on Ritual and Cult in Crete in Honor of Geraldine C. Gesell*, 19–30. *Hesperia* Supplement 42. Princeton.

Hatzaki, E. 2013. The end of an intermezzo at Knossos: ceramic wares, deposits, and architecture in a social context. In C. Macdonald, and C. Knappett (eds.), *Intermezzo: Intermediacy and Regeneration in MM III Palatial Crete*, 37–45. BSA Studies 21. London: British School at Athens.

Hatzaki, E. 2018. Pots, frescoes, textiles and people. The social life of decorated pottery at Late Bronze Age Knossos and Crete. In A. G. Vlachopoulos (ed.), *Paintbrushes: Wall-Painting and Vase-Painting of the Second Millennium BC in Dialogue*, 315–327. Athens: University of Ioannina/Hellenic Ministry of Culture and Sports – Archaeological Receipts Fund.

Haysom, M. 2010. The double-axe: a contextual approach to the understanding of a Cretan symbol in the Neopalatial period. *Oxford Journal of Archaeology* 29(1), 35–55.

Heidegger, M. 1971. The thing. In *Poetry, Language, Thought*, trans A. Hofstadter, 163–186. New York: Harper & Row.

Henare, A., Holbraad, M. and Wastell, S. (eds.), 2007. *Thinking through Things: Theorising Artefacts Ethnographically*. London: Routledge.

Hersey, G. L. 1980. *The Lost Meaning of Classical Architecture: Speculations on Ornament from Vitruvius to Venturi*. Cambridge: MIT Press.

Herva, V.-P. 2006. Flower lovers, after all? Rethinking religion and human-environment

relations in Minoan Crete. *World Archaeology* 38(4), 586–598.

Hetherington, K. 2004. Secondhandedness: consumption, disposal, and absent presence. *Environment and Planning D: Society and Space* 22, 157–173.

Higgins, R. 1967. *Minoan and Mycenaean Art.* New York: F.A. Praeger.

Hodder, I. 1990. *The Domestication of Europe: Structure and Contingency in Neolithic Societies.* Oxford: Blackwell.

Hodder, I. 2012. *Entangled: An Archaeology of the Relationships between Humans and Things.* Malden, MA: Wiley-Blackwell.

Hodder, I. 2016. *Studies in Human–Thing Entanglement.* Creative Commons.

Holbraad, M. 2011. Can the thing speak? OAC Press Working Paper Series 7. Available online at: http://openanthcoop.net/press/wp-content/uploads/2011/01/Holbraad-Can-the-Thing-Speak2.pdf (Last accessed 1 Feb 2018).

Holbraad, M. and Pedersen, M. A. 2016. *The Ontological Turn: An Anthropological Exposition.* Cambridge: Cambridge University Press.

Hood, M. S. F. 1978. *The Arts in Prehistoric Greece.* Harmondsworth: Penguin.

Hood, M. S. F. 2005. Dating the Knossos frescoes. In L. Morgan (ed.), *Aegean Wall Painting: A Tribute to Mark Cameron*, 45–81. BSA Studies 13. London: British School at Athens.

Hooker, J. T. 1967. The Mycenae Siege Rhyton and the question of Egyptian influence. *American Journal of Archaeology* 71(3), 269–281.

Hopkins, R. 2017. Review of Bence Nanay's 'Aesthetics and the Philosophy of Perception'. *The British Journal of Aesthetics* 57(3), 340–344.

Houseman, M. and Severi, C. 1998. *Naven or the Other Self: A Relational Approach to Ritual Action.* Leiden: Brill.

Houston, S. 2014. *The Life Within: Classic Maya and the Matter of Permanence.* New Haven, CT: Yale University Press.

Hull, M. S. 2012. *Government of Paper: The Materiality of Bureaucracy in Urban Pakistan.* Berkeley: University of California Press.

Hunter-Anderson, R. 1977. A theoretical approach to the study of house form. In

L. R. Binford (ed.), *For Theory Building in Archaeology: Essays on Faunal Remains, Aquatic Resources, Spatial Analysis, and Systemic Modeling*, 287–315. New York: Academic Press.

Hurcombe, L. M. 2014. *Perishable Material Culture in Prehistory: Investigating the Missing Majority.* London: Routledge.

Hutchins, E. 1995. *Cognition in the Wild.* Cambridge: MIT Press.

Hutchins, E. 2005. Material anchors for conceptual blends. *Journal of Pragmatics* 37, 1555–1577.

Iliopoulos, A. 2016. The evolution of material signification: tracing the origins of symbolic body ornamentation through a pragmatic and enactive theory of cognitive semiotics. *Signs and Society* 4(2), 244–276.

Immerwahr, S. 1990. *Aegean Painting in the Bronze Age.* University Park: Pennsylvania State University Press.

Ingold, T. 2000. *The Perception of the Environment: Essays on Livelihood, Dwelling and Skill.* London: Routledge.

Ingold, T. 2013. *Making: Anthropology, Archaeology, Art and Architecture.* London: Routledge.

Ingold, T. 2016. A naturalist abroad in the museum of ontology: Philippe Descola's *Beyond Nature and Culture. Anthropological Forum*, DOI 10.1080/00664677.2015.1136591

Jones, A. M. 2007. *Memory and Material Culture.* Cambridge: Cambridge University Press.

Jones, A. M. 2012. *Prehistoric Materialities: Becoming Material in Prehistoric Britain and Ireland.* Oxford: Oxford University Press.

Jones, A. M. 2017. The art of assemblage: styling Neolithic art. *Cambridge Archaeological Journal* 27(1), 85–94.

Jones, A. M. and Cochrane, A. 2018. *The Archaeology of Art: Materials, Practices, Affects.* New York: Routledge.

Jordan, P. 2014. *Technology as Human Social Tradition: Cultural Transmission among Hunter–Gatherers.* Oakland: University of California Press.

Jordanova, L. 2004. Material models as visual culture. In S. de Chadarevian and N. Hopwood (eds.), *Models: The Third Dimension of Science*, 443–451. Stanford, CA: Stanford University Press.

Kanta, A., Godart, L. and Tsigounaki, A. 2001. Clay model of a two storey shrine. In A. Karetsou and M. Andreadaki-Vlasaki (eds.), *Crete-Egypt, Three Thousand Years of Cultural Links*, 63–64. Crete-Cairo: Ministry of Culture.

Karetsou, A. 1981. The peak sanctuary of Mt Juktas. In R. Hägg and N. Marinatos (eds.), *Sanctuaries and Cults in the Aegean Bronze Age*, 137–153. Stockholm: Svenska Institutet i Athen.

Karetsou, A., Andreadaki-Vlasaki, M. and Papadakis, N. (eds.) 2000. *Crete-Egypt. Three Thousand Years of Cultural Links: Catalogue*. Heraklion: Hellenic Ministry of Culture.

Karnava, A. 2018. *Seals, Sealings and Seal Impressions from Akrotiri in Thera*. Corpus der Minoische und Mykenische Siegel, Beiheft 10. Heidelberg.

Karo, G. 1930. *Die Schachtgräber von Mykenai*. München: F. Bruckmann.

Keane, W. 2005. Signs are not the garb of meaning: on the social analysis of material things. In D. Miller (ed.), *Materiality*, 182–205. Durham, NC: Duke University Press.

Keller, E. Fox. 2000. Models of and models for: theory and practice in contemporary biology. *Philosophy of Science* 67 (Supplement) S72–S86.

Khatchadourian, L. 2016. *Imperial Matter: Ancient Persia and the Archaeology of Empires*. Oakland: University of California Press.

Kiernan P. 2009. *Miniature Votive Offerings in the North-West Provinces of the Roman Empire*. Ruhpolding: Verlag Franz Philipp Rutzen.

Kilian, K. 1990. Patterns in the cult activity in the Mycenaean Argolid: Hagia Triada (Klenies), the Profitias Elias Cave (Haghios Hadrianos) and the citadel of Tiryns. In R. Hägg and G. C. Nordquist (eds.), *Celebrations of Death and Divinity in the Bronze Age Argolid*, 185–197. Stockholm: Svenska Institutet i Athen.

Kiriatzi, E. and Knappett, C. (eds.). 2016. *Human Mobility and Technological Transfer in the Prehistoric Mediterranean*. British School at Athens Studies in Greek Antiquity 1. Cambridge: Cambridge University Press.

Kirsh, D. and Maglio, P. 1995. On distinguishing epistemic from pragmatic action. *Cognitive Science* 18, 513–549.

Kissel, M. and Fuentes, A. 2017. Semiosis in the Pleistocene. *Cambridge Archaeological Journal* 27 (3), 397–412.

Klose, A. 2015. *The Container Principle. How a Box Changes the Way We Think*. Cambridge, MA: MIT Press.

Knappett, C. 2002. Photographs, skeuomorphs and marionettes: some thoughts on mind, agency and object. *Journal of Material Culture* 7(1), 97–117.

Knappett, C. 2004. The affordances of things: a post-Gibsonian perspective on the relationality of mind and matter. In E. DeMarrais, C. Gosden and C. Renfrew (eds.), *Rethinking Materiality: The Engagement of Mind with the Material World*, 43–51. Cambridge: McDonald Institute Monographs.

Knappett, C. 2005. *Thinking Through Material Culture: An Interdisciplinary Perspective*. Philadelphia: University of Pennsylvania Press.

Knappett, C. 2007. Malia et ses relations régionales à l'époque du Minoen Moyen: les échanges céramiques à travers trois siècles (2000–1700 av. J.-C.). *Bulletin de Correspondance Hellénique* 131(2), 861–864.

Knappett, C. 2011. *An Archaeology of Interaction: Network Perspectives on Material Culture and Society*. Oxford: Oxford University Press.

Knappett, C. 2012. A regional approach to Protopalatial complexity. In I. Schoep, P. Tomkins and J. Driessen (eds.), *Back to the Beginning: Reassessing Social, Economic and Political Complexity in the Early and Middle Bronze Age on Crete*, 384–402. Oxford: Oxbow Books.

Knappett, C. 2015. Palatial and provincial pottery revisited. In E. Hatzaki, C. Macdonald and S. Andreou (eds.), *Festschrift for Gerald Cadogan – Crete and Cyprus*, 63–66. Athens: Capon.

Knappett, C. and Cunningham, T. F. 2012. *Palaikastro Block M: The Proto- and Neopalatial Town. Excavations 1986–2003*. British School at Athens Suppl. vol. 47, London: British School at Athens.

Knappett, C. and Nikolakopoulou, I. 2008. Colonialism without colonies? A Bronze Age case study from Akrotiri, Thera. *Hesperia* 77, 1–42.

Knappett, C., Tomkins, P. and Malafouris, L. 2010. Ceramics as containers. In D. Hicks and M. Beaudry (eds.), *The Oxford Handbook of Material Culture Studies*, 588–612. Oxford: Oxford University Press.

Knappett, C. and van der Leeuw, S. 2014. A developmental approach to ancient innovation: the potter's wheel in the Bronze Age east Mediterranean. *Pragmatics and Cognition* 22(1), 64–92.

Koehl, R. B. 2006. *Aegean Bronze Age Rhyta*. Prehistory Monographs 19. Philadelphia: INSTAP Academic Press.

Kohn, E. 2013. *How Forests Think: Toward an Anthropology Beyond the Human*. Berkeley : University of California Press.

Kohring, S. 2011. Bodily skill and the aesthetics of miniaturization. *PALLAS* 86, 31–50.

Kolrud, K. and Prusac, M. (eds.). 2014. *Iconoclasm from Antiquity to Modernity*. Farnham: Ashgate.

Koos, M. 2014. Wandering things: agency and embodiment in late sixteenth-century English miniature portraits. *Art History* 37(5), 836–859.

Kotovsky, L. and Baillargeon, R. 2000. Reasoning about collisions involving inert objects in 7.5-month–old infants. *Developmental Science* 3(3), 344–859.

Kourou, N. 2011. Following the sphinx. Tradition and innovation in Early Iron Age Crete. In *Identità culturale, etnicità, processi di trasformazione a Creta fra Dark Age e Arcaismo: per i cento anni dello scavo di Prini, 1906–2006: convegno di studi (Atene, 9–12 novembre 2006)*, edited by G. Rizza, 165–177. Studi e materiali di archeologia greca 10. Catania.

Kristiansen, K. and Suchowska-Ducke, P. 2015. Connected histories: the dynamics of Bronze Age interaction and trade 1500–1100 BC. *Proceedings of the Prehistoric Society* 81, 361–392.

Krzyszkowska, O. 2005. *Aegean Seals: An Introduction*. London: Institute of Classical Studies, School of Advanced Study, University of London.

Krzyszkowska, O. 2012. Seals from the Petras cemetery: a preliminary overview. In M. Tsipopoulou (ed.), *Petras, Siteia: 25 Years of Excavations and Studies*, 145–156.

Monographs of the Danish Institute at Athens vol. 16. Aarhus: Aarhus University Press.

Kuhn, S. L. and Stiner, M. C. 2007. Paleolithic ornaments: implications for cognition, demography and identity. *Diogenes* 214, 40–48.

Kuijt, I. 2008. The regeneration of life: Neolithic structures of symbolic remembering and forgetting. *Current Anthropology* 49, 171–197.

Kumler, A. 2011. The multiplication of the species: Eucharistic morphology in the Middle Ages. *RES* 59/60, 179–191.

Laffineur, R. 2001. Seeing is believing: reflections on divine imagery in the Aegean Bronze Age. In R. Laffineur and R. Hägg (eds.), *POTNIA: Deities and Religion in the Aegean Bronze Age. Proceedings of the 8th International Aegean Conference Göteborg, Göteborg University, 12–15 April 2000*, 387–392. Aegaeum 22. Liège.

Lakoff, G. and Johnson, M. 1999. *Philosophy in the Flesh: The Embodied Mind and Its Challenge to Western Thought*. New York: Basic Books.

Lane, D. A., Maxfield, R., Read, D. and van der Leeuw, S. E. 2009. From population to organization thinking. In D. A. Lane, S. E. van der Leeuw, D. Pumain and G. West (eds)., *Complexity Perspectives in Innovation and Social Change*, 11–41. Methodological Prospects in the Social Sciences, vol. 7. Berlin: Springer.

Lapatin, K. 2001. *Chryselephantine Statuary in the Ancient Mediterranean World*. Oxford: Oxford University Press.

Larkin, B. 2013. The politics and poetics of infrastructure. *Annual Review of Anthropology* 42, 327–343.

Latour, B. 1986. Visualisation and cognition: drawing things together. In H. Kuklick (ed.), *Knowledge and Society: Studies in the Sociology of Culture Past and Present*, vol. 6, 1–40. Jai Press.

Latour, B. 2000. The Berlin key or how to do words with things. In P. M. Graves-Brown (ed.), *Matter, Materiality and Modern Culture*, 10–21. London: Routledge.

Latour, B. 2002. What is iconoclash? Or is there a world beyond the image wars? In B. Latour and P. Weibel (eds.), *Iconoclash*, 14–37. Cambridge, MA: MIT Press.

Latour, B. 2009. Perspectivism: 'type' or 'bomb'? *Anthropology Today* 25(2), 1–2.

Laugrand, F. 2010. Miniatures et variations d'échelle chez les Inuit. In P. Descola (ed.), *La fabrique des images: visions du monde et formes de la représentation.* Exposition, février 2010–juillet 2011 52–59. Paris: Somogy-Musée du Quai Branly.

Laugrand, F. and Oosten, J. 2008. When toys and ornaments come into play: the transformative power of miniatures in Canadian Inuit cosmology. *Museum Anthropology* 31(2), 69–84.

Law, J. 1986. On the methods of long distance control: vessels, navigation and the Portuguese route to India. In J. Law (ed.), *Power, Action and Belief: A New Sociology of Knowledge?* Sociological Review Monograph 32, 234–363. London: Routledge and Kegan Paul.

Law, J. and Mol, A. 2008. The actor-enacted: Cumbrian sheep in 2001. In C. Knappett and L. Malafouris (eds.), *Material Agency: Towards a Non-Anthropocentric Approach*, 57–77. New York: Springer.

Ledderose, L. 2000. *Ten Thousand Things: Module and Mass Production in Chinese Art.* Princeton, NJ: Princeton University Press.

Lefèvre-Novaro, D. 2001. Modèles réduits trouvés dans la grande tombe de Kamilari. In R. Laffineur and R. Hägg (eds.), *POTNIA: Deities and Religion in the Aegean Bronze Age. Proceedings of the 8th International Aegean Conference Göteborg, Göteborg University, 12–15 April 2000*, 89–98. Aegaeum 22. Liège.

Legarra Herrero, B. 2014. *Mortuary Behavior and Social Trajectories in Pre- and Protopalatial Crete.* Philadelphia: INSTAP Academic Press.

Lehmann, S.-A. 2014. The matter of the medium: some tools for an art-theoretical interpretation of materials. In C. Anderson, A. Dunlop and P. H. Smith (eds.), *The Matter of Art: Materials, Practices, Cultural Logics, c.1250–1750*, 21–41. Manchester: Manchester University Press.

Lemonnier, P. 2012. *Mundane Objects: Materiality and Non-Verbal Communication.* Walnut Creek, CA: Left Coast Press.

Lemonnier, P. 2014. The blending power of things. *Hau: Journal of Ethnographic Theory* 4(1), 537–548.

Lending, M. 2017. *Plaster Monuments: Architecture and the Power of Reproduction.* Princeton, NJ: Princeton University Press.

Leone, M. 2014. Wrapping transcendence: the semiotics of reliquaries. *Signs and Society* 2:S1, S49–S83.

Letesson, Q. 2009. *Du phénotype au génotype: analyse de la syntaxe spatiale en architecture minoenne (MM IIIB–MR IB).* Aegis 2. Louvain-la-Neuve: Presses Universitaires de Louvain.

Letesson, Q. 2013. Minoan halls: a syntactical genealogy. *American Journal of Archaeology* 117, 303–351.

Letesson, Q. 2014a. 'Open Day Gallery' or 'Private Collections'? An insight on Neopalatial wall paintings in their spatial context. In S. Cappel, U. Günkel-Maschek, and D. Panagiotopoulos (eds.), *Minoan Archaeology, Challenges and Perspectives for the 21st Century*, 27–61. Louvain: Aegis, Presses Universitaires de Louvain.

Letesson, Q. 2014b. From building to architecture: the rise of configurational thinking in Bronze Age Crete. In E. Paliou, U. Lieberwirth and S. Polla (eds.), *Spatial Analysis and Social Spaces: Interdisciplinary Approaches to the Interpretation of Prehistoric and Historic Built Environments*, 49–90. Berlin: de Gruyter.

Letesson, Q. 2015. Fire and the holes: an investigation of low-level meanings in the Minoan built environment. *Journal of Archaeological Method and Theory* 22, 713–750.

Letesson, Q. and Knappett, C. (eds.). 2017. *Minoan Architecture and Urbanism: New Perspectives on an Ancient Built Environment.* Oxford: Oxford University Press.

Lévi-Strauss, C. 1962. *La Pensée Sauvage.* Paris: Plon.

Lichtenstein, J. 2009. The fragment: elements of a definition. In W. Tronzo (ed.), *The Fragment: An Incomplete History*, 115–129. Los Angeles, CA: Getty Research Institute.

Macdonald, C. F., Hallager, E. and Niemeier, W.-D. (eds.). 2009. *The Minoans in the Central, Eastern and Northern Aegean: New Evidence.* Monographs of the Danish Institute at Athens 8. Athens: The Danish Institute at Athens.

Macdonald, C. F. and Knappett, C. 2007. *Knossos: Protopalatial Deposits in Early Magazine*

A and the South-West Houses, BSA Supplementary vol. 41. London: British School at Athens.

MacGillivray, J. A. 1998. *Knossos: Pottery Groups of the Old Palace Period*. BSA Studies 5. London: British School at Athens.

MacGillivray, J. A. 2000. *Minotaur: Sir Arthur Evans and the Archaeology of the Minoan Myth*. London: Jonathan Cape.

MacGillivray, J. A., Sackett, L. H. and Driessen, J. (eds.). 2000. *The Palaikastro Kouros: A Minoan Chryselephantine Statuette and Its Aegean Bronze Age Context*, BSA Studies 6. London: British School at Athens.

Mack, J. 2007. *The Art of Small Things*. London: British Museum Press.

Malafouris, L. 2005. *Projections in Matter: Material Engagement and the Mycenaean Becoming*. Unpublished PhD dissertation, University of Cambridge.

Malafouris, L. 2013. *How Things Shape the Mind: A Theory of Material Engagement*. Cambridge, MA: MIT Press.

Manby, T. G. 1995. Skeuomorphism: some reflections of leather, wood and basketry in Early Bronze Age pottery. In I. Kinnes and G. Varndell (eds.), *Unbaked Urns of Rudely Shape*, 81–88. Oxford: Oxbow.

Maran, J. and Stockhammer, P. W. (eds.). 2012. *Materiality and Social Practice. Transformative Capacities of Intercultural Encounters*. Oxford: Oxbow Books.

Marangou, C. 1992. *Eidolia. Figurines et Miniatures du Néolithique Récent et du Bronze Ancien en Grèce*. Oxford BAR Int. Series 576.

Marangou, C. 1996a. Assembling, displaying and dissembling Neolithic and Eneolithic figurines and models. *Journal of European Archaeology* 4, 177–202.

Marangou, C. 1996b. Figurines and models. In G. Papathanassopoulos (ed.), *Neolithic Culture in Greece*, 146–151. Athens: Goulandris Foundation.

Margueron, J.-Cl. 2001. Conclusions: aujourd'-hui et demain. In B. Muller (ed.), *'Maquettes architecturales' de l'Antiquité : regards croisés (Proche-Orient, Chypre, bassin égéen et Grèce, du néolithique à l'époque hellénistique) : actes du colloque de Strasbourg 3–5 décembre 1998*, 533–544. Paris: De Boccard.

Matthäus, H. 1980. *Die Bronzegefässe der Kretisch-mykenischer Kultur (Prähistorischer Bronzefunde II.1)*. Munich: C. H. Beck.

Matthews, R. 1993. *Cities, Seals and Writing: Archaic Seal Impressions from Jemdet Nasr and Ur*. Berlin: Gebr. Mann.

Matz, F. 1928. *Die frühkretischen Siegel. Eine Untersuchung über das Werden des Minoischen Stiles*. Berlin: Walter de Gruyter.

McCullough, T. 2014. *Metal to Clay: 'Recovering' Middle Minoan Metal Vessels from Knossos and Phaistos through their Ceramic Skeuomorphs*. Unpublished PhD thesis, University of Pennsylvania.

McEnroe, J. 2010. *Architecture of Minoan Crete: Constructing Identity in the Aegean Bronze Age*. Austin: University of Texas Press.

Mee, C. 2011. *Greek Archaeology: A Thematic Approach*. Malden, MA: Wiley-Blackwell.

Meyer, M. 2012. Placing and tracing absence: a material culture of the immaterial. *Journal of Material Culture* 17(1), 103–110.

Miller, D. 2005. Materiality: an introduction. In D. Miller (ed.), *Materiality*, 1–50. Durham, NC: Duke University Press.

Mills, B. J. 2008. Remembering while forgetting: depositional practices and social memory at Chaco. In B. Mills and W. Walker (eds.), *Memory Work: Archaeologies of Material Practices*, 81–108. Santa Fe, NM: School for Advanced Research Press.

Mills, B. J. 2016. Communities of consumption: cuisines as networks of situated practice. In A. P. Roddick and A. B. Stahl (eds.), *Knowledge in Motion, Constellations of Learning Across Time and Place*, 248–270. Amerind Studies in Anthropology (SAA–Amerind Series). Tucson: University of Arizona Press.

Mochizuki, M. 2013. Iconoclasm. In Frank Burch Brown (ed.), *The Oxford Handbook of Religion and the Arts*, 450–468. Oxford: Oxford University Press.

Morgan, L. 1988. *The Miniature Wall Paintings of Thera: A Study in Aegean Culture and Iconography*. Cambridge: Cambridge University Press.

Morgan, L. 2010. An Aegean griffin in Egypt: the hunt frieze at Tell el-Daba, *Ägypten und Levante/ Egypt and the Levant* 20, 303–323.

Morris, C. 2009. Configuring the individual: bodies of figurines in Minoan Crete. In A.-L. D'Agata and A. Van De Moortel (eds.), *Archaeologies of Cult: Essays on Ritual and Cult in Crete in Honor of Geraldine C. Gesell*, 180–187. Hesperia Supplement 42. Princeton, NJ.

Morris, C. and Peatfield, A. 2002. Feeling through the body: gesture in Cretan Bronze Age religion. In Y. Hamilakis, M. Pluciennik and S. Tarlow (eds.), *Feeling Through the Body: Archaeologies of Corporeality*, 105–120. New York: Kluwer Academic/Plenum.

Morris, M. 2006. *Models: Architecture and the Miniature – Architecture in Practice*. London: John Wiley.

Morrison, J. E. and Park, D. P. 2007. Reconstructing the ritual killing of the ceramic vessels from Tomb 15. In J. Soles (ed.), *Mochlos IIA: Period IV, The Mycenaean Settlement and Cemetery: The Sites*, 207–214. Philadelphia: INSTAP Academic Press.

Moxey, K. 2011. Review of Nagel and Wood's Anachronic Renaissance. *Contemporaneity* vol. 1, DOI 10.5195/contemp.2011.35

Muhly, P. 2012. A terracotta foot model from the Syme sanctuary, Crete. In E. Mantzourani and P. P. Betancourt (eds.), *Philistor: Studies in Honor of Costis Davaras*, 133–138. Philadelphia: INSTAP Academic Press.

Muller, B. (ed.) 2001. *Maquettes architecturales' de l'Antiquité : regards croisés (Proche-Orient, Chypre, bassin égéen et Grèce, du néolithique à l'époque hellénistique) : actes du colloque de Strasbourg 3–5 décembre 1998*. Paris: De Boccard.

Muller, B. 2016. *Maquettes Antiques d'Orient. De L'Image d'Architecture au Symbole*. Paris: Picard.

Mumford, L. 1934. *Technics and Civilization*. New York: Harcourt, Brace & Co.

Murphy, C. 2018. Solid items made to break, or breakable items made to last? The case of Minoan peak sanctuary figurines. *Les Carnets de l'ACoSt* 17, 1–10.

Nagel, A. and Wood, C. S. 2010. *Anachronic Renaissance*. New York: Zone Books.

Naji, M. and Douny, L. 2009. Editorial. *Journal of Material Culture* 14(4), 411–432.

Nakou, G. 2007. Absent presences: metal vessels in the Aegean at the end of the third millennium. In P. M. Day and R. C. Doonan (eds.), *Metallurgy in the Early Bronze Age Aegean*, 224–244. Sheffield Studies in Aegean Archaeology 7. Oxford: Oxbow.

Nanay, B. 2016. *Aesthetics as Philosophy of Perception*. Oxford: Oxford University Press.

Nanoglou, S. 2008. Representation of humans and animals in Greece and the Balkans during the earlier Neolithic. *Cambridge Archaeological Journal* 18, 1–13.

Nanoglou, S. 2009. Animal bodies and ontological discourse in the Greek Neolithic. *Journal of Archaeological Method and Theory* 16, 184–204.

Nativ, A. 2017. No compensation needed: on archaeology and the archaeological. *Journal of Archaeological Method and Theory* 24(3), 659–675.

Neer, R. 2010. *The Emergence of the Classical Style in Greek Sculpture*. Chicago: University of Chicago Press.

Neer, R. 2012. *Art and Archaeology of the Greek World: A New History, c. 2500– c.150 BCE*. London: Thames & Hudson.

Nikolakopoulou, I. 2010. Middle Cycladic iconography: a new chapter in Aegean art. In O. Krzyszkowska (ed.), *Cretan Offerings: Studies in Honour of Peter Warren*, 213–222. BSA Studies 18. London: British School at Athens.

Nikolakopoulou, I. and Knappett, C. 2016. Mobilities in the Neopalatial southern Aegean: the case of Minoanisation. In E. Kiriatzi and C. Knappett (eds.), *Human Mobility and Technological Transfer in the Prehistoric Mediterranean*, 102–115. British School at Athens Studies in Greek Antiquity 1. Cambridge: Cambridge University Press.

Noë, A. 2012. *Varieties of Presence*. Cambridge, MA: Harvard University Press.

Onians, J. 2008. *Neuroarthistory: From Aristotle and Pliny to Baxandall and Zeki*. New Haven, CT: Yale University Press.

Overmann, K. A. 2013. Material scaffolds in numbers and time. *Cambridge Archaeological Journal* 23(1), 19–39.

Padgett, J. F. and Powell, W. W. 2012. *The Emergence of Organizations and Markets*. Princeton, NJ: Princeton University Press.

Paliou, E., Wheatley, D. and Earl, G. 2011. Three-dimensional visibility analysis of architectural spaces: iconography and visibility of the wall paintings of Xeste 3 (Late Bronze Age Akrotiri). *Journal of Archaeological Science* 38, 375–386.

Pallasmaa, J. 2009. *The Thinking Hand: Existential and Embodied Wisdom in Architecture*. Chichester: Wiley.

Palyvou, C. 2002. Central courts: the supremacy of the void. In J. Driessen, I. Schoep and R. Laffineur (eds.), *Monuments of Minos: Rethinking the Minoan Palaces*, 167–177. Aegaeum 23. Liège and Austin.

Palyvou, C. 2004. Outdoor space in Minoan architecture: community and privacy. In G. Cadogan, E. Hatzaki and A. Vasilakis (eds.), *Knossos: Palace, City, State*, 207–217. London: British School at Athens.

Panagiotaki, M. 1999. *The Central Palace Sanctuary at Knossos*, BSA Suppl. vol. 31. London: British School at Athens.

Panagiotaki, M., Maniatis, Y., Kavoussanaki, D., Hatton, G. and Tite, M. S. 2004. Production technology of Aegean Bronze Age vitreous materials. In J. Bourriau and J. Phillips (eds.), *Invention and Innovation. The Social Context of Technological Change 2: Egypt, the Aegean and the Near East, 1650–1150 BC*, 149–175. Oxford: Oxbow Books.

Panagiotopoulos, D. 2010. A systemic approach to Mycenaean sealing practices. In W. Müller (ed.), *Die Bedeutung der minoischen und mykenischen Glyptik. VI. Internationales Siegel-Symposium, Marburg, 9.–12. Oktober 2008*. CMS Beiheft 8, 297–307.

Panagiotopoulos, D. 2012. Aegean imagery and the syntax of viewing. In D. Panagiotopoulos and U. Günkel-Maschek (eds.), *Minoan Realities: Approaches to Images, Architecture and Society in the Aegean Bronze Age*, 63–82. Aegis 5. Presses Universitaires de Louvain.

Panagiotopoulos, D. 2014. *Mykenische Siegelpraxis: Funktion, Kontext und administrative Verwendung mykenischer Tonplomben auf dem griechischen Festland und Kreta*. Athenaia 5. Munich: Hirmer.

Papagiannopoulou, A. 2008. From pots to pictures: Middle Cycladic figurative art from Akrotiri, Thera. In N. Brodie, J. Doole, G. Gavalas and C. Renfrew (eds.), *Horizon. Ορίζων. A Colloquium on the Prehistory of the Cyclades*, 433–449. Cambridge: McDonald Institute Monographs.

Papapetros, S. 2010. World ornament: The legacy of Gottfried Semper's 1856 lecture on adornment. *RES: Anthropology and Aesthetics* 57/58, 309–329.

Parker, C. 2009. Avoided object. In W. Tronzo (ed.), *The Fragment: An Incomplete History*, 92–113. Los Angeles, CA: Getty Research Institute.

Pauketat, T. 2013. *An Archaeology of the Cosmos: Rethinking Agency and Religion in Ancient America*. London: Routledge.

Paulsen, K. 2013. The index and the interface. *Representations* 122(1), 83–109.

Payne, A. 2012. *From Ornament to Object: Genealogies of Architectural Modernism*. New Haven, CT: Yale University Press.

Peatfield, A. 1992. Rural ritual in Bronze Age Crete: the peak sanctuary at Atsipadhes. *Cambridge Archaeological Journal* 2(1), 59–87.

Peatfield, A. 2001. Divinity and performance on Minoan peak sanctuaries. In R. Laffineur and R. Hägg (eds.), *POTNIA: Deities and Religion in the Aegean Bronze Age. Proceedings of the 8th International Aegean Conference Göteborg, Göteborg University, 12–15 April 2000*, 51–55. Aegaeum 22. Liège.

Peatfield, A. 2016. A metaphysical history of Minoan religion. In E. Alram Stern et al. (eds.), *Metaphysis: Ritual, Myth and Symbolism in the Aegean Bronze Age*, 485–494. Aegaeum 39. Leuven: Peeters.

Pedersen, M. A. 2007. Talismans of thought: shamanist ontologies and extended cognition in northern Mongolia. In A. Henare, M. Holbraad and S. Wastell (eds.), *Thinking through Things: Theorising Artefacts Ethnographically*, 141–166. London: Routledge.

Pedersen, M. A. 2011. *Not Quite Shamans: Spirit Worlds and Political Lives in Northern Mongolia.* Ithaca: Cornell University Press.

Peirce, C. S. 1931–1958. *The Collected Papers of Charles Sanders Peirce.* 8 vol. Edited by Charles Hartshorne and Paul Weiss. Cambridge, MA: Belknap Press of Harvard University Press.

Pentcheva, B. V. 2006. The performative icon. *The Art Bulletin* 88(4), 631–655.

Perlès, C. 2001. *The Early Neolithic in Greece: The First Farming Communities in Europe.* Cambridge: Cambridge University Press.

Peters, J. Durham. 2015. *The Marvelous Clouds: Toward a Philosophy of Elemental Media.* Chicago: Chicago University Press.

Phelps, W. W., Varoufakis, G. J. and Jones, R. E. 1979. Five copper axes from Greece. *Annual of the British School at Athens* 74, 175–184.

Pickering, A. 2010. Material culture and the dance of agency. In D. Hicks and M. Beaudry (eds.), *The Oxford Handbook of Material Culture Studies,* 191–208. Oxford: Oxford University Press.

Pilz, O. 2011. The uses of small things and the semiotics of Greek miniature objects. *PALLAS* 86, 15–30.

Pini, I. 2009. On early Late Bronze Age signet rings and seals of gold from the Greek mainland. In D. Daniilidou (ed.), *Doron: Timitikos Tomos Yia Ton Kathiyiti Spiro Iakovidi,* 599–610. Athens: Academy of Athens.

Pitrou, P. 2012 Figuration des processus vitaux et co-activité dans la Sierra Mixe de Oaxaca (Mexique). *L'Homme* 202, 77–112.

Pitrou, P. 2016. Co-activity in Mesoamerica and the Andes. *Journal of Anthropological Research* 72(4), 465–482.

Pittman, H. 2012. Seals and sealings in the Sumerian world. In H. Crawford (ed.), *The Sumerian World,* 319–341. London: Routledge.

Platon, L. 2016. Some fresh thoughts on the use of the Minoan 'strainer'. In E. Papadopoulou-Chrysikopoulou, V. Chrysikopoulos and G. Christakopoulou (eds.), *Achaios: Studies Presented to Professor Thanasis I. Papadopoulos,* 241–253. Oxford: Archaeopress.

Platt, V. 2006. Making an impression: replication and the ontology of the Graeco-Roman seal stone. *Art History* 29(2), 233–257.

Platt, V. 2011. *Facing the Gods: Epiphany and Representation in Graeco-Roman Art, Literature and Religion.* Cambridge: Cambridge University Press.

Pointon, M. 2001. 'Surrounded with brilliants': miniature portraits in eighteenth-century England. *The Art Bulletin* 83(1), 48–71.

Polychronopoulou, O. 2005. Existe-t-il un art préhistorique égéen? In P. Darcque, M. Fotiadis and O. Polychronopoulou (eds.), *Mythos. La préhistoire égéenne du XIX au XXI siècle après J.-C. Actes de la table ronde international d'Athènes (21–23 novembre 2002),* 345–355. BCH Suppl. 46 Athènes: BCH.

Porada, E. (ed.). 1980. *Ancient Art in Seals.* Princeton, NJ: Princeton University Press.

Porada, E. 1981/1982. The cylinder seals found at Thebes in Boeotia. *Archiv für Orientforschung* 28, 1–70.

Porter, J. I. 2010. *The Origins of Aesthetic Thought in Ancient Greece.* Cambridge: Cambridge University Press.

Poursat, J.-C. 1980. Reliefs d'appliqué moulé. In B. Detournay, J.-C. Poursat and F. Vandenabeele (eds.), *Fouilles Exécutées à Mallia: Le Quartier Mu II,* 116–132. Paris: Etudes Crétoises 26.

Poursat, J.-C. 2001. Les maquettes architecturales du monde créto-mycénien: types et fonctions symboliques. In B. Muller (ed.), *'Maquettes architecturales' de l'Antiquité: regards croisés (Proche-Orient, Chypre, bassin égéen et Grèce, du néolithique à l'époque hellénistique): actes du colloque de Strasbourg 3–5 décembre 1998,* 485–495. Paris: De Boccard.

Poursat, J.-C. 2008. *L'Art égéen, vol. 1. Grèce, Cyclades, Crète jusqu'au milieu du IIe millénaire av. J.-C.* Paris: Picard.

Poursat, J.-C. 2014. *L'Art égéen, vol. 2. Mycènes et le monde mycénien.* Paris: Picard.

Poursat, J.-C. and Knappett, C. 2005. *Le Quartier Mu IV. La Poterie du Minoen Moyen II: Production et Utilisation.* Paris: Etudes Crétoises 33.

Poursat, J.-C. and Knappett, C. 2006. Minoan amphoras and inter-regional exchange:

evidence from Malia. In *Proceedings of the Ninth International Congress of Cretan Studies*, vol. A1, 153–163. Heraklion: Historical Society of Crete.

Pratt, C. E. 2016. The rise and fall of the transport stirrup jar in the Late Bronze Age Aegean. *American Journal of Archaeology* 120 (1), 27–66.

Preston, L. 2004. Contextualising the larnax: tradition, innovation and regionalism in coffin use on Late Minoan II–IIIB Crete. *Oxford Journal of Archaeology* 23(2), 177–197.

Preucel, R. 2006. *Archaeological Semiotics*. Oxford: Blackwell.

Pullen, D. 1992. Ox and plow in the Early Bronze Age. *American Journal of Archaeology* 96(1), 45–54.

Pullen, D. 2013. 'Minding the Gap'. Bridging the gaps in cultural change within the Early Bronze Age Aegean. *American Journal of Archaeology* 117, 545–553.

Rampley, M. 2000. Anthropology and the origins of Art History. *de–, dis–, ex–*. 4, 138–163.

Rampley, M. 2017. *The Seductions of Darwin: Art, Evolution, Neuroscience*. University Park: The Pennsylvania State University Press.

Reeves, L. C. 2003. *Aegean and Anatolian Bronze Age Metal Vessels: A Social Perspective*. Unpublished PhD thesis, University of London.

Rehak, P. 1995a. The 'Genius' in Late Bronze Age glyptic: the later evolution of an Aegean cult figure. In I. Pini (ed.), *Sceaux Minoens et Myceniens*. Corpus der Minoischen und Mykenischen Siegel, Beiheft 5, 215–231. Berlin.

Rehak, P. 1995b. The use and destruction of Minoan stone bull's head rhyta. In R. Laffineur and W.-D. Niemeier (eds.), *Politeia: Society and State in the Aegean Bronze Age*. *Proceedings of the 5th International Aegean Conference*, 435–460. Liège: Aegaeum 12.

Relaki, M. 2012. The social arenas of tradition. Investigating collective and individual social strategies in the Prepalatial and Protopalatial Mesara. In I. Schoep, P. Tomkins and J. Driessen (eds.), *Back to the Beginning: Reassessing Social and Political Complexity on Crete During the Early and Middle Bronze Age*, 290–324. Oxford: Oxbow Books.

Renfrew, C. 1972. *The Emergence of Civilisation: The Cyclades and the Aegean in the Third Millennium BC*. London: Methuen.

Renfrew, C. 1985. *The Archaeology of Cult: The Sanctuary at Phylakopi*. London: British School at Athens.

Renfrew, C. 2003. *Figuring It Out: The Parallel Visions of Artists and Archaeologists*. London: Thames & Hudson.

Renfrew, C. 2004. Art for archaeology. In C. Renfrew, C. Gosden and E. DeMarrais (eds.), *Substance, Memory, Display: Archaeology and Art*, 7–33. Cambridge: McDonald Institute Monographs.

Renfrew, C. 2007. Monumentality and presence. In C. Renfrew and I. Morley (eds.), *Image and Imagination: A Global Prehistory of Figurative Representation*, 121–133. Cambridge, MA: McDonald Institute Monographs.

Renfrew, C. 2009. Situating the creative explosion: universal or local? In C. Renfrew and I. Morley (eds.), *Becoming Human: Innovation in Prehistoric Material and Spiritual Culture*, 75–92. Cambridge: McDonald Institute Monographs.

Renfrew, C. 2012. Towards a cognitive archaeology: material engagement and the early development of society. In I. Hodder (ed.), *Archaeological Theory Today*, 2nd edition, 124–145. Cambridge: Polity Press.

Renfrew, C. 2013. The sanctuary at Keros: Questions of materiality and monumentality. *Journal of the British Academy* 1, 187–212.

Renfrew, C. 2015. Evidence for ritual breakage in the Cycladic Early Bronze Age. In K. Harrell and J. Driessen (eds.), *Thravsma: Contextualising Intentional Destruction of Objects in the Bronze Age Aegean and Cyprus*, 81–98. Aegis 9. Louvain: Presses Universitaires de Louvain.

Renfrew, C., Philaniotou, O., Brodie, N., Gavalas, G. and M.J. Boyd (eds.). 2015. *The Sanctuary on Keros and the Origins of Aegean Ritual Practice: The excavations of 2006–2008, Vol. II: Kavos and the Special Deposits*. Cambridge: McDonald Institute for Archaeological Research.

Renfrew, C. and Zubrow, E. (eds.). 1994. *The Ancient Mind: Elements of Cognitive Archaeology*. Cambridge: Cambridge University Press.

Rethemiotakis, G. 2001. *Minoan Clay Figures and Figurines: From the Neopalatial to the Subminoan Period.* The Archaeological Society at Athens Library no. 219. Athens: The Archaeological Society at Athens.

Rethemiotakis, G. 2009. A Neopalatial shrine model from the Minoan peak sanctuary at Gournos Krousonas. In A.-L. D'Agata and A. van de Moortel (eds.), *Archaeologies of Cult: Essays on Ritual and Cult in Crete in Honor of Geraldine C. Gesell,* 189–199. Hesperia Suppl. 42.

Rethemiotakis, G. 2014. Images and semiotics in space: the case of the anthropomorphic figurines from Kophinas. *Cretica Chronika ΛΔ',* 147–162.

Rethemiotakis, G. and Christakis, K. 2011. Landscapes of power in Protopalatial Crete: new evidence from Galatas Pediada. *Studi Micenei ed Egeo-Anatolici* 53, 195–218.

Robb, J. 2015. Prehistoric art in Europe: a deep-time social history. *American Antiquity* 80(4), 635–654.

Robbins, P. and Aydede, M. (eds.). 2009. *The Cambridge Handbook of Situated Cognition.* Cambridge: Cambridge University Press.

Rodenwaldt, G. 1927. *Die Kunst der Antike* [Hellas und Rom]. Berlin: Propyläenverlag.

Root, M. C. 2008. The legible image: how did seals and sealing matter in Persepolis? In P. Briant, W. Henkelman and M. W. Stolper (eds.), *L'archive des fortifications de Persépolis: état des questions et perspectives de recherches,* 87–148. Paris: De Boccard.

Rose, M. 2011. Secular materialism: a critique of earthly theory. *Journal of Material Culture* 16(2), 107–129.

Roux, V. 2010. Technological innovations and developmental trajectories: social factors as evolutionary forces. In M. J. O'Brien and S. J. Shennan (eds.), *Innovation in Cultural Systems: Contributions from Evolutionary Anthropology,* 217–134. Vienna Series in Theoretical Biology. Cambridge, MA: MIT Press.

von Rüden, C. 2013. Beyond the East–West dichotomy in Syrian and Levantine wall paintings. In B. Brown and M. Feldman (eds.), *Critical Approaches to Near Eastern Art,* 55–78. Berlin: de Gruyter.

Rugoff, R. (ed.) 1997. *At the Threshold of the Visible* (with contribution by S. Stewart). New York: Independent Curators International.

Rupp, D. and Tsipopoulou, M. 1999. Conical cup concentrations at Neopalatial Petras: a case for a ritualised reception ceremony with token hospitality. In P. P. Betancourt, V. Karageorghis, R. Laffineur and W.-D. Niemeier (eds.), *Meletemata. Studies in Aegean Archaeology Presented to Malcolm H. Wiener as he enters his 65th Year,* 729–739. Aegaeum 20. Liège.

Rutkowski, B. 1968. The origin of the Minoan coffin. *Annual of the British School at Athens* 63, 219–227.

Rutkowski, B. 1991. *Cult Places of the Aegean.* New Haven, CT: Yale University Press.

Rutter, J. B. 1988. Early Helladic III vasepainting, ceramic regionalism, and the influence of basketry. In E. B. French and K. A. Wardle (eds.), *Problems in Aegean Prehistory,* 73–89. Bristol: Bristol Classical Press.

Sager, T. forthcoming. The modular house: a space syntax approach to exploring social complexity in Late Minoan II-IIIB architecture.

Sakellarakis, I. and Sakellaraki, E. 1997. *Archanes. Minoan Crete in a New Light.* Athens: Ammos/Eleni Nakou Foundation.

Salapata, G. 2015. Terracotta votive offerings in sets or groups. In S. Huysecom-Haxhi and A. Muller (eds.), *Figurines grecques en context: Présence muette dans le sanctuaire, la tombe et la maison,* 179–195. Villeneuve d'Ascq.

Salapata, G. 2018. Tokens of piety: inexpensive dedications as functional and symbolic objects. *Opuscula, Annual of the Swedish Institutes at Athens and Rome* 11, 97–109.

Salmond, A. 2014. Transforming translations (part 2): addressing ontological alterity. *HAU: Journal of Ethnographic Theory* 4(1), 155–187.

Sanavia, A. 2014. How to improve on nature: some Middle Minoan triton shells from Phaistos (Crete). In G. Touchais, R. Laffineur and F. Rougemont (eds.), *Physis: L'Environnement Naturel et la Relation Homme-Milieu dans le*

Monde Egéen Protohistorique, 543–546. Aegaeum 37. Leuven-Liège: Peeters.

Sanavia, A. and Weingarten, J. 2016. The transformation of tritons: some decorated Middle Minoan triton shells and an Anatolian counterpart. In E. Alram-Stern, F. Blakolmer, S. Deger-Jalkotzy, R. Laffineur and J. Weilhartner (eds.), *Metaphysis: Ritual, Myth and Symbolism in the Aegean Bronze Age*, 335–344. Aegaeum 39. Leuven–Liège: Peeters.

Sarri, K. 2010. Minyan and Minyanizing pottery. Myth and reality about a Middle Helladic type fossil. In A. Philippa-Touchais, G. Touchais, S. Voutsaki and J. Wright (eds.), *Mesohelladika. La Grèce continentale au Bronze moyen*, 603–613. BCH Suppl. 52. Athens: BCH.

Sbonias, K. 2012. Regional elite-groups and the production and consumption of seals in the Prepalatial period. A case-study of the Asterousia region. In I. Schoep, P. Tomkins and J. Driessen (eds.), *Back to the Beginning: Reassessing Social and Political Complexity on Crete During the Early and Middle Bronze Age*, 273–289. Oxford: Oxbow Books.

Schachermeyr, F. 1955. *Die ältesten Kulturen Griechenlands*. Stuttgart: W. Kohlhammer.

Schnapp, A. 1996. *The Discovery of the Past: The Origins of Archaeology*. London: British Museum Press.

Schoep, I. 1994. 'Home Sweet Home': some comments on the so-called house models from the Prehellenic Aegean. *Opuscula Atheniensia* 20, 189–210.

Scott, M. W. 2013. The anthropology of ontology (religious science?). *JRAI (N.S.)* 19, 859–872.

Scott, M. W. 2014. To be a wonder: anthropology, cosmology, and alterity. In A. Abramson and M. Holbraad (eds.), *Framing Cosmologies: The Anthropology of Worlds*, 31–54. Manchester: Manchester University Press.

Severi, C. 2015. *The Chimera Principle: An Anthropology of Memory and Imagination*. Translated by Janet Lloyd. Chicago: Hau Books.

Shapland, A. 2013. Shifting horizons and emerging ontologies in the Bronze Age Aegean. In C. Watts (ed.), *Relational Archaeologies: Humans, Animals, Things*, 190–208. London: Routledge.

Shaw, J. W. and Lowe, A. 2002. The 'lost' portico at Knossos: the Central Court revisited. *American Journal of Archaeology* 106(4), 513–523.

Shaw, M. C. 2000. Anatomy and execution of complex Minoan textile patterns in the Procession Fresco from Knossos. In A. Karetsou (ed.), *Kriti-Aigyptos: Politismikoi Desmoi Trion Xilieton*, 52–63. Athens: Ministry of Culture.

Shryock, A. and Lord Smail, D. 2018. On containers: a forum. Introduction. *History and Anthropology* 29(1), 1–6.

Sillar, B. 2016. Miniatures and animism: the communicative role of Inka carved stone *conopa*. *Journal of Anthropological Research* 72(4), 442–464.

Simandiraki, A. 2011. Miniature vessels in Minoan Crete. In *Proceedings of the 10th International Cretological Congress*, Khania, 1–8 October 2006, A3, 45–58.

Simandaraki-Grimshaw, A. 2012. Miniature vessels from Petras. In M. Tsipopoulou (ed.), *Petras, Siteia: 25 Years of Excavations and Studies*, 255–264. Monographs of the Danish Institute at Athens vol. 16. Aarhus: Aarhus University Press.

Simandiraki-Grimshaw, A. 2013. Anthropomorphic vessels as re-imagined corporealities in Bronze Age Crete. *Creta Antica* 14, 17–68.

Simondon, G. 1958. *Du mode d'existence des objets techniques*. Paris: Aubier.

Sinclair, A. 2000. Constellations of knowledge: human agency and material affordance in lithic technology. In J. Robb and M.-A. Dobres (eds.), *Agency in Archaeology*, 196–212. London: Routledge.

Sinha, C. 2005. Blending out of the background: play, props and staging in the material world. *Journal of Pragmatics*, 37, 1537–1554.

Skeates, R. 2017. Towards an archaeology of everyday aesthetics. *Cambridge Archaeological Journal* 27(4), 607–616.

Slingerland, E. 2008. *What Science Offers the Humanities: Integrating Body and Culture*. Cambridge : Cambridge University Press.

Slingerland, E. and Collard, M. 2012. Creating consilience: toward a second wave. In E. Slingerland and M. Collard (eds.), *Creating Consilience: Integrating the Sciences and the*

Humanities, 3–40. Cambridge: Cambridge University Press.

Slinkachu, 2012. *Global Model Village: The International Street Art of Slinkachu*. New York: Blue Rider Press.

Sloterdijk, P. 2011–2016. *Spheres*. 3 volumes. translated by Wieland Hoban. Los Angeles, CA: Semiotext(e).

Smith, R. A. K. 2019. Death on the Isthmus: Late Minoan IIIA–B tombs of the Mirabello Bay and Ierapetra Areas. In K. Chalikias and E. Oddo (eds.), *Exploring a Terra Incognita: Recent Research on Bronze Age Habitation in the Southern Ierapetra Isthmus*. Philadelphia: INSTAP Academic Press.

Smith, T. J. and Plantzos, D. (eds.). 2012. *A Companion to Greek Art*. London: Wiley-Blackwell.

Snijder, G. A. S. 1936. *Kretische Kunst: Versuch einer Deutung*. Berlin: Gebr. Mann.

Sofaer, J. 2015. *Clay in the Age of Bronze: Essays in the Archaeology of Prehistoric Creativity*. Cambridge: Cambridge University Press.

Sofaer, J. 2011. Human ontogeny and material change at the bronze age tell of Százhalombatta, Hungary. *Cambridge Archaeological Journal* 21(2), 217–227.

Sofia, Z. 2000. Container technologies. *Hypatia* 15(2), 181–201.

Soles, J. 1999. The ritual 'killing' of pottery and the discovery of a Mycenaean *Telestas* at Mochlos. In P. Betancourt, V. Karageorghis, R. Laffineur and W.-D. Niemeier (eds.), *Meletemata. Studies in Aegean Archaeology Presented to Malcolm H. Wiener*, 787–793. Liège: Aegaeum 20.

Soles, J. and Davaras, C. 2010. 2010 Greek–American excavations at Mochlos. *Kentro: The Newsletter of the INSTAP Study Centre for East Crete*.

Solso, R. L. 1996. *Cognition and the Visual Arts*. New York: Bradford Books.

Sonesson, G. 1989. *Pictorial Concepts. Inquiries into the Semiotic Heritage and Its Relevance for the Analysis of the Visual World*. Lund: Lund University Press.

Sonesson, G. 2006. The meaning of meaning in biology and cognitive science: a semiotic reconstruction. *Sign System Studies* 34, 135–213.

Sontag, S. 1977. *On Photography*. New York.

Sorge, A. and Roddick, A. P. 2012. Mobile humanity: the delocalization of anthropological research. *Reviews in Anthropology* 41, 273–301.

Spelke, E. S., Breinlinger, K., Macomber, J. and Jacobson, K. 1992. Origins of knowledge. *Psychological Review* 99, 605–632.

Sperber, D. 1996. Why are perfect animals, hybrids, and monsters food for symbolic thought? *Method and Theory in the Study of Religion* 8(2), 143–169.

Spuybroek, L. 2016. *The Sympathy of Things: Ruskin and the Ecology of Design*. 2nd edition. London: Bloomsbury.

Stafford, B. 2007. *Echo Objects: The Cognitive Work of Images*. Chicago: Chicago University Press.

Stafford, B. (ed.). 2011. *A Field Guide to a New Meta-field: Bridging the Humanities–Neurosciences Divide*. Chicago: University of Chicago Press.

Stansbury-O'Donnell, M. D. 2015. *A History of Greek Art*. Hoboken: John Wiley & Sons.

Sterelny, K. 2010. Minds: extended or scaffolded? *Phenomenology and the Cognitive Sciences* 9, 465–481.

Stewart, P. 2007. Gell's idols and Roman cult. In R. Osborne and J. Tanner (eds.), *Art's Agency and Art History*, 158–178. Oxford: Blackwell.

Stewart, S. 1993. *On Longing: Narratives of the Miniature, the Gigantic, the Souvenir, the Collection*. 1st paperback edition. Durham, NC: Duke University Press.

Stocker, S. R. and Davis, J. L. 2017. The combat agate from the grave of the Griffin Warrior at Pylos. *Hesperia* 86(4), 583–605.

Stockhammer, P. W. 2012. Conceptualizing cultural hybridization in archaeology. In P. W. Stockhammer (ed.), *Conceptualizing Cultural Hybridization: A Transdisciplinary Approach*, 43–58. New York: Springer.

Stockhammer, P. W. and Maran, J. (eds.). 2017. *Appropriating Innovations: Entangled Knowledge in Eurasia, 5000–1500 BCE*. Oxford: Oxbow Books.

Stordeur, D. and Khawam, R. 2007. Les crânes surmodelés de Tell Aswad (PPNB, Syrie).

Premier regard sur l'ensemble, premières réflexions. *Syrie* 84, 5–32.

Stout, D. 2002. Skill and cognition in stone tool production: an ethnographic case study from Irian Jaya. *Current Anthropology* 43(5), 693–722.

Summers, D. 2003. *Real Spaces: World Art History and the Rise of Western Modernism*. London: Phaidon.

Swenson, E. 2015. The archaeology of ritual. *Annual Review of Anthropology* 44, 329–345.

Talalay, L. E. 1993. *Deities, Dolls, and Devices. Neolithic Figurines from Franchthi Cave, Greece*. Bloomington and Indianapolis: Indiana University Press.

Tallis, R. 2011. *Aping Mankind: Neuromania, Darwinitis and the Misrepresentation of Humanity*. Durham, NC: Acumen.

Tanner, J. 2006. *The Invention of Art History in Ancient Greece: Religion, Society and Artistic Rationalisation*. Cambridge: Cambridge University Press.

Taussig, M. 1993. *Mimesis and Alterity: A Particular History of the Senses*. New York: Routledge.

Taylor, T. 2010 *The Artificial Ape: How Technology Changed the Course of Human Evolution*. New York: Palgrave Macmillan.

Theiner, G. and Drain, C. 2017. What's the matter with cognition? A 'Vygotskian' perspective on material engagement theory. *Phenomenology and the Cognitive Sciences* 16, 837–862.

Thomas, C. G. and Wedde, M. 2001. Desperately seeking Potnia. In R. Laffineur and R. Hägg (eds.), *POTNIA: Deities and Religion in the Aegean Bronze Age. Proceedings of the 8th International Aegean Conference Göteborg, Göteborg University, 12–15 April 2000*, 3–14. Aegaeum 22. Liège.

Todaro, S. 2003. Il deposito AM I del Piazzale dei Sacelli di Haghia Triada. I modellini architettonici. *Annuario della Scuola Archeologica di Atene* 81, 547–572.

Tournavitou, I. 2009. Does size matter? Miniature pottery vessels in Minoan peak sanctuaries. In A. -L. D'Agata and A. Van de Moortel (eds.), *Archaeologies of Cult: Essays on Ritual and Cult in Crete in Honor of Geraldine C. Gesell*. Hesperia Supplement 42, 213–230.

Trever, L. 2016. The artistry of Moche mural painting and the ephemerality of monuments. In C. L. Costin (ed.), *Making Value, Making Meaning: Techné in the Pre-Columbian World*, 253–279. Washington, DC: Dumbarton Oaks.

Tronzo, W. 2009. Introduction. In W. Tronzo (ed.), *The Fragment: An Incomplete History*, 1–7. Los Angeles, CA: Getty Research Institute.

Tsipopoulou, M. and Hallager, E. 2010. *The Hieroglyphic Archive at Petras, Siteia*. Oakville, CT: The David Brown Book Company.

Turner, M. 2014. *The Origin of Ideas: Blending, Creativity, and the Human Spark*. Oxford: Oxford University Press.

Tuzin, D. 2002. Art, ritual, and the crafting of illusion. *The Asia Pacific Journal of Anthropology* 3(1), 1–23.

Tyree, L. 2001. Diachronic changes in Minoan cave cult. In R. Laffineur and R. Hägg (eds.), *POTNIA: Deities and Religion in the Aegean Bronze Age. Proceedings of the 8th International Aegean Conference Göteborg, Göteborg University, 12–15 April 2000*, 39–50. Aegaeum 22. Liège.

Tzonou-Herbst, I. 2010. Figurines. In E. Cline (ed.), *The Oxford Handbook of the Bronze Age Aegean*, 210–221. Oxford: Oxford University Press.

Ucko, P. 1962. The interpretation of prehistoric anthropomorphic figurines. *Journal of the Royal Anthropological Institute of Great Britain and Ireland* 92(1), 38–54.

Van der Leeuw, S. E. and Torrence, R. (eds.). 1989. *What's New?: A Closer Look at the Process of Innovation*. London: Unwin Hyman.

Van Oyen, A. forthcoming. Provincialising Roman Italy: what makes a 'provincial' Roman archaeology? Paper presented Jan 4th 2017, Toronto.

Vavouranakis, G. 2014. Funerary pithoi in Bronze Age Crete: their introduction and significance at the threshold of Minoan palatial society. *American Journal of Archaeology* 118(2), 197–222.

Verge, B. (ed.) 1997. *Zoom sur les Miniatures*. Québec: Musée de la Civilisation et Editions Fides.

Vernant, J.-P. 1991. *Mortals and Immortals: Collected Essays*. Edited by F. I. Zeitlin. Princeton, NJ: Princeton University Press.

Vickers, M. and Gill, D. 1994 *Artful Crafts: Ancient Greek Silverware and Pottery*. Oxford: Clarendon Press.

Viveiros de Castro, E. 1998. Cosmological deixis and Amerindian perspectivism. *Journal of the Royal Anthropological Institute* 4, 469–488.

Viveiros de Castro, E. 2010. In some sense. *Interdisciplinary Science Reviews* 35(3–4), 318–333.

Vlachopoulos, A. 2007. Disiecta Membra : the wall paintings from 'the "Porter's Lodge" at Akrotiri, Thera'. In M. Nelson, H. Williams and P. Betancourt (eds.), *Krinoi kai Limenes: Studies in Honor of Joseph and Maria Shaw*, 127–134. Philadelphia: INSTAP Academic Press.

Vlachopoulos, A. 2008. The wall paintings from Xeste 3 building at Akrotiri. Towards an interpretation of the iconographic programme. In N. Brodie, J. Doole, G. Gavalas and C. Renfrew (eds.), *Horizon. Ορίζων. A Colloquium on the Prehistory of the Cyclades*, 451–465. Cambridge, MA: McDonald Institute Monographs.

Voskos, I. and Knapp, A. B. 2008. Cyprus at the end of the Late Bronze Age: crisis and colonization or continuity and hybridization? *American Journal of Archaeology* 112, 659–684.

Voutsaki, S. 2012. From value to meaning, from things to persons: the Grave Circles of Mycenae reconsidered. In G. Urton and J. Papadopoulos (eds.), *The Construction of Value in the Ancient World*, 160–185, Cotsen Institute Monographs. Los Angeles, CA: University of California, Los Angeles.

Vygotsky, L. 1978. *Mind in Society: The Development of Higher Psychological Processes*. Edited by M. Cole, V. John–Steiner, S. Scribner, and E. Souberman. Cambridge, MA: Harvard University Press.

Wallis, N. J. 2013. The materiality of signs: enchainment and animacy in Woodland Southeastern North American pottery. *American Antiquity* 78(2), 207–226.

Warnier, J.-P. 2001. A praxeological approach to subjectivation in a material world. *Journal of Material Culture* 6(1), 5–24.

Warnier, J.-P. 2006. Inside and outside: surfaces and containers. In C. Tilley, W. Keane, S. Küchler, M. Rowlands, and P. Spyer (eds.), *Handbook of Material Culture*, 186–195. London: Sage.

Warnier, J.-P. 2007. *The Pot-King: The Body, Material Culture and Technologies of Power*. Leiden: Brill.

Warren, P. 1969. *Minoan Stone Vases*. Cambridge: Cambridge University Press.

Warren, P. 1972. *Myrtos: An Early Bronze Age Settlement in Crete*. London: Thames & Hudson (for the British School at Athens).

Watts, C. 2008. On mediation and material agency in the Peircean semeiotic. In C. Knappett and L. Malafouris (eds.), *Material Agency: Toward a Non-Anthropocentric Approach*, 187–207. New York: Springer.

Weingarten, J. 1991. *The Transformation of Egyptian Taweret into the Minoan Genius: A Study of Cultural Transmission in the Middle Bronze Age*. SIMA 88. Göteborg: P. Åströms.

Weinryb, I. 2013. Living matter: materiality, maker, and ornament in the Middle Ages. *Gesta* 52(2), 113–132.

Wendrich, W. (ed.). 2012. *Archaeology and Apprenticeship: Body Knowledge, Identity, and Communities of Practice*. Tucson: University of Arizona Press.

Wengrow, D. 2001. The evolution of simplicity: aesthetic labour and social change in the Neolithic Near East. *World Archaeology* 33(2), 168–188.

Wengrow, D. 2008. Prehistories of commodity branding. *Current Anthropology* 49(1), 7–34.

Wengrow, D. 2011. Cognition, materiality and monsters: the cultural transmission of counter-intuitive forms in Bronze Age societies. *Journal of Material Culture* 16(2), 131–149.

Wengrow, D. 2014. *The Origins of Monsters : Image and Cognition in the First Age of Mechanical Reproduction*. Princeton, NJ: Princeton University Press.

Wertsch, J. V. 1998. *Mind as Action*. Oxford: Oxford University Press.

Weston, D. M. 2009. 'Worlds in Miniature': some reflections on scale and the microcosmic meaning of cabinets of curiosities. *Architectural Research Quarterly* 13(1), 37–48.

Wheeler, M. 2005. *Reconstructing the Cognitive World: The Next Step*. Cambridge, MA: MIT Press.

White, R. 2003. *Prehistoric Art: The Symbolic Journey of Humankind*. New York: Harry N. Abrams.

White, R. 2007. Systems of personal ornamentation in the early Upper Palaeolithic: methodological challenges and new observations. In P. Mellars, K. Boyle, O. Bar-Yosef and C. Stringer (eds.), *Rethinking the Human Revolution: New Behavioural and Biological Perspectives on the Origin and Dispersal of Modern Humans*, 287–302. Cambridge: McDonald Institute Monographs.

Whitley, J. 2013. Homer's entangled objects: narrative, agency and personhood in and out of Iron Age texts. *Cambridge Archaeological Journal* 23(3), 395–416.

Wilkinson, T. C. 2014a. *Tying the Threads of Eurasia: Trans-regional routes and material flows in Transcaucasia, Eastern Anatolia and Western Central Asia, c. 3000–1500 BC*. Leiden: Sidestone Press.

Wilkinson, T. C. 2014b. Dressing the house, dressing the pots: textile-inspired decoration in the late 3rd and 2nd millennia BC east Mediterranean. In Y. Galanakis, T. Wilkinson, J. Bennet (eds.), *ΑΘΥΡΜΑΤΑ (athyrmata). Critical Essays on the Archaeology of the Eastern Mediterranean in Honour of E. Susan Sherratt*, 261–274. Oxford: Archaeopress.

Williams, L. E., Huang, J. Y. and J. A. Bargh, 2009. The scaffolded mind: higher mental processes are grounded in early experience of the physical world. *European Journal of Social Psychology* 39, 1257–1267.

Wimsatt, W. C. and Griesemer, J. 2007. Reproducing entrenchments to scaffold culture: the central role of development in cultural evolution. In R. Sansom and R. Brandon (eds.), *Integrating Evolution and Development: From Theory to Practice*, 227–323. Cambridge, MA: MIT Press.

Winnicott, D. W. 1971. *Playing and Reality (1971; reprint)*. Harmondsworth: Penguin Books, 1988.

Wiseman, B. 2003. Claude Lévi-Strauss. In C. Murray (ed.), *Key Writers on Art: The Twentieth Century*, 185–192. London: Routledge.

Wiseman, B. 2007. *Lévi-Strauss, Anthropology, and Aesthetics*. Cambridge: Cambridge University Press.

Witmore, C. 2012. The realities of the past: archaeology, object-orientation, pragmatology. In B. R. Fortenberry and L. McAtackney (eds.), *Modern Materials: Proceedings from the Contemporary and Historical Archaeology in Theory Conference 2009*, 25–36. Oxford: Archaeopress.

Witmore, C. 2014. Archaeology and the new materialisms. *Journal of Contemporary Archaeology* 1(2), 203–246.

Wood, C. 2014. Aby Warburg, *Homo victor*. *Journal of Art Historiography* 11.

Wood, D., Bruner, J. S. and Ross, G. 1976. The role of tutoring in problem solving. *Journal of Child Psychology and Psychiatry* 17, 89–100.

Woolf, G. 2016. Movers and stayers. In L. de Ligt and L. Tacoma (eds.), *Migration and Mobility in the Early Roman Empire*, 438–461. Leiden: Brill.

Xu, F. and Carey, S. 1996. Infants' metaphysics: the case of numerical identity. *Cognitive Psychology* 30, 111–153.

Younger, J. 2010. Mycenaean seals and sealings. In E. Cline (ed.), *The Oxford Handbook of the Bronze Age Aegean*, 329–339. Oxford: Oxford University Press.

Zanker, P. 2012. Reading images without texts on Roman sarcophagi. *RES: Anthropology and Aesthetics* 61/62, 167–177.

Zedeno, M. N. 2008. Bundled worlds: the roles and interactions of complex objects from the North American Plains. *Journal of Archaeological Method and Theory* 15, 362–378.

Zedeno, M. N. 2009. Animating by association: index objects and relational taxonomies. *Cambridge Archaeological Journal* 19(3), 407–417.

Zeimbekis, M. 2004. The organisation of votive production and distribution in the peak sanctuaries of state society Crete: a perspective offered by the Juktas clay animal figurines. In G. Cadogan, E. Hatzaki and A. Vasilakis (eds.), *Knossos: Palace, City, State*, 351–361, BSA Studies 12. London: British School at Athens.

Zeki, S. 2003. *Inner Vision: An Exploration of Art and the Brain*. Oxford: Oxford University Press.

INDEX